# County Courthouses of OHIO

# County Courthouses of OHIO

## By Susan W. Thrane

### Photographs by Tom Patterson & Bill Patterson

Indiana University Press
Bloomington & Indianapolis

This book is a publication of

Indiana University Press
601 North Morton Street
Bloomington, IN 47404-3797 USA

http://www.indiana.edu/~iupress

*Telephone orders* 800-842-6796
*Fax orders* 812-855-7931
*Orders by e-mail* iuporder@indiana.edu

The paper used in this publication meets the minimum requirements
of American National Standard for Information Sciences—Permanence
of Paper for Printed Library Materials, ANSI Z39.48-1984.

Printed in China

Library of Congress Cataloging-in-Publication Data

Thrane, Susan W.
    County courthouses of Ohio / by Susan W. Thrane ; photographs
by Tom & Bill Patterson.
        p.  cm.
    Includes bibliographical references.
    ISBN 0-253-33778-X (cloth : alk. paper)
    1. Courthouses—Ohio—Guidebooks.   I. Patterson, Tom, date
II. Patterson, Bill, date   III. Title.

NA4472.O3 T48 2000
725'.15'09771—dc21                                    00-035005

1  2  3  4  5  05  04  03  02  01  00

# Table of Contents

# Alphabetical List of Counties

County government in Ohio predates statehood. Ohio's first county, Washington County, formed in 1788, was also the first county established in the Northwest Territory. Over the next 15 years, and by the time statehood was declared in 1803, nine more counties had been carved out of the wilderness that was then the "Ohio Country".

Building on a strong tradition of egalitarian democracy, 78 additional counties were established during the next 48 years providing a basic framework for the provision of essential local government services to an expanding population. Noble County, Ohio's 88th and last county was organized in 1851 when Ohio was the third most populous state with a population of 1,980,329. Hamilton County was then Ohio's largest county with 156,844 residents, while Paulding County residents numbered but 1,766.

It was not unusual after the formation of a county for a tavern or other gathering place to serve as the temporary home of the county court and as the meeting place for county commissioners until a permanent courthouse was constructed.

As Ohio approaches its Bicentennial, county government has changed greatly to respond to the needs of its citizens and of a changing society. No longer are those convicted of crimes allowed to pay fines in deer skins, corn, or pork. No longer do judges punish minor offenders with sentences like "thirty-nine lashes on the bare back." No longer can a county construct a courthouse for the $4,766 it cost to build the first Montgomery County Courthouse in 1806.

Yet, through the years, it is the courthouse that is the dominant symbol associated with the county and its government. It is the house that guarantees fair and impartial justice. It is the place citizens come to register complaints and demand a response from those elected to serve. It is the place to pay taxes and to support government services; the place to review property records; and the place to obtain a marriage license, record the birth of a child, or the death of a parent. It's halls have witnessed joy, pain and sorrow. It stands today, as it has from the beginning, dignified and solemn, a source of pride and a reminder of the blessings of freedom as embodied in our governmental institutions.

The County Commissioners Association of Ohio is proud to sponsor this extraordinary book that highlights Ohio's courthouses. Please join me on this journey. From the large city to small village. From the shores of Lake Erie to the banks of the Ohio River. From the black swamp of northwest Ohio to the rolling hills of Appalachia. Ohio's spectacular county courthouses–architectural and historical gems glistening on the horizon.

Sincerely,

Larry L. Long
Executive Director

# Preface

One crisp, bright November day, my husband and I were driving from Columbus on U.S. Route 33 toward a Thanksgiving family reunion in Chicago. As we approached Wapakoneta, a tower emerged above the treetops. Even at a distance I recognized it as part of a courthouse; Ohioans easily identify them, especially in the smaller communities throughout the state. But my sight of the courthouse that morning brought many questions to mind. Who built it? When? Why does it look the way it does? What is inside? After seeing one, have you seen them all? Before the turkey was carved, I had resolved to visit Ohio's eighty-eight county courthouses and find out the answers for myself.

When I subsequently discussed the idea of collaborating on a book about courthouses with photographer and graphic artist Bill Patterson and his son Tom, our focus was on the buildings. Later we realized that what is most important is not the building, but what it represents. As a result, *County Courthouses of Ohio* is not so much a comprehensive history of courthouse architecture as a way of observing the buildings in their larger context. This process involved examining a wide range of courthouse records and historical documents, and studying the buildings themselves from many angles: their style, materials, artwork, decorations, and location. Gradually the book evolved into a pattern of layered glimpses of Ohio–its early settlers, the partition of its land into counties, the emergence of Ohio's county seats, its commercial development and technological advances. Other topics included the historical preservation movement, and such factors as population growth, increasing governmental activity, and the ability of Ohioans to adapt to it all. Since the evolution of the courthouses' architectural styles is itself of great interest, the courthouses, with a few exceptions discussed in the text, are presented in chronological order.

*County Courthouses of Ohio* is the story of these buildings not only for the judges, lawyers and persons working in them, but also as a guide for

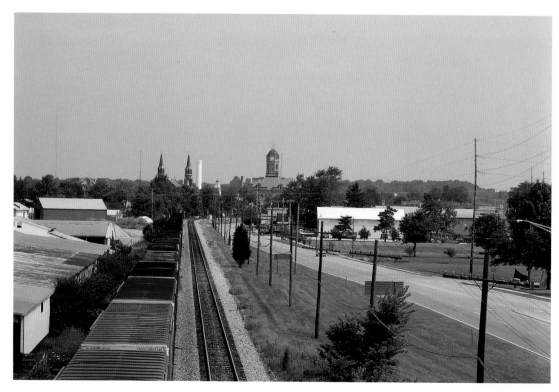

*Above: The tower of the Auglaize County Courthouse in Wapokoneta viewed from an overpass on U.S. Route 33.*

those who pass them every day and those citizens who are proud of their communities, and who may also wonder what goes on inside these buildings.

Gathering information and anecdotes, along with photographing the courthouses, took over five years. Driving thousands of miles, we endured ice, snow, numbing cold, and oppressive heat. Through it all, Bill and Tom Patterson remained unflappable and optimistic as they produced the magnificent photographs of this volume that I believe artistically capture the essence of the Ohio courthouse as a monument not only to our past but to the future. I am no less grateful to my husband Bill, for his encouragement, assistance, and good humor. Nor could this project have been completed without the generous assistance of courthouse judges, magistrates, courthouse residents, county historical society staffs, local law librarians, and the professionals at the Ohio Historical Society. Many county officials, most notably from Wood, Knox, Fairfield, Clinton, and Licking counties, offered unpublished but researched and printed materials that were helpful in flushing out lesser known details of their county and courthouse history.

Larry Long, Executive Director of the County Commissioners Association of Ohio, and Mary Jane Neiman, Public Relations Associate, graciously contacted officials of all eighty-eight counties to update and verify facts regarding their county. Franklin and Allen County administrators rewrote their chapter texts and they appear verbatim at their request.

The Bibliography lists books I have consulted in preparing this book. Among these, the following were of particular use, and I wish to take this opportunity to acknowledge their help:

Burke, Thomas Aquinas, *Ohio Lands–A Short History*, Ohio Auditor of State, 1997. In its eighth edition, this history was important in clarifying and mapping the early land subdivisions and federal land grants in Ohio along with the origin of the state's county names.

O'Bryant, Michael, editor, *The Ohio Almanac*, Orange-Frazier Press, Wilmington, Ohio, 1997.

A resource for verifying dates and specific details such as origin of the county names.

Knepper, George W., *Ohio and Its People*, The Kent State University Press, Kent, Ohio, 1989. This history was especially useful for incorporating a historical background to the dates and historical periods.

*Ohio Historic Inventory Manual*, Ohio Historic Preservation Office, Ohio Historical Society, Columbus, Ohio, 1992 and *Ohio and National Registries/Inventories*, Ohio Historic Preservation Office, Ohio Historical Society, Columbus, Ohio, 1992. The Manual explained, among other things, how to ascertain the dates attributed to the courthouses and access to the registries was especially valuable regarding architectural descriptions, names of the architects, and other details.

I wish to thank Bill Patterson, Jr. for his early interest and support in the courthouse project and for taking time from his busy schedule to assist with production aspects, Dan Patterson for flying the plane for our aerial photographs, and Weir McBride for the loan of his camera for the aerial shots. And to Graphics Terminal for all their assistance with film processing and enlargements in addition to Steve Krivian of Quickscan who carefully color corrected many of the scans. Also, Matt Drummy who gave me important encouragement along with the ongoing support of Sara Wilfong, John Wilfong, Mariann Quinn, and especially Jane Patterson. Nor can I forget to express my gratitude to Belinda Sifford whose red marker notations and suggestions periodically helped me to organize extensive scattered information into a book, and to Director John Gallman and the staff at Indiana University Press. Lastly, I want to express my appreciation to Paul Merchant, who through the miracle of cyber-space and more ordinary means, provided valuable editing assistance.

Susan Waddell Thrane

# Introduction

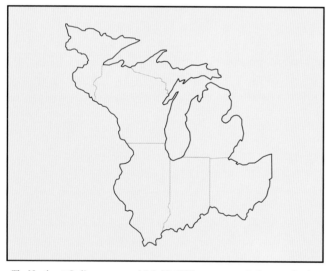

*Above: Mural in the Scioto County Courthouse depicting the inauguration of the first court in the Northwest territory at Marietta on September 2, 1788.*

*The Northwest Ordinance, enacted July 13, 1787, set out an orderly process for the formation of new states from western territory. The Northwest Territory (with Chillicothe as its capital) was later divided into six states: Ohio (1803); Indiana (1816); Illinois (1818); Michigan (1837); Wisconsin (1848); Minnesota (1848).*

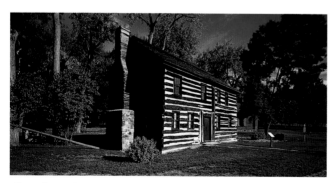

*Above: George Newcom's two-story log hewn house and tavern first used for Montgomery County Court. Preserved and relocated to Carillon Park, south of downtown Dayton.*

## Historical and Architectural Background

Ohio's eighty-eight county courthouses are an essential part of its landscape and history. While the buildings have evolved over years, their prime function of dispensing justice, whether keeping law and order in a frontier territory, later dividing up land and establishing rights to national resources, and most recently, determining the stock values of dissenting shareholders in a corporate sale, has been a key contribution to the state's history since its settlement in April 1788. The first governor of the Northwest Territory, Arthur St. Clair, organized the Court of Common Pleas when he established Washington County by proclamation on July 16, 1788. On September 2, 1788, the first Ohio court session took place in a blockhouse at Marietta, Washington County.

Subsequent courts, providing rough justice, were held in structures designed for other purposes. With statehood in 1803 and the developing of communities, settlers built log courthouses, then frame, and gradually more substantial masonry buildings. Even the brick and stone buildings included wooden interiors, which frequently burned, destroying courthouses and with them, valuable documents and records.

During the early years of the United States, from the late 1700s through the 1830s, the Federal style became a popular design for many first-generation courthouses. (See Glossary for definition of architectural and other terms throughout.) Brought from the British Isles to New England and on to Ohio, this style is characterized by a square or rectangular shape (brick or frame) topped with a low-hipped roof and a central entranceway. The doors and windows frequently incorporate fan and oval forms, narrow columns, and moldings. While few survive, two early examples remain, in Meigs and Perry counties, although neither presently serves as its county courthouse.

As the fledgling state flourished, Ohioans sought more substantial public buildings. This was to demonstrate their progress as well as to preserve the expanding birth and death registries, tax rolls, and the property deeds accumulating in larger numbers as a result of increased migration and acquisition of property at government land offices, through speculation, or by veterans' exercise of their bounty warrants.

The choice of courthouse architectural styles is a reflection of the politics and aspirations of the people. Influenced by studies of the antiquities of Greece, Ohioans adopted those symmetrical and orderly forms as a symbol of their own freedom and democracy. An added merit in adopting this style for buildings constructed in the largely uncivilized wilderness by unskilled workers was its uncomplicated plan of rectangular shapes with few adornments: simple columns, plain pilasters, and pedimented gables. One surviving example of these Greek Revival "temples of justice" is located in Brown County. The courthouses, crowned with towers, belfries, or cupolas, are often situated prominently in public squares, just as New Englanders frequently positioned their churches on or across from the village common. In fact, many of the Greek Revival courthouses resemble New England churches, perhaps indicating the early settlers' pride in taming the wilderness and establishing these shrines to the rule of law.

After the Civil War, as Ohioans became increasingly successful, among other things, in building transportation systems connecting them more easily with a wider world, they were eager to emulate European architecture, particularly that of Italy and the Parisian style of Napoleon III's Second Empire.

Italianate (sometimes known as Tuscan) features include: rectangular shape, shallow hip roofs, overhanging eaves with decorative brackets, entrance towers, paired round-headed windows with hood moldings, corner quoins, and balustraded balconies. The courthouse in Delaware county is representative of this style.

Second Empire is primarily characterized by its mansard roof, which was often decorated with colored slates in geometric patterns. Dormer windows, often with heavy carved trim, provide light for the additional floor space resulting from this roof design. Some ornamentation is similar to Italianate, such as oversized eaves with brackets, and paired windows with hood moldings. Later embellishments included classical pediments (often with

*Above: The old Meigs County Courthouse in Chester.*

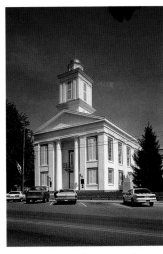

*Above: The Brown County Courthouse.*

*Above: The Delaware County Courthouse.*

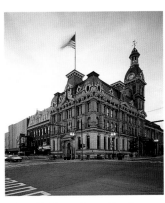

*Above: The Wayne County Courthouse*

The Cadiz Republican reported in September of 1895: "...the new Court House of Harrison County is now completed, and the various county offices have been moved into the new building this week. In point of architecture and construction, it is acknowledged by everybody to be one of the most beautiful court buildings in the state, and in all such matters as location, light, convenience of arrangement, and practical utility in general, it is absolutely unsurpassed."

sculpture groups), balustrades, and windows flanked by columns or pilasters, as evident in the Wayne County building.

During the 1870s and 1880s, considered the golden age of Ohio courthouse construction, as many as thirty of the eighty-eight were erected. This was the period of Ohio's industrialization and growing influence in national affairs. The state's visibility was enhanced during the Civil War both by the large number of its soldiers fighting and through the influence of military leaders with Ohio connections, such as Ulysses S. Grant, William Tecumseh Sherman, and Philip Sheridan, along with political leaders such as Secretary of War Edwin M. Stanton, Secretary of Treasury Salmon P. Chase, and financier Jay Cooke. Ohio's national status was also increased by its position between the established east and the emerging west. Moreover, as the third most populous state, its large electoral delegation exerted national political influence. As Ohio's urban centers grew, so its population represented a cross-section of Americans. Also, significantly, the state contained abundant natural resources for cheap energy to assist industrial development, along with a plentiful labor force during a time of mass immigration.

This was also a time when the counties competed with each other in building the largest and most lavish courthouses. The rich colors and materials typical of the exuberance of the period provided a measure of growing self-esteem. Civic pride was most readily expressed in public buildings, and local newspaper accounts from the period repeatedly boasted that their county capitol was the finest in the state.

Contributing to this building boom was an Act of the State Legislature, passed on April 27, 1869, that permitted counties to issue bonds, not exceeding one thousand dollars, to acquire funds for constructing large buildings. Referred to as the "Seven Year Act," it directed county commissioners to levy taxes each year to pay the interest and at least one-seventh of the principal on these bonds. The statute further distinguished

professional architects from carpenters and builders who incorporated architectural patterns from books written by master builders. According to the statute, architects were to draw up plans and supervise the construction of the buildings. Many were later influenced by American Henry Hobson Richardson's Romanesque style, which incorporated rough-textured stone or mixed stone and brick with round arches framing windows and doors, cavernous door openings, carved stone ornamentation, and a single tower, often asymmetrical. Of this style, Greene County Courthouse is an example.

By the turn of the century, advancing technology brought heating and electrical systems to public buildings. It was also a time of reaction to the heavy eclectic ornamentation of the Gilded or Victorian period. Towers disappeared, and the emphasis became more horizontal. Some of the architects working during this period received their training at, or were inspired by, the École des Beaux-Arts in Paris, the most influential school of the period. These architects produced designs once again based on classical precedents.

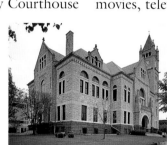
*Above: The Greene County Courthouse.*

Neo-classical designs are characterized by large-scale columns supporting porticos or pediments, full eave-line entablatures, and stone balustrades or parapets rimming the edges of low roofs. Mercer Courthouse is one of the best examples. Renaissance Revival designs differentiated stories by the use of stringcourses, contrasts in the degree of rustication, or arched openings on one floor and a columned balustrade above. Other elements include centrally placed doorways, windows arranged in an ordered manner, and decorative detail.

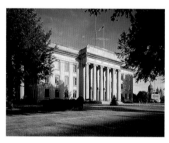
*Above: The Mercer County Courthouse.*

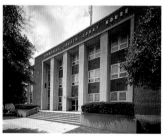
*Above: The Champaign County Courthouse.*

Although there were federally financed courthouse activities of the Works Progress Administration (W.P.A.) during the 1930s, from 1929, when the Ashland County Courthouse was completed, until 1957 there was no locally financed courthouse construction. At that time, Champaign County dedicated an unadorned courthouse to replace one destroyed by fire nine years earlier. Champaign officials encountered difficulties in raising financial support for construction, even to replace a missing courthouse.

Nor was courthouse construction a priority during the following years.

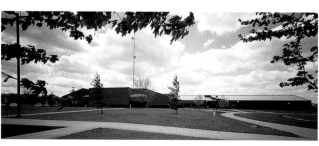
*Above: The Warren County Courthouse.*

Some areas of the state were experiencing a loss of their industrial base to southern states, or to foreign lands where labor was cheaper and the factories updated. As a result of lean times, many courthouses were neglected, and others "modernized" or compromised by alterations damaging their integrity. While some courthouses were still respected as centers of the community, citizens sometimes viewed them negatively, as reminders of such onerous duties as child-support payments, jury duty, and taxes. At the same time, movies, television and other forms of entertainment replaced the communal activities of public celebrations and trials at the local courthouse.

By the 1960s and 1970s, as the state adapted to changes and prosperity returned, counties started outgrowing their historic edifices. Today, lack of space or exorbitant costs can prohibit building nearby. Some are replacing their old centrally located buildings with functional, suburban office structures surrounded by parking lots. Warren County Courthouse, situated within the urban sprawl of Cincinnati in the southwestern corner of Ohio, is an example. Designated "judicial or justice centers," these modern buildings include the county jail and juvenile detention center, while offering citizens the convenience of suburban shopping malls.

Coincidentally, in an effort to bring public attention to the courthouses' plight, most of them were designated historical treasures by the National Register of Historical Places. This Registry contains a list of properties determined to be of national, state, or local significance, worthy of preservation and consideration in planning and development decisions. Many view the revitalization of old historic buildings, our heritage, as an effort to fulfill the need for stability and substance, to counteract the nation's growing rootless development. Furthermore, county officials are increasingly making decisions to restore rather than to demolish, although some, especially in the less populated counties, are faced with a difficult choice. While the courthouses and jails have long met their requirements, counties are confronted with an expansion of laws and regulations (such as the Americans with Disabilities Act) as well as increasing

judicial, administrative and law enforcement demands, limited parking, extra expenses of transporting surplus prisoners to other counties, and outdated jail conditions. These issues raise serious questions whether courthouses and jails should be preserved and restored or abandoned.

Relocation may hurt downtown businesses and increase urban sprawl. Moreover, the cost of constructing outlying facilities may be less than that of preservation. On the other hand, it is difficult to upgrade safety codes, functional demands and technology without sacrificing the character and integrity of the buildings. Meanwhile, as Ohio prepares to mark the bicentennial of its statehood, the courthouse continues to evolve and to reflect Ohio's diversity and changing environment. Technology is further modifying the function and scale of the courthouse, with recently constructed buildings, such as that of Franklin County, becoming monuments to the future.

# The Courthouse and its Organization

Today, the county courthouse is the symbolic center of county government although, as the name implies, its primary purpose has always been to provide facilities for court functions. While the exterior choice of architecture depends, among other things, on current taste, on the level of resources, and on available technology, the interior must also reflect its judicial and administrative functions. The earliest courthouses had at least one room for the circuit judges who were constantly on the move, "riding the circuits," to struggling settlements in the wilderness. Under the state's first Constitution, Ohio was divided into three judicial circuits, each with a legislature-appointed judge, who served as president of the court, and three associate justices who sometimes had no legal background.

Under the 1851 Constitution, still in effect although significantly amended, the judges were removed from the circuits by dividing Ohio into nine Judicial Districts, each with three subdivisions. Common Pleas Judges were elected by the people within the subdivision rather than appointed by the Legislature.

In 1912, the 1851 document was amended to abolish the Judicial Districts and subdivisions, and to institute the election of at least one Common Pleas Court judge per county. Today, courts are presided over by a judge elected every six years on a non-partisan ballot. These courts hear civil matters such as personal injury and damage cases. In criminal actions, it has original jurisdiction when a defendant is indicted for a felony, such as burglary, armed robbery, murder, or arson.

The **Common Pleas** courtroom consists of the traditional elevated judge's bench, clerk's desk, counsel tables, witness stand, jury box, and, separated by a bar, seats for the public. During the mid-nineteenth century, courtrooms were the focal point of their courthouses. Large, with high ceilings, they accommodated spectators at trials and other events-civil, religious, military, social, and political. Interiors were frequently ornate, with references to local judicial history.

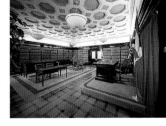

*Above: A Common Pleas courtroom in Stark County.*

*Above: A Probate courtroom in Mercer County.*

The number of courtrooms in a courthouse depends on the population of the county. Seven of the lesser-populated counties have one Common Pleas judge who hears all cases; in others, the **Probate** and **Juvenile** courts are unified under one judge. Increasingly, these courts have been assigned separate judges and courtrooms. Newer buildings specifically provide for them, while older ones must often convert offices or divide historic courtrooms, or do whatever is necessary to accommodate demand.

The Ohio Revised Code (state law) assigns over two hundred duties to the Probate Court, including settling and administering estates of deceased persons, issuing marriage licenses and birth records, and overseeing adoptions. Each county has a Probate Court judge who is *ex officio* clerk of his own court, and administers its records department.

Juvenile courts hear cases involving persons younger than eighteen whose acts would have been criminal if committed by adults. The court also considers circumstances of unruly, dependent and neglected children, and adult actions regarding paternity, child abuse, non-support, contributing to delinquency, and failure to send children to school. Twenty-three counties have Domestic Relations Divisions of the Court of Common Pleas, where family matters including divorce, dissolution of marriage, separation, child custody, support, and visitation are considered.

Closely associated with well-functioning courts are the county **Law Libraries**. While some may consist of no more than bookshelves lining a courtroom, others

# County Courthouses of Ohio

*Above: The Law Library in Seneca County.*

are staffed, and contain extensive collections, such as Hamilton County's, considered the oldest law library west of the Allegheny Mountains. In 1823, an act of the state legislature appointed the first court stenographers (reporters) of adjudicated cases. Courthouse libraries contain multitudes of such cases gathered into volumes (also called reporters), where recorded decisions are accompanied by the court's arguments and rationale. Digested and indexed, these cases are the source of precedents for common-law arguments.

One of the busiest locations in a courthouse is the office of the **Clerk of Courts**. The clerk maintains all civil and criminal records, as well as divorce and Courts of Appeals cases. Lawsuits begin here with the filing of a complaint. The clerk issues summonses, court orders, and other papers for service upon litigants, and is responsible for disbursing money received from court judgments, court costs, and other fees. The responsibilities and duties of the clerk are set out in over two hundred and fifty sections of the Ohio Revised Code.

Reflecting an increasingly violent society, a recent Franklin County Courthouse addition was constructed as a high-rise fortress. In addition to a technologically sophisticated security system, it is specifically designed to provide separate elevators and corridors for judges, juries, defendants and the public.

The Ohio Supreme Court/Judicial Conference Committee on Court Security recommends such separation and other measures for each trial court, in order to provide a safe environment for the administration of justice. Every county is mandated to file a written Security Policy and Procedures Manual with the Committee. Security systems have been added, with varying degrees of aesthetic and functional success, to the courthouses, but Ohio's counties are diverse, and each county reflects its unique circumstances. In Muskingum, for example, security measures enacted include closed-circuit video surveillance (viewed by the Sheriff's department), metal detectors, bullet-proof judicial benches, a roving deputy, probation officers and bailiffs licensed to carry guns, installation of duress alarms and restricted access to offices—particularly the judges' chambers.

From the 1870s to the turn of the century, county officials sometimes decided to combine sheriffs' living quarters and jails, next to or nearby the courthouses. Usually the residence was located near the street, with the jail behind, built from the same material. It was believed that the sheriff's wife could maintain the jail, cook, and serve meals to the prisoners, and the "family atmosphere" would be a positive model for the inmates. Later, some architects incorporated the jail into the courthouse itself.

Pickaway County, like many others, has a vacant jail and residence on its hands. One option under consideration is to demolish the jail portion of the structure, while retaining the residence and incorporating it into an office building. Reflecting the nation's prison population growth, Ohio counties are building fewer courthouses and larger and more modern jails that are rarely next to the courthouses. The new Trumbull County Jail, however, is across the street from the courthouse and echoes its rounded turrets.

The courthouse has historically accommodated more than the county courts. During the colonial era, the establishment of counties as political institutions was imported from England. Their formation in Ohio predated the organization of the state or the adoption of the first constitution. In 1787, the United States Congress, through the Northwest Ordinance, directed the governor of the Northwest Territory "to lay out the parts of the district in which the Indian titles shall have been extinguished, into counties and townships, subject however, to such alterations as may thereafter be made by the legislature." When Ohio became a state, on March 1, 1803, that responsibility shifted to the legislature, pursuant to the Constitution of 1802.

Until a county was formally organized, it remained attached to its parent or surrounding counties. This could continue for years, depending on the date of the legislative act establishing it. Since counties were usually created from existing ones, earlier records sometimes existed in parent or surrounding counties making it possible for a land owner, without once moving, to have records showing as many as four different counties of residence.

The Constitution of 1851 limited legislative power in creating counties, by requiring that new counties contain at least four hundred square miles, and that the voters affected must approve the change. Since this revision no new counties have been formed, so that the last county to be created was Noble County on April 1, 1851, before the constitutional change.

The Ohio constitution further recognized counties as subdivisions of the state, with only those powers delegated to them by the General Assembly. For example, by statute, each county is required to provide administrative offices and a safe place for official documents. This requirement further influences the courthouse's interior design.

Initially, the offices were located in the courthouses, but with increasing populations and corresponding growth in paper work, many counties have chosen to retain their historic courthouses for court proceedings, at the same

time constructing or renting additions and/or annexes as office-space for administrators. These court officials include the following:

*Above: The office of the Logan County Commissioners.*

The three elected **County Commissioners**, the executive officers of the county, who act for it in financial, contractual, and business matters.

The **County Engineer**, who establishes the legal boundary lines of properties, and administers roadwork and other forms of public improvement in the county. The Engineer is also responsible for plans, estimates, surveys, construction, supervision, and maintenance of county buildings.

The **County Recorder**, who keeps account of the sales and transfers of land, maintains a record of plats and descriptions of all county land, and records, deeds, mortgages, contracts, and other legal papers.

The **County Auditor**, the chief fiscal officer, who is responsible for an accounting of all money paid into or out of the treasury, and for determining the tax value of real estate and personal property, and the distribution of tax money to agencies.

The **County Treasurer**, who collects, invests, and disburses public funds.

The **Prosecuting Attorney**, who represents the county and state in criminal and civil actions, investigates criminal activities, and determines if there is evidence to present a case to the grand jury. If the grand jury returns an indictment, the attorney prepares the case for prosecution in court.

The **Sheriff**, who preserves the public peace by enforcing the laws, investigating civil and criminal offenses, and making arrests. He or she has the duty of executing all warrants, writs and other process issued, and is in charge of the county jail as well as transporting prisoners to courts, penal institutions or medical facilities.

The **Board of Elections**, which is responsible for administering elections and supervising voter registration.

The **Coroner**, who investigates sudden and mysterious deaths and keeps a record of investigations, inquests, and the properties of the deceased.

The **Public Defender**, who provides for legal representation to indigent persons accused of criminal acts for which the penalty may include incarceration.

In addition to administrative agencies, there are numerous county boards and commissions such as the **Board of Health** and the **Department of Human Services**, that place additional stress upon courthouse facilities with their demand for additional services and personnel.

But the courthouses are not only judicial and administrative workplaces, they are about and for the people, and in examining them we see unfold a portion of Ohio's history. We will start with the oldest building that still houses a county court, and then, with only the few exceptions noted in each case, move chronologically to the newest and most technologically advanced.

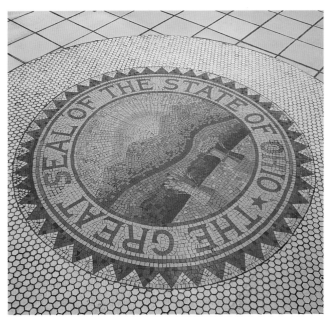

*Above: The Great Seal of the State of Ohio in the lobby of the Ross County Courthouse in Chilicothe. Nearby is Adena, the home of Thomas Worthington, where the view that inspired the seal can be seen.*

# *Ohio Counties*

### Date Established

### *Date Organized*

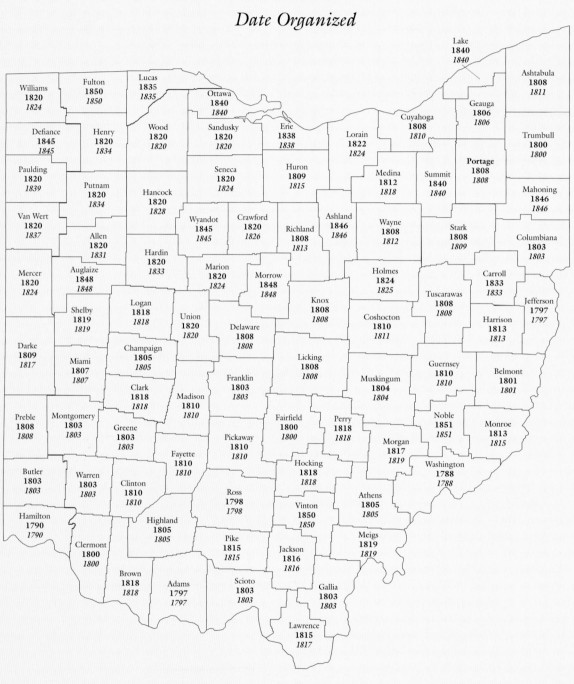

# County Courthouses of OHIO

# Highland County

*Origin of name: the county's terrain*
*County Seat: Hillsboro*
*Courthouse construction: 1832-35*
*Architect: Pleasant Arthur (attributed)*

The Highland County Courthouse is the oldest Ohio structure still in continuous use as a courthouse. The rear wings date from 1884. Located in a rural county, outside the reach of the urban sprawl spreading inevitably eastward from Cincinnati, the Highland County Courthouse endures largely because it still meets the county's requirements.

It is an example of a recurring theme of Ohio county courthouse construction—incorporating elements of more than one architectural style. Since the early courthouses were built by local contractors, self-educated in popular European designs, they often blended their favorite modes into the construction. This building combines Federal and Greek architectural elements. The fanlight of the main entrance, arcading of the side windows and the octagonal belfry are Federal characteristics, while the rectangular form, Ionic columns and key cornice are considered Greek Revival elements.

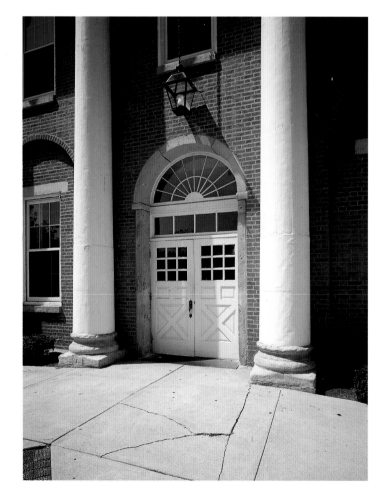

*Above: A fanlight above the transom of the main entrance.*

*Above: Detail of Greek key cornice and arcading of the west windows. Window sashes are made up of small panes of glass, larger pieces being more difficult to fashion in the 1830s.*

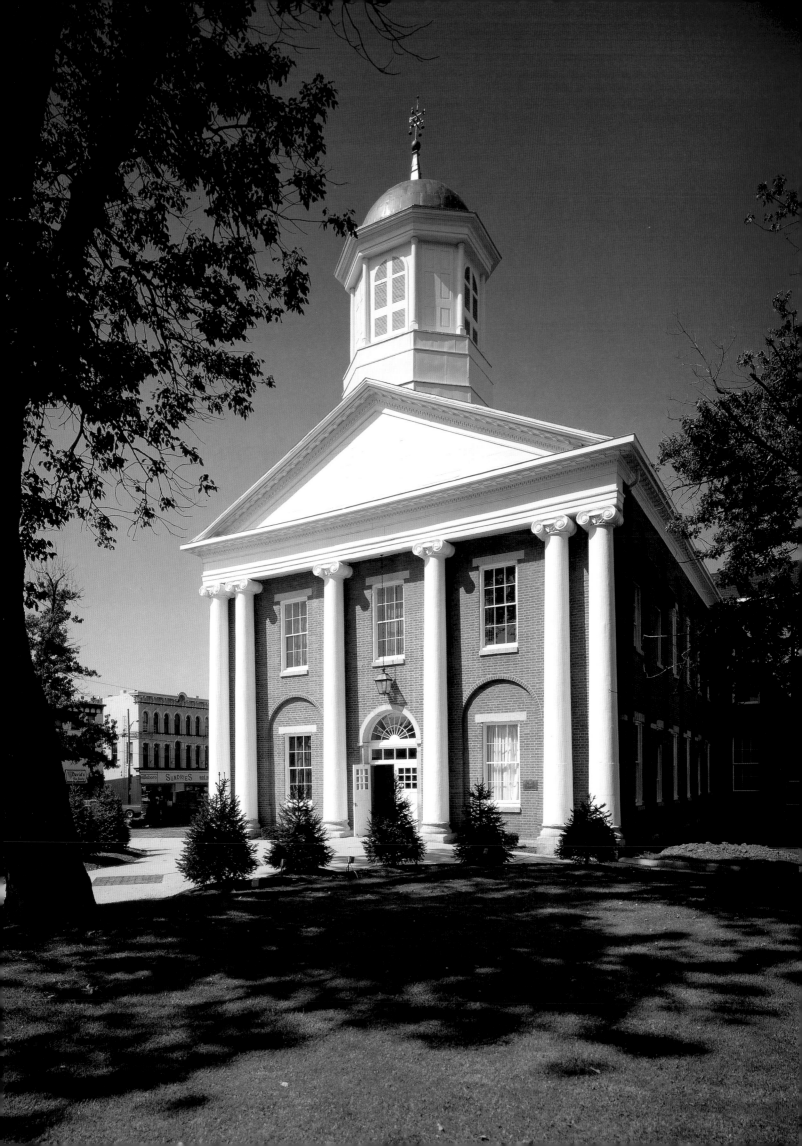

# Highland County

The shelves of Ohio's oldest courthouse contain reporters that record disputes arising from the last will of Englishman Samuel Gist, dated June 22, 1808. His testament provided for the purchase of Ohio land from the proceeds of the sale of his Virginia plantation, to be held in trust for nearly two hundred of his freed slaves and heirs. It was Gist's paternalistic intention that the properties be handed down intact to future generations, and an endowment set up so the land would remain, to the freedmen, tax exempt.

With Gist's death in 1815, a tangle of land claims and lawsuits emerged. While the Virginia General Assembly permitted the liberation, or manumission, of his slaves, it stipulated that the slaves be removed from the state. It also required that the estate's debts be settled before money and properties could be distributed to the beneficiaries.

So it was not until 1831 that the last of the former slaves was moved to a tract of land in Highland County—207 acres costing $1,300. The freedmen, however, lacked titles, as the trust distributed the land in common.

In 1851, the Ohio General Assembly passed an "Act for the Relief of the Negroes resident in this state, emancipated in the state of Virginia by the last will and testament of Samuel Gest, late of England." This sought to shelter the freedmen from the risk of land forfeiture through confusion over individual ownerships, and whether former slaves or trust fund were liable for taxes. Confusion continued even after a new division of the land in 1895, and as late as 1941 county tax maps left the tract blank. Disorder persists today.

*Above: Gist records. Left, handwritten in 1857; right, documents from 1948 to 1962.*

# Medina County

*Origin of name: Medina, where Mohammed fled from Mecca*
*County Seat: Medina*
*Courthouse construction : 1840-1841*
*Architect: Contractor D.H. Weed*

Next to the old Medina County Courthouse entrance hangs a 1970 National Register of Historical Places plaque declaring it an historical treasure. This is not only because it is one of the oldest county courthouses in continuous use and is located across the street from an early common, but it is an example of a building destined to be rebuilt, each generation adapting and modifying it for its own needs.

The original 1841 two-story rectangular Greek Revival building featured a cupola topped by a wooden ball. Its transformation began in 1873 in a conversion to the then more popular Second Empire style. The façade was recessed between two side-wing additions, connected by a two-story iron portico with a second-floor balcony. A mansard roof extension was heightened further with a three-tiered tower. The development of cast iron and pressed metal technology made possible economical mass production of such decorative features as the cornice, eliminating the need for hand-carved stone.

Additions to the rear of the building were completed in 1906, 1933, and 1951. The Medina County Gazette reported on September 15, 1933 that plaster fell from the ceiling, injuring the custodian, who was sent home to recuperate. Subsequently, an office addition and a basement "public comfort station" were constructed by a hundred workmen with an $18,000 federal Works Progress Administration (W.P.A.) subsidy.

In 1969, in order to meet the demands of the growing population for a second Common Pleas Court, a building, also called the Medina County Courthouse, was completed next to the altered original. A passageway connects the new with the old.

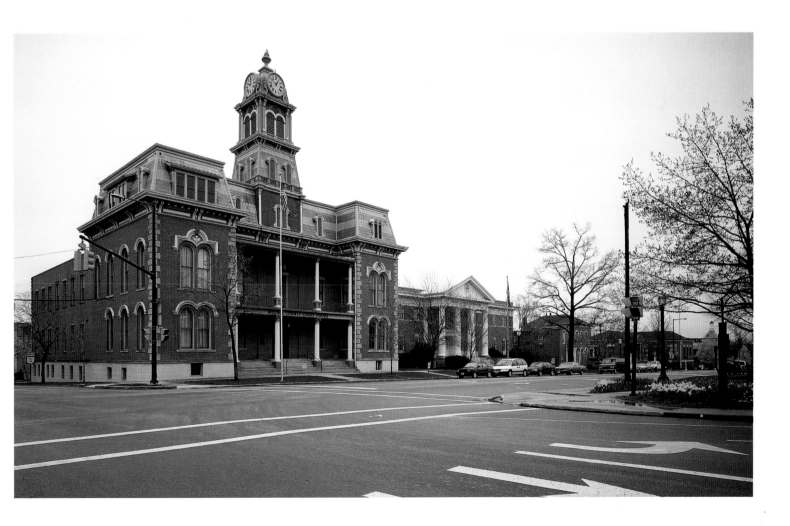

*Above: Old courthouse with mansard roof, dormer windows, cornice supported by brackets, clock tower and later additions.*

# Medina County

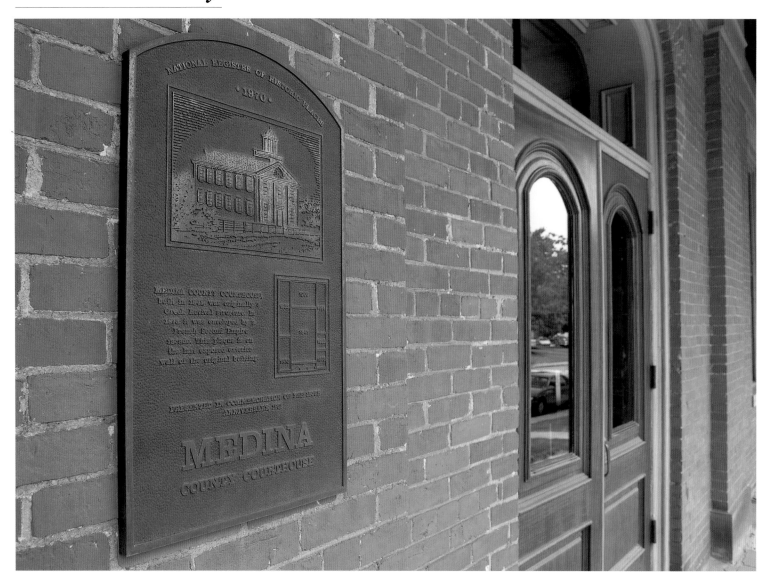

Above: 1970 National Register of Historical Places plaque beside the old courthouse entrance, with brief history, the dates of additions, and a plan illustrating the additions enveloping the 1841 Greek Revival styled building.

Above: The First Medina County Courthouse, completed in 1821, the oldest public building in Medina, now houses Whitey's Army-Navy Store and Strictly Bears.

Above: Sixteen-inch diameter weathered wooden ball, original to 1841 courthouse before its transformation. Now located at Medina County Historical Society along with two of eight wooden hands from the clock of the Second-Empire tower donated to the Society in 1995 by the Medina County Commissioners.

# Sandusky County

*Origin of name: Native American word meaning "cold water"*
*County Seat: Fremont*
*Courthouse construction: 1840-44*
*Architect: Cyrus Williams*

For half a century after the Civil War, Ohio became known as the "mother of Presidents." It was a period when Ohio became an important influence in national affairs. One of the seven Ohio native-born sons (all Republicans) was Rutherford B. Hayes (1822-1893). Hayes, born in Delaware, graduated from Kenyon College and Harvard Law School.

From 1845 to 1849, at the start of his professional career, Hayes practiced law in Sandusky County. His last appearance at the local bar was in support of a "Petition to Change the Name of Lower Sandusky to Fremont" on October 15, 1849. Hayes promoted the name change, believing there were too many towns called Sandusky within one hundred miles from the river's source to Lake Erie. This resulted, among other things, in problems with mail delivery. He selected the name Fremont in honor of the explorer, John

C. Frémont, who eloped with Jessie Benton, daughter of Senator Thomas H. Benton. Soon after the Court affirmed the name-change, Hayes left for Cincinnati, where his career spanned a period as City Solicitor, Civil War Major General, Member of Congress, three-term Governor of Ohio (1868-1876) and, after a disputed 1876 election, President of the United States.

One of the most notable historic events to occur in the county was the defense of Fort Stephenson during the War of 1812. Located on the high west bank of the Sandusky River, the fort was successfully defended on August 2, 1813 by a single artillery piece, "Old Betsy," against an overwhelming force of Native Americans and British soldiers. This clash was the last major British operation on American soil.

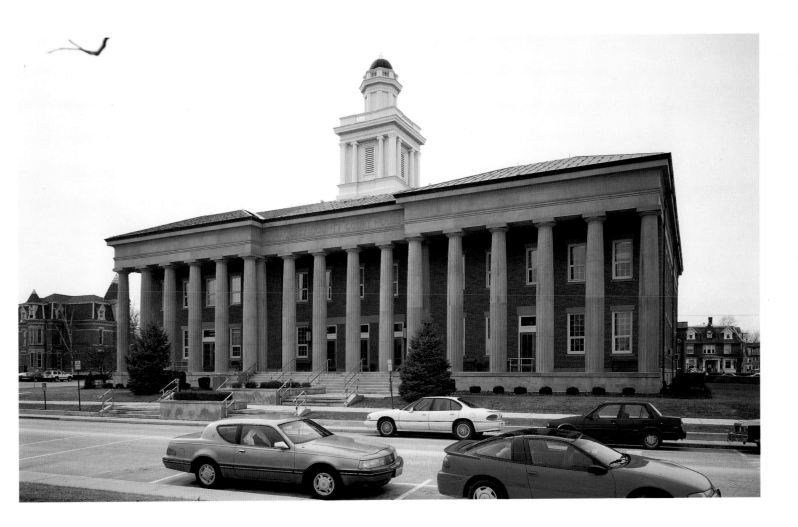

*Above: The Sandusky County Courthouse.*

# Sandusky County

*In the square across the street from the courthouse is a plaque outlining part of the county's rich heritage:*

*Fremont*

• *County Seat of Sandusky County, Ohio*
• *The Junguindundeh of the Indians, and the Lower Sandusky of the Revolutionary War and War of 1812.*
• *An old neutral town of the Eries used as a refuge on the destruction of the Huron Commonwealth by the Iroquois in 1650.*
• *Westernmost point reached by the British and Colonial Troops from New York, New Jersey and Connecticut under Israel Putnam in Bradstreet's expedition against Pontiac in 1764.*
• *A British Post established here during the Revolutionary War.*
• *Daniel Boone, Simon Kenton, the Moravians Heckewelder, Zeisberger and over 1000 whites held here as prisoners by Indians.*
• *Fort Stephenson built in 1812, and gallantly defended by Major George Croghan, 17th U.S. Infantry with 160 men against 2000 British and Indians under Proctor and Tecumseh, August 1st and 2nd, 1813.*
• *Spiegel Grove the home of Rutherford B. Hayes, 19th President of the United States.*

Situated nearby, on the west bank, is the courthouse. In keeping with the preservation of the historic area, the county retained the original 1844 courthouse as a north wing when it became necessary to increase court and administrative space during the 1930s. Using funds from the Works Progress Administration (W.P.A.), compatible southern and central sections were added to the original building. The octagonal cupola, with its small circular copper dome, was transferred to the central portion, and the original six wooden columns were replaced with eighteen elongated fluted Doric sandstone columns. The wide portico is encompassed by a wooden entablature.

Below the north wing, twelve small dungeon-like cells, the stone foundation for the first courthouse, remain intact—a reminder of early jail conditions. Perhaps their crudeness precipitated Hayes to work for prison reform, and later to serve as president of the National Prison Association from 1884 to 1892.

*Above: Dungeon, consisting of limestone blocks hand-quarried from local quarries. Prisoners were confined here until about 1854. At that time, land was purchased behind the courthouse, and a jail was constructed above ground.*

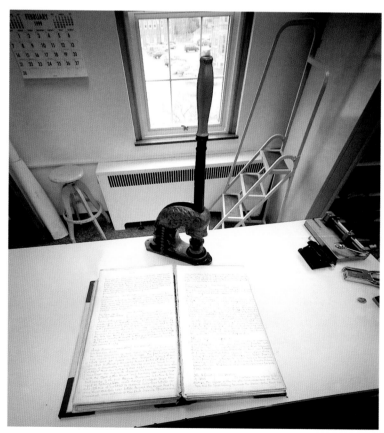

*Above: Journal, no. 6, page 437, October 15, 1849: Petition to Change the Name of Lower Sandusky to Fremont, filed by the young attorney Rutherford B. Hayes beside an early hand-stamp on the counter in the Clerk of Courts office.*

# Meigs County

*Origin of name: Return Jonathan Meigs, Jr., Ohio Governor 1810 to 1814*
*County Seat: Pomeroy*
*Courthouse construction: 1845-48*
*Architect: S.S. Bergin*

Public sculptures, a visible reminder of the people and events that shape a community, are often erected on courthouse grounds. The Civil War statue, dedicated in 1870, on the Meigs County Courthouse lawn, is such a monument. Engraved on its bronze plaque are the names of over five hundred Meigs Countians who died in the conflict.

With Meigs County located on the Ohio River directly across from Virginia (after 1863, West Virginia), some of its soldiers died in Ohio's only significant Civil War battle (July 19, 1863). This took place when a confederate officer, John Hunt Morgan (1825-1864) led nearly two thousand troops ("raiders") into Meigs County after crossing southern Ohio. Running into resistance around Pomeroy and Chester, Morgan tried to escape to Virginia by fording the river, but at Buffington Island was engaged by federal troops and the Ohio militia. Morgan fled with about twelve hundred men, and traveled north until finally surrendering near East Liverpool, in the furthest northerly confederate penetration into Ohio.

Morgan and his officers were sent to the Ohio Penitentiary in Columbus, where on November 26, 1863, he and six others successfully escaped. This rare feat was reportedly accomplished by cutting through the cell's stone floor until they reached an air chamber below. From there they tunneled through the fortress and scaled the outer wall using ropes made from their bedding. Returning to fight for the south, Morgan was killed the following year in Tennessee.

Overlooking the Ohio River, the courthouse building includes a central structure with Doric columns and pediment. Decorative features include pilasters, bracketed cornice, and the cylindrical tower with its dome. The cupola has two bands of round-arched louvered windows. Its position close against the cliffs meant that new office space had to be constructed to each side of the building. These wings, dating from 1877, form the recessed entranceway, with curved exterior stairwells facilitating outside entrances to all three floors.

This early courthouse survives, abutting the cliffs of Pomeroy and looking down Court Street

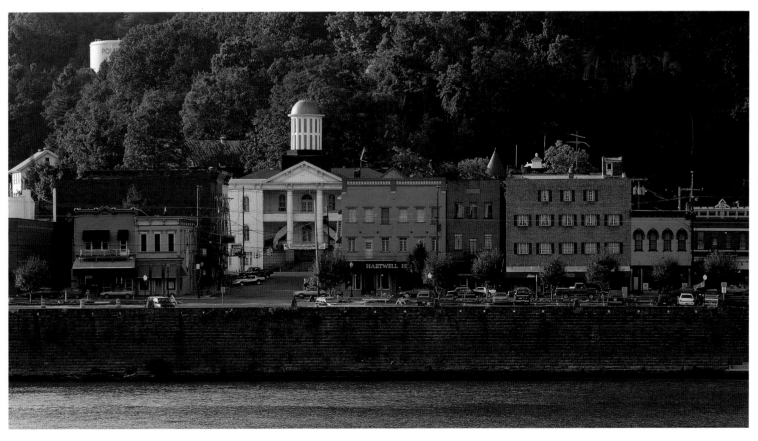

*Above: A West Virginia view of Pomeroy with its courthouse tower.*

# Meigs County

toward the Ohio River, primarily due to the county's limited growth. Since World War I, the area's major business, coal mining, has diminished, restricting its growth and inhibiting new construction. Ironically, the benign neglect of generations contributed to its preservation.

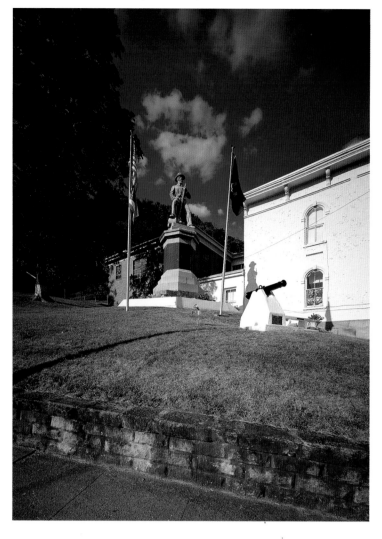

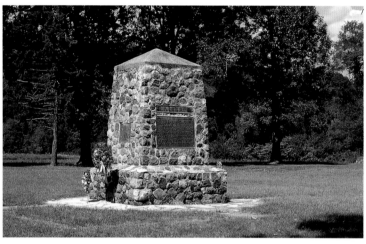

*Above: A monument on Buffington Island commemorating the rebuff of the Confederate troops led by John H. Morgan.*

*Above: A Civil War statue standing on the south lawn.*

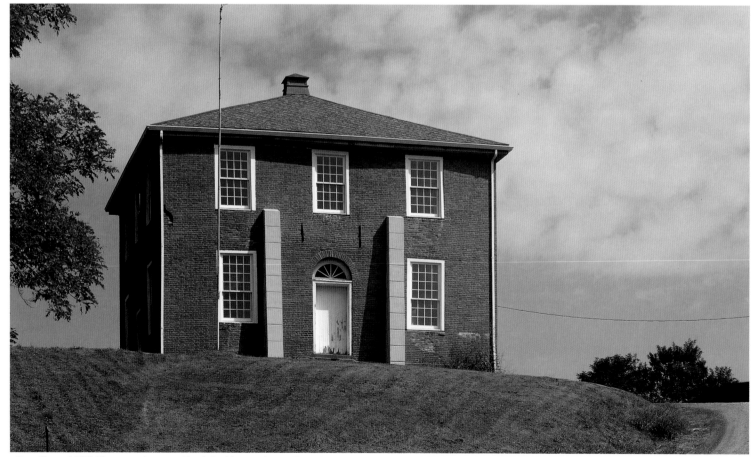

*Above: Restored 1820 Chester courthouse, considered the oldest courthouse still standing in Ohio. Chester was Meigs County's original seat of government until the move to Pomeroy in 1841. When the two-story Federal-styled brick building (with four downstairs rooms and four upstairs) was built, a log cabin was erected nearby for a jail.*

# Montgomery County

*Origin of name: General Richard Montgomery, Revolutionary War Hero*
*County Seat: Dayton*
*Courthouse construction: 1847-50*
*Architect: Howard Daniels*

The 1850 Greek Revival "temple of justice" has been replaced by twentieth-century office buildings. Because of its historical and architectural significance (it is considered one of the best examples of Greek Revival architecture in the United States), the largely unaltered old courthouse represents Montgomery County in *County Courthouses of Ohio.*

Situated in the center of downtown Dayton, the courthouse steps have been the location of historic events. One of the most notable was on September 17, 1859, when Abraham Lincoln (1809 - 1865) denounced slavery in this center for antiwar Peace Democrats (Copperheads) who opposed him and later his administration's policies. Copperheads believed slavery to be constitutionally protected, and states had a right to secede. Dayton's congressman, attorney Clement L. Vallandigham (1820-1871), was a leader of the Copperhead Party and a vocal critic of Lincoln in Congress. Even after Vallandigham was defeated in the 1862 election, his condemnation of Lincoln persisted. His unyielding criticism reportedly prompted General Ambrose E. Burnside, headquartered in Cincinnati, to issue an order forbidding any denunciation of the Lincoln's administration's war policies.

Vallandigham continued. On May 5, 1863, he was arrested and convicted by a military tribunal for violating the order. Rioting broke out in Dayton in support of his right to free speech but before he could be imprisoned, Lincoln, under

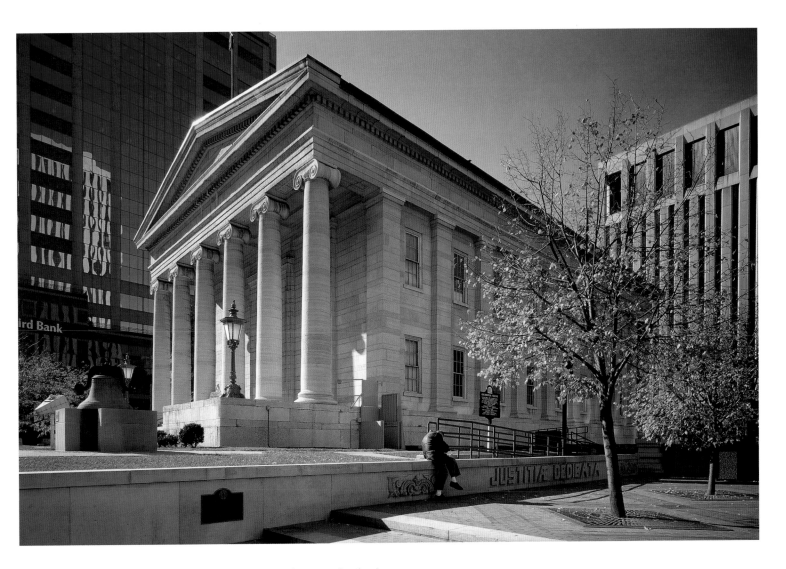

*Above: Courthouse. Stones for the wall were part of the new county courthouse, erected at that site in 1884 and razed in 1974. Cast iron lamps on the portico originally burned whale oil.*

pressure, intervened and commuted his sentence to expulsion to the Confederacy. Journeying from there to a brief exile in Canada, Vallandigham returned during 1864 to practice law in Dayton. His career came to an abrupt halt during June 1871. While Vallandigham was defending an alleged murderer, in demonstrating how the victim died, he fatally wounded himself. He did, however, win the case. The citizens of Dayton, who loved and admired Vallandigham's advocacy of free speech, flocked to his funeral-reportedly one of the longest processions in Dayton's history.

The courthouse where he practiced survives as a monument to our ancestors. It is constructed with alternate wide and narrow courses of limestone, quarried entirely in the Dayton vicinity. This stone, called Dayton marble, was extracted from the Dickey and Frybarger quarries in nearby Centerville and Beavertown, and transported by oxen over wooden tracks (Dayton's first railroad, built to carry stone for the Miami-Erie Canal locks) to the construction site. There, stonecutters dressed or prepared the limestone using saws, sand, and water as in ancient Egypt.

Cincinnati architect Howard Daniels designed the building in temple form, although he substituted pilasters on the sides for columns, and incorporated Roman arches and vaults for its support. His plan for the rear elevation is unique. A single freestanding Ionic column stands at each corner with pilasters between, giving the side elevation the appearance of a rear portico, to match the one in front. The rear walls curve on a semi-circular arc, corresponding to the elliptical configuration of the courtroom.

The cantilevered stone staircase in the central tower, with nearly one third of its length embedded in the inner wall, leads first to the courtroom gallery and continues to the second-floor offices. This unusual design, with no apparent support, is attributed to a Swiss immigrant who came to the Dayton area to work on the stone locks of the Miami and Erie Canal.

Today, the courthouse has been adapted to house the Montgomery County Historical Society.

*Above: Wood and exterior iron doors as viewed from courtroom.*

*Above: Brick arches in the attic support the stone roof above.*

# Montgomery County

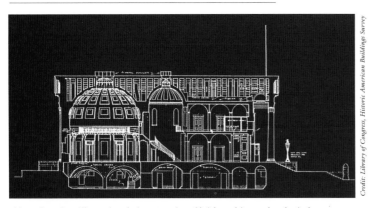

*Above: Drawing, illustrating the incorporation of brick vaulting and arches in basement to support the weight of the building, including the stone slab roof.*

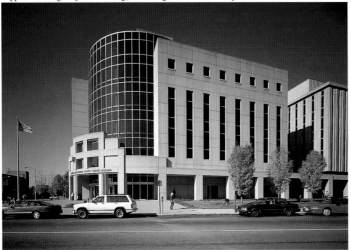

*Above: The Dayton and Montgomery County Courts Building, part of the modern judicial complex.*

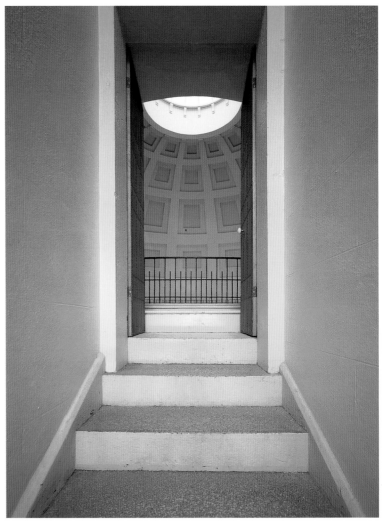

*Above: The entrance to the visitors gallery above the courtroom*

*Above: Cantilevered staircase.*

# Brown County

*Origin of name: General Jacob Brown, a hero of the War of 1812*
*County Seat: Georgetown*
*Courthouse construction: 1849-51*
*Architect: Hubbard Baker*

The Brown County Courthouse, focal point of the county seat, provides the community with its source of identity. It was completed in 1851; the transverse wings were added in 1914. Over the years, the courthouse and the courthouse-square were not only the center of daily activities but also the site of public events such as elections and holiday celebrations along with such notable events as a raid by the troops of confederate general John Hunt Morgan. Upon entering the town on July 15, 1863, they hitched their horses on the courthouse square. While there was not a skirmish, one soldier, home on leave, was shot, and reportedly a number of horses and some valuables were missing. Union General, and later President, Ulysses S. Grant, who claimed Georgetown as his boyhood home, was said to have trained horses on the courthouse square while he was a child.

So on June 18, 1977, after fire nearly destroyed the small Greek Revival building, a group of local citizens formed The Brown County Courthouse Reconstruction Association for the purpose of raising funds to rebuild it. Despite many obstacles, including the difficult task of soliciting reconstruction funds without cost to the taxpayers and recalcitrant officials, the courthouse was rededicated nine years later.

The cause of the fire was arson—started on the northern stairwell and in the judge's chambers where his robe was burned and then left hanging in a metal closet. No one was prosecuted for setting the fire, but accusations have continued to surface from time to time.

The courthouse is the centerpiece to the Georgetown Historic District—an intact example of an early Ohio county seat. On all sides of Courthouse Square are restored commercial buildings and early Federal style houses with only a few intrusions. Two Doric columns enclose the courthouse entrance, with shuttered windows on either side, one down and one up. Above the square belfry is an octagonal section with clocks on four of its eight sides. The bell was hoisted from the burning courthouse and, for continuity, reinstalled in the reconstructed one on November 5, 1986.

*Above: The first-floor hallway.*

# Brown County

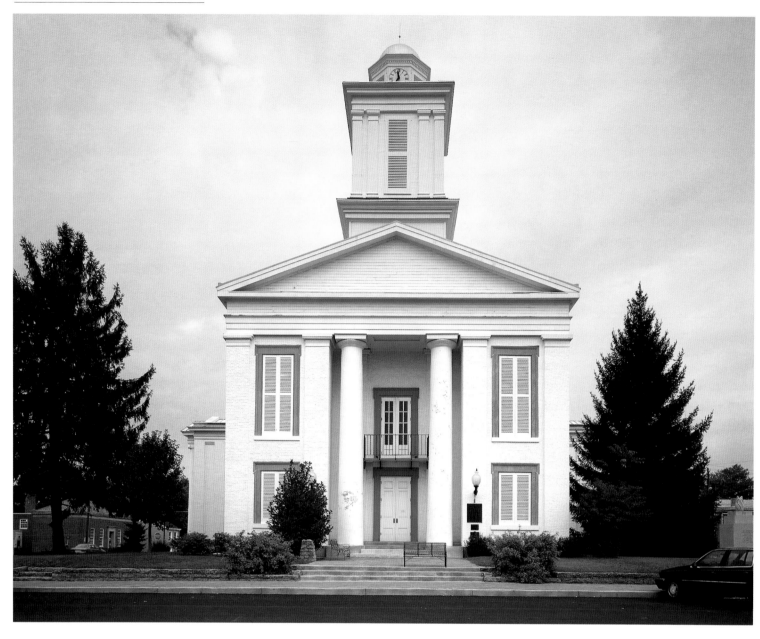

*Above: The Brown County Courthouse.*

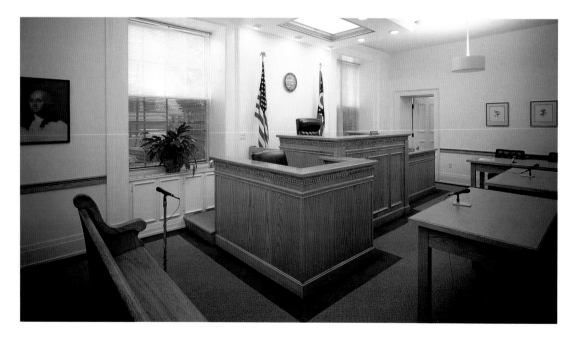

*Above: The Probate/Juvenile courtroom. The lower halves of the windows are tinted to screen the proceedings from outside viewers.*

# Morrow County

*Origin of name: Jeremiah Morrow, Congressman 1803-1813, 1840-1843;*
*U.S. Senator 1813-1819; Ohio Governor 1822-26*
*County Seat: Mt. Gilead*
*Courthouse construction: 1852-54*
*Architect: David Auld*

Morrow County was one of the last counties to be organized. The local citizens, opposed to the burden of traveling to the surrounding county seats, petitioned the legislature for relief. The General Assembly responded by forming Morrow County in 1848 from parts of neighboring Crawford, Richland, Knox, Delaware, and Marion counties, and designating Mt. Gilead as the county seat. Construction of the courthouse took many years, so the court and county offices were scattered throughout the community until it was completed. Although the façade was altered and sections added in 1896 and during the 1930s, it is the county's only courthouse, and continues to be utilized exclusively for county functions.

The courthouse's entrance is located on the south side of the two-story brick building. The walls are lined with square brick pilasters that formed the flues for numerous chimneys in the original construction. A blank frieze and denticular cornice complete the walls. The tower is square and rises about fifty feet above the ground. The shaft contains a belfry, and above it four clock faces are set between square pilasters. The tower roof is pagoda-shaped, and is crowned by a finial.

During the 1930s, when federal funds became available for building a rear addition, it was on condition that a new courtroom for the Court of Common Pleas be constructed. The county agreed, and the courtroom dates from that period.

In January 1992, Court TV broadcast a trial from the courtroom involving one of the worst accidents concerning Amish people in the United States. The defendant was convicted of vehicular homicide and aggravated vehicular assault for driving his pickup truck, while intoxicated, into the rear of an Amish buggy, killing six occupants and wounding four others. The faces of the Amish witnesses were not shown when they testified, in accordance with their religious preference not to be photographed.

*Above: View of the second-floor hallway, showing through the doorways its three construction stages in progression: original, 1896 expansion, and 1930s addition.*

# Morrow County

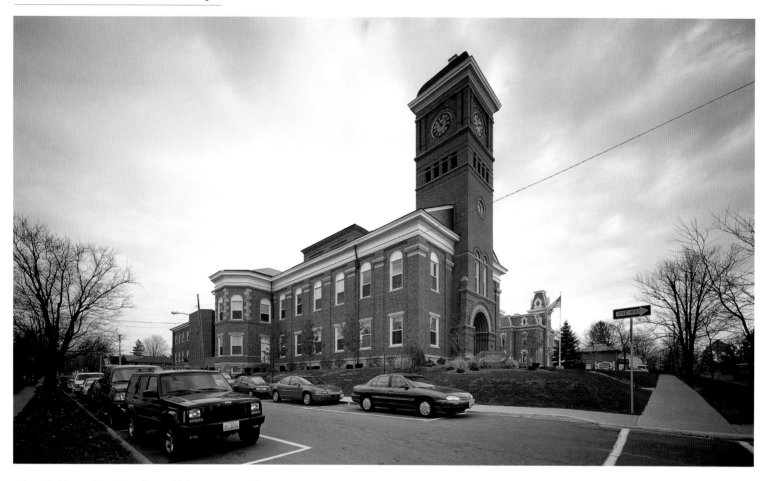

*Above: The Morrow County Courthouse, with its square tower rising nearly fifty feet from the ground.*

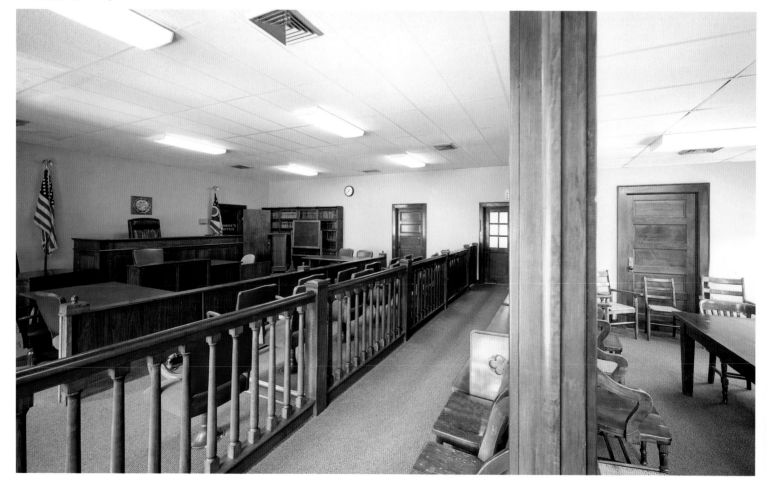

*Above: Courtroom, with adjourning jury room.*

# Knox County

*Origin of name: Henry Knox, the first U.S. Secretary of War*
*County Seat: Mt. Vernon*
*Courthouse construction: 1854-56*
*Architect: Daniel Clark*

When Knox County was established in 1808, the communities of Mt. Vernon and Clinton competed to secure the designation of county seat. The County Commissioners, charged with the selection, first visited Mt. Vernon, where they found the people well behaved and industrious, clearing stumps and trees from the streets and land. But according to local legend, when the Commissioners arrived in Clinton, the Mt. Vernon supporters arrived ahead of them and created drunken disturbances, in order to give an unsatisfactory impression of Clinton. Their ploy worked. The less populated Mt. Vernon was selected and flourished, while Clinton's fortunes dwindled.

Even before the first flimsy courthouse of logs and plaster was constructed, the first Knox County jury trial was held in a makeshift courtroom, where the defendant was found guilty of stealing a watch, a bay mare, a pair of overalls, and a bell and collar. His penalty was a public whipping of forty lashes across his exposed back. With his hands stretched up over his head, he was tied to a hickory tree while the sheriff beat him with a heavy rawhide whip, which cut to the bone in several places. Local historians later insisted it was the county's only public whipping, although they praised it as having the desired effect: the "culprit" left and never returned.

The courthouse is a rare example of a Greek Revival courthouse still in use in Ohio. White trim contrasts with the brick construction, emphasizing the temple form. The recessed entry is flanked by fluted Doric columns. In 1890 the building was lengthened, the roof rebuilt, and the present cupola and an interior staircase added.

The size of the second-floor courtroom, where disputes of the growing county have always been settled, was substantially reduced and its ceiling lowered. The plaster relief design in the courtroom is patterned after the original molding.

Population growth and the addition of new service agencies have expanded county government's role. A building across the street was rehabilitated in order to alleviate the courthouse's overcrowding, and to meet present and future demands.

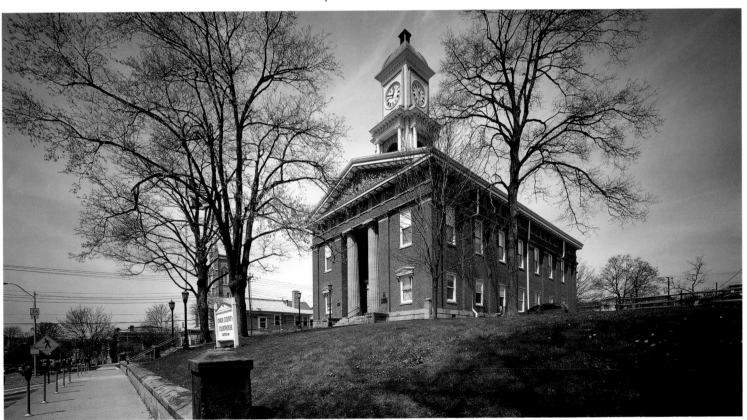

*Above: The Knox County Courthouse.*

# Knox County

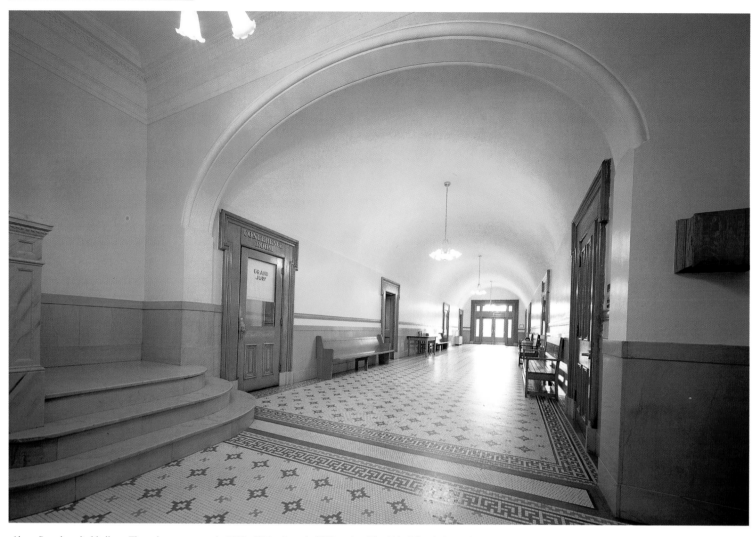

Above: Barrel-vaulted hallway. The archway separates the 1890 addition from the 1850s section. The old building had exterior staircases and plain wooden door-frames, but in the 1890s the marble and steel staircase and plaster moldings were incorporated. Before the move to the space across the street, the courthouse was so cramped and congested that many records were stored in the bell tower and in this hallway.

Above: Sign to right of judge's bench is original even as to the spot where it still hangs.

*Above: The masonry-vaulted ceiling in the Probate Court Record Room, with metal file drawers holding records dating from 1808, conforms to the vault shape.*

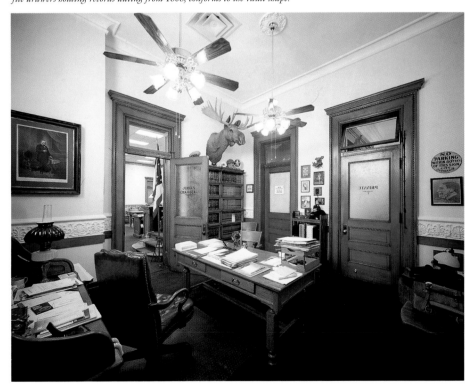

*Above: Adjacent to the courtroom is the Judge's chamber, with an early courthouse table and bookcases from the old law library.*

# Ross County

*Origin of name: Named by Territorial Governor Arthur St. Clair*
*for his friend James Ross of Pennsylvania, U.S. Senator 1794-1803*
*County Seat: Chillicothe*
*Courthouse constructed: 1855-58*
*Architects: Collins & Autenrieth*

Chillicothe, the county seat of Ross County, is one of Ohio's most historic cities. Designated the capital of the Northwest Territory by the United States Congress under The Northwest Ordinance, it became the first capital of Ohio on its admission to the Union. The courthouse stands on the site of Ohio's first statehouse (demolished 1852).

The motifs in the courthouse reflect Ross County's unique place in Ohio history. For example, embedded into the floor of the courthouse entrance hall is a mosaic Seal of Ohio. The tile forms the design of a demi-sun, rising above a mountain. Tradition maintains that it was inspired when Thomas Worthington (one of Ohio's first U.S. Senators and sixth governor), Edward Tiffin (Ohio's first governor), and William Creighton (Ohio's first Secretary of State) watched the sun rise over Mount Logan after an all night gathering at Adena, Worthington's Ross County mansion.

The first Ohio legislature provided for the great seal to be applied on all official documents. The act, passed March 25, 1803, designated it as follows:

*On the right side, near the bottom, a sheaf of wheat, and on the left a bundle of seventeen arrows, both standing erect: in the background, and rising above the sheaf and arrows, a mountain, over which shall appear a rising sun. The state seal to be surrounded by these words: "The great seal of the State of Ohio."*

The rising sun represents the new state, the mountains celebrate Ohio as the first state west of the Allegheny Mountains, the sheaf of wheat signifies agriculture (at that time, the state's most important industry) and the bundle of seventeen arrows symbolizes the Union with Ohio, the seventeenth state to be admitted.

The building's exterior remains unaltered since 1858. A two-story pavilion is fronted by a portico

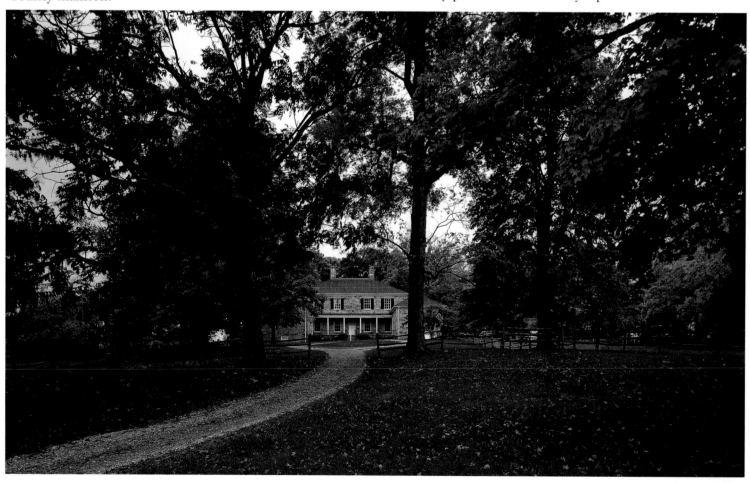

*Above: Adena, a stone mansion built 1806-1807, was designed by Benjamin Latrobe, who directed the construction of the U.S. Capitol. Adena was the home of Ohio's sixth governor and first U.S. senator, Thomas Worthington. Here he entertained James Monroe and Tecumseh, and from here the view of Mount Logan inspired the design of Ohio's Great Seal.*

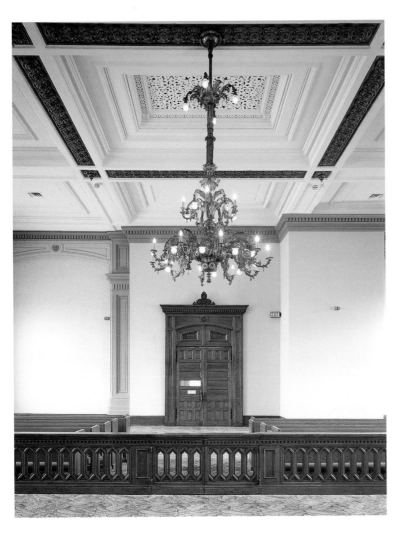

*Above: Large double doors into courtroom. Elevator shaft protrudes on their left.*

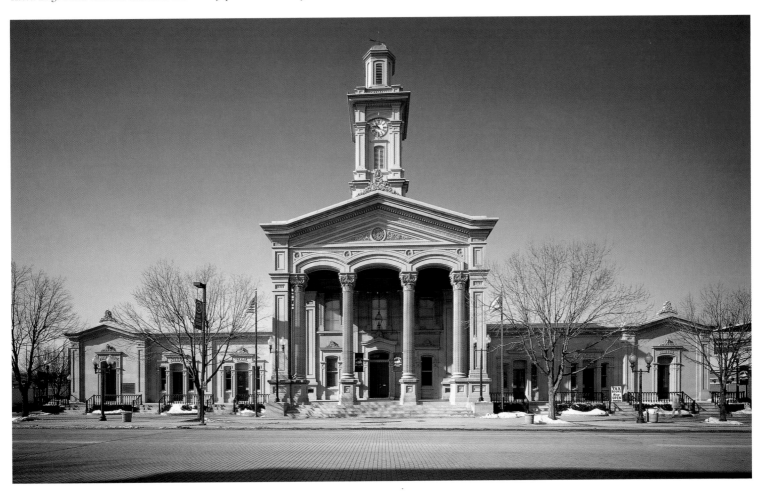

*Above: The Ross County Courthouse.*

# Ross County

supported by columns with Corinthian capitals. Iron fence segments from Ohio's original statehouse stand before the low side wings that repeat, at the roof-line, the design of the building's two-story main block. These wings house county offices labeled by stone inscriptions over the separate entrances. With its two additions, dating from 1929 and 1961, constructed behind the original building and hidden from view, the courthouse retains the spirit of its original design.

Though the interior has been modified, a few remaining symbols remind visitors of the county's heritage. Above the judge's bench is a sculptural relief of Edward Tiffin, the first governor of Ohio, and carved into the Judge's oak bench, dating from 1901, is the seal of Ohio.

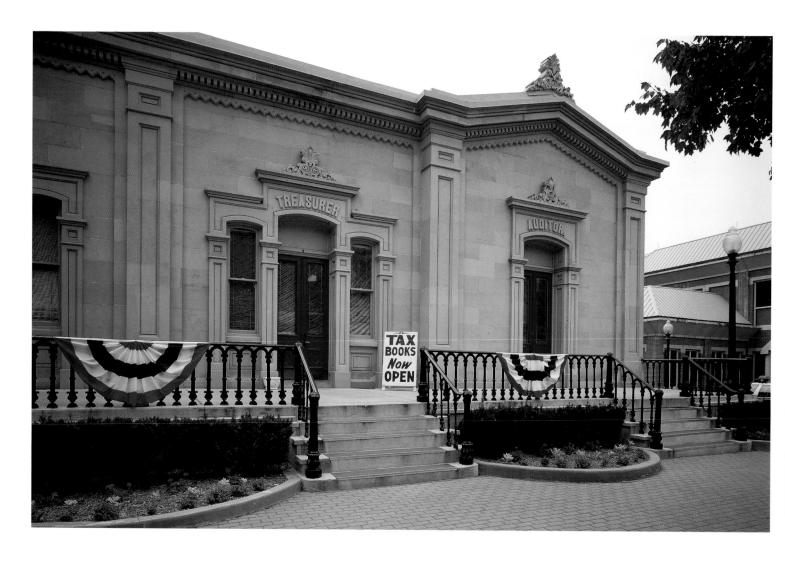

*Above: The separate entrance to the Treasurer's office.*

# Morgan County

*Origin of name: General Daniel Morgan, Revolutionary War Hero*
*County Seat: McConnellsville*
*Courthouse constructed: 1857-58*
*Architect: William P. Johnson*

When Morgan County was organized, no attorneys were living in McConnellsville. Under Ohio's first constitution, the Courts of Common Pleas consisted of a president judge and three associates elected by the legislature for a term of seven years. The president was a lawyer and held court in the different counties of his judicial district. The associate judges, however, were citizens of the county but not necessarily lawyers. One early reporter described Morgan County associates as being

> *. . . generally honest, substantial gentlemen of sound judgment and good appearance, of fair ability and of general information; without prejudice, hatred or ill-will toward any one. In some instances, however, there were failures in all or a part of these important qualifications. If there should be any such it was set down as a mistake by the judge-makers and patiently borne with, for in those days impeachment was seldom resorted to.*

The Morgan County Courthouse, constructed prior to the Civil War, was originally a Greek Revival style design. Over the years, however, it was substantially transformed when repairs such as a new roof became necessary. While some classic forms remain, such as the portico supported by four columns, Second Empire elements appeared, such as a bracketed cornice and a clock tower with a mansard roof. The clock arrived via boat from Zanesville, twenty-seven miles above McConnellsville, on the Muskingum River—after the ice melted in March 1886. For over a hundred years, it has and continues to keep citizens on time.

In 1959, upon receipt of additional revenues from a large generating plant on the Muskingum River, the county enlarged its "Palace of Justice" by adding a rear addition and, after moving county offices to rented rooms throughout McConnellsville, completely gutted and remodeled it. Air conditioning was installed and an elevator was added to make the second-floor courtroom accessible to the handicapped and senior citizens.

*Below: A photographic compilation of the all-male 1992 Morgan County Bench and Bar Association displayed on the wall of the courtroom. Framed photographs of the local bar organizations and of past judges are frequently exhibited on courthouse walls. The differences in hairstyle and dress offer a sense of the building's chronology.*

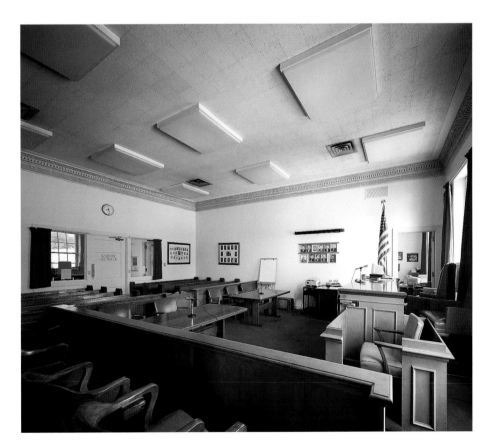

*Above: View of the courtroom. The judge's bench, jury box and witness chair are elevated so they can be seen from anywhere in the room.*

# Morgan County

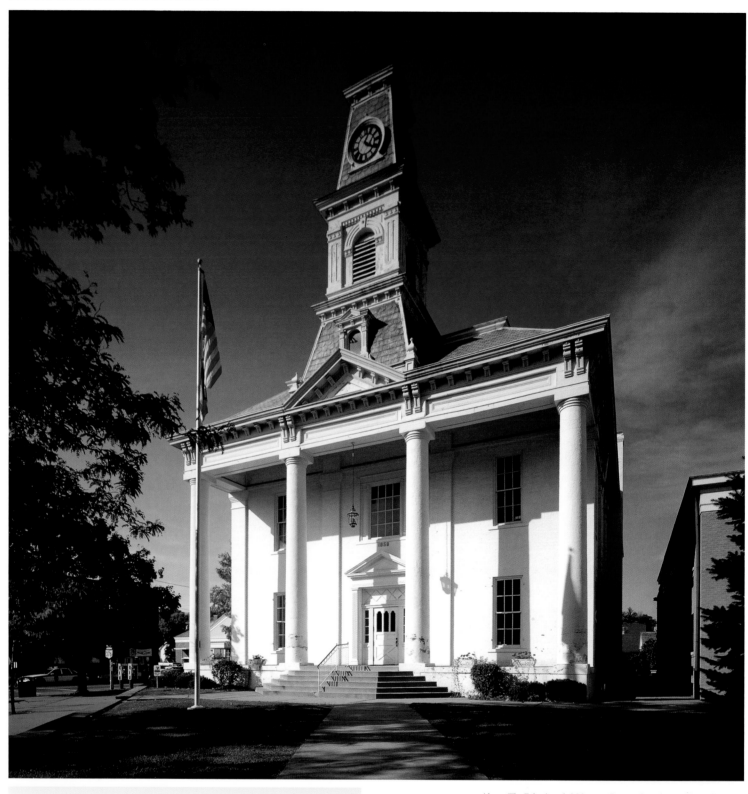

*Sometimes when people are alone in the courthouse and they think they hear footsteps, a door closing or a light going off they refer to it as "The Ghost of the Prosecutor" or prosecutor, Francis (Frank) Parsons. Soon after Parsons was elected Morgan County Prosecutor, in 1908, the Marshall of McConnelsville was murdered. Parsons kept the murder weapon, a gun, in his desk drawer and one Sunday night came into the courthouse and committed suicide with it. No one knows why. The weapon remained in the desk until 1982 when it was finally removed and transferred to the Morgan County Historical Society.*

# Pike County

*Origin of name: General Zebulon Montgomery Pike, who discovered*
*"Pike's Peak," in Colorado in 1806*
*County Seat: Waverly*
*Courthouse constructed: 1865-66*
*Architect: Unknown*

In 1815, when Piketon was designated the county seat of Pike County, court sessions were held in a local home. By 1819, the county constructed its first courthouse on Main Street, not far from the Scioto River. During the 1830s, as county seats emerged as important centers in the commercial and political development of a region, James Emmitt, who apparently wanted to benefit financially, sought to remove the Pike county seat from Piketon to Waverly. A merchant, sawmill operator, whiskey distiller, and large Waverly property owner, he successfully influenced voters to approve a relocation referendum by promising to build a road and a covered bridge across the Scioto river.

Soon afterward, the Eclectic brick two-story part of the courthouse, measuring 80 x 47 feet, was completed at the edge of Waverly's business district. The exterior walls comprise five recessed brick arcades with double rows of semi-circular arched windows. Above the first and fifth are small round windows. The upper row of windows in the three center recessed arcades are two stories in height (location of courtroom).

A three-story addition, constructed in 1909, enlarged the front of the building. During the rest of the century little remodeling and upgrading was authorized and now Pike Countians must decide whether to preserve and update the historic building or construct a third.

*Above: The first Pike County Courthouse, with barely discernible imprints of*
*county offices on the stone window lintels, is adapted to an apartment house.*

# Pike County

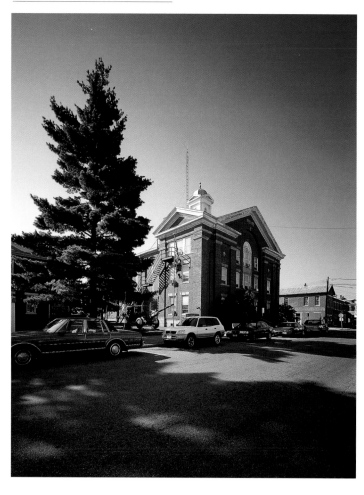

*Above: The Pike County Courthouse. Front addition incorporates a Palladian window.*

*Above: Display case, outside the courtroom, commemorates World War I veterans, some shown standing in front of the courthouse entrance.*

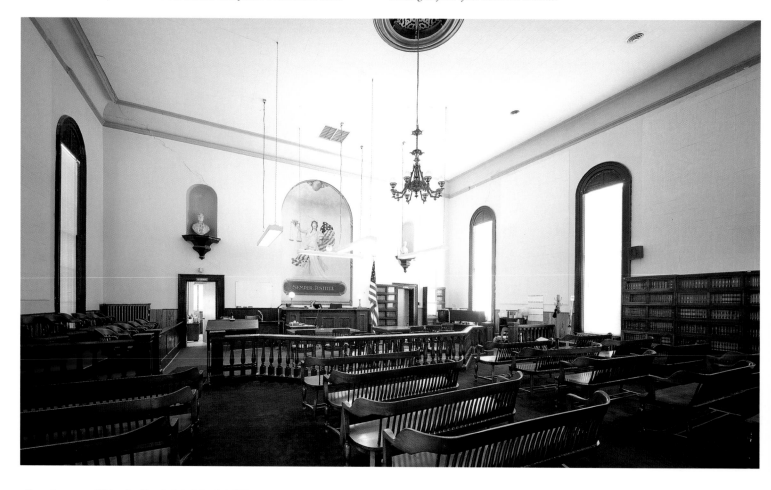

*Above: Courtroom. Niches, flanking the judge's bench, hold busts of James and Louisa Emmitt. Behind is a painting of "Justice"— attributed to a former local attorney.*

# Delaware County

*Origin of name: Delaware tribe who came from the Delaware River area near Philadelphia*
*County Seat: Delaware*
*Courthouse constructed: 1868-69*
*Architect: Robert N. Jones*

Delaware County, directly north of Franklin County with its exploding growth threatening to envelop it, continues to maintain most of its judicial business from its early post Civil War Italianate styled courthouse. Built on a square at the edge of Delaware's largely restored business district, it is primarily surrounded by houses rather than commercial establishments. It is an example of the courthouse, rather than a church, which was typically the only monumental structure in many small Ohio towns such as Delaware.

Its Italianate style is evident in its bracketed cornice, wooden rooftop cupola, and paired round arched windows surrounded by stone hoodmolds. A shall triangular pediment accents the slightly projecting center section, below which is a balcony covering the main entrance. The roof is edged with ornamental iron cresting.

A statue of Justice stands atop the courthouse's cupola. Similar symbols decorate many courthouses, representing a continuum of tradition and history from England where they first embodied justice sometime during the late fifteenth century. The early ones, such as in London's Old Bailey, were without blindfolds. According to legend, the English Church, fearing the secular courts would undermine the ecclesiastical court, covered Justice's eyes to suggest the absence of judgment. Today, Justice is usually blindfolded with a sword in one hand and scales in the other. The blindfold symbolizes impartiality and the sword represents swift and true justice or that justice is capable of retribution when necessary. The scales suggest all dealings are to be fair and equal.

The county, with its growing population, plans to construct a new Justice center in 2020. The future of the second courthouse in the new

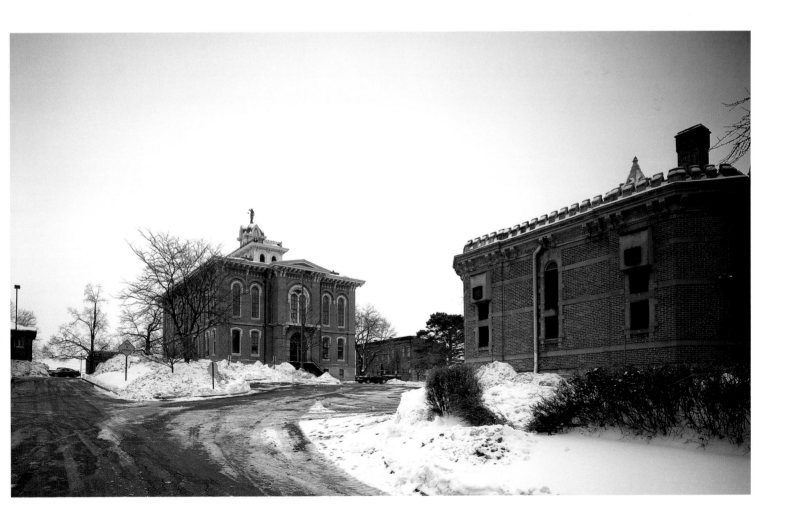

*Above: The Delaware County Courthouse from rear; the old jail is in the foreground.*

# Delaware County

millennium is uncertain but at present, in an effort to retain continuity with the past, county officials are committed to preserving it as is apparent by a nearly half a million dollar renovation in 1996. As part of the six-month project, 102 window frames (some over six feet tall) and the two sets of wood and glass entrance doors were restored. Workers spent at least eighty hours scrapping away fifeeen to seventeen layers of green and mustard colored paint from the doors nine feet tall and nearly three feet wide, and over a hundred years old.

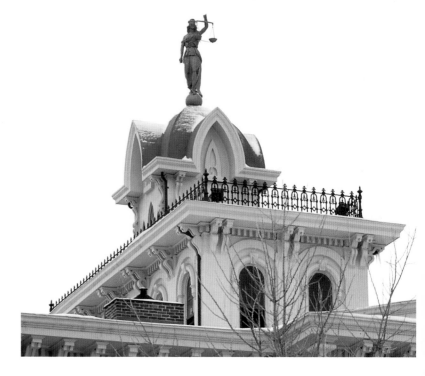

*Above: View of Justice with scales, identifying the building as a courthouse.*

*Above: Judge Henry E. Shaw, Jr. beside the public entrance to the courtroom where he has presided since March 29, 1976.*

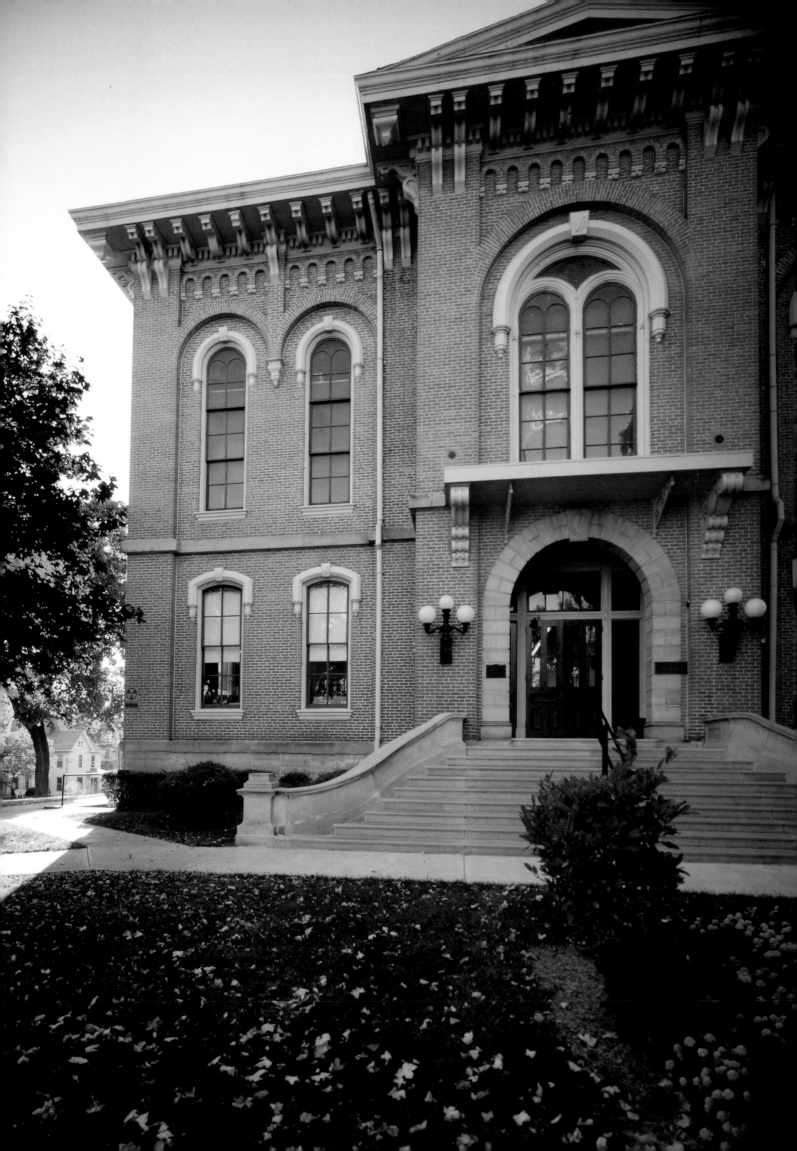

# Geauga County

*Origin of name: Sheauga, which means raccoon*
*County Seat: Chardon*
*Courthouse constructed: 1869-70*
*Architect: Joseph Ireland*

Geauga County's Italianate courthouse is located on the northern half of the Chardon public green. The courthouse and the two blocks of storefronts to its west form a historic district, a collection of architecturally related buildings, listed on the National Registry of Historic Places. In 1868 a fire destroyed the business district, including shops, offices, meeting halls, and the predecessor of the present courthouse.

No county and court records were lost during the fire, because the old courthouse was the last building to ignite, giving Geaugans time to haul the records across the street to the park. According to local legend, some of the documents had been removed from an earlier structure, during the War of 1812, and hidden underneath a natural stone bridge over a nearby ravine. This was to protect them from an anticipated British and Indian invasion.

The courthouse's exterior remains intact, although the interior has been altered to increase court and administrative office space. The square tower, consisting of main entrance, octagonal louvered cupola, and dome, gives the building its distinctive look. The cupola is topped by a bracketed cornice that is repeated on the main block below. The dome's roof has clock faces on four sides. The crowning feature, at a height of 112 feet, is a weathervane.

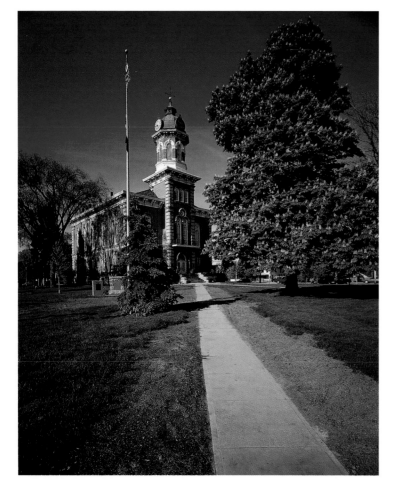

*Above: Front of courthouse with tower, showing slim lancet windows with tracery and hood moldings of cut sandstone.*

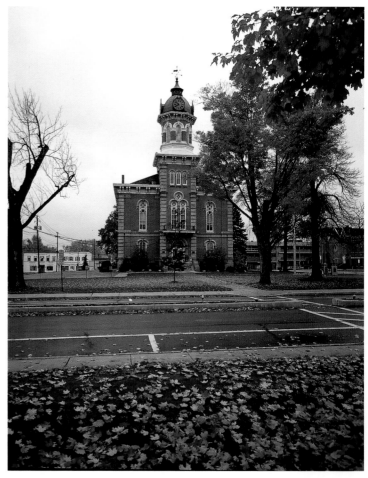

*Above: The primary tower windows have a clustered trefoil effect with tracery mullions.*

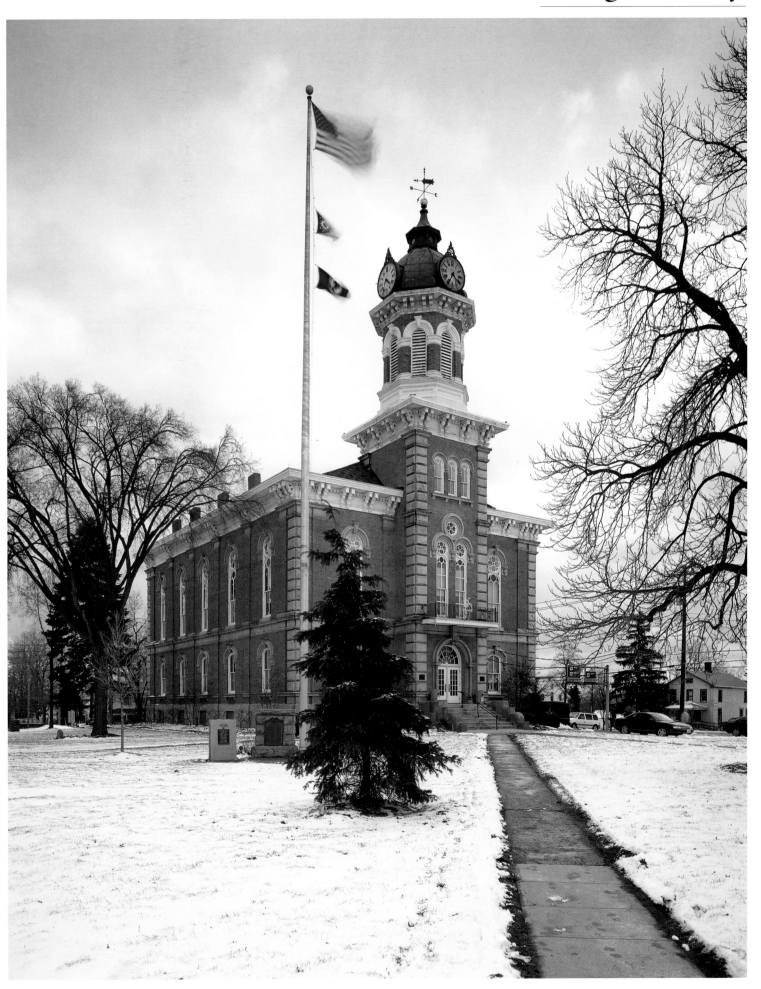

*Above: The Geauga County Courthouse, with contrasting brick walls and stone quoins.*

# Columbiana County

*Origin of name: Christopher Columbus*
*County Seat: Lisbon*
*Courthouse constructed: 1870-71*
*Architect: H.E. Myer*

The Wyandot, Delaware, and Mingo Native American tribes first occupied the area encompassing what is now Columbiana County. During the 1780s, squatters, traders, hunters, along with settlers from Virginia, Maryland, and Pennsylvania populated the land. Many came by way of the Ohio River (created at Pittsburgh by the joining of the Allegheny and the Monongahela), that forms part of the county's border as it starts to trace Ohio's eastern and southern borders.

The Land Ordinance Act of 1785 required all land to be surveyed and platted, establishing the rectangular system of surveys, and reserving certain land for support of education and for Congress' future dispersal. This was completed before the area could be permanently settled and it influenced the subsequent orderly sale and settlement of public lands throughout Ohio and the United States.

Once the land was surveyed Congress sold or granted it to individuals or companies, and, on May 10, 1800, it opened the frontier of the Northwest Territory to settlement. From that time until the Civil War one of the federal government's objectives was the management and sale of western public lands. Federal land offices were initiated in July of 1800 at nearby Steubenville.

Lewis Kinney settled in Columbiana County in 1802 and, on August 7, 1805, he became the first county property owner when he bought section fourteen of Center Township, Columbiana County, Ohio by patent deed which was signed by President Thomas Jefferson and Secretary of State James Madison.

Soon after the county was established with New Lisbon (now Lisbon) as the county seat, the first courthouse was built of logs on lots donated by Kinney. The second was completed in 1817.

The present Italianate styled courthouse was built on the southwest corner of the public square. It features tall round-arched windows and a square clock tower and Statue of Justice above the projected entrance. In 1934, with funds from the Works Progress Administration (W.P.A.), the original mansard roof and cornice were replaced with the present flat roof. A rear addition was constructed using stone from the same local quarry as the original building, for consistency and to hold down construction costs. The interior is not original.

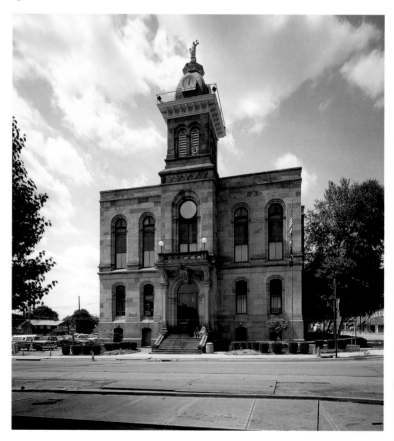

*Above: A security guard monitors activity throughout the courthouse*

*Above: Columbiana County Courthouse*

*Above: A view from the lobby*

# Logan County

*Origin of name: General Benjamin Logan, who destroyed the*
*Shawnee Mac-o-chee Villages in the area in 1786*
*County Seat: Bellefontaine*
*Courthouse constructed: 1870-71*
*Architect: Alexander Koehler*

The Logan County Courthouse sits prominently in Bellefontaine's "Court House Square." It is enhanced by its setting and surrounded by clues to the county's past achievements and calamities: a sign proclaiming Logan County the home of the Shawnee Chief, Blue Jacket; statues and markers referring to America's first portland cement concrete street built just south of the courthouse in 1891; and an eternal flame Veterans Memorial.

The Shawnee nation, largely located in the area that is now Logan County, included twelve clans. During the eighteenth century, they allied themselves with the British. But after Blue Jacket led the "Seven Nations" in their defeat at Fallen Timbers in 1794, the Shawnees sought refuge with the British at Fort Meigs only to have them close the gates as they approached the stronghold. Left to defend themselves, the Shawnees, along with chiefs of ten other Nations, later signed the Treaty of Greenville that set aside specific land for the Native Americans, restricted their movement, and opened up more land for settlement.

The area, now comprising Logan County, was densely populated with Native American villages and tribes. Throughout Ohio courthouses references, artistic renditions, and names borrowed from Native Americans are a reminder of this heritage. "Ohio" derives from the Iroquois expression for great water, "o-y-o." Rivers and tribal names appropriated for county appellation include Ashtabula, Muskingum, Cuyahoga, Miami, Scioto, Tuscarawas, Delaware, Erie, Huron, Ottawa, Pickaway (Piqua), and Wyandot. County seats named for tribal villages previously occupying their sites include Sandusky, Wapakoneta, Coshocton, and Chillicothe.

Architecturally, the courthouse incorporates overlapping styles. Its size, shape, entrance tower, balcony supported by stone brackets above the doorway, and round headed windows with hood moldings indicate Italianate influences although the mansard roof and fancy dormers with oval windows reflect a Second Empire influence.

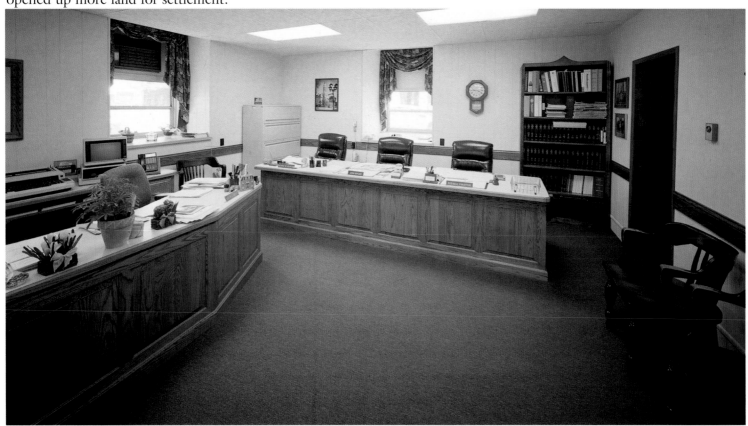

*Above: County commissioners share a basement office together and with office employees.*

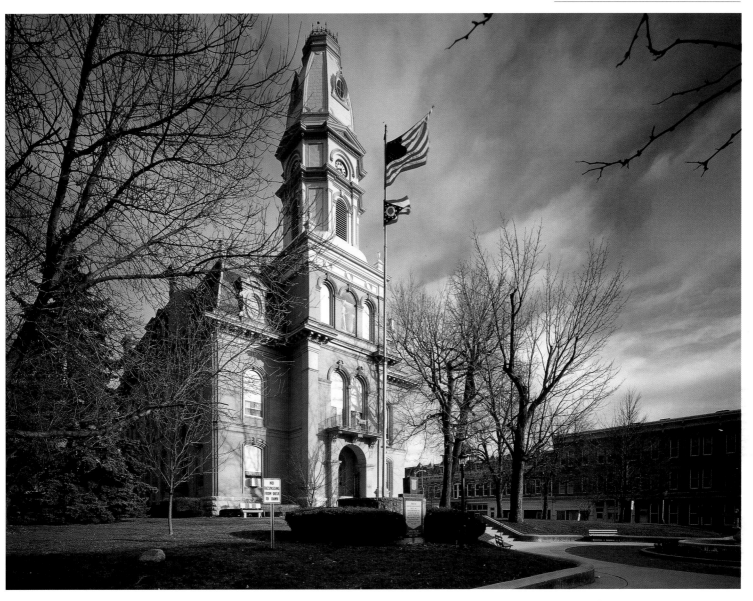

*Above: Logan County Courthouse with restored mansard roof consisting of variegated slate-tile conforming to the original. The mansard roof tower with a six-sided metal dome is topped with ornamental iron cresting.*

*Left: On courthouse lawn, a 1940s monument, commemorating the past with a piece of cement, is inscribed as follows: This is the first Portland Cement Concrete Street built in the United States, constructed in 1891. Here started the Better Roads Movement that has given our citizens from Coast to Coast swift and sure transportation. 1891 1941*

# Fairfield County

*Origin of name: its "fair fields"*
*County Seat: Lancaster*
*Courthouse constructed: 1868-72*
*Architect: Jacob B. Orman*

The Fairfield County Seat, Lancaster, was one of the area's first settlements. It was laid out by Noah and John Zane, sons of Ebenezer Zane (1747-1812), on land given to him in 1796 by the United States Congress in return for opening a road across the Ohio Territory. The road, Zane's Trace, started from the first permanent settlement on the Ohio River (now Wheeling, West Virginia), and continued to what is now the location of Maysville, Kentucky.

The Fairfield County Hall of Justice, completed May 15, 1975, is officially designated the county's third courthouse. It houses the General Division of the Court of Common Pleas, and the Probate and Juvenile Courts while its predecessor, the second courthouse, accommodates the county administrative offices. The second's bold Tuscan design of the Italianate style and size, however, eclipses the newer Colonial Revival building, making it another exception to the chronological courthouse order in *County Courthouses of Ohio*.

Constructed entirely of locally quarried stone with a flat roof, the courthouse is rectangular in shape, with three front bays and nine side bays. The entrance is round-arched, and windows are covered with hood moulds. The iron cornice incorporates dentils. The interior is modified. High on its first-floor walls are small historical paintings illustrating community life. Such renderings, often directly on the plaster walls, are valuable decorative and informative courthouse additions.

Time capsules provide another source of historical information, through material deposited in steel containers, usually positioned at a corner, to celebrate the completion of a building's foundation, and as a means of sharing documents or objects with future generations. Cornerstones are hollowed out to hold the capsules, and they are typically inscribed with a date. On September 23, 1868 at 9 A.M. the second Fairfield Courthouse cornerstone was set, but possibly because of recent construction no one knows where the cornerstone is located, apparently a rather common occurrence. Court records, however, indicate it contains the following articles:

| | |
|---|---|
| *The Weekly Times*, Cincinnati | *The Cleveland Plain Dealer* Weekly |
| *The Daily Times*, Cincinnati | *The Cleveland Plain Dealer* Friday |
| *The Daily Enquirer*, Cincinnati | *The Cleveland Plain Dealer* Daily |
| *The Crisis* | *The Cleveland Plain Dealer* Junior |
| *The Ohio Eagle* | Autographs of the Attorneys of Lancaster |
| *The Lancaster Gazette* | Minutes of General Council Christian Union |
| *The Zanesville Signal* Weekly | Invitation to a Masonic Celebration |
| *The Zanesville Signal* Daily | Bylaws of Lancaster Lodge Number 57 |
| *The Democratic Herald* | Proceedings of Grand Encampment 1868 |
| *The Journal of Commerce* | Bottle of Dunbar and Raineys Wine 1865 |
| *The Ohio State Register* | Historical Sketch of the M.E. Church |
| *The Mount Vernon Banner* | Baptist Church Confession of Faith |
| *The Western Standard* | The Lutheran Church Council Proceedings |
| *The Ohio Patrick* | Jubille Medal 1867 of the Lutheran Church |
| *The Putnam County Sentinel* | Methodist Hymns, Historical Sketch |
| *The Democratic Engineer* | City Ordinances Lancaster, Ohio 1867 |
| *The Miamisburg Bulletin* | Names of Lancaster High School students |
| *The Marietta Times* | *The Auglaize County Democrat* |
| *The Piqua Democrat* | *The Peoples Defender* |
| *The Hancock Courier* | List of County Officers |
| Date of Erection of Building | Name of Architect |
| Autographs of County Officers | Tax Receipt for 1868 |
| *The Holy Bible* | Christian Union Church Book |
| Laws of Ohio | Bottle of Dayton ale |
| Bottle of Niersheimer wine | 1865 Minutes of Baptist Church 63rd |
| Common Prayer Book | Baptist Church Hymn Book |
| Bottle of Durain ale | Baptist Hymn Book |
| Bible of Old Baptist Church | Presbyterian Hymn Book |
| *The Western Christian Advocate* | Reformed Church *Messenger* |
| *The Christian World* | Almanac 1868 |

Premium List of Fairfield County Agricultural Society
Fourteenth Annual Report of Common Schools
Digest of I.O.O.F. Laws of the I.O.O.F.
Constitution of the W. and O. Beneficial Society
Proceedings of Grand Lodge of the I.O.O.F. of Ohio 1868
Hymnal of the Christian Union Sabbath Schools
Four Papers Containing the Trial of President Johnson
Four Papers Containing the Proceedings of the Chicago and New York Conventions
Eight Papers Containing an Account of the Visit to America of the Chinese Embassy
Bible from the F. Company Bible Society and Correspondence
Morning Service Evangelical Lutheran Church
Proceedings of the General Council of Evangelical Lutheran Church
Minutes of the Ohio M.E. Annual Conference
Heidleberg Catechism, Constitution and Forms
Acts and Proceedings of Synod German Reformed Church of Ohio

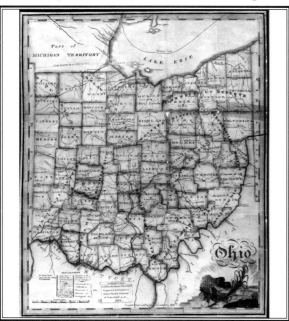

*Credit: Ohio Historical Society*

*Above: 1826 Ohio county map when Zane's Trace was a well-travelled road through Lancaster and Fairfield County.*

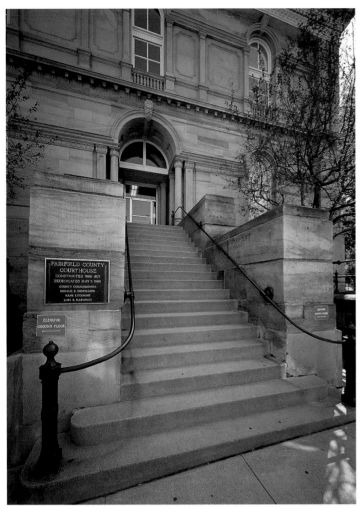

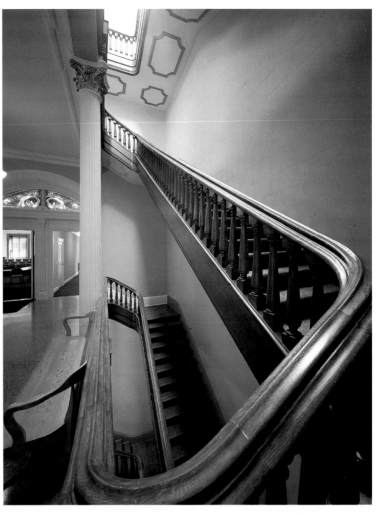

*Above: The contractor of the courthouse, Henry Ebner, left his signature by having his likeness sculpted into the keystone above the main entrance.*

*Above: Staircase, the sole remaining of two. It was a common practice for one of two original staircases to be eliminated, in order to add an elevator.*

*Above: The Hall of Justice, where the courtrooms are located, east of the courthouse.*

# Fulton County

*Origin of name: Robert Fulton, inventor of the steamboat*
*County Seat: Wauseon*
*Courthouse constructed: 1870-72*
*Architect: C.C. Miller (attributed)*

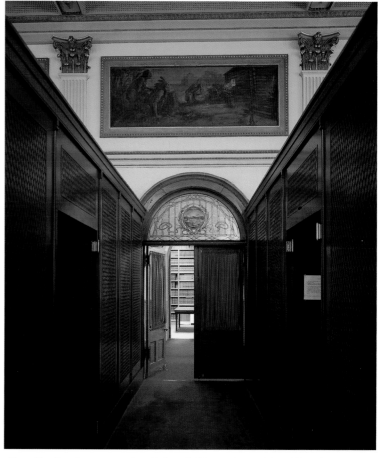

Fulton County's Italianate courthouse, was permeated with art by the agricultural community and continues to serve the county's requirements while commemorating its past and present, through its ornamentation. Entering the courthouse at the base of a square tower and belfry, which projects from the front of the building, a staircase to the left leads visitors to the decorative second floor. There the courtroom is embellished with murals, framed oil paintings, a stained glass dome, and hand-carved woodwork. The murals depict early interpretations of law and justice and the influence of Native Americans on early life in this region.

American political history is represented with portraits of George Washington, Abraham Lincoln, Ulysses S. Grant, William McKinley, along with two former local judges—Fred H. Wolfe (the county's first Common Pleas judge) and Charles Ham (a popular judge who served from 1962 to 1978). The Seal of Ohio, in cut glass, is above wooden arched doors (consistent throughout the building) leading into the courtroom.

*Above: View from the courtroom through the arched door to the second-floor lobby with a partial view of the law library. The blackened mural portrays warriors outside a log cabin.*

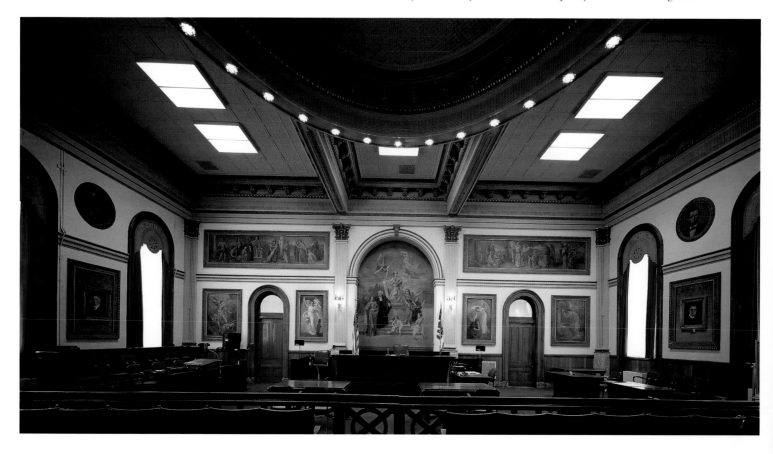

*Above: The courtroom; a view toward the front with the judge's bench surrounded by murals. The coffered ceiling features an elliptical dome of stained-glass and tin.*

RULES OF COURT.

**All Persons**
outside the BAR must be seated.

**No Talking**
allowed outside the BAR while
Court is in Session.

**No Persons**
permitted inside the BAR except
Officers of Court, Attorneys, and
Witnesses on the Stand.

**No Smoking**
allowed in Court-Room.

NO SPITTING ON FLOOR.

*Left: On the courtroom's south
wall hangs a sign advising visitors
on proper courtroom behavior.*

During the 1920s, (the period following
the passage of the Volstead Act or Eighteenth
Amendment that prohibited the sale and use
of intoxicating beverages) the manufacture and
selling of bootlegged beer and liquor became a
highly lucrative enterprise along with a growth
of crime, graft, and corruption. This spilled
into Fulton County because of its proximity to
Toledo, Detroit, and Canada. Occasionally local
farmers sought a piece of the action and
Wauseon became the setting for prosecuting at
least one farmer for providing members of the
notorious Licavoli gang (with ties to Detroit's
Purple mob) ingredients for their profitable
bootlegging business. The prosecutor was the
grandfather of Judge James E. Barber who
followed his grandfather and father in donning
judicial robes.

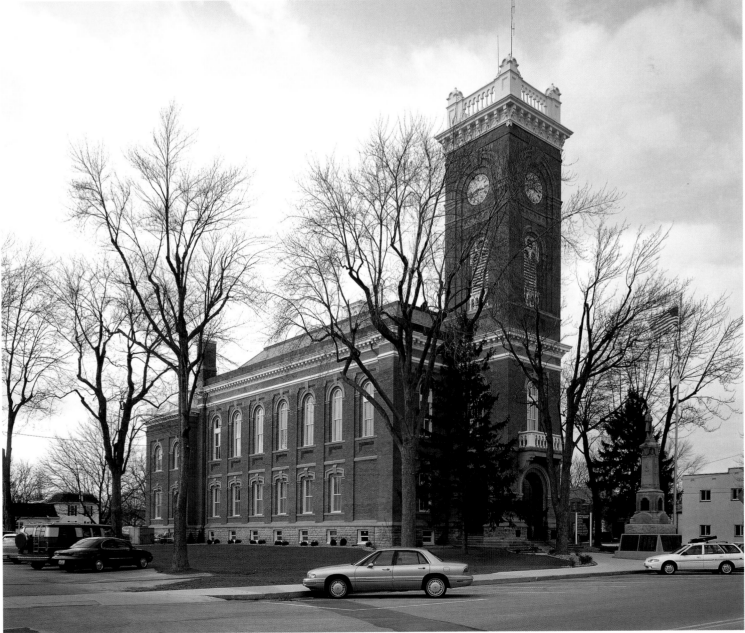

*Above: The Fulton County Courthouse.*

# Defiance County

*Origin of name: Fort Defiance*
*County Seat: Defiance*
*Courthouse construction: 1871-73*
*Architect: J.C. Johnson*

ort Defiance, built in 1794 by General Anthony Wayne (1745-1796), is the namesake of Defiance and Defiance County. A Revolutionary War colleague of President George Washington, Wayne was chosen by him to open the northwest for settlement, by subduing a confederacy of tribes formed to repel the encroaching settlers and land speculators.

After a victory over the confederation at Fallen Timbers, on August 3, 1795, Wayne and representatives of the allied tribes met at Fort Green Ville, where they signed the Treaty of Greenville. The treaty ended hostilities and established a boundary between the lands claimed by the United States (two-thirds of territorial Ohio) and those reserved for Native Americans. The resulting increase in immigration and permanent settlement accelerated the demise of the Indians, who were increasingly restricted to reservations until they were removed to the West.

The passing of the Native Americans from this area led to the creation first of the state and then of counties in the northwestern part of the state.

Defiance became the county seat of Williams County when it was organized in 1824, encompassing the present territory of Henry, Paulding, Putnam counties, and parts of Defiance County. But when an area of about 150 square miles was annexed to the northern section of the county after the Michigan/Ohio boundary dispute (described later under Williams County) voters chose to remove the county seat from Defiance to the more centrally located town of Bryan.

The citizens of Defiance, unhappy at losing their county seat status, petitioned the legislature for the establishment of a separate Defiance County. Their success was celebrated on March 4, 1845 at old Fort Defiance.

In 1873, the county's second courthouse was constructed in the Second Empire and Tuscan Villa styles, with a 125-foot clock tower jutting out from the mansard roof. In the late 1950s the building was substantially altered, when the roof was removed and a third story added. Economy and requirements for additional space have resulted in later alterations to the interior.

*Above: On the south courthouse lawn a plaque describes the unusual circumstances surrounding the courthouse's early bell: this bell was cast for the courthouse clocktower in 1873. The metal for the bell was obtained by breaking up an old brass cannon found sitting at a foundry in Cincinnati, Ohio. The old field piece was made in Strassburg, Germany, and dated 1502. It had been used in the Napoleonic Wars seeing service in Italy, Egypt, Spain, Austria, and Germany and had been dragged over the Alps on its way to Moscow. The cannon was returned to France, then to the United States by the old soldier who had used it in all the Napoleonic Wars. Adam Wilhelm, County Commissioner, obtained the bell, having witnessed the breaking up of the old cannon.*

*Above: The remains of Old Fort Defiance.*

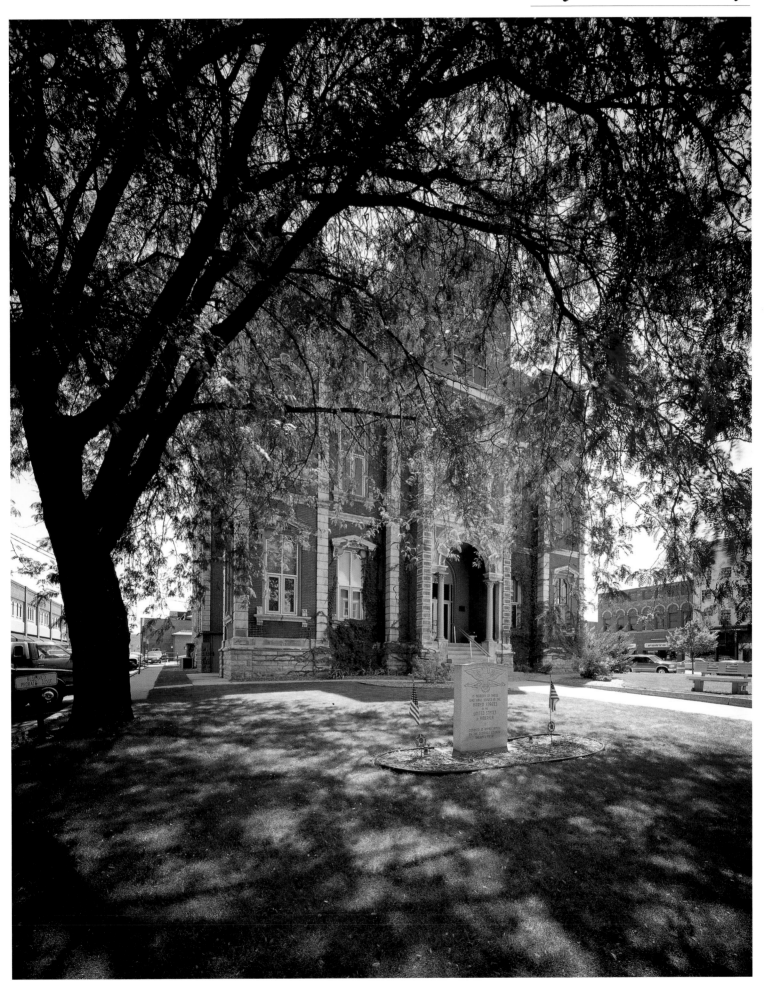

*Above: The Defiance County Courthouse.*

# Jefferson County

*Origin of name: Thomas Jefferson, President of the U.S. (1801-09)*
*County Seat: Steubenville*
*Courthouse constructed: 1871-74*
*Architects: Heard & Blythe*

A statue depicting a corpulent Edwin McMasters Stanton (1814-1869) stands before the Jefferson County Courthouse. Born in Steubenville, Stanton attended Kenyon College and was admitted to the Ohio bar in 1835. When his law practice took him to Washington D.C., he appeared regularly before the U.S. Supreme Court and became a special counsel to the federal government until President Abraham Lincoln appointed him Secretary of War.

Following Lincoln's assassination, in 1867, President Andrew Johnson removed Stanton from the Cabinet because he perceived Stanton was aligned with the Radical Republicans and opposed to his reconstruction policies. The United States House of Representatives, however, declared the removal illegal (a violation of the Tenure of Office Act which was passed by Congress to limit presidential authority over Reconstruction matters). Subsequently, Johnson survived the politically

inspired impeachment during a Senate trial and served until replaced by Ulysses S. Grant. Thereafter, Grant nominated Stanton to the Supreme Court. Confirmed by the Senate, he died four days later—without having taken the oath of office.

Constructed during a period of prosperity when Steubenville was developing from a rural community to an industrial one known for manufacturing steel, the courthouse featured a mansard roof with ornate dormer windows and a mansard roofed tower. During a heavy snowstorm in 1950, the roof collapsed. Rather than building a new courthouse or restoring the damaged one, the county, suffering from a sharp decline in its industrial base, compromised—the tower was removed and the mansard was converted to a flat roof. The round arched windows with hood-moulds and keystones, paired Corinthian columns, central pediment, pilasters, console (bracket in the

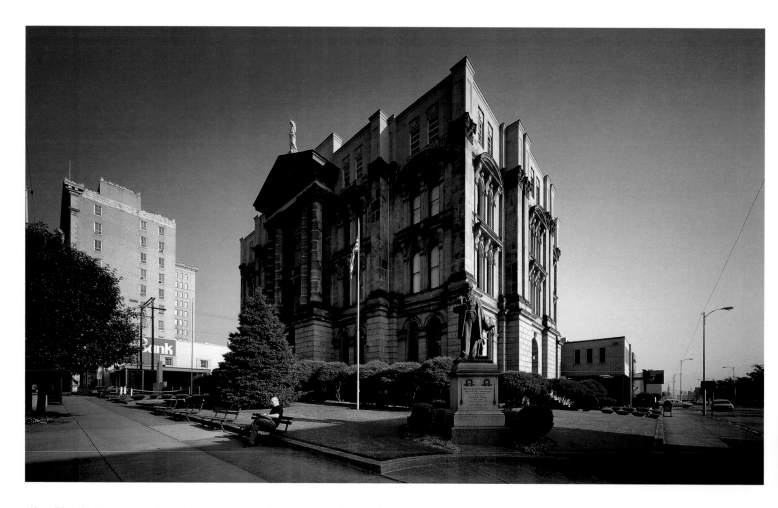

*Above: Edwin M. Stanton statue with the Jefferson County Courthouse in background Stanton is further commemorated with an oil portrait in one of the courtrooms.*

shape of a human) and brackets supporting entablatures over the windows indicate its former grandeur.

The sandstone courthouse remains blackened from pollution that spewed out from the steel industry's emission stacks in the surrounding upper Ohio Valley. During the post World War II period, many considered this the nation's most polluted air.

*Above: Main entrance. Set between two piers above which rises a large portico supported by pairs of two story high Corinthian columns. Plaque to left of main entrance reads: "In memoriam USS Maine— destroyed in Havana Harbor February 15th 1898. This tablet is cast from metal recovered from the USS Maine." 267 American sailors died in the still-unexplained sinking of the battleship that led to a four-month war, the freeing of Cuba from Spanish rule and establishment of Puerto Rico as an American possession. Similar tablets are found in the lobbies of the Hamilton County and Hardin County Courthouses.*

*Above: Courtroom, with oil portrait of Stanton.*

# Darke County

*Origin of name: General William Darke, Revolutionary War hero*
*County Seat: Greenville*
*Courthouse construction: 1873-74*
*Architect: Edwin May*

Since Darke County was formed from Miami County there have been three courthouses in Greenville (site where Fort Greene Ville was erected in 1793 by General Anthony Wayne). The first two were built on the public square on West Main Street but after the Civil War the county commissioners realized Broadway Avenue, not West Main Street, was becoming Greenville's main thoroughfare. Property was bought on Broadway where a sheriff's house and jail was constructed in 1870 followed by the Italianate styled courthouse.

There was, however, a controversy regarding the selection of a builder for the courthouse. The Act of April 27, 1869 authorized the County Commissioners to erect county buildings. After advertising and receiving sealed proposals for the furnishing of labor and materials towards the building on June 21, 1871, the commissioners were obligated to award the contract to the builder who offered the lowest price and gave bond for the performance of the contract. Of the many bids received the lowest were F.L. Farman ($87,000), Boren & Guckes ($102,105) and Rouzer &

Rouzer ($115,000). The commissioners chose Rouzer & Rouzer. Boren & Guckes and Farman filed separate proceedings in the Supreme Court of Ohio asking the commissioners be ordered to award the contract to them. Although Rouzer & Rouzer had purchased much of the material and started construction, the Court found against the commissioners by issuing an order in favor of Boren & Guckes for the awarding of the contract to them on the basis of their proposal (Farman did not have the proper bonding to work in Ohio). In compliance with the Supreme Court ruling, the commissioners signed a contract with Boren & Guckes on March 30, 1872.

The exterior remains largely intact. In 1973, however, the dome was removed after a portion of the gutter fell from above the clock tower. Many in the county wanted to remove the clock tower and raze the building but a group of citizens organized the Project Dome Committee of the County Bicentennial Committee to raise funds for the clock tower's repair including restoration of the cupola and the bell. Although it took eight years to

*Above: View from remaining stairwell. Elevator fills site of displaced stairwell.*

*Above: 1870 Italianate styled former jail and sheriff's house restored to an administrative office.*

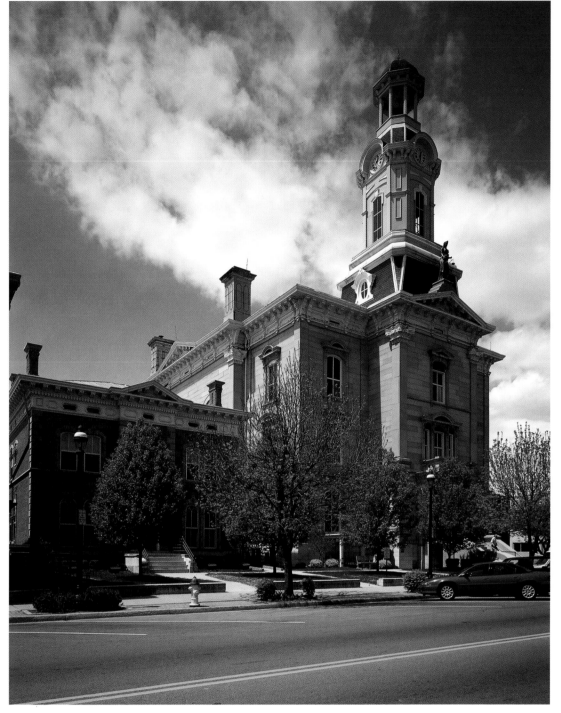

finance the project, on July 2, 1983, a helicopter hoisted a replica dome into place on a new base and columns.

The courthouse is constructed in a rectangular shape featuring central projections on three sides with Corinthian pilasters on rusticated bases. Rusticated blocks also frame the entrance doorway that supports a stone balcony. A statue of Justice precedes the tower. The cornice is supported with paired brackets at the eaves of cast metal that were designed to match the 1870 sheriff's home and jail's cornice.

A courtroom originally extended across the building and occupied nearly the entire second-floor except for offices of the clerk, sheriff, judge and law library. Extensive remodeling and the resultant smaller courtroom reflect the generally reduced number of spectators at court proceedings.

*Above: The Darke County Courthouse.*

*Above: Adverstisement from the* Daily Advocate, *November 2, 1945, when the courthouse was the focus of community activity.*

# Coshocton County

*Origin of name: Indian village, "Goschachgunk" or "Goschaching"*
*meaning "Black Bear Town"*
*County Seat: Coshocton*
*Courthouse construction: 1873-75*
*Architects: Carpenter & Williams*

A large mural in the courtroom of the Coshocton County Courthouse depicts an event that occurred near the Walhounding River outside Coshocton—Bouquet's Treaty with the Delaware Indians. When the English and settlers (mostly from Virginia and Pennsylvania) arrived in the Muskingum Valley during the eighteenth century they discovered Native American settlements. For over a hundred years, these natives had been friends and trading partners with the French and fought the English.

In an effort to pacify the Ohio natives, an expedition of 1,500 soldiers was organized and led by the British Colonel, Henry Bouquet. Bouquet, an experienced military officer, adapted traditional military discipline and tactics to wilderness warfare. In 1763, he defended Fort Pitt from the Delaware, Shawnee, Wyandot, and Mingoe tribes and then led this expedition to the Muskingum Valley where a bloodless campaign resulted in the submission of the tribes and the release of an estimated 200 captive settlers.

The mural portrays the treaty signing on November 1764. Following the peace with the local tribes, pioneers increasingly settled and during the treaty negotiations, following the American Revolution, those settlements facilitated United States' claims to western lands.

The courthouse, located on a central four-acre square, is an unaltered Second Empire styled structure. The mansard roof contains dormer windows with curly pediments that are repeated in the windows of the clock tower. Iron cresting crowns the tower. Carved stone trim accentuates the corners and window openings.

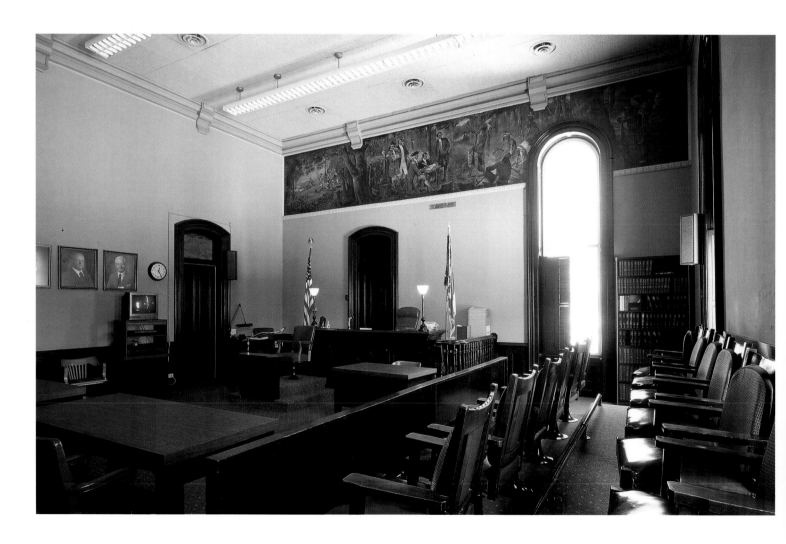

*Below: Courtroom with mural attributed to Arthur William Woelfle*

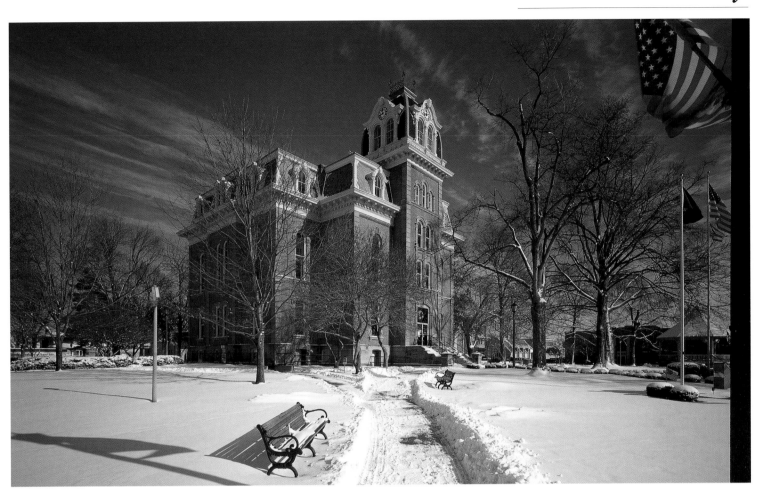

*Above: The Coshocton County Courthouse*

*Above: Metal cases in the office of the Clerk hold records dating back to 1811. Clerk of Courts, Irene Crouso Miller, reaches for an early document.*

*Above: View of the second-floor hallway with the open cast-iron stairway incorporating wooden banisters shows the intimacy of the building, measuring approximately seventy-five square feet.*

# Van Wert County

*Origin of name: Isaac Van Wart, one of the three captors of*
    *British spy Major John Andre*
*County Seat: Van Wert*
*Courthouse construction: 1874-76*
*Architect: Thomas J. Tolan & Son*

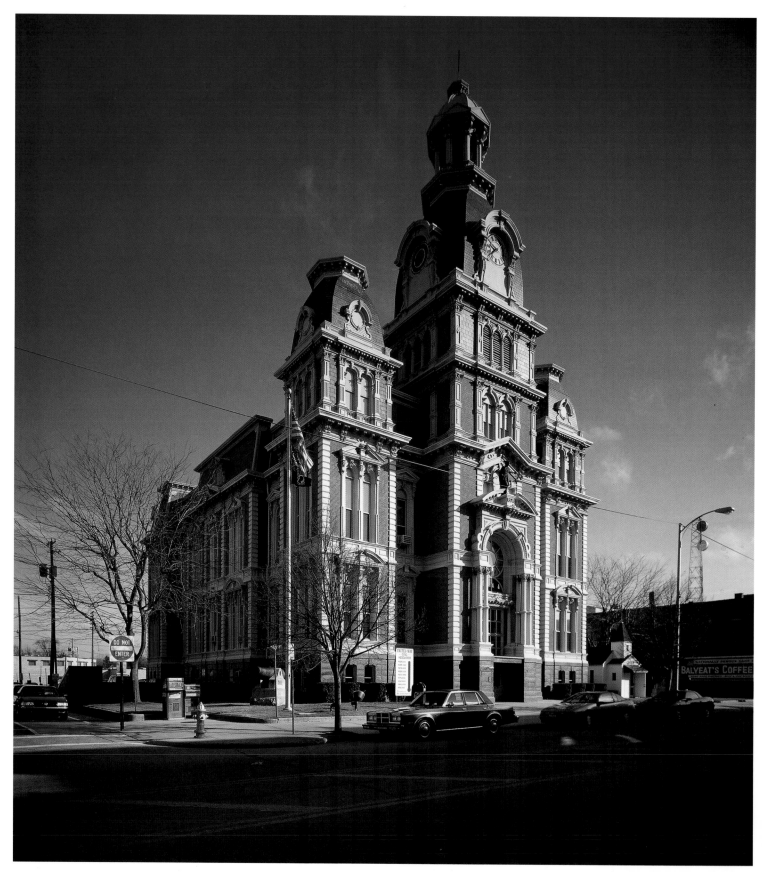

*Above: The Van Wert County Courthouse, with tower and Victorian period "gingerbread."*

In the fall of 1873, the local newspaper reported that the floor of the first Van Wert County Courthouse "started to collapse under the weight of an election-night crowd gathered there to await results. The weight of so many persons on the floor caused the rotten timbers to give way and a portion of the floor sank down some four inches. It was too sudden for a stampede, but was the cause of a first-class scare. The heavy safe leaned forward, menacingly, as though it was about to throw its great weight upon those crowded and packed so closely about it, bringing up visions of crushed bodies and broken legs. The interests of the citizens of Van Wert will not be properly protected until this rubbish is carted off."

As a result, without opposition, the county commissioners started the process of replacing the courthouse. They took a bold step on April 15, 1874 when they approved the plans and specifications of Architect Thomas J. Tolan of Fort Wayne for construction of the courthouse by approving the use of materials that were not tested by time. Apparently, they did not have much choice, as the Technologist of *Industrial Monthly*, published in New York City, said in an article in its December 1876 issue, "This building (the court house) is remarkable for the free use of sheet metal finish, both upon the exterior and interior, and the fine effect thereby attained at a minimum of cost.

It is situated in a section of the country wherein no good building stone is to be found, and so far removed from quarries of first class stone that transportation renders its use out of the question."

The entire exterior finish of the courthouse is composed of galvanized iron with pressed zinc trimmings including belt-courses of the first and second stories, quoins (constructed of cushion pattern crimped iron presenting a close resemblance to cut stone), finish around windows and the front entrance, main cornices and balustrades, dormer windows, and the mansard finish and tower work. The walls are of pressed brick making the entire building fireproof.

Completed in 1876, the courthouse dominates the county seat's small business district and can be seen from afar jutting out of the surrounding flat farm land. Especially prominent is the clock tower with an open columned cupola far above the central entrance. The mansard roofs are de-emphasized by the vertical tower, tall corner pavilions, and narrow elongated windows. Above the entrance stands an eight-foot tall zinc statue of Justice. Before it was brought to Van Wert, it won a prize in a Philadelphia statue competition during the Centennial Celebration. County folklore maintains the goddess dropped her scales on November 10, 1876 during a highly contested trial. Not until February 4, 1965, were they replaced through the collaborative efforts of the Van Wert County Bar Association, the Ohio Restoration Co., and three students from the industrial arts metal shop class at Van Wert High School.

When the courthouse was completed it was considered by many to be the finest in northwestern Ohio. For those who practiced in the spacious courtroom, however, acoustic problems were apparent from the beginning and its size was soon reduced and remodeled. The courtroom originally occupied the entire second floor with the judge's bench in the north end. The jury box remains about as it was but a larger seating arrangement ran east and west. All the space occupied by the present library was included in the courtroom which extended to the east wall. There was an entrance to the east similar to the present one. Because the corridor was built along the courtroom and direct lighting from front windows was diminished, it became necessary to provide more light. A colored-glass dome was built over the room to provide skylight. Later, after the installation of electricity, it was covered.

*The story of Benedict Arnold and his conspiracy with the British to capture West Point during the American Revolutionary War is significant for the naming of three counties in Northwestern Ohio, among them Van Wert. Arnold apparently conspired with the British in an attempt to bring about the fall of West Point by sending plans to the British hidden in the boot of Major John Andre, a British spy. Although Arnold issued a pass to get Andre through Colonial lines, problems for Andre developed when he tried to cross the lines where three New York Dutch patriots, fighting in the Colonial Army, were on duty. Not able to read Andre's pass, written in English, they searched him and discovered the plans in his boot. The three were John Paulding, David Williams, and Isaac Van Wart. In 1820, the legislature designated the county as Van Wert in honor of Isaac Van Wart. According to local legend, the discrepancy between Isaac Van Wart's name and Van Wert is traced to a clerical error from one of several sources, possibly even George Washington.*

# Van Wert County

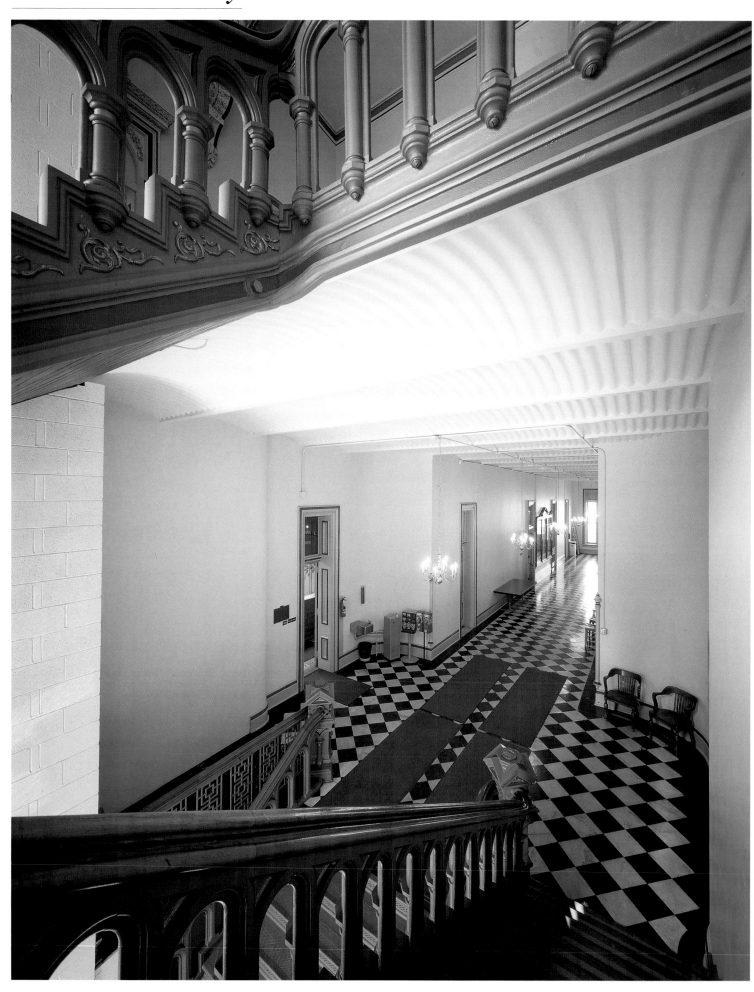

*Above: Staircase and hallway*

# Muskingum County

*Origin of name: Delaware Indian word meaning "a town by the river"*
*County Seat: Zanesville*
*Courthouse construction: 1874-77*
*Architect: H.E. Meyer*

In 1804, when Muskingum County was created from Washington and Fairfield counties it included nearly all of the Muskingum Valley north of Washington County. North of Zanesville, the land was surveyed into six-mile square townships, which were subdivided into quarter-townships containing 4000 acres. These were part of the Congressional bounty lands awarded to the Continental Army officers and soldiers as the United States Military District Lands (USMD). Overall, the USMD comprised more than 2 1/2 million acres. The size of grants (payment for military service) varied according to rank and length of service— noncommissioned officer or soldier, 100 acres; Ensign, 150 acres; Lieutenant, 200 acres; Captain, 300 acres; Major, 400 acres; Lieutenant Colonel, 450 acres; Colonel, 500 acres; Brigadier General, 850 acres; and Major General 1,100 acres. Since no one received a 4000 acre warrant, land was pooled, traded, and sold which often lead to ownership by nonmilitary persons and confusion in court records. South of Zanesville the land was surveyed into the usual square townships and sold directly to settlers.

From October 1810 until May 1812, the Ohio General Assembly, unhappy with its location in the state capital of Chillicothe, held its 9th and 10th sessions in Zanesville instead of Chillicothe. Still not satisfied, the legislature returned to Chillicothe where the General Assembly decided to create a new capital closer to the center of the state. As a result, the town of Columbus was platted on the east bank of the Scioto River and the state government moved there in 1816.

The Muskingum building, housing the temporary state legislature, became the county's first courthouse until the dedication of the present one in 1877. The 1809 date stone, removed from the old capitol and incorporated into the second, is visible over the front portico.

The limestone building, with mansard roof characteristic of the Second Empire architectural style and interconnected window hood moldings on the first and second floors indicating Italinate influences, rests on a stone foundation with the tower rising to 156 feet. The main entrance is located in a projecting pavilion which forms the base for the two stage clock tower that rises about 40 feet above the roof's line culminating with a dome of four sides topped with iron cresting and a weathervane.

*Above: Lobby with Belgian encaustic tile floor. These machine-made tiles were mass-produced and became fashionable during the latter part of the nineteenth century.*

# Muskingum County

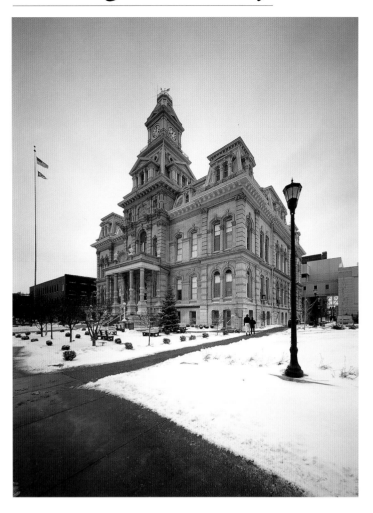

Above: The Muskingum County Courthouse.

Above: Map showing Ohio's land surveys and current county configuration.

Above: Modern lamp unexpectedly juxtaposed with a recently discovered molded plaster.

Above: A view of the first and second-floor lobbies from the stairway landing

# Licking County

*Origin of name: Licking River flowing through the county which derived its name from local salt licks*
*County Seat: Newark*
*Courthouse construction; 1876-78*
*Architect: H. E. Myer*

Four courthouses, all located on the tree-shaded public square in Newark, mark Licking County history. A small bronze bell displayed in the present courthouse symbolizes their continuity. The bell first summoned people to court sessions and county meetings when it hung outside a log building used for both a tavern and a courthouse in 1809. Officials transferred it to the second brick courthouse in 1815 and, around 1832, when that building became too small, the bell was removed to a newly constructed Greek Revival styled courthouse. When that structure was destroyed by fire, in 1875, Judge Samuel M. Hunter rescued the bell. It remained in his family until 1979 when they donated it to the people of Licking County.

The stone courthouse was constructed at the height of the Second Empire stylistic period in the United States. It retains an integration of design between its exterior and the interior courtroom where the blue color, heavy drapery, and gilded accents of the second-floor courtroom add to the building's French ambience. Further decoration includes religious murals depicting Moses and the Ten Commandments and the story of Solomon's Wisdom. In addition, there are portraits, busts, and stained glass windows of local and national jurists, heroes and presidents—William Woods (Mayor of Newark, member of U.S. Supreme Court), Salmon P. Chase (U.S. Senator, Governor of Ohio, Secretary of the Treasury in President Lincoln's cabinet and Chief Justice of the Supreme Court), George Washington, Benjamin Franklin, Thomas Jefferson, James Madison, Ulysses S. Grant, Henry Clay, Daniel Webster, William McKinley, and Abraham Lincoln.

All the portrayals of presidents from Ohio are surrounded by seventeen stars (in reference to Ohio being the seventeenth state of the Union and its flag with seventeen stars). The depiction of McKinley and Lincoln were added after the courthouse was constructed because McKinley was about 29 years old and not yet Governor of Ohio. McKinley's portrait, on the wall behind the bench and next to Lincoln's, is surrounded by stars. In order to balance the images, Lincoln, who was not from Ohio, was also given seventeen stars. When additional county government office space became necessary, a modern styled annex was constructed across the street from the square, on the southeast corner, so as not to detract from the courthouse's presence.

*Above: Bell which is part of the four courthouses' history.*

# Licking County

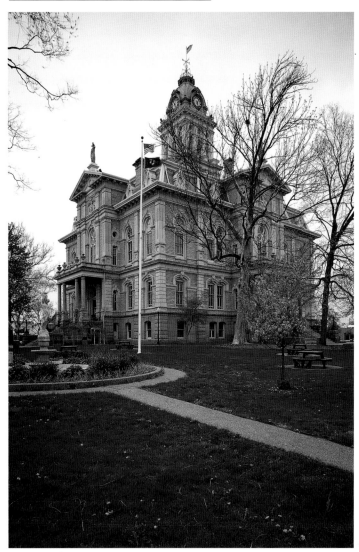

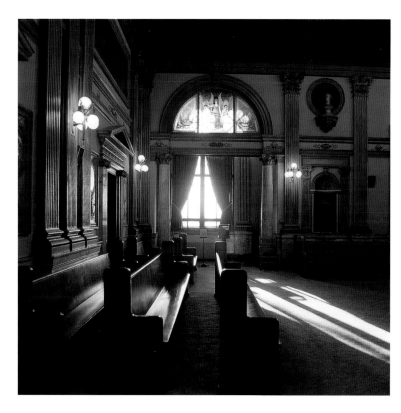

*Above: Shadow on courtroom floor from a window with circular, leaded insets*

*Left: The Licking County Courthouse. On each of its sides the central area forms a tower-like pedimented, projecting bay which extends slightly above the roofline. The tower, in the center of the mansard roof, has three louvered round-headed arches on each side. Above the arches are clock faces. At the top is an iron balustrade surrounding a flagpole.*

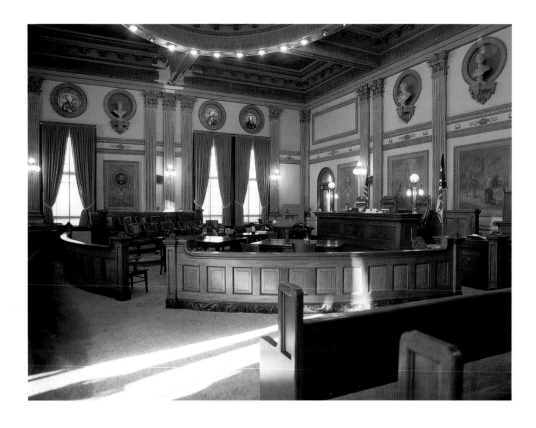

*Above: The Courtroom, with an intimate feel for the Judge and other officers of the Court inside the bar.*

# Wayne County

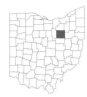

*Origin of name: Major General Anthony Wayne, Revolutionary War hero,*
*General-in-Chief U.S. Army 1791-1796*
*County Seat: Wooster*
*Courthouse construction: 1877-79*
*Architect: Thomas Boyd*

The Second Empire styled courthouse's original symmetrical plan, by Pittsburgh architect, Thomas Boyd, failed to be executed because the north annex (completed 1868) of the previous courthouse (1832) was still sound and cost-conscious county officials decided to preserve and connect it to the new building. Consequently, an asymmetrical clock tower rises from its northeast corner.

Sculptural detail distinguishes the courthouse. While incorporating decorative mythological characters into architecture was fashionable during the latter part of the nineteenth century, the giant sculptures flanking the south and east entrances are unusual for Ohio. Boyd adopted four carved figures of Atlantes to support the entrance pediments. Atlantes are related to Atlas, the Titan who was sentenced to support the heavens because he joined in a revolt against the gods. From solid blocks of Berea stone, already set into place, a pair of itinerant Prussian sculptors carved these double life-size statues, consisting of heads and torsos

with their midsections turning into architectural elements. Additionally, two sculpted figures representing Justice look out from a split pediment at the cornice line. One holds scales of justice while the other grasps a tablet inscribed with the Ten Commandments.

In the Probate Court, located in the 1868 annex, the vault secures its records. Accumulation of paperwork for more than fifty kinds of county documents, ranging from auto titles and criminal documents to wills and land deeds, became a storage problem for Wooster officials. In order to alleviate it, during 1993 and 1994, Mormon volunteers microfilmed Wayne County's probate records (from 1812 through 1917). This effort is part of a mission by the Genealogical Society of Utah (sponsored by the Mormon Church) to preserve, on microfilm, historical records of American communities in order to assist in their efforts to baptize their ancestors. One copy remains in Wooster and another is secure inside the archival repository at Utah's Granite Mountain.

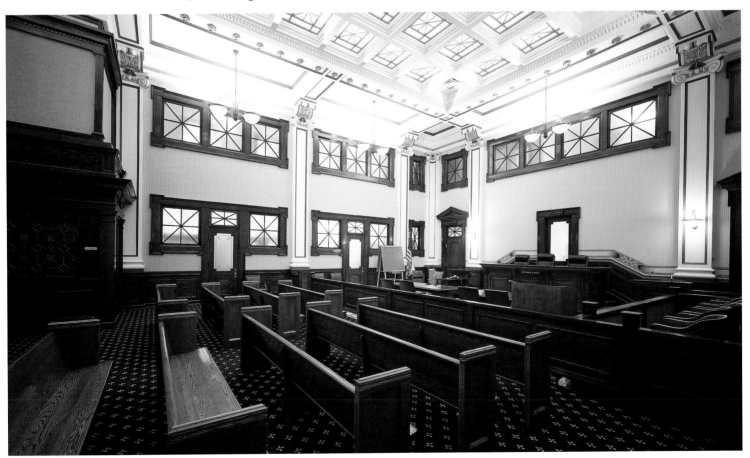

*Above: Courtroom with original carved rosettes. A fire on May 20, 1969 caused extensive damage but one panel of the original 28 leaded glass panels forming a skylight was saved and its design copied for today's ceiling. It was later incorporated into the public entrance (to left).*

# Wayne County

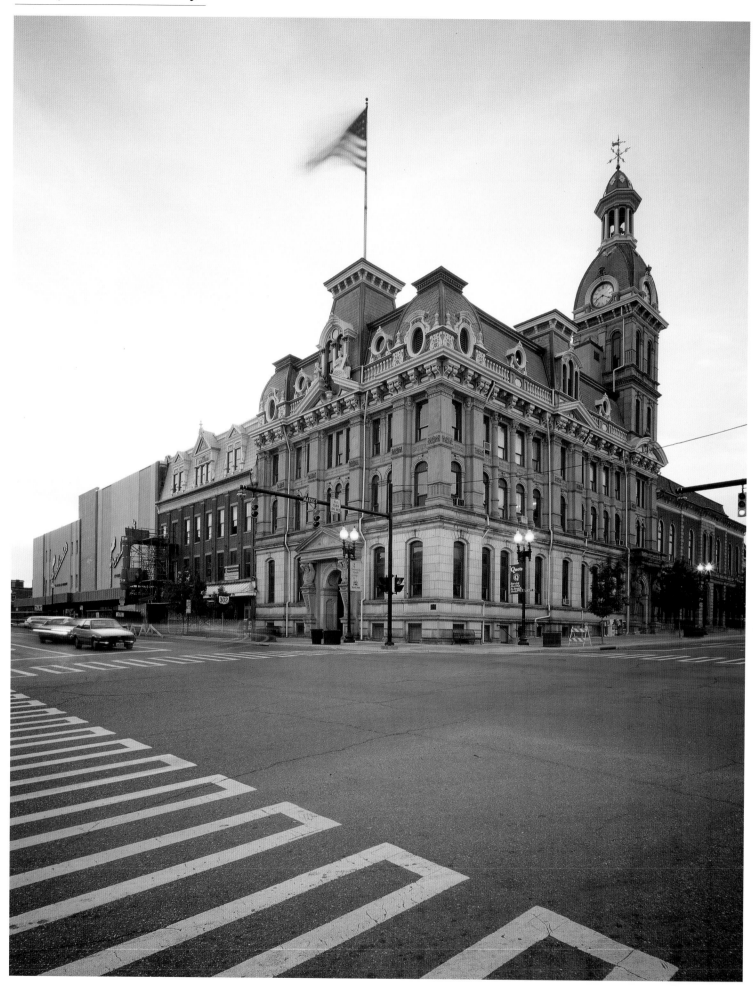

*Above: The Wayne County Courthouse. Note, flanking the entrance, partly emerging, muscular, Atlantes that are weary-looking from the long task of supporting the pediment of the round arched entrance.*

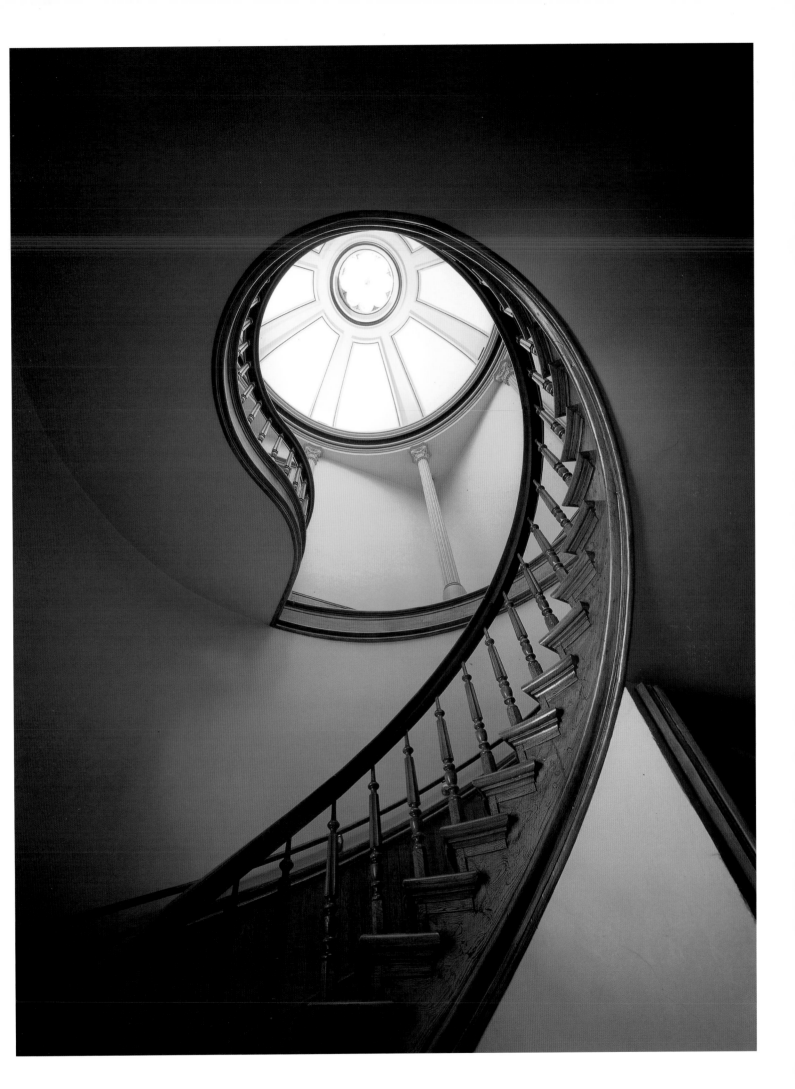

*Above: Spiral staircase with columns and pilasters in annex.*

# Wayne County

Wayne County was established by a proclamation of General Arthur St. Clair, governor of the Northwest Territory, August 15, 1796. It was the sixth county formed in the Northwest Territory. At this time, the county included the territory from the present limits of the Cuyahoga River and running west to include the towns of Akron, Massillion, Dover, Millersburg, Mt.Gilead, Belfontaine, Fort Laramie then to Fort Recovery on the Indiana state line. The line continued to Ft.Wayne and included the northern counties of Indiana to Chicago. It included all of Michigan and the area draining into Lake Michigan to the west. The line continued on the International boundary separating Canada and the United States back to Cleveland and terminating at the starting place, the mouth of the Cuyahoga River. It contained 133,000 square miles with government at Fort Detroit. This remained as the boundary and primitive organization for eight years until the formation of the state of Ohio when the present counties began to be developed. In 1803, Montgomery, Green and Franklin counties were formed separating off the territory east of Franklin south of Connecticut Western Reserve and north of the old Greenville treaty line from the rest of Wayne County leaving it without any county organization. It was known as the New Purchase for five years, an uncivilized part of Ohio. In 1808, it became a part of Columbiana County until January 1, 1809 when Stark County was organized with Wayne under it jurisdiction. Finally on January 4, 1812, the state legislature recognized Wayne County. It was reduced to its present boundaries following the formation of Ashland County on February 24, 1846.

*Above: Roof detail.*

*Above: View upon entry of central hallway and main staircase. As in years past, real estate auctions are sometimes held at the foot of the staircase.*

*Above: Clock glass dials, 6' in diameter and weighing 140 pounds each. The Roman numerals are painted on the outside. On wall is a framed piece of wood signed by clock keeper, C.R. Rice, dated 1899. Since then, there have been seven clock keepers that carved their names and dates served on the frames of the clock tower.*

# Athens County

*Origin of name: Athens, Greece*
*County Seat: Athens*
*Courthouse construction: 1878-80*
*Architect: H. E. Myers*

In March 1786, during a three-day meeting at the Bunch of Grapes Tavern in Boston, the Ohio Company was formed. Comprised of former Revolutionary War officers and soldiers from Massachusetts and surrounding states, its purpose was to acquire land in the Ohio territory for settlement. On October 27, 1787, it successfully completed the first large land sale in the United States with the Continental Congress consisting of about 1,500,000 acres. Congress reserved two townships, consisting of about 46,000 acres, "perpetually for the purpose of a university." Ohio Company records from December 16, 1795 state:

*The reconnoitering committee, having reported that townships number eight and nine in the fourteenth range are the most central in the Ohio Company's purchase, and it being fully ascertained that the lands are of excellent quality, resolved unanimously that the aforesaid townships number eight and nine in the fourteenth range be reserved for the benefit of an university, as expressed in the original contract with the Board of Treasury of the United States.*

The lands are located in Athens and Alexander townships. Ohio University, established February 18, 1804, was the recipient of the land grant. In 1805, the legislature permitted the University trustees to lease the land to settlers for 99 years, renewable forever, with a fixed annual rent of six percent of the appraised value. Reportedly, some persons still pay only the rent established in the 1805 law.

The county's first log courthouse, built in 1807, was replaced by a brick one in 1818 which existed until 1880 when the third was constructed on the site of the first two. Instead of standing apart from the other buildings on the street, it nearly fills its site and is a part of and a

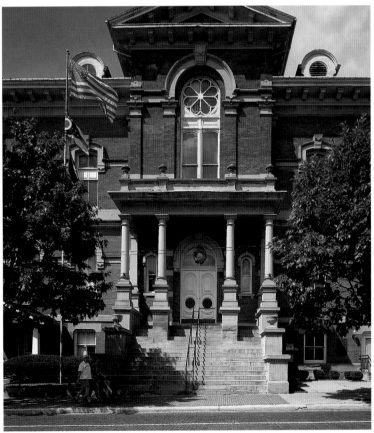

*Above: A view of the lobby.*

*Above: Main entrance*

# Athens County

continuation of the Court Street façade where most of the buildings date from between 1880 and 1910. Steep steps from the street lead up toward the sandstone portico supported by four columns and capped by a balustrade. Teddy Roosevelt, William Howard Taft, and John Glenn, among others, addressed crowds from there.

During the 1930s, the interior was remodeled with funding from the Works Progress Administration (W.P.A.). The courtroom was reduced in size, the ceiling lowered, and the spectator benches were turned from west to face south. New offices were created from other large areas.

A two-story addition to the courthouse was completed to the west in 1976. In 1992, the renovated 1903 Cline building, located next to it, became the Athens County Administration Building. The two landmarks are connected and form a governmental complex.

*Above: Map of Ohio Company Purchase highlighting townships eight and nine.*

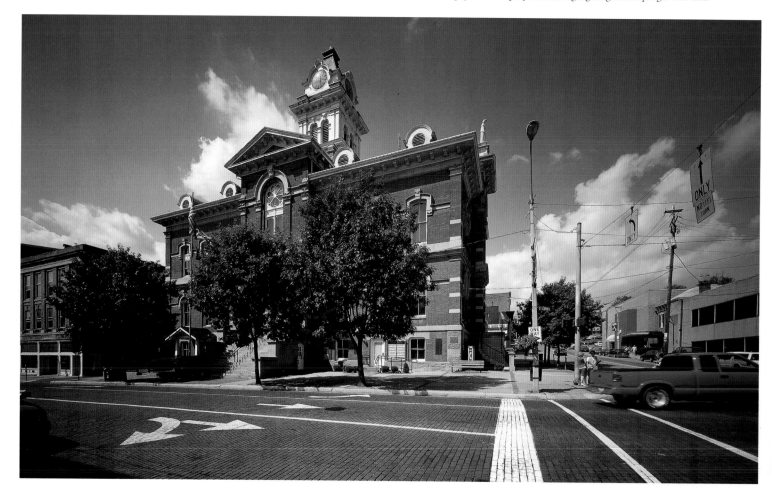

*Above: The Athens County Courthouse as part of the Court Street façade.*

# Lorain County

*Origin of name: French Province of Lorraine*
*County Seat: Elyria*
*Courthouse construction: 1879-82*
*Architect: Elijah E. Myers*

At the height of the "Gilded Age," the Lorain County Commissioners hired architect Elijah E. Myers to design their courthouse. Myers was well known for his statehouse designs in Texas, Colorado, and Michigan. When nearly every other Ohio courthouse was being constructed in the Second Empire style, he created, in Elyria, one with a central dome on a drum with a peristyle, in the Renaissance Revival Style.

Its base is rusticated sandstone block, while the upper stories are smooth-cut sandstone. Ornamentation includes pilasters, a denticular cornice, and a balustrade. The central bay of each façade projects, and is pedimented.

Myers specialized in fireproof buildings. The floors are vaulted brick between iron beams, forming scalloped ceilings below. The grand stairway is cast iron, and terminates in an overscaled newel post.

The dome was removed in 1943, and during 1981-82 the interior was remodeled. The original large ornate courtroom was divided, and woodwork, fireplaces, and vaults were removed. A view of the third floor reveals pipes, air conditioning chiller, and wires, along with elements of the ornamental plaster ceiling and molding of the original courtroom. Today, many of the courthouse's original functions have been relocated to the Lorain County Administration Building (dating from 1973) across the street, leaving the image of the original intact.

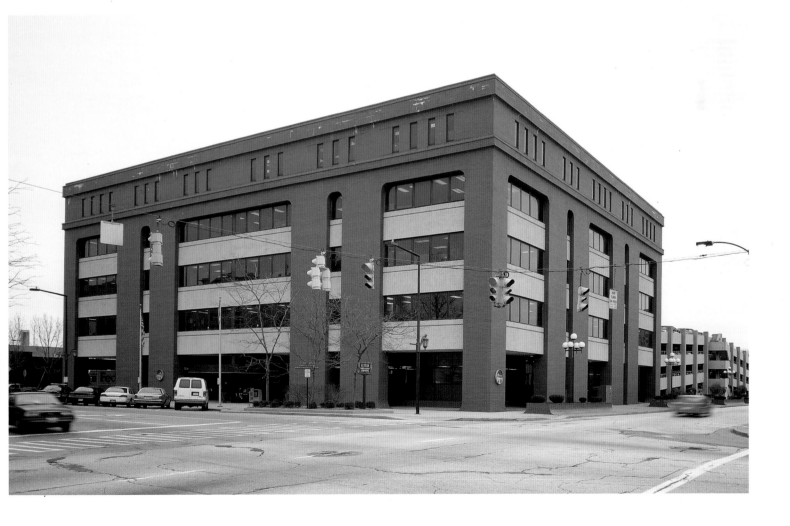

*Above: The 1973 Lorain County Administrative Building.*

# Lorain County

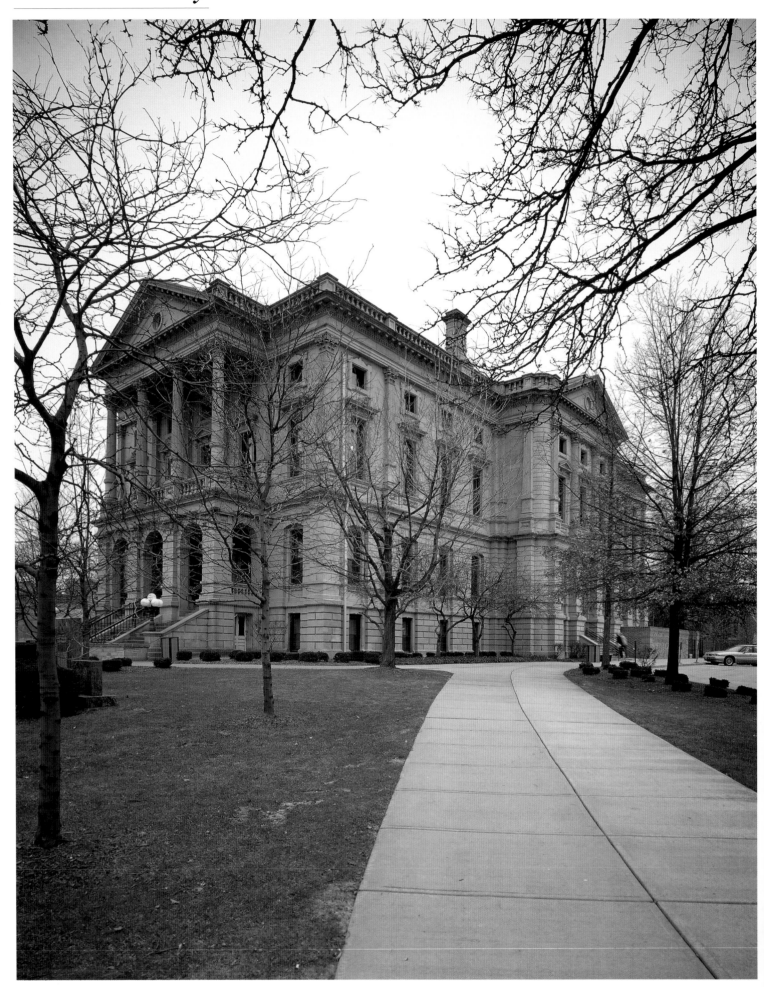

*Above: The Lorain County Courthouse incorporates slightly projecting pavilions at the center of each side, and an open portico in front.*

# Henry County

Origin of name: *Patrick Henry, Governor of Virginia and Revolutionary War Hero*
County Seat: *Napoleon*
Courthouse construction: *1880-82*
Architect: *David W. Gibbs*

The area encompassing Henry County was once a part of the infamous "Black Swamp" which covered the region north of the Treaty of Green Ville line and west of the Connecticut Reserve, roughly the size of Connecticut. The swampy conditions were the result of a lake plain (supplied by Lake Erie and the Maumee River) that was so level drainage was difficult and a dense growth of trees restricted the penetration of sunlight. The situation of standing water, or soil that was so wet water oozed when walked upon, obstructed and slowed settlement in northwest Ohio.

During the War of 1812, especially after the fall of Fort Detroit (where American General William Hull surrendered without a gun being fired in defense), marching through the swamp wilderness was essential in order to control Lake Erie and for the army to reach Detroit. Soldiers related stories of suffering and hardship as they moved along an early road, approximating Route 68, from Urbana northward—"man and horse had to travel mid leg deep in mud" and "the mud was ankle deep in our tents."

Following the war, the region south of the Maumee River was ceded to the United States and, after it was surveyed, became available for purchase. Pioneers bought units as small as 80 acres and promptly tiled it in order to aerate the soil. Once drained, it became fertile. The roads, built and used by the military, and the opening of canal service between Toledo and Fort Wayne in 1843 and Toledo and Cincinnati in 1845 further encouraged settlement and facilitated the transportation of products to market which further promoted development.

Toledo architect, David W. Gibbs, designed the courthouse that is distinguished by four projecting corner towers with four sided steeply pitched mansard roofs capped with finials. Its clock tower is crowned by a statue of Justice. During the 1990's the tower's deterioration, with water leaking to the floor below, necessitated attention. County officials decided to ask the voters if they would agree to a four million-dollar bond issue for the landmark's overall restoration. The answer was yes and, after suffering years of neglect and inattention, the courthouse, complete with computer terminals and air conditioning, was rededicated on April 19, 1998.

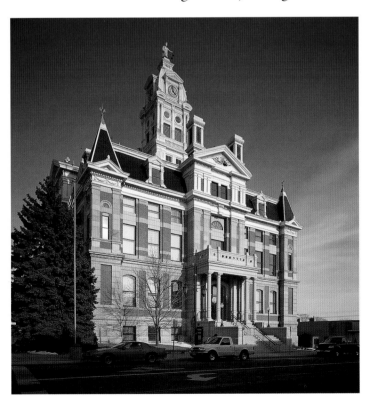

*Right: The Henry County Courthouse*

*Above: Recorder's Office with table original to courthouse*

# Henry County

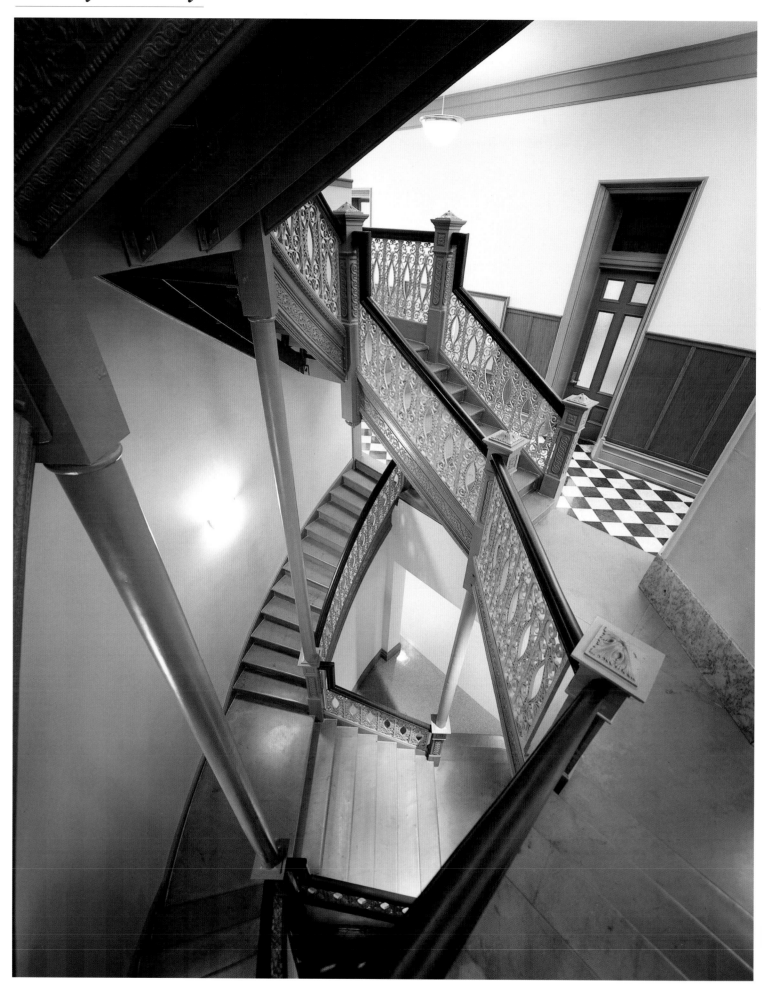

*Above: Child's-eye-view, looking down from first-floor staircase landing toward basement.*

# Union County

*Origin of name: From the union of parts of Delaware, Franklin, Madison, and Logan counties*
*County Seat: Marysville*
*Courthouse construction: 1880-83*
*Architect: David W. Gibbs*

Architect David W. Gibbs designed the Union County Courthouse as a simultaneous twin to Henry County's. In the Second Empire style, it is brick with cut stone and galvanized iron trimmings, with a mansard roof and pointed corner towers. Above three similarly designed stone porticos is a pediment on short pilasters, ornamented with a flag sculpture in the center.

Although both Marysville and Napoleon courthouses are similar in overall design, their location in their respective county seats sets them apart. Union County's is set in the middle of a large grass-and tree-filled square, whereas Henry County's building fills its lot, abutting the sidewalk, within the business district of Napoleon. Another distinction is that during recent restoration efforts, the structural changes needed in the two buildings differed greatly.

Restored and rededicated on April 23, 1994, Union County's courthouse revitalization reflects the spirit of the original, while incorporating new technological systems and reorganizing some public areas. For example, the Probate and Juvenile Court (unified under one judge) was relocated from a small combination court and office on the first floor to a larger, separate, and more prominent space. The original judge's bench is now bulletproof. Other additions include access for disabled patrons, attorney-client conference rooms, and a holding cell for recalcitrant juveniles.

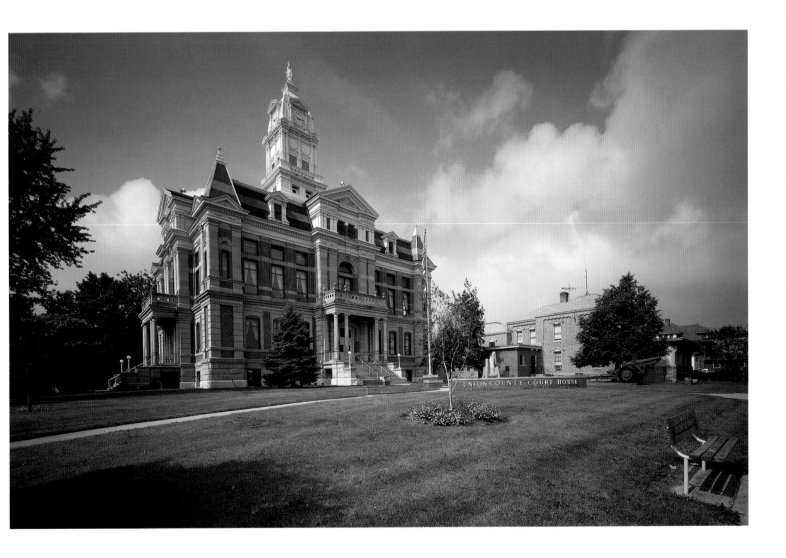

*Above: The tower bells of the Union County Courthouse play such melodies as "America the Beautiful" on the hour.*

# Union County

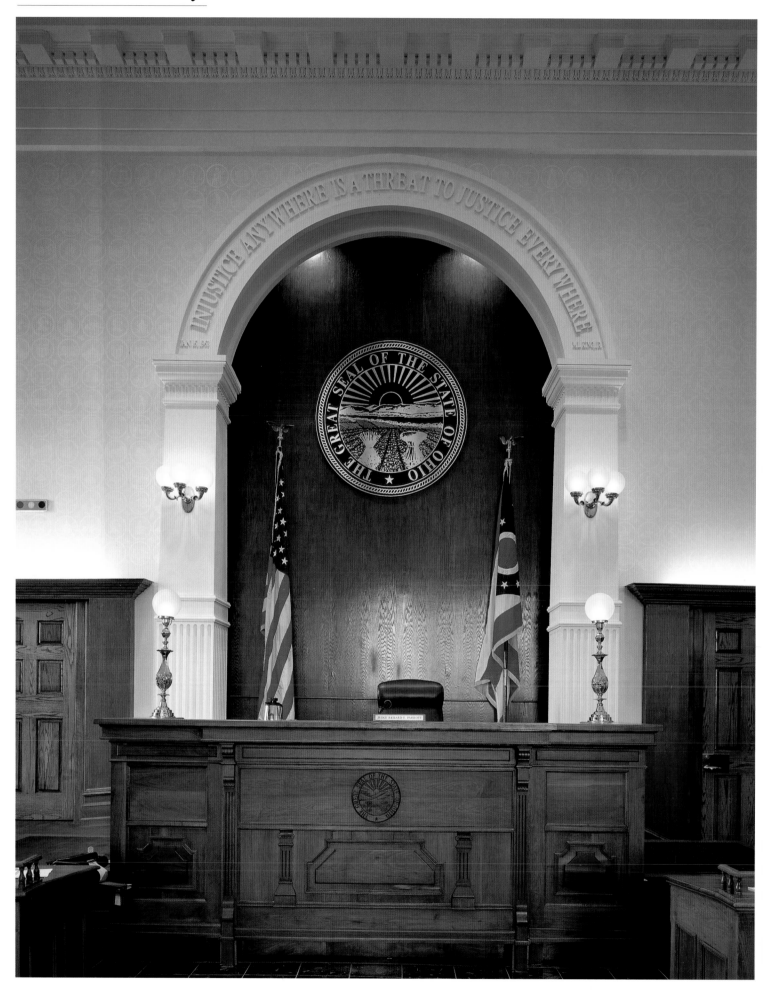

*Above: When the Court of Common Pleas courtroom was reconfigured, it provided an opportunity to add a quotation from Martin Luther King, Jr.*

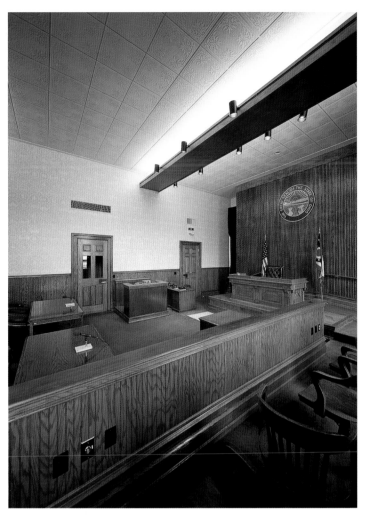

*Above: Probate and Juvenile courtroom. Note hard floor before bench designed to hold the attention of those appearing before the court. The door to the left leads to attorney/client conference rooms that allow for privacy absent in many older and overcrowded courthouses. Note also the wallpaper created as part of the restoration and especially designed for the first and second-floor courtrooms, depicting scenes of historical significance to the region as outlined in a framed description hanging on the wall of each courtroom.*

*Above: Wood and steel curving staircase rising from the lobby of marble floor tiles.*

Both courtrooms found in the Union County Courthouse display wallcovering containing 24 circled images, symbolic of various scenes of importance to Union County. Each of the 14 townships are represented, with the name of the township and the date it was established. Allen Township has its covered bridge; Claibourne its opera house, now the police station; Liberty its shield; York a farm scene in commemoration of its reputation for fine agriculture; Dover Township has a train for its being the first railhead in Union County; Paris its blockhouse as the first fortification here; Jackson and Washington contain images of the respective presidents for which each was named.

Union Township has the replica of the buggy works formerly located there; Millcreek's circle has the stream for which the township is named; Leesburg has the "magnetic spring;" and Taylor has Broadway's J.J. Watts general store. Darby Township has Chief Darby, for whom it is named; while Jerome Township has the Civil War Statue long located in New California. Union County itself is represented by the map of the county, with the various municipal corps shown by stars. In addition, each of the four buildings that serve as Union County Courthouses since we became a county in 1820 are shown with the dates of use. The courthouse cannon is also shown, representing those Union County natives who have served in this country's armed services.

The scales of justice, Miss Justice, and the Lamp of Knowledge celebrate the dedication of these rooms to fairness, wisdom and justice under the law. The last circle contains the peace pipe, symbolic of the Greenville Treaty, whose line extends through northern Union County.

# Guernsey County

*Origin of name: Isle of Guernsey, origin of many settlers*
*County Seat: Cambridge*
*Courthouse constructed: 1881-83*
*Architect: Joseph W. Yost*

America's first federal highway, the Cumberland Road or National Road (later U. S. 40) was created by Congress and signed into law by Thomas Jefferson in 1806. From its eastern terminus in the Alleghenies, at Cumberland, Maryland, westward migration moved over the the road through the center of Ohio to Vandalia, Illinois. After Guernsey County was formed in 1810, Cambridge's location on what later became the Cumberland Road was a factor in its being named the county seat.

The county's first courthouse, completed in 1818, was the setting in 1821 for a politically damaging trial that attracted countywide attention. The case involved Simon Beymer, who served as captain of a company of Guernsey County soldiers during the War of 1812, and who was a candidate for state senator. The other party to the suit, David Robb, a Jacksonian Democrat, was politically opposed to Beymer. During the election campaign, Robb accused Beymer of embezzling money entrusted to him for the payment of the soldiers, by retaining and appropriating nearly one-third of it for his own use. Robb's accusations against Beymer provide a sample of contemporary political campaign rhetoric:

> *Let any one imagine to himself the pains and sufferings endured by those brave men who fought and bled in their country's cause. Let him present to his mind the husband parting from his wife, the father from his child, perhaps to see that wife or child no more–his life surrendered on the field of battle for our safety and protection. Where is his reward? The money which should sustain the widow and the orphan becomes the spoils of an unprincipled speculator.*

> *And can you, fellow-citizen, who know the facts, vote for a candidate whose wealth has been thus procured? Shall he receive a seat in the senate as a reward of his merits? This man (Beymer) is not entitled to your suffrage. No, a man who will filch from, or keep back a soldier's money, ought and will sink into infamy and disgrace.*

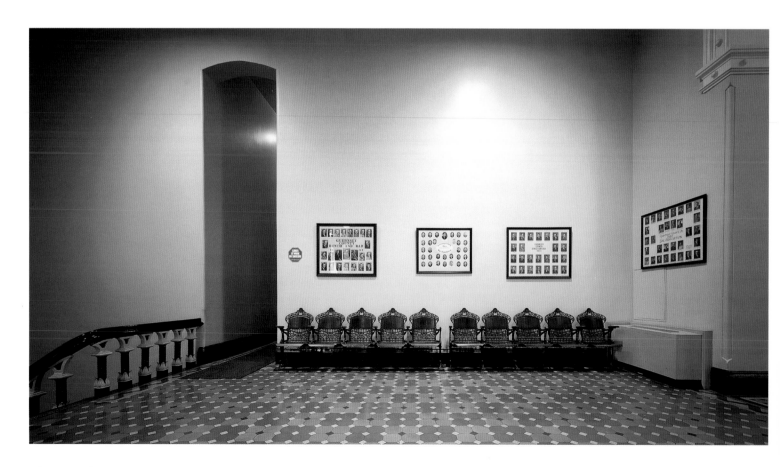

*Above: Original courtroom seating, near rotunda and courtroom entrance. Above them is a series of Guernsey County Bar Association member photographs, taken at ten-year intervals.*

*If there is a man who burns not with indignation when he reads these facts, whose feelings recoil not at the contemplation of such a character, let him vote for Simon Beymer. But on the other hand, if he feels what every honest man must feel, emotions of detestation, let him vote for honest and upright Republican Wilson McGowan.*

*"A Democratic Republican"*

Beymer was defeated. Attributing his defeat to a partisan smear, he filed the lawsuit against Robb, demanding three thousand dollars in damages. Depositions were taken from all the surviving soldiers. A jury found that Beymer had turned all the money he had received over to the soldiers, and that Robb's charges were groundless. Robb was ordered to pay Beymer damages of one hundred dollars, and all court costs.

The county's second courthouse was dedicated on September 11, 1883, after the growing population of the county demanded a better place for conducting county business than the earlier building, now nearly seventy years old. Located on the same public square as the old courthouse, the sandstone building features a hipped roof with mansard-roofed towers topped with iron cresting at each corner. The round-arched oak doors are covered by a porch located in a pedimented bay. The pediment on the south side is broken, and at the center is a statue of Justice. A square tower in the center of the roof consists of louvered arched openings, columns, and a mansard-roofed dome topped by a wooden lantern and finial.

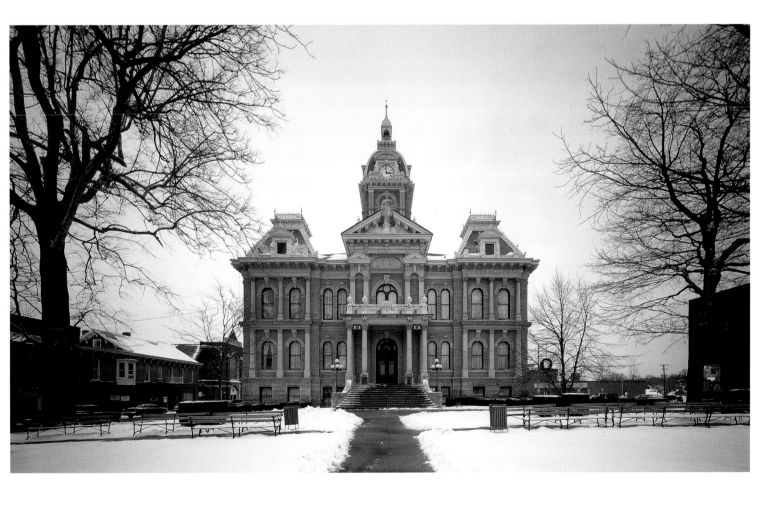

*Above: The Guernsey County Courthouse*

# Guernsey County

Above: View of Law Library, created from part of the original courtroom. The ceiling decorations are continuous across both rooms. They include a plaster likeness of the English jurist Lord Coke (1552-1634), the defender of the right to be judged by one's peers.

Above: View out from main entrance through oak doors.

Above: Map of the National Road.

# Shelby County

*Origin of name: Isaac Shelby, Revolutionary War hero and*
*    first Governor of Kentucky*
*County Seat: Sidney*
*Courthouse construction: 1881-83*
*Architect: George H. Maetzel*

A surveyor hired by the Board of Shelby County Commissioners set aside the Sidney public square in the original town plat that is now the site of Shelby County's third courthouse. The courthouse dominates this park surrounded by a business district comprised of buildings in such disparate styles as Federal, Greek Revival, Italianate, Romanesque Revival, Victorian Gothic, Second Empire, Victorian Italianate, New Classical Revival, Renaissance Revival, Georgian Revival, and Moderne. On the southeast corner, for example, is the 1875 Shelby County Jail connected to the sheriff's quarters. The Italianate residence contrasts sharply with the unadorned stone cell block. On the southwest corners stand the 1876 Victorian Gothic Monumental Building erected to memorialize the Civil War dead, and the 1917 bank building designed by architect Louis H. Sullivan. The courthouse and the district represent evidence of the community's prosperous history, located in a rich agricultural area close to early canal, railroad, and highway transportation systems, where industry and banking also flourished.

The Second Empire courthouse, designed by George H. Maetzel of Columbus, features four identical façades with entrances located within a projecting pavilion. A columned porch with a stone balustrade on its roof frames the doorway. A centrally placed tower with four clocks rises from the center of the mansard roof.

*The square is also a grim reminder of early public hangings held throughout the state, because it was here in 1855 that a man was hanged for abusing and killing his daughter. According to the handwritten indictment, the defendant regularly abused his eleven-year old daughter by chaining her around the neck to a block of wood in a cold room without clothing, bedding, a fire, or other means of protection; depriving her of meat and drink sufficient for her sustenance; forcing her to work outside in the cold until she froze her hands and feet; when she became sick, neglecting to provide suitable medicine and nursing; and using a long pole to beat her on the head, back, stomach and breasts. When on February 17, 1854, she was found dead, the cause was determined to be the abuse she received from her father. A jury of twelve local men found him guilty of murder as charged in the indictment, and he was hanged.*

*Above: A view of downtown Sidney from the courthouse tower.*

# Shelby County

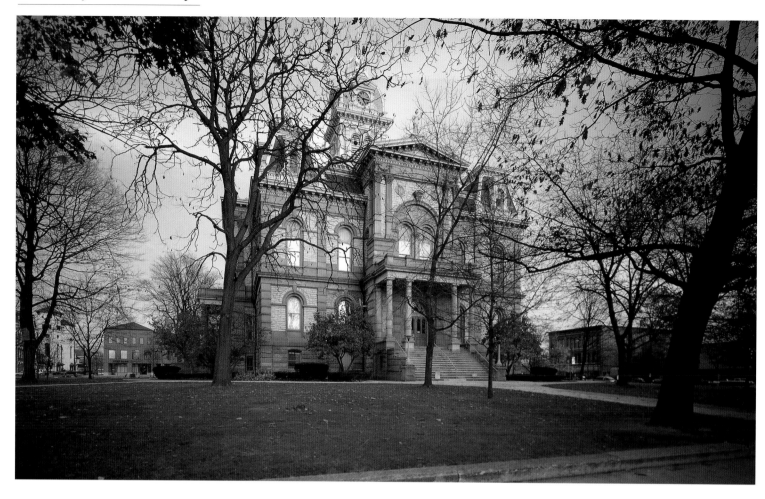

*Above: The Shelby County Courthouse on an autumn evening.*

*Above: Leather-bound books contain the records of Shelby County, now stored in the courthouse's fourth-floor attic.*

# Allen County

*Origin of name: Colonel John L. Allen, hero of the War of 1812*
*County Seat: Lima*
*Courthouse constructed: 1881-84*
*Architect: George H. Maetzel*

The present courthouse is Allen County's third, built in 1882 at a cost of $360,000 and financed through a voter approved levy. Approximately 120 feet square, it rests on a stone foundation and is constructed of rock-faced sandstone with smooth stone trim. Flanking the center projecting pavilion on the south side are two short mansard-roofed towers. The entrance is located in a two-story arch. Smooth stone quoins and belt courses provide contrast to the rock-faced stone walls. The roof is mansard, with a square tower that contains a belfry with louvered openings, and a dome with four clock faces.

The three-story courthouse was built on the threshold of an industrial and economic boom that began when oil was discovered in 1885. For a few years the Lima oil field was the largest in the nation and the steam locomotive industry caused the Lima locomotive to have world renown.

The Allen County courthouse was the focus of national attention in 1933 when John Dillinger, then a prisoner in the Allen County Jail, was freed when gang members shot and killed the Allen County Sherrif. The second-floor courtroom was the center of attention when those responsible for such a murder were brought to justice.

In 1990 the Justice Center, which includes a jail, courts and sherrif administration, was constructed north of the existing courthouse connected by an overhead walkway. The architectural blend of the old and the new depicts matching colors and rooflines that makes the two structures blend together as one complex.

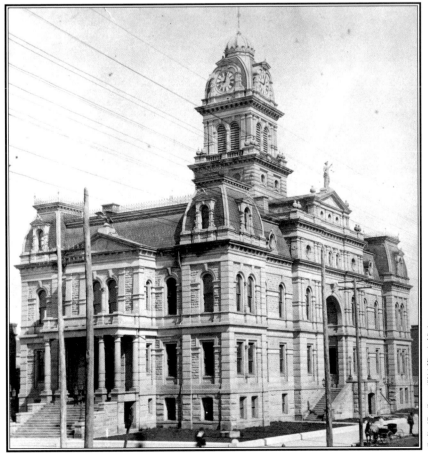

Credit: Allen County (Ohio) Historical Society

*Above: Allen County's courthouse upon completion.*

# Allen County

George Maetzel, as architect, designed other Ohio county courthouses. His special design incorporates the French Second Empire style with the mansard roof archways and clock towers. With minor renovations to adapt to modern and efficient use, the one hundred eighteen year old edifice still stands as a focal point in Allen County.

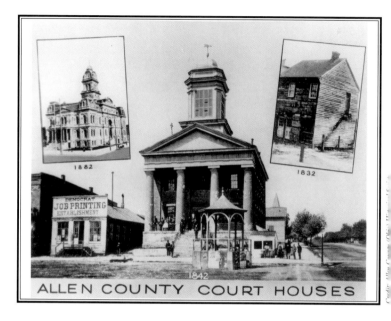

Above: Three Allen County Courthouses.

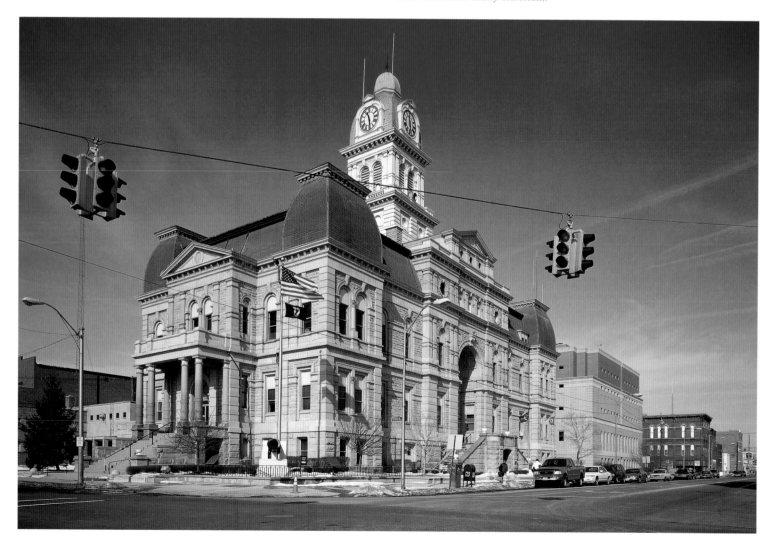

*Above: The Allen County Courthouse with the 1990 Justice Center addition.*

# Tuscarawas County

*Origin of name: Tuscarawas tribe who lived on the Tuscarawas River*
*County Seat: New Philadelphia*
*Courthouse constructed: 1882-84*
*Architect: Thomas Boyd*

The Tuscarawas County Courthouse was built during that time of growth and prosperity when counties were constructing ambitious buildings, almost of state capitol size, whose interiors were attracting increasing attention. The square chamber below the dome, similar to the rotunda in a state capitol, displays murals intended as speaking pictures of the history of the area: pioneers arriving by covered wagon, the small homes of early settlers, agricultural progress from ox-drawn to gasoline-powered equipment, and a steel mill. There are also paintings of the first courthouse and jail, a canal boat, a covered bridge, teepees, the Great Seal of the state of Ohio (1802), the Seal of the Territory of the U.S. Northwest of the River Ohio, and the Gnadenhutten Monument outside New Philadelphia.

Below the courthouse's dome, open Roman arch windows adorn the circular tower. Originally, the dome was topped with a hand-hammered zinc-plated statue of three women. The statue deteriorated, and when a piece of its metal fell to the ground, it was removed. The three heads, all that remain, sit on a shelf in the County Commissioners' hearing room. Today a cupola, weighing over a thousand pounds, tops the dome, a brass eagle crowning its copper roof. The cupola was lifted into place by a helicopter on July 26, 1973.

The doorway is recessed, and the arch is flanked by square columns with Doric capitals. The pedimented entrance is supported by round columns with Corinthian capitals. Many modifications and alterations have been incorporated into the exterior. Aluminum doors and windows have been added, and walls inserted behind the second-floor balconies, supported by columns.

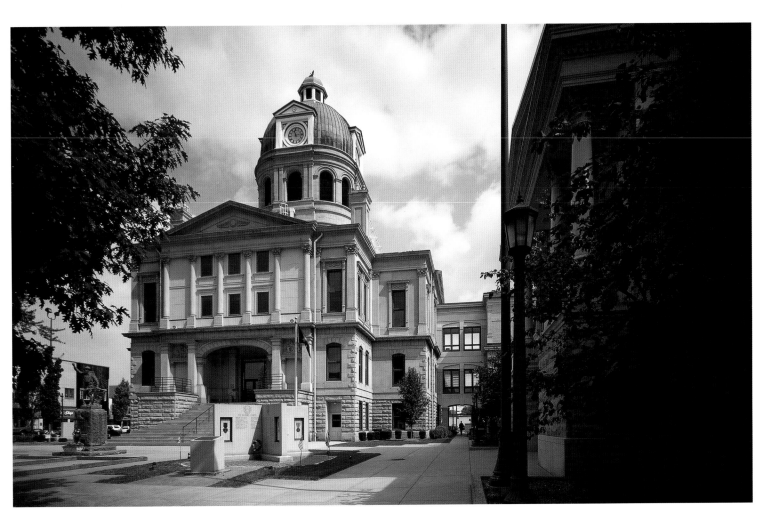

*Above: View of Tuscarawas County Courthouse, with plaza and, at right,*
*the administrative building constructed in 1990.*

# Tuscarawas County

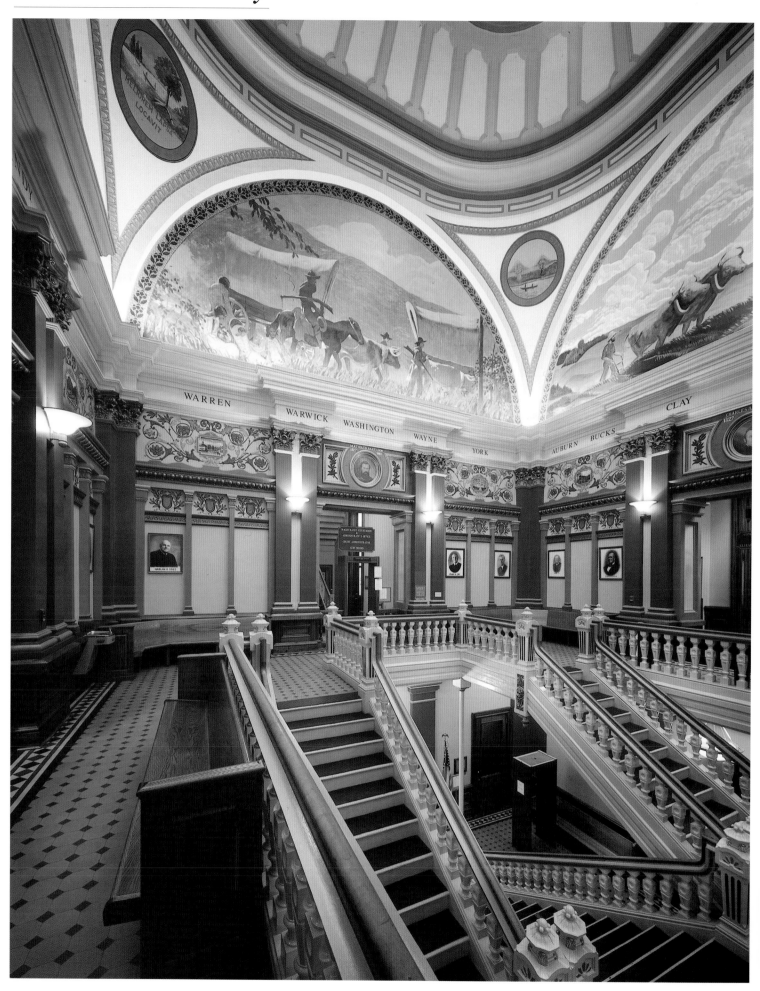

*Above: The Rotunda.*

*Above: Three heads of former dome statues watch over
meetings held in the Commissioners' boardroom.*

The large shaft of the Gnadenhutten Monument
commemorates over ninety Native Americans who
were slaughtered on March 8, 1782 in retaliation for
an alleged raid of a settlement near the Ohio River.
The response of Congress was to grant twelve
thousand acres along the Tuscarawas River,
Gnadenhutten, to the "Society of the United
Brethren" (Moravian-Brethren) to be held in trust for
the Native Americans, on condition the missionaries
"civilize" them and propagate the Gospel to them. In
1823, agreements revoking the trust and transferring
this valuable land to the U.S. were signed by
representatives of the United States, the United
Brethren, and the Christian Native Americans.
In 1825, subdivided into farm lots, the lands were
sold at public auction by government officials, from
the Tuscarawas courthouse. From the land sale
proceeds, the Christian Native Americans received
a $400 annuity, and the United Brethren Society
received money to pay the debt remaining from its
improvement of the tract. By this time most of the
Indians had been moved out of Tuscarawas County
by the federal government to Indian Territory given to
them in the west.

# Carroll County

*Origin of name: Charles Carroll, last surviving signer of the*
    *Declaration of Independence*
*County Seat: Carrollton*
*Courthouse construction: 1884-1885*
*Architect: Frank Weary*

Carroll County was established by the Ohio General Assembly on December 25, 1832. Soon after the first courthouse was completed in 1835, it was the site of a rare but raucous impeachment trial of the first Carroll County Clerk of Courts, Daniel McCook. McCook survived the state's effort to expel him from office on the charge that he breached good behavior in office. According to the Articles of Impeachment, McCook filed a false congressional election certificate for the purpose of altering the outcome. When the grand jury convened to consider indicting him, he "packed" it with his friends, illegally held political and electioneering meetings in his public courthouse office, and distributed political handbills.

During the 1837 trial, the prosecutor focused on the state's accusation of altering the election return. Although there were only two candidates, one of them, Andrew Loomis, was listed on some returns as Andrew W. Loomis. The prosecutor argued McCook knew the two listings were the same man and yet split their votes, thus delivering the election to his brother, George McCook. McCook's defense attorneys denied the allegations, contending they were nothing but a political vendetta conceived from the prosecutor's personal malice toward him. At the conclusion, the Court took the case under advisement until the next Term. It remained undecided until the June Term, 1839, when the case was quietly dismissed.

Daniel went on to father one of the two families often referred to as "The Fighting McCooks." Seventeen McCook men fought for the Union army in the Civil War, and twelve became officers–three of them generals. Daniel himself died from wounds received in the Battle of Buffington Island fighting John Morgan's raiders.

Fifteen years after Daniel McCook's death, the county had outgrown the first courthouse where he had worked, and machinery was set in motion for its replacement. Although there was opposition to a new courthouse, eventually the present and second

*Above: Lobby, with cast iron staircase and tile floor.*

courthouse was constructed of Berea sandstone behind the first, which was not demolished until the second had been completed.

A stone portico frames the central entrance of the eclectic styled courthouse. Above is a round-arched window, flanked by pilasters, capped with a stone cornice inscribed with the name of the county and the date 1885. The original windows were flat-arched on the first floor and round-headed on the second floor, with wooden sash, although they are now fitted with aluminum sash. The center bays of both the east and west sides project and end in gables above the irregular roofline. In the center of the hip roof is a square tower with a dome pierced by four clock faces. This originally had a statue of Justice at its peak. The spacious interior has also been modified by lowering ceilings and installing modern lighting. In 1976, a county jail and annex were attached to the building.

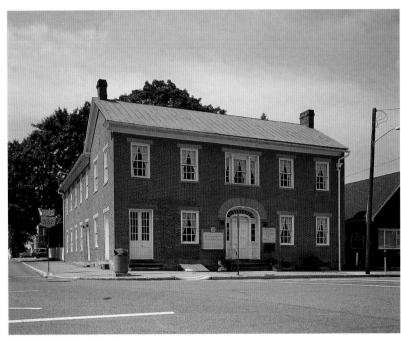

*Above: Federal style McCook House was erected on the southwest corner of the Carrollton Public Square in 1837.*

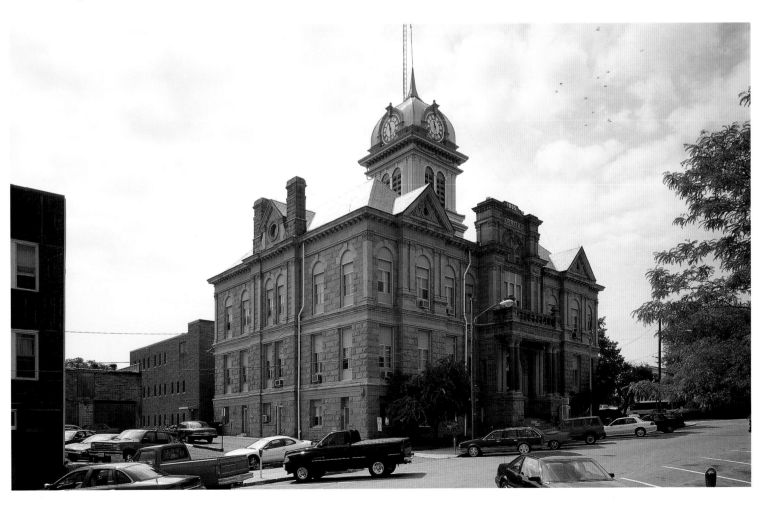

*Above: The Carroll County Courthouse.*

# Fayette County

*Origin of name: Marquis de Lafayette, a Major General in the Revolutionary War, and honorary U.S. citizen*
*County Seat: Washington Court House*
*Courthouse construction: 1882-85*
*Architect: David W. Gibbs*

A small hand-painted sign stands on the lawn in front of the south entrance to the Fayette County Courthouse reading "Willard Murals are on Third Floor. Take elevator." The courthouse has long been known for the murals, hanging on the walls outside the courtroom, depicting female figures representing the Spirits of Electricity, Telegraphy and the U.S. Mails. The artist, however, was unknown until the 1950s, when they were finally attributed to Ohioan Archibald M. Willard.

According to the Fayette County Commissioners and the local historical society, sometime during the 1940s a Mrs. M. R. Cooks, member of a tour group passing through Washington Court House, asked to see the courthouse murals by Willard. Her inquiry prompted a closer inspection, resulting in the discovery that the envelope held in the hand of *"The Spirit of the U. S. Mail"* was addressed to "A.M. Will-, Cleveland, Ohio," her fingers covering the remaining letters. Courthouse records dated August, 1882, show that the county commissioners contracted with the Cooks Brothers for "painting and fresco work, $2,445." Further confirmation of Willard's attribution was correspondence dated September 12, 1956, from Mrs. Cooks, written on Cooks Brothers letterhead to Fayette officials, a copy of which hangs in the lobby:

> As I told you by phone, I am the widow of Max Cooks, who, with his brother William founded Cooks Brothers Decorating Company.
>
> My late husband often talked about frescoing the court House at Washington C.H., Ohio.
>
> He was proud of the fact that he had been able to get Archibald M. Willard (who painted the "Spirit of '76") to do the murals in the Fayette County Court House.
>
> I am positive, therefore, that these murals were painted by Archibald M. Willard.

But not everything was fairies and flowing scarves in the community. Nine years after the completion of the courthouse, bullet holes tarnished its entrance doors, from shots fired through the doors by the state militia from inside the building, in a successful attempt to protect an unpopular prisoner from lynching by an angry crowd gathering outside. Five persons were killed and many wounded.

The bullet holes remain in the doors of the courthouse designed by David W. Gibbs. Constructed entirely of stone, the Eclectic building measures 100 feet square. The round-arched entrance is recessed in the pedimented projecting pavilion. Included in the pavilion are stone balustrades on the second floor and columns with Corinthian capitals on the third. The roof is flat, and its principal feature is the belfry and dome in the center that is surmounted by a statue of Justice.

Ironically, the county's limited resources during the mid-twentieth century restricted its ability to "modernize." Recent growth, with concomitant revenues, and a heightened awareness of historical preservation, resulted in a three-year renovation of the building. The tower was painted, a new roof

*Above: Willard's mural, " The Spirit of the U. S. Mail."*

JUDGE
NANCY D. HAMMOND

# Fayette County

installed, unsightly communications antennae were removed, and the twelve-foot tall statue of Justice received a new coat of gold leaf. Some artwork was cleaned and offices upgraded, but the murals have not been retouched.

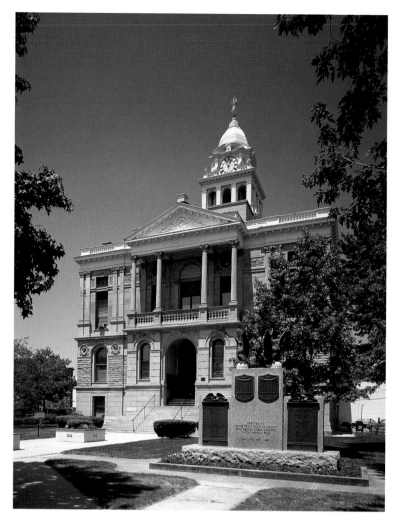

*Above: The Fayette County Courthouse.*

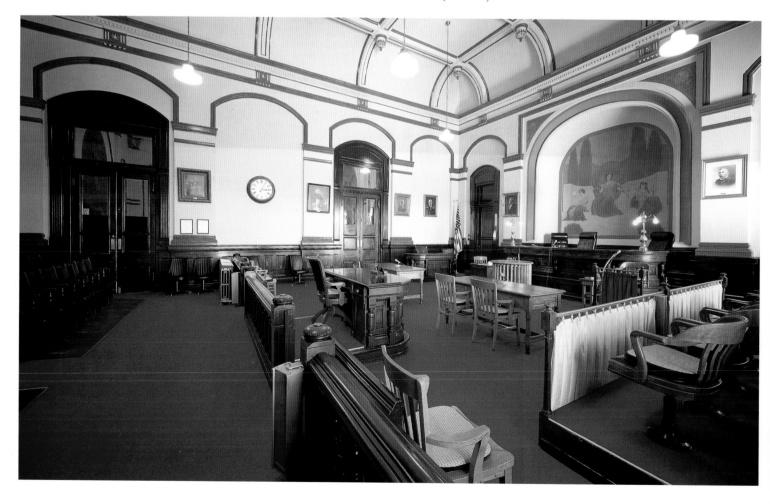

*Above: The Common Pleas Courtroom.*

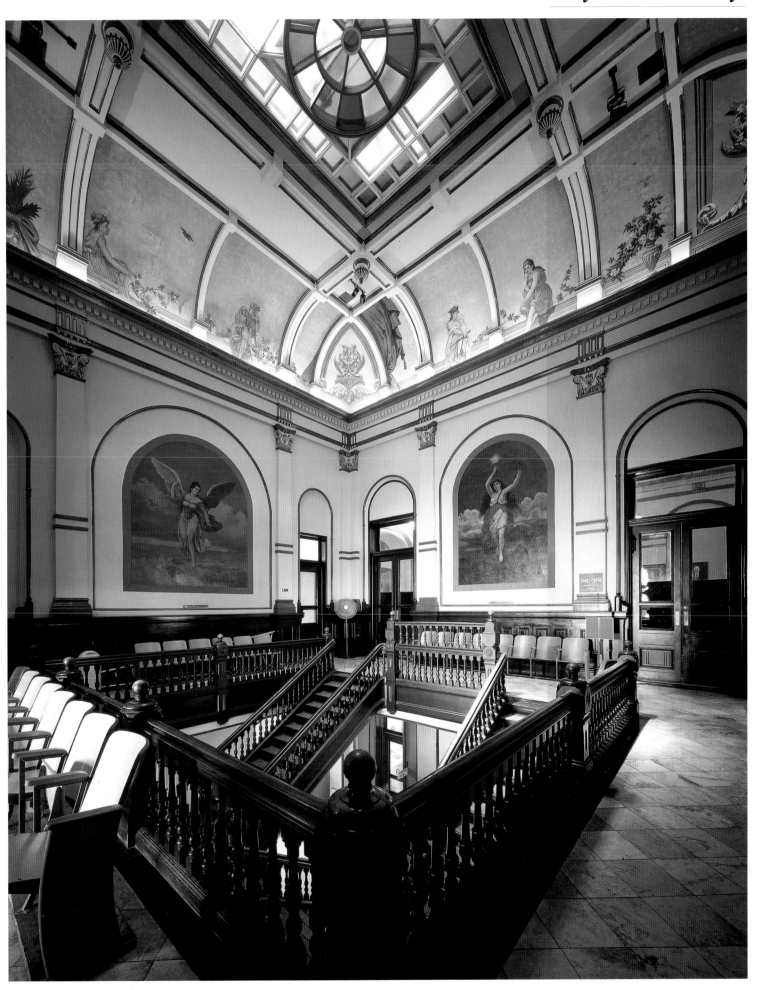

*Above: Lobby outside courtroom with murals. Each measures approximately 15 x 10 feet.*

# Marion County

*Origin of name: Revolutionary War General Francis Marion*
*County Seat: Marion*
*Courthouse construction: 1884-86*
*Architect: David W. Gibbs*

The Marion County Courthouse, like its nearly identical twin in Fayette County, was designed by David W. Gibbs. After designing the matching courthouses in Henry and Union counties, Gibbs modified their blueprints for Marion and Washington Court House by eliminating the corner towers and mansard roofs, and substituting porticos in the center of each façade. The successors are distinguished by the incorporation of cut stone cornices, balustrades and center pediments in the Marion structure, while Fayette's are finished in metal.

Perched midway up the exterior façade of the courthouse, ten sandstone faces watch over the Marion community, as they have since the courthouse was constructed in 1886. Four of the images portray the races of man–a Native American chief, an African-American, an Asian, and a Caucasian woman. Others represent the pioneer spirit of the early settlers and the ages of man,
including a young girl with a beaded necklace, an older girl wearing a straw hat, a woman with garlands of fruit and grain, and an aged man who resembles portraits of Shakespeare.

The Amherst stone carvings were first modeled in clay. Usually unidentified reliefs are modeled after real people, friends or acquaintances of the artisans who made them. The little girl's countenance was reportedly modeled from the daughter of a local hotel manager. Many of the courthouse construction workers roomed at the hotel, where they noticed the child and believed she would be a good model for one of the carvings. It was later reported her family kept it a secret because they were afraid the prominence of having her portrait carved into the courthouse would make her vain.

Many courthouses need, or will need, substantial rehabilitation to keep functioning into the twenty-first century. Marion is an

*Above: View of second floor toward front entrance.*

example of how difficult it is to upgrade safety codes, functional demands, and technology without sacrificing the character and integrity of the building. During the 1970s the Marion community became aware of an official decision to update and renovate the courthouse interior.

Fearful that much of the original elegance would be destroyed, the County Historical Society led a fight against the refurbishing project. When all its efforts failed, the society proposed a referendum against the renovation. Petitions were drawn up, and the necessary number of signatures obtained, only to be rejected by the County Board of Elections on the grounds there were no provisions in Ohio law for building referendums. The modernization proceeded. The staircase, ornate woodwork and large courtroom were ripped out and discarded. Other compromising alterations involved the installation of lowered ceilings, the

addition of aluminum doors, and, during rewiring, the destruction of historic decorative murals.

As a compromise with those who opposed the interior mutilation, and in conjunction with a downtown improvement effort, the exterior was cleaned and left intact, except for closing the entrance on East Center Street. The statue of Justice was removed, repaired, and a helicopter returned it to its position atop the building.

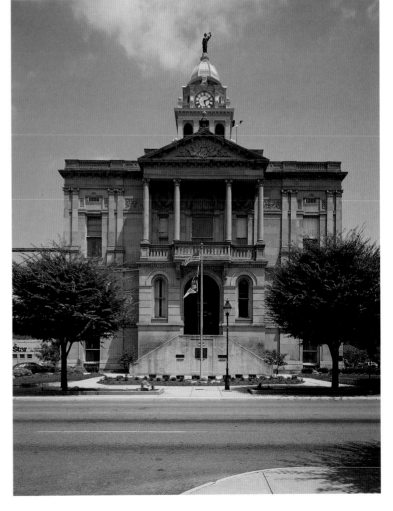

*Above: The female heads bearing garlands of fruit and flowers are representations of fertility to ensure abundance in most endeavors. The aged man resembles Shakespeare.*

*Above: The Marion County Courthouse. To the rear, Star newspaper office, once owned by President Warren G. Harding, Marion's most famous son.*

# Seneca County

*Origin of name: Seneca Indian tribe*
*County Seat: Tiffin*
*Courthouse construction: 1884-86*
*Architect: Elijah E. Myers*

Seneca County was established on January 22, 1824, and in the following April county files record the first naturalization petition. Before the Court of Common Pleas, William Doyle of Ireland vowed loyalty to his new American citizenship, while renouncing fidelity to any other government.

This was a period when pioneer lawyers and judges not only studied the law and represented clients but also traveled the circuit, a task they found dangerous and difficult. One judge reminisced:

> *The journeys of the court and bar to those remote places through a country in its primitive state, were unavoidably attended with fatigue and exposure. They generally traveled with five or six in company, and with a pack-horse to transport such necessaries as their own horses could not conveniently carry, because no dependence could be placed on obtaining supplies on the route; although they frequently passed through Indian camps and villages, it was not safe to rely on them for assistance. Occasionally small quantities of corn could be purchased for horse feed, but even that relief was precarious and not to be relied on. In consequence of the unimproved condition of the country, the routes followed by travelers were necessarily circuitous and their progress slow. In passing from one county seat to another they were generally from six to eight, and sometimes ten days in the wilderness, and at all seasons of the year were compelled to swim every water-course in their way which was too deep to be forded; the country being wholly destitute of bridges and ferries travelers had, therefore, to rely on their horses as the only substitute for those conveniences. That fact made it common, when purchasing a horse, to ask if he were a good swimmer, which was considered one of the most valuable qualities of a saddle horse.*

Practicing law was less physically demanding

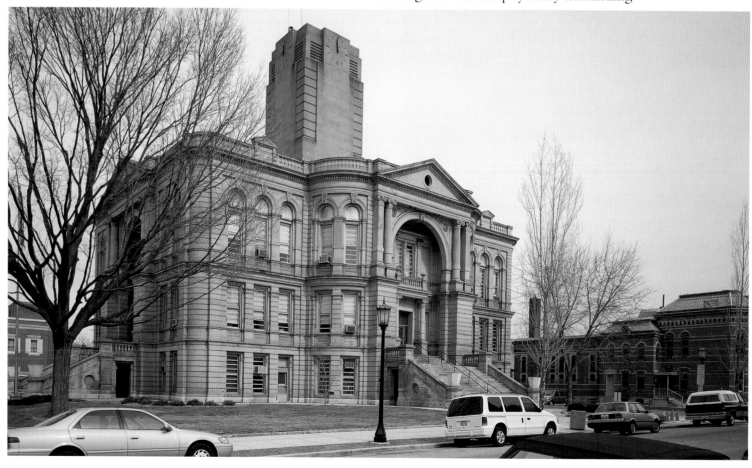

*Above: The Seneca County Courthouse, built of sandstone.*

by the time the county's third courthouse was constructed primarily in the Beaux-Arts style. A two-story archway enclosed the south entrance, framed by paired fluted columns and a triangular pediment. A statue of Justice crowned the tower, 148 feet from the ground. The ornate courtroom included twenty-seven pilasters supporting an ornamental stucco cornice. Its ceiling was divided into twenty plaster panels and a skylight, in a central vaulted area. The rotunda was open to the second floor, where an iron railing surrounded the

well, with a dome about thirty-five feet above. An arch led into each of the corridors, with pilasters supporting a cornice and the dome. In each wall was a shallow recessed arch, with a railing forming four false balconies.

Requirements of modern government and changing popular tastes produced many alterations to the building. A lowered ceiling, housing the Law Library above it, hides the decorative ceiling of the old courtroom. The windows have aluminum sash replacements. The most controversial change is the modernization of the tower. In the 1940s there was a master plan to resurface and modernize the courthouse, but after the tower was rebuilt, the remaining funds never materialized.

The new tower was lower, at 107 feet. The statue of Justice was scrapped. The inner brick core of the old tower was left inside the new tower. In 1944 the upper section of the rotunda was sealed off, and an elevator installed through the center of the building. The false balconies still exist inside the base of the present tower, and are visible from the steps leading up to the clock.

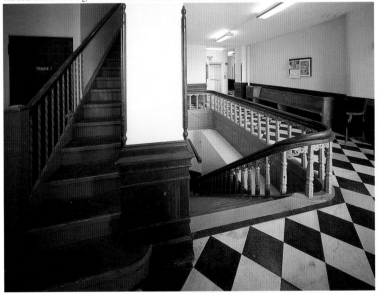

*Above: Law Library, created from space above the courtroom when the courtroom's ceiling was lowered. Decorative detail remains.*

*Above: Second floor, showing elevator shaft through the well of the courthouse, staircase to Law Library, and partial roof of an office constructed in the hallway below.*

*Above: First-floor War Memorial, with service flags and plaques, including a signed proclamation from President George Bush.*

# Holmes County

*Origin of name: Major Andrew H. Holmes, War of 1812 hero*
*County Seat: Millersburg*
*Courthouse construction: 1884-86*
*Architect: Joseph W. Yost*

The citizens of largely rural Holmes County take pride in their courthouse. Now that the area is a major tourist attraction for, among other things, Amish restaurants and crafts, interest in its history, including that of the courthouse, has revived.

The county erected three courthouses on or near the same site. The design of the second courthouse was preserved by a drawing by Henry Howe in 1846.

At the time of his 1846 drawing Henry Howe (1816-1893) wrote in Historical Collections of Ohio:

> *The new court-houses, through Central Ohio more especially, are elegant structures, in which the people of their respective counties have a just affection and pride, for with them cluster the associations connected with the protection of society through the administration of law, the preservation of titles to the savings of honest industry in the form of real estate and its proper distribution to the widow and the fatherless. The church, the court-house and the school-house are three prime factors of our civilization.*

The first edition, published in 1847, resulted from Howe riding his horse, Old Pomp, to seventy-nine of Ohio's then eighty-three counties. He collected information about each, sketching objects of interest and "every where obtained information by conversation with early settlers and men of intelligence." Forty years later, Howe repeated his journey. The second edition updates the earlier 1846 text and his engravings. It allows us to compare later modifications to the courthouse and the surrouning streetscape.

The Goddess of Liberty balancing the Scales of Justice, seen by Howe on his second journey, welcomes visitors in the courthouse lobby. The statue originally stood on the pediment of the

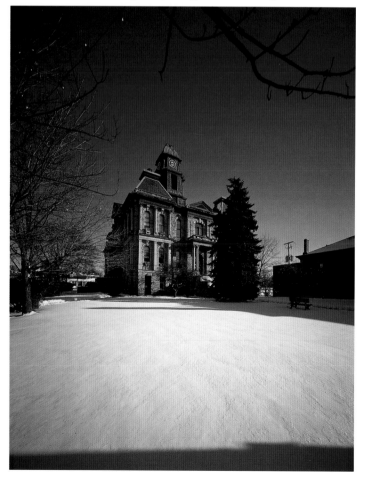

*Above: The Holmes County Courthouse, designed by Joseph W. Yost.*

Ross Hall, Millersburg, Photo., 1886.

MILLERSBURG.

*Above: Henry Howe's depiction of the Holmes County Courthouse.*

north entrance. In the 1950s it was removed and stored in the courthouse basement, until local attorneys paid for its restoration and prominent placement. This is an example of attorney and bar association involvement in courthouse rehabilitation efforts. Frequent visitors to courthouses, they respect them as symbols of law and order, and especially value the continuity they provide between past, present, and future.

The two-story courthouse, constructed from locally-quarried stone and steel, incorporates entrance porticos supported by Corinthian columns. Pilasters and columns adorn the second and third stories. The corners of the flat-topped mansard roof contain small towers, but dormers were removed from the roof when the tower was altered. Inside, the floors are decorated with tile, and the courtroom has a freshly painted plaster cast ceiling.

*Above: Hitching rail for Amish buggies east of the building. In 1990, the Holmes County population was 32,800. It is estimated that thirty to forty per cent of the population is Amish.*

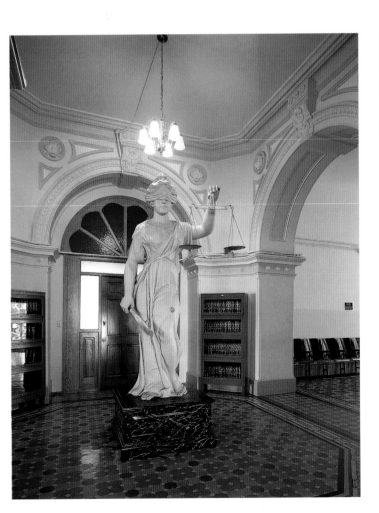

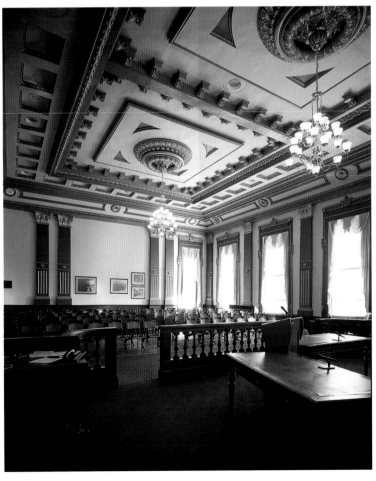

*Above: The Goddess of Justice in the lobby.*

*Above: Restored courtroom. View from beside the Judge's bench out into courtroom. The original spectator chairs have hat racks underneath.*

# Miami County

*Origin of name: Miami Indians whose principal village, Pickawillany, was located near Piqua*
*County Seat: Troy*
*Courthouse construction: 1885-1888*
*Architect: Joseph W. Yost*

The Miami County Courthouse endures as a quintessential late nineteenth century courthouse. It was built during the period when courthouses were the focal point of local landscapes, and counties openly competed for the most architecturally distinctive building as self-affirmation.

The Miami County Commissioners engaged the well-known courthouse architect Joseph Warren Yost to design the structure. He created a courthouse with a colonnade of Corinthian order columns encircling a cast-iron dome, in the manner of the United States Capitol. Other notable features, adapted from many sources, include raised pediments, subsidiary domed corner attics, an archway over the main entrance, and a copper statue of Justice 185 feet from the ground.

Behind the courthouse, a two-story brick powerhouse was constructed for steam heat and cooling by air circulation. It was separated from the courthouse, as a fire precaution during a period of many fires.

The interior is decorated with colored encaustic floor tiles, cast iron stairways (painted golden oak), flora and fauna ornamented plaster ceilings and rotunda arches, and in the third-floor rotunda life-sized heads of the races of man. A dome of stained glass and metal illuminates the courtroom. Also noteworthy are the original furnishings, decorative wooden pillars, and original rosewood bench.

The courthouse underwent an extensive restoration in 1982 and again in 1998, when the main dome and the four corner domes were stripped of the cast iron veneer, repaired or recast, and re-installed. The clock in the center dome was repaired, and the bell to chime the hour was restored. The limestone exterior was cleaned, tuck-pointed, and sealed. The windows were replaced with more energy efficient copies.

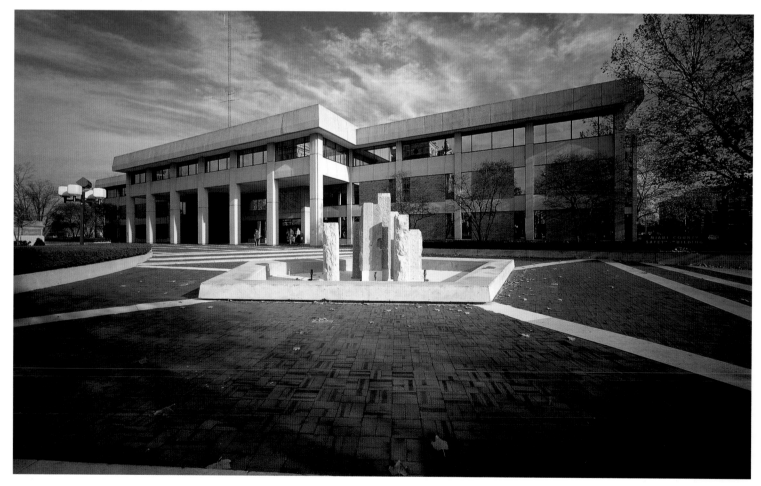

*Above: The fountains at the north and south ends of the plaza, comprised of limestone taken from the former jail (1854-1972), now the location of the Safety Building or the fifth county courthouse, symbolize the transition from old to new.*

Six copper statues representing education, agriculture, industry, and transportation along with the Statue of Justice were sent to Vermont for restoration. The slate roof was repaired, and an exterior automatic lighting system was added.

The "Pride of Miami County" houses county offices and the municipal court. It is because it has become a symbol of Justice that the 1888 courthouse represents Miami County in *County Courthouses of Ohio*

The remaining county affairs are conducted in the Safety Building across the plaza. It is a minimally-articulated building, that serves as the county's fifth seat of justice.

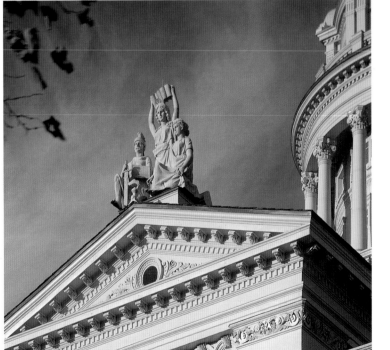

*Right: One aspect of the 1998 renovation project was restoring the seven copper statues that grace the courthouse. Left to right, they are: Agriculture–carrying a sheaf of wheat and a scythe; Justice–blindfolded and with a sword and scales; Education represented by the center group of three (see below right); Transportation–a figure carries a small locomotive; and Industry–a figure holding a wrench and standing by a lathe.*

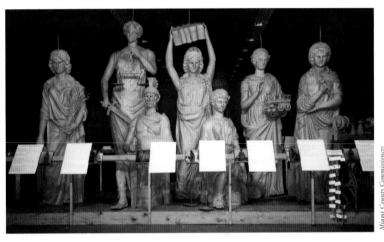

*Above: Polychrome reliefs, representing the world's racial diversity, outside the courtroom. These two are portraits of Princess Pocahontas and John Rolfe.*

*Above: The statuary group representing Education in place on the pediment of the courthouse. The center lady raises a book over her head, while a male figure, thought to be a Trojan, carries a lion, a Greek symbol of education. The muse represents literature, arts, and sciences.*

# Miami County

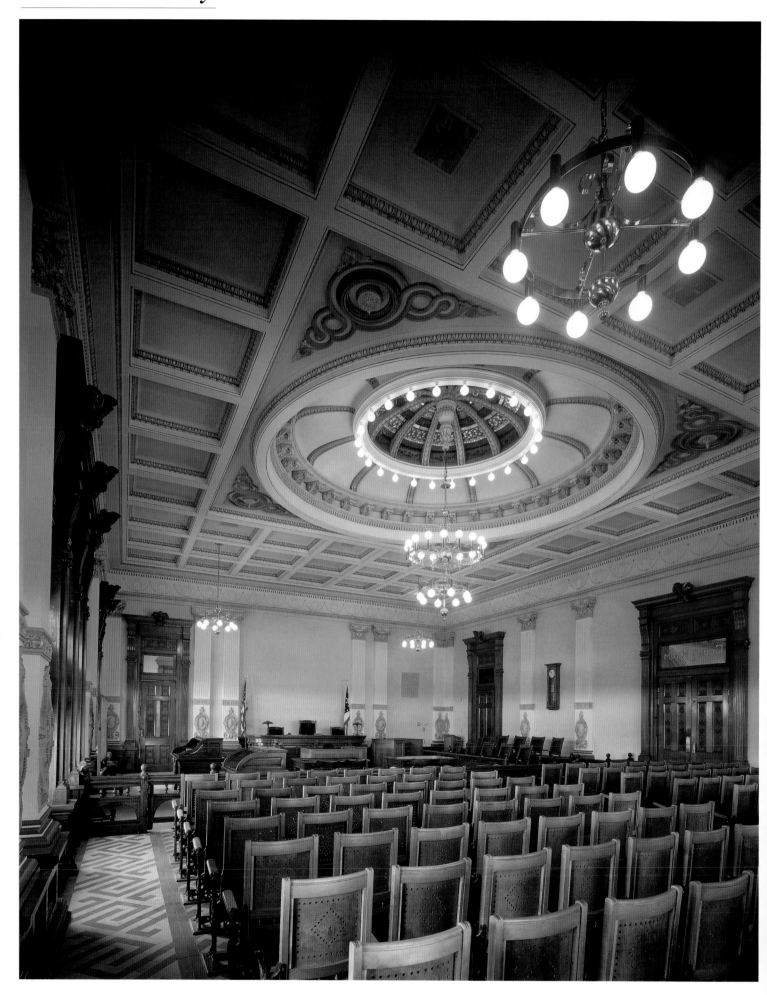

*Above: The restored original courtroom, adapted to a municipal courtroom.*

*Right: The Miami County Courthouse.*

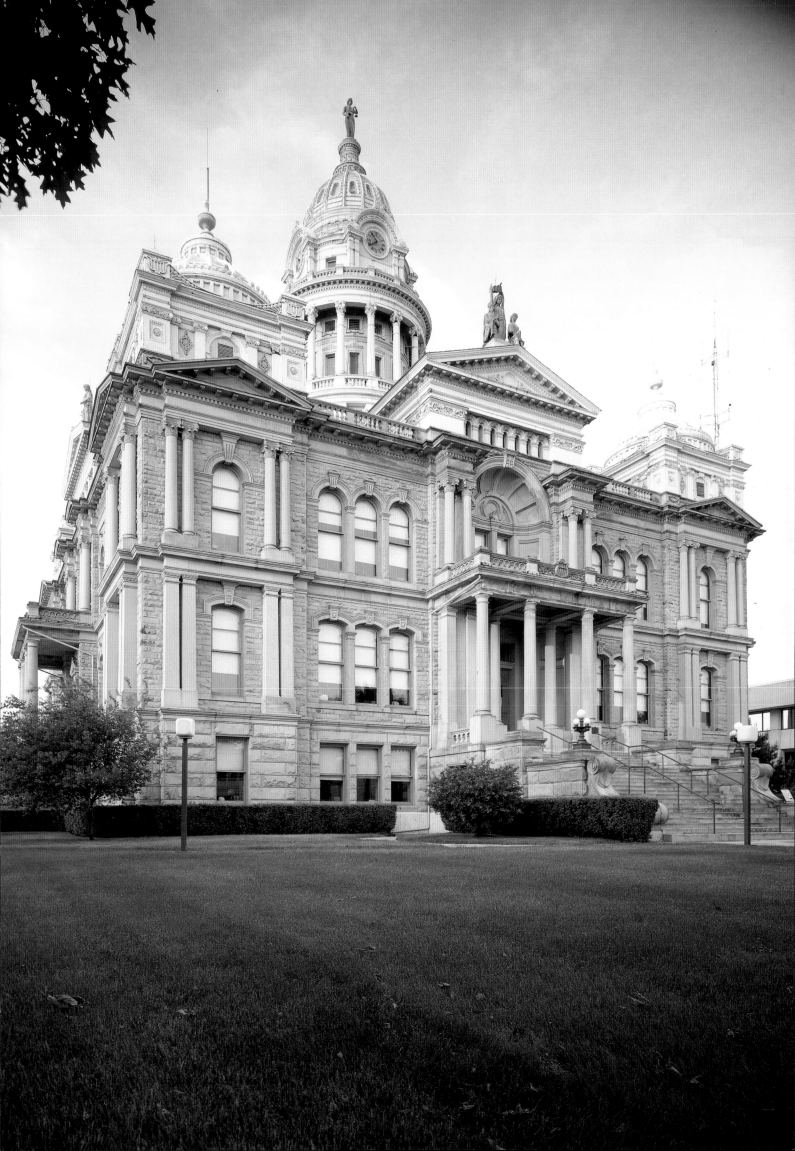

# Belmont County

*Origin of name: From the French words for "beautiful mountain"*
*County Seat: St. Clairsville*
*Courthouse construction: 1885-88*
*Architect: Joseph W. Yost*

Joseph Warren Yost (1847-1923) designed the Belmont County Courthouse concurrently with the Miami County Courthouse. The buildings share the same square size, and feature a central dome with smaller corner domes. While detailing exists on the windows, cornice, and tower, the Belmont courthouse appears unadorned in comparison to its Miami counterpart.

Yost devised a boiler plant nearby for the heating and cooling of both courthouses and county jails. In St. Clairsville, an underground tunnel connected the powerhouse with the courthouse, from which airshafts led to the rooms on the first floor. The high red brick chimney allowed warm air to circulate from it through the tunnels into the rooms. With the high ceilings of all the rooms and this circulation of air, summer temperatures were lower in the courthouse than other buildings. The chimney further carried the smoke away from the coal fire under the steam boiler in the winter, while the tunnel carried the steam pipes into the building. Another tunnel led from the powerhouse to the jail and the sheriff's residence and similarly heated and cooled them. The service tunnels remain today, although the plant was removed in a 1970s restoration.

A major part of the repair and restoration involved the roof-upgrading the four corner dormers, repairing the clock tower, replacing the original ½-inch thick slate, and refinishing all deteriorated sheet metal. Originally the roof was composed of slate without sheeting. It was laid at horizontal angles and tied with metal wires. In spite of technological advances, those who maintain the courthouse believe Yost's heating and roofing designs suited the thick-stoned edifice better than those of the restoration.

Another modification was the removal of the 3,800-pound steel bell from the tower to its position in front of the courthouse. A notable event during its hundred years occurred when it

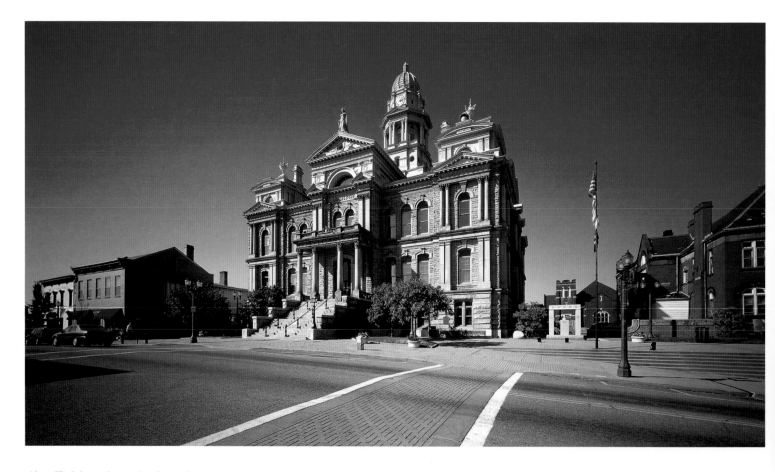

*Above: The Belmont County Courthouse. The exterior, black with coal dust from the surrounding area mines, was chemically washed during 1993.*

rang for one continuous hour at the close of World War II. The bell, replaced by carillon chimes, had not been in use for many years, and the county commissioners wanted to display it publicly. The chimes ring twenty-six times daily at 12:30, in memory of the twenty-six flash flood victims from the Belmont County Ohio River town of Shadyside during the spring of 1991.

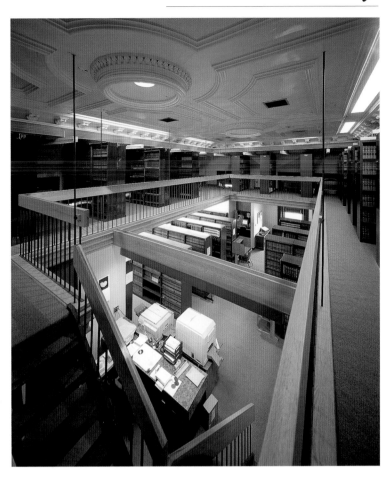

*Above: The original courtroom, now adapted for use as the Law Library.*

*Above: Two views of the dome, consisting of small skylights of stained glass. During 1990 the glass, which had been painted black, was cleaned.*

# Hancock County

*Origin of name: John Hancock, most vigorous signer of the Declaration of Independence*
*County Seat: Findlay*
*Courthouse construction: 1885-88*
*Architects: Frank Weary and George Washington Kramer*

Profits realized from the discovery of a natural gas and petroleum reservoir in and around Findlay funded the construction of the Hancock County Courthouse. The community's affluence during the "Gilded Age" is reflected in the quality of building materials and accompanying architectural details in the public buildings, such as the thirteen-foot statue of Hancock County's namesake, John Hancock (1737-1793) that tops the courthouse, cast in bronze, rather than zinc, tin, or another less expensive metal. Akron architects Frank Weary and George Washington Kramer further incorporated stained-glass windows, black walnut trim, Maine marble, granite columns, and an open rotunda into their design. The façade is symmetrical, with two gables and a central portico. Stained glass windows and composite pilasters comprise the gables.

A twelve-foot high stone portico supported by four polished granite columns covers the entrance. A small stone balustrade surrounds the roof of the portico. The first two stories have rectangular windows while the third floor (containing the courtroom) is more decorative, its windows incorporating semi-circular stained glass arches.

Many architects designed more than one Ohio courthouse, and similarities in style and materials are frequently apparent. Weary & Kramer planned the Pickaway County Courthouse a few years after this one. The repoussé copper medallions representing the four seasons, on the main staircase balustrade and the second-floor balcony, are repeated in the Pickaway County courthouse staircase balustrade.

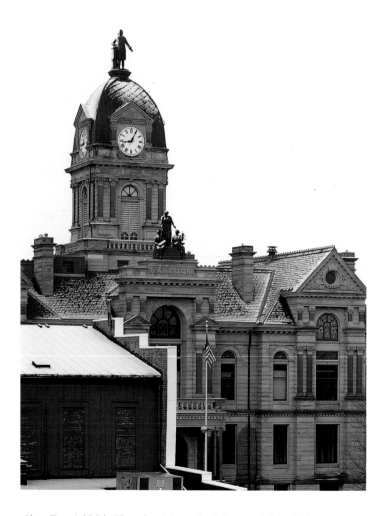

*Above: Tower, with John Hancock and three sculpted figures symbolizing Justice, Law and Mercy below.*

*Above: As on the staircase balustrade, copper medallions surround the railing.*

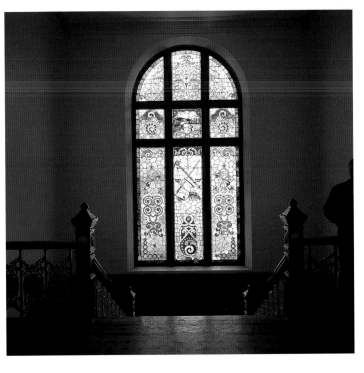

The area's petroleum heritage is also reflected in local court proceedings, sometimes showing an impact on the growing national economy. During the 1980s, Marathon Petroleum Company (with headquarters in Findlay) and a subsidiary of the United States Steel Corporation merged. This resulted in the filing of lawsuits by dissenting shareholders of Marathon in the Common Pleas Court seeking a determination of the "fair cash value" for their shares of stock. After Marathon objected to the Hancock trial court's method of compilation, the Ohio Supreme Court considered the issue.

In a lengthy decision, the Supreme Court held, among other things, that the Hancock County trial court should have first established the correct date for the valuation of the stock and all factors concerned with any appreciation of the stock should have been reviewed and decided by it. So the case was reversed and remanded to the Findlay court for the limited determination of what appreciation or depreciation, if any, resulted from the U.S. Steel proposal submitted to the Marathon shareholders.

*Above: Stained glass window, with each piece beveled.*

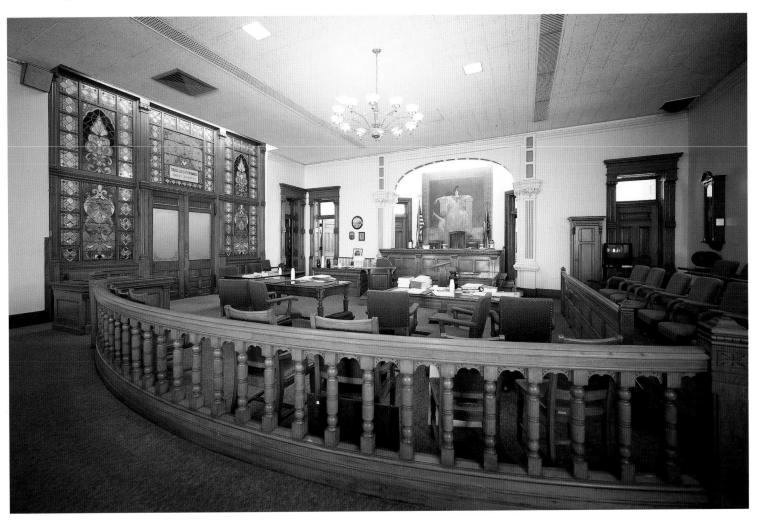

*Above: View of the courtroom with jury box. Around 1921, when women received the suffrage and started serving on juries, a new screen was added to the front of the jury box to hide their legs.*

# Hancock County

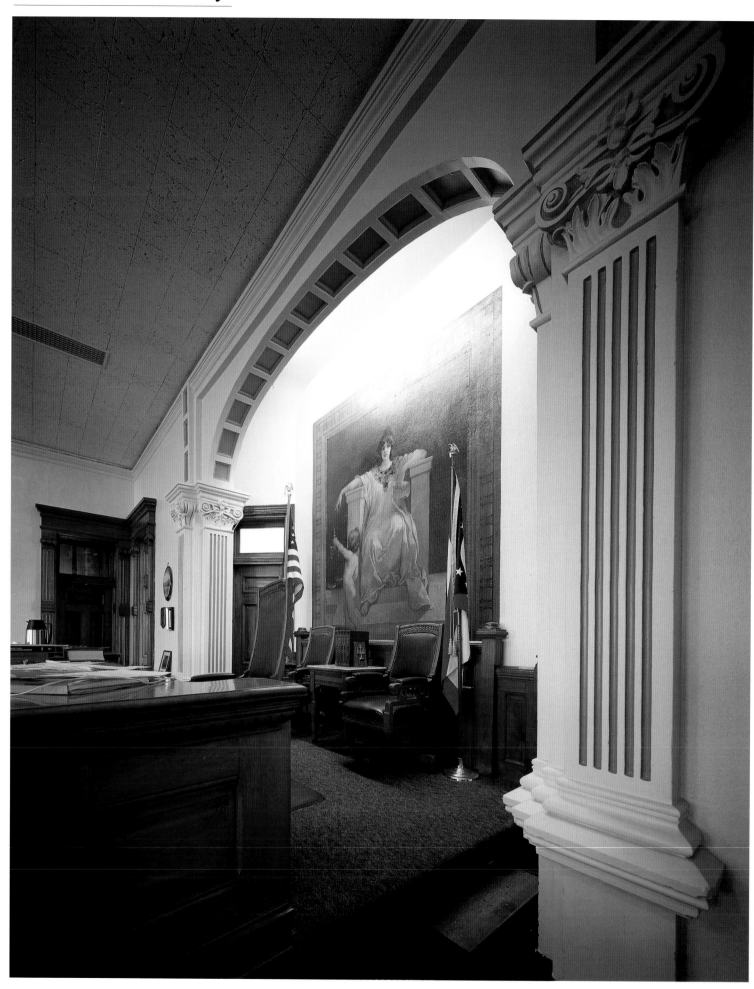

*Above: Behind the judge's bench, Justice is depicted in an unusual manner, without her blindfold.*

# Paulding County

*Origin of name: John Paulding, one of three soldiers who captured*
  *Major John Andre, British spy, in the Revolutionary War*
*County Seat: Paulding*
*Courthouse construction: 1886-88*
*Architect: Edward O. Fallis*

In 1886, a Paulding County committee was organized to plan the construction of a new courthouse. The delegation traveled to Celina, Ottawa, Lima and Findlay for ideas, studied proposals, and interviewed several architects before choosing Edward Oscar Fallis. Fallis, from nearby Toledo, had recently completed the Lenawee County Courthouse in Adrian, Michigan and the committee wanted a similar, but more modest, interpretation for Paulding County.

The resultant structure, standing in the center of a public square, is built in the four-front style with four similar façades, each with an entrance set behind triple-arched porches. A cylindrical tower composed of a series of arches on a square base, with a larger dome topped by a much smaller one, rises 163 feet from the ground. Brick corbelling is incorporated throughout, including two pairs of bridged chimneys over opposite entrances and on the projecting bays and the cornice. The decorative

effect of the corbelling was more affordable than the stone and terra cotta floral trim of the Michigan courthouse.

The courthouse acquired an early telephone system almost by happenstance. Two Paulding County judges were business acquaintances of the inventor Alexander Graham Bell (1847-1922), and traveled to Nova Scotia to purchase sheep from him during the period he was working on the telephone.

Later, when Bell applied for a patent, the Patent Office challenged him as to the time of its conception. The judges became his corroborating witnesses by testifying they had seen the telephone years before in Nova Scotia. Their testimony contributed to Bell's defeating the challenge of the patent for the telephone issued to him in 1876. The grateful inventor reciprocated by later supplying the jurists' workplace with a telephone communication system.

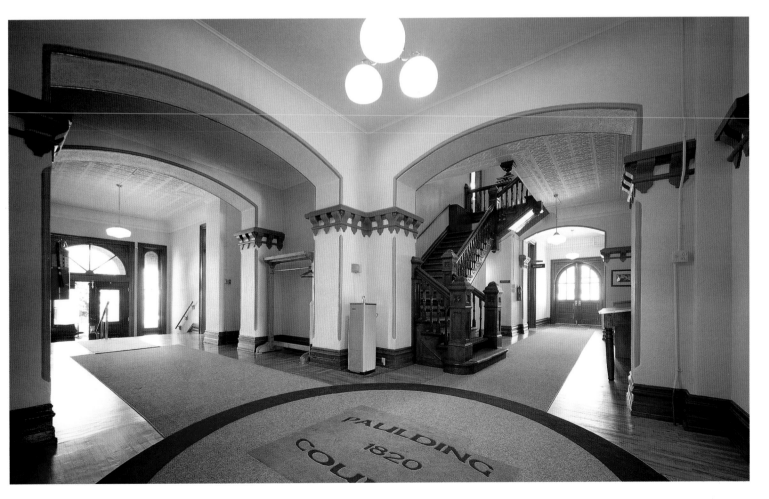

*Above: Intersection of main-floor hallways.*

# Paulding County

During the courthouse construction, on the night of April 25, 1887, a group of local farmers, "Dynamiters," took the law into their hands and blew up a reservoir that had been a feeder to the Wabash and Erie Canal. The reservoir covered some 3600 acres, and during rainy seasons much more. After the canal had been abandoned, around 1870, the farmers sought unsuccessfully to reclaim the land for farming purposes by petitioning the state legislature. Finally, under a black banner with the words "No Compromise" on one side and "The Reservoir Must Go" on the other, a group of between two hundred and three hundred men, masked, armed with guns, and carrying dynamite, exploded the reservoir's dikes. The governor ordered state militia to protect the state's property and to preserve peace. The rioters dispersed and no action was taken against them. The General Assembly subsequently passed a bill abandoning the reservoir, and the lands were sold. Wheat and corn now grow where the waters once stood.

## Paulding County Seal:

- The Red Circle represents the letter "O" for Ohio.
- The Bald Eagle clutching the sword of General "Mad" Anthony Wayne represents the supreme authority of the Federal Government.
- The Blue Stripe represents the streams flowing northeasterly across the county to Lake Erie.
- "No Compromise" is the motto displayed on the banner carried by the county citizens who marched in the Reservoir War of 1887, in defiance of the special interests' unjust advantages.
- The Black Field shows the county to have been part of the Black Swamp.
- The Green Field signifies the rich green fields of today's agriculture.
- The Tepee, the Fleur-de-Lis, and the Royal Crown of England commemorate the Indians, French and British who dominated the area prior to the establishment of the United States.
- The Canal Boat and Steam Locomotive denote the two modes of transportation which contributed to immigration and development of the county.
- The Tree, the Crossed Pick and Sledge, and the Shock of Wheat denote the three main resources of past and present: timber, stone quarries, & grain crops.

*Above: The Paulding County Courthouse.*

*Above: View from second floor. In 1978, the second-floor balcony, overlooking the intersection of the main-floor halls, was closed off and turned into a lawyer's conference room. On the wall is the Paulding County Seal, adopted by the Paulding County Commissioners in 1967.*

# Perry County

*Origin of name: Commodore Oliver Hazard Perry, hero of*
*Battle of Lake Erie (1813)*
*County Seat: New Lexington*
*Courthouse construction: 1886-88*
*Architect: Joseph W. Yost*

When Perry County was organized, a number of villages aggressively sought the county seat: Somerset, Rehoboth, Overmyertown, Bristol, and New Lexington. Somerset was chosen, and the 1829 courthouse still stands on Somerset's public square. New Lexington, however, continued to campaign for the county seat, and in 1851, sympathetic state legislators passed a bill to remove the county seat from Somerset to New Lexington if a majority of Perry Countians agreed. A vigorous campaign followed, and relocation was carried by 292 votes. Somerset responded by filing an action questioning the constitutionality of a law providing for an election, but the law was upheld.

In 1853, legislators sympathetic to Somerset passed a bill for the return of the county seat from New Lexington to Somerset. The susequent vote was again hotly contested, with allegations of fraud from both sides. Somerset prevailed. But in December 1856, the Ohio Supreme Court ruled the 1853 law unconstitutional—the removal act of 1851, favoring New Lexington, was reaffirmed. The following January county records were removed from Somerset and taken to New Lexington. In 1859 a final law, passed and brought to vote, for the return to Somerset, was defeated by a majority of 300, thus ending the controversy.

The New Lexington courthouse was built with funds raised by private subscription, as an incentive to voters to keep the county seat at New Lexington. After the county outgrew that courthouse, the present courthouse was dedicated in 1888. A stone structure of the Richardsonian Romanesque style, it features a large wall rising above the recessed arched entrance with corner tourelles similar to those on the corner of the tower. The foundation stones are laid in regular ashlar bonds, while those on the building are random ashlar.

More recently, the courthouse became the site

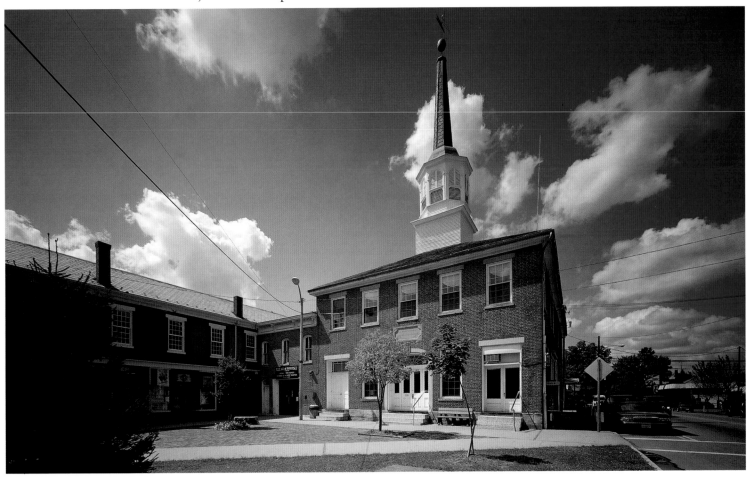

*Above: Old Perry County Courthouse (1828-29) in Somerset. An example of a first-generation Ohio courthouse, nearly square with a hipped roof and a central tower, it bears the inscription above the entrance "Let Justice be done if the Heavens fall." The message was intended to read "Let Justice be done though the Heavens fall;" it is said the stonemasons ran out of room when engraving.*

# Perry County

of another Perry County controversy, a statewide debate on educational funding. Parents of a student who, among other things, did not have books to take home because the school district provided too few, filed suit objecting to Ohio's school funding system on the grounds of inadequacy and inequity. The Perry County Local School Districts joined the suit, along with a coalition of property-poor school districts, located primarily in this southeastern part of the state. Eventually the suit expanded to include a majority of school districts throughout Ohio. On July 1, 1994 the Perry County judge ruled in their favor.

When the case, *DeRolph v. State of Ohio*, reached the Ohio Supreme Court, the justices upheld the county court judge's decision and concluded, largely in light of the deplorable physical conditions present in many Ohio schools, that the public school financing system violates the Ohio Constitution mandating a thorough and efficient system of schools throughout the state. A major thrust of the Court's ruling was that

Ohio must achieve greater equality among its school districts.

In a later ruling (*DeRolph II*), the Court stated that although local property taxes may be "part of the funding solution," they "can no longer be the primary means" of funding public education. On March 24, 1997, the Supreme Court gave the General Assembly a year to make a "complete and systematic overhaul" of the way it funds primary and secondary education. But on February 26, 1999, after further hearings on the disparities in the quality of Ohio's schools and the formula for funding them, Judge Linton D. Lewis, Jr., the Perry County Common Pleas judge who originally ruled the system unconstitutional, found that the state failed to meet the mandate. So once again, the drama shifts from the small rural southeastern Ohio community to metropolitan Columbus, where the Supreme Court has heard oral arguments and is expected to issue a final and perhaps landmark decision with national implications, at the beginning of the new millennium.

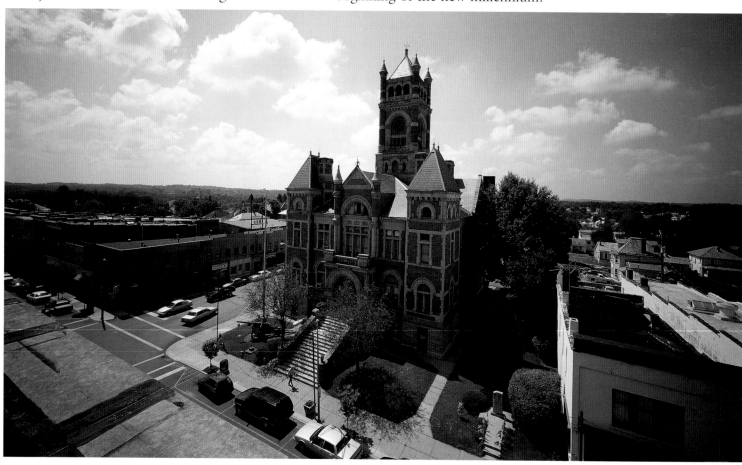

*Above: The Perry County Courthouse.*

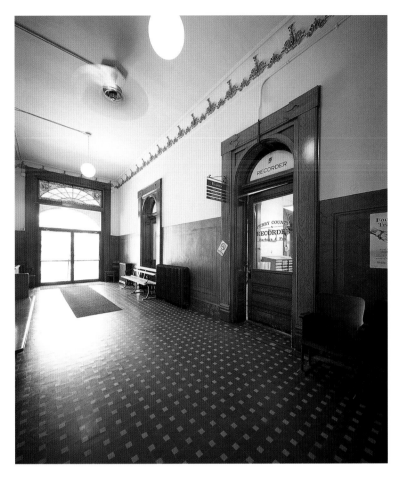

*Above: Entrance and main-floor hallway, decorated with plaster relief.*

*Above: Judge Luann Cooperider presides, beneath her portrait, over the small makeshift Probate and Juvenile courtroom housed in the basement.*

# Butler County

*Origin of name: Major General Richard Butler, killed by Native Americans during the defeat of General Arthur St. Clair on November 4, 1791*
*County Seat: Hamilton*
*Courthouse constructed: 1885-89*
*Architect: David W. Gibbs*

On Thursday, October 29, 1885, at the cornerstone-laying ceremony for the Butler County Courthouse, one of the speakers was Butler County's State Senator, George F. Elliott, who had introduced the necessary legislation authorizing bonds for the courthouse's construction. One hundred years later, on October 29, 1985, at the courthouse centennial program, his great grandson read portions of the senior Elliott's speech. George H. Elliott, whose father had also been a county lawyer, served as a Common Pleas judge in Butler County.

Since his mandatory retirement in December 1996, Judge Elliott continues presiding over a full caseload of jury trials assigned to him by the Ohio Supreme Court. Judge Elliott maintains his commitment to preserving the courthouse as a continuing tradition. He believes in the response of people to their surroundings, and that just as medieval churches commanded respect, so too will an impressive traditional courtroom. In their décor courthouses can aspire, he believes, to something better than "contemporary motel décor" justice.

At the time of its construction, the courthouse was crowned with a four-tiered clock tower topped with a dome and a statue of Justice. In 1912, a fire caused the collapse of the tower into the center of the building's interior. A new three-tiered, eight-sided tower with dome replaced the original. In the 1920s, after a lightning strike, the dome was removed.

The interior has undergone alterations over the years, to accommodate the changing and expanding requirements of the county. After a building was constructed across the street to house administrative offices, the interior was restored to emphasize its symmetry and early splendor. The second-floor lobby opens up to a skylight. Walnut woodwork is found throughout the building. The lobby with its chairs not only serves as a meeting place but is also a courthouse museum, with its old clerk of court's desk and antique cabinet containing the hand of the original Statue of Justice. This hand was rescued by an observer of the fire in 1912.

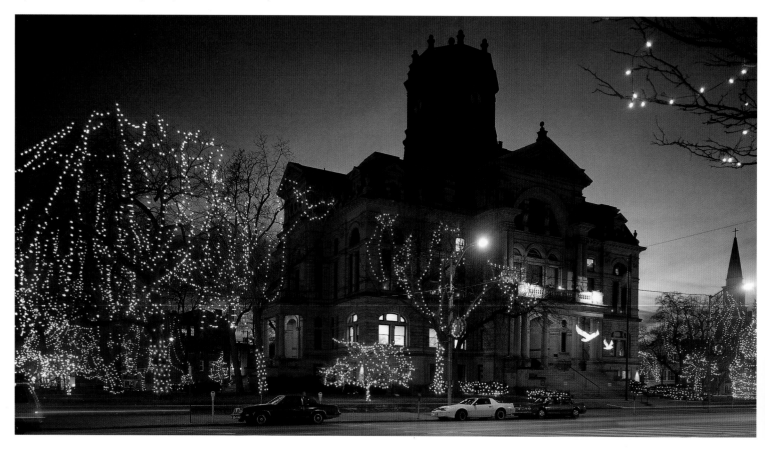

*Above: The Butler County Courthouse.*

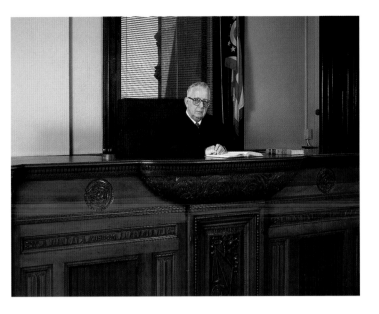

*Above: Judge George H. Elliot sitting at his former bench.*

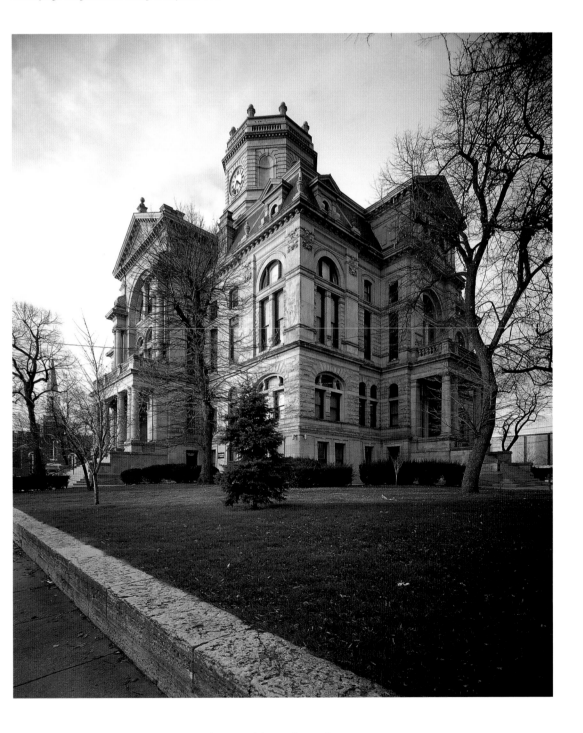

*Above: East side of courthouse with stone wall that also surrounded an earlier courthouse.*

# Butler County

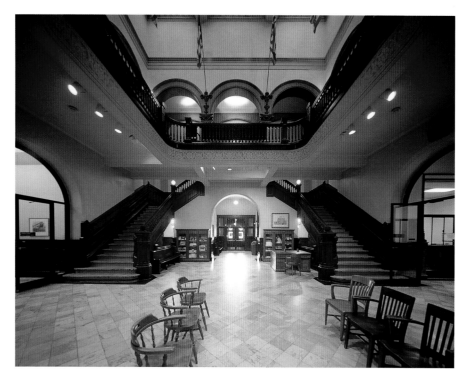

*Above: The main lobby from the north entrance. The painting of the courthouse is by Judge Elliott.*

*Left: A poster from the ceremony for the laying of the cornerstone.*
*On the wall are the original plans for the Courthouse.*

# Pickaway County

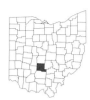

*Origin of name: A misspelling of the Piqua tribe*
*County Seat: Circleville*
*Courthouse construction: 1888-90*
*Architects: Frank Weary and George Washington Kramer*

Pickaway County's county seat was originally laid out, around 1810, in a circular pattern over the Circleville Earthworks or prehistoric Indian Mounds. These mounds, attributed to the ancient Moundbuilders who inhabited the southern Ohio river valleys from about 100 B.C. until A.D. 600, consisted of a circle 1,100 feet in diameter, and, adjoining it to the east, a 900-foot square.

The first courthouse, an octagonal-shaped brick building, was constructed in the middle of the circle mound. By 1838, the circular formation impeded orderly growth, so the city started to square the circle, and demolished the courthouse in 1841. No vestige of the town's circular nucleus remains.

The second courthouse, completed in 1847, in the Greek Revival style, was widely cherished by the community. But by the 1880s, county officials believed the county had outgrown it and wanted a new courthouse. When they were unable to convince the citizens, officials persuaded state legislators to pass a bill providing for a remodeling of the 1847 building. Whereupon the remodeling of the old courthouse turned into a demolition except for its basement jail cells, used as the foundation for today's courthouse. When the old classic pediment was found too weak to support the new ninety-foot tower in the center, the tower was offset to the side. The clock, installed in the 1847 courthouse in 1872, remains operative in the turreted tower today. During the 1940s the clock was converted to electricity, to eliminate the weekly chore of hand winding.

Inside the louvered belfry hangs the 8825-pound Foresman Memorial Chimes, dedicated April 29, 1926. There are eleven bells in the chime; eight tuned in the key of F-Major, plus three extra bells in B-natural, E-Flat and G, an octave above the second largest bell. The chimes are played weekly and on special occasions.

Marble floors decorate the lobby along with salmon and smoke-colored marble wainscoted walls, and plaster pillars. The cast iron and bronze staircase features four variations of embossed copper plates depicting cherubs representing the four seasons, similar to the medallions in the Hancock County Courthouse.

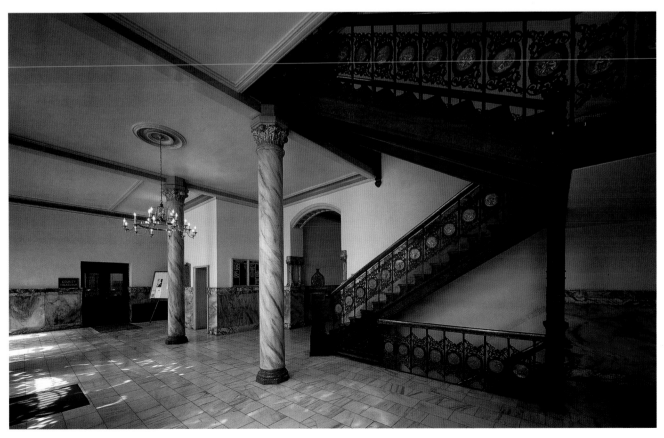

*Above: Entrance lobby.*

# Pickaway County

*Above: Civil War Memorial erected in 1889, using a column from the beloved 1847 courthouse.*

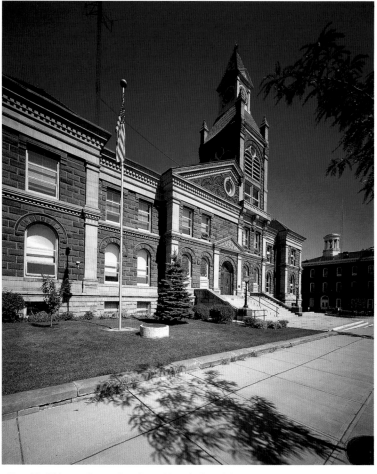

*Above: The Pickaway County Courthouse. Near the flagpole is a piece of one of the columns from the 1847 Greek Revival courthouse.*

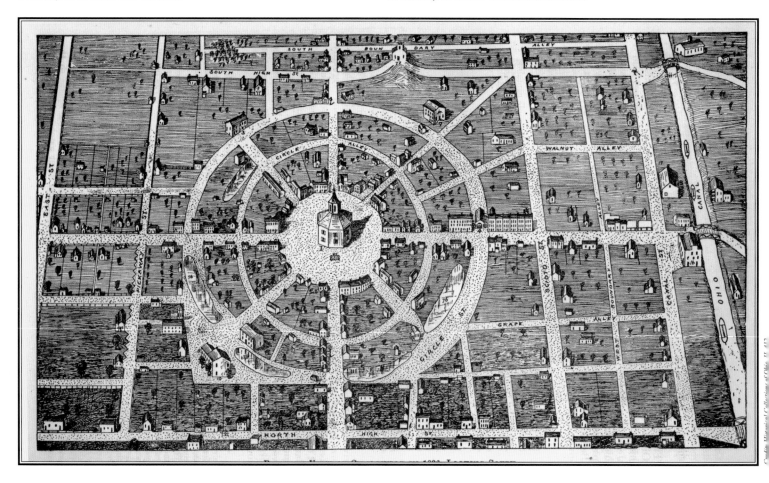

*Above: "Birdseye View of Circleville in 1836, Looking South."*

# Williams County

*Origin of name: David Williams, one of three soldiers who captured the British spy*
*Major John Andre on September 23, 1780*
*County Seat: Bryan*
*Courthouse construction: 1888-91*
*Architect: Edward O. Fallis*

Williams County, located in the crossroads of the northwest corner of Ohio, is in an agriculturally rich area notable for its history of transition. The land that encompasses Williams County was seized from the Native Americans by the French, then from the French by the British, and, finally, from the British by the Americans. In 1835, part of the county's northern region, along with the northern sections of Fulton and Lucas counties, was claimed by both the State of Ohio and the Territory of Michigan. (see map under Fairfield County) Unable to reach a peaceful settlement, the Ohio militia prepared to invade what was then in the hands of Michigan.

But on June 15, 1836, Congress interceded and granted the nearly four hundred square miles of contested land, including the Toledo harbor, to Ohio. Michigan received the region that is now its Upper Peninsula, and attained admission to the Union. Michigan realized valuable assets, such as iron and copper mines and vast forests. So although it appeared at the time of the compromise that Ohio, with representatives in Congress, prevailed over the less well represented territory of Michigan, both acquired precious resources. Many, in fact, trace the rivalry between the states back to this controversy.

When approaching Bryan, the copper-covered pyramidal roof of the courthouse clock tower is visible above the treetops. The tower 160 feet high and 26 feet square, with brick walls three feet thick, has rounded corners, paired columns, and a corbelled cornice. It reflects the overall massiveness of the Romanesque Revival building. Stonecutters from Scotland dressed the Berea and Amherst stone on the site, and worked on high scaffolding carving delicate designs that are mirrored in the interior plaster.

The interior also consists of marble from Georgia, for floors, stairs and wainscoting. Large pillars supporting the central tower form the corners of the traverse corridors of the three lower stories. Originally, the tower well opened through the center with a glass skylight, but this was altered with the addition of a fourth floor for added office space. Another interior modification was the lowering of the courtroom ceiling.

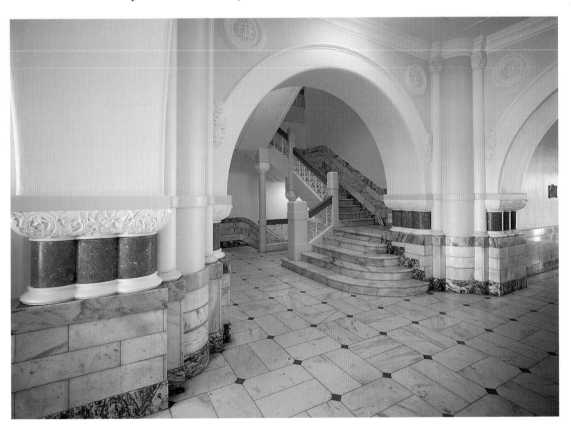

*Above: Pillars of oak, marble, plaster, and metal in the corners of the traverse corridors support the large central tower.*

# Williams County

*Left: Detail: faces peering through leaves formed on the corridor walls when the plaster was still wet.*

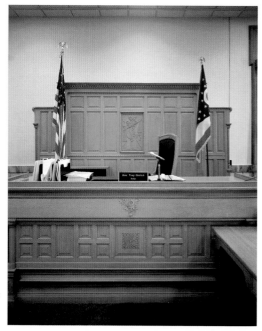

*Right: Carved detail in the judge's oak bench. Behind the partition is a door to the judge's chamber.*

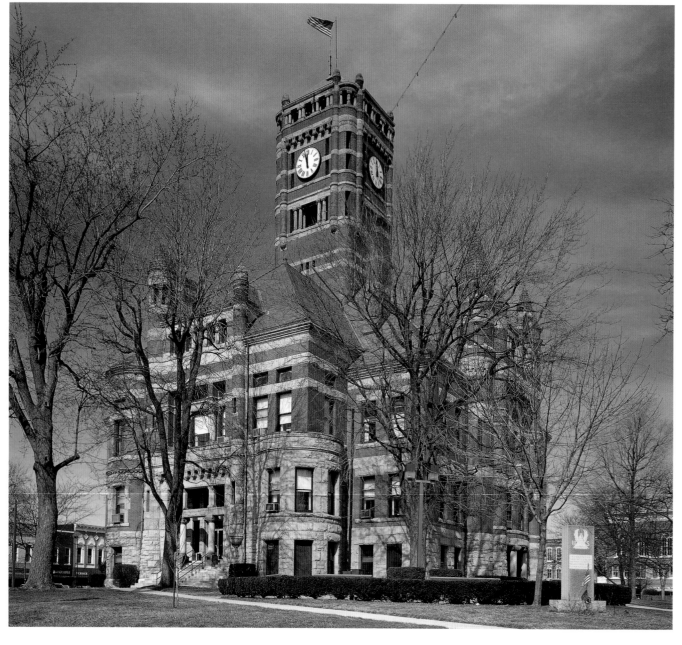

*Above: Stone and red brick courthouse, with many towers and turrets: rounded, "pepper-pot," and square.*

# Madison County

*Origin of name: James Madison, fourth U.S. President (1809-1817)*
*County Seat: London*
*Courthouse constructed: 1890-92*
*Architect: George H. Maetzel*

"Nemo inauditus condemnari debet" promises that "no one should be condemned unheard" to all those appearing before the Madison County Court of Common Pleas courtroom bench. This sense of justice along with respect for the past permeates the courthouse.

The architect of the well-preserved building, George H. Maetzel of Columbus, designed the Second Empire Franklin County Courthouse, dedicated July 13, 1887 and demolished 1974, and Madison officials wanted a smaller but similar version. In the London rendition overlapping architectural styles predominate. Beaux-Arts Classicist elements are incorporated into Second Empire designs, the courthouse's mansard roof with dormer windows and corner pavilions coexisting with dual columniation and classic pediments.

The interior remains intact with dark wood, tile, a barrel-vaulted light court with stained glass skylight, pressed metal ceilings, and a large courtroom. Rams' heads carved into the bench are similar to those in Butler County. The tin ceiling frames portraits of famous judiciary: north wall, Daniel Webster (1782-1852) and Samuel P. Chase (1808-1873); south wall, John Marshall (1755-1835) and Allen G. Thurman, an Ohio jurist who served on the Ohio Supreme Court from February 1852 to March 1856 and later opposed Rutherford Hayes for governor in 1867.

Throughout, fireplaces decorate offices. When steam heat replaced fireplaces or stoves in public buildings constructed after 1900, fireplaces were often ripped out or boarded over, but this county's officials retain its early heating system.

One of the fireplaces graces the Treasurer's Office, along with the elaborate hand-carved teller's cage where residents pay their real

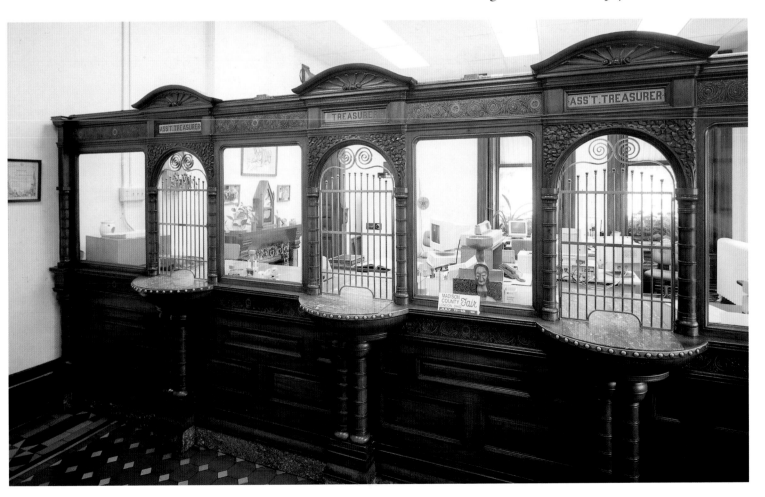

*Above: Treasurer's Office, with hand-carved tellers' cage and fireplace juxtaposed with the technologically advanced office equipment.*

# Madison County

*Opposite: Barrel-vaulted light court, with stained-glass skylight, and double staircase with twenty-eight steps. Framed prints of historic figures (Presidents Taft, Wilson, Lincoln, and others) line the walls.*

estate and property taxes. A function of county government, through the county treasurer, is to collect and disburse public funds. As the public money is received it is put into a vault for safekeeping.

During the depression, a state examiner discovered that Scott D. Slaughter, the thirty-ninth treasurer, discredited his office by converting public funds to his own use during the period from September 1937 to December 1938. He was indicted on three counts: embezzlement of $12,220.57 in county funds; loaning $203.50 in county funds to an assistant; and embezzlement of

a total in excess of $35. On January 30, 1939 the prosecutor declined to proceed with the case.

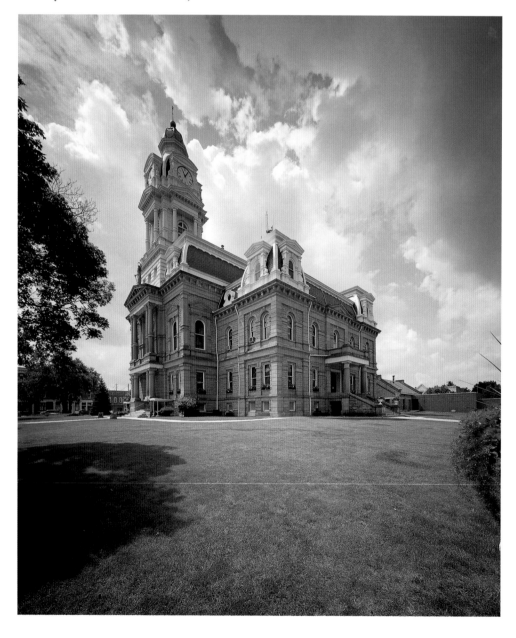

*Above: The Madison County Courthouse.*

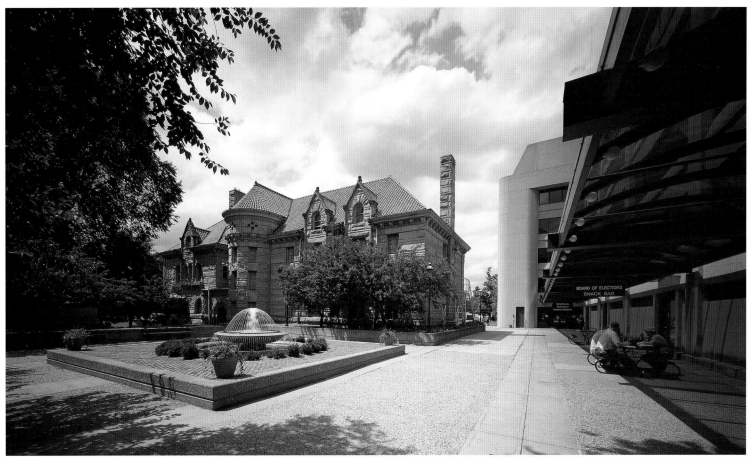

*Above: Former Wood County Jail on Courthouse Square, finished in 1902 and vacated 1990 when the Wood County Justice Center was completed. Although only six years younger than the courthouse, its design (by other architects and contractors) is of a slightly different style.*

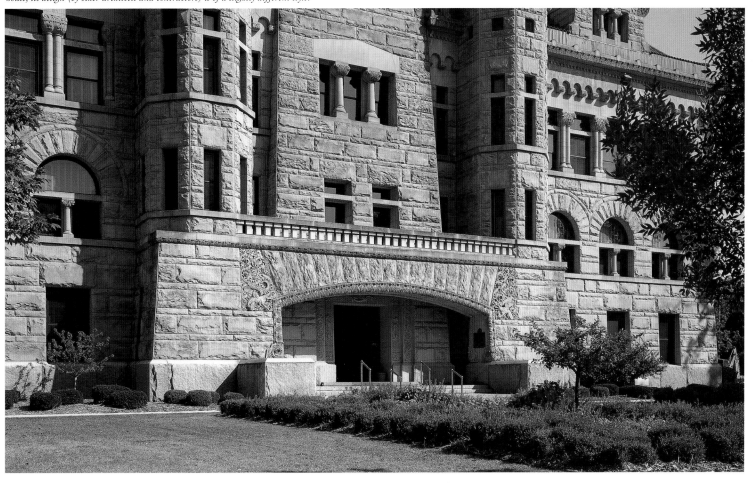

*Above: South entrance. The Vermont granite stonework alternates large and small courses in a rough texture contrasting with smooth columns and intricate decorative detail.*

145

# Lucas County

*Origin of name: Robert Lucas, Ohio Governor, 1832-1836*
*County seat: Toledo*
*Courthouse construction: 1894-97*
*Architect: David.L. Stine*

The names of twenty-six thousand Toledo area school children are embedded in the cornerstone of William McKinley's statue before the Adams Street entrance to the Lucas County Courthouse. The children financed the statue through their contributions. Support of art in the City of Toledo public places, both its creation and preservation, continues today on an official level, with one percent of all capital spending, even on sewer extensions, targeted for public art.

Another famous Ohioan, Robert Lucas (1781-1853), the namesake for the county, is commemorated by a plaque at the Adams Street entrance of the courthouse and an engraving on the landing of the main staircase. Under his leadership, laws were passed establishing free schools, and supporting banking and transportation systems. Significantly for Toledoans, the 1835 settlement of the Ohio-Michigan boundary war, while Lucas was governor, transferred the city from Michigan to Ohio jurisdiction.

The Toledo architect of the courthouse designed a sandstone building on a rusticated base. The entrance consists of Roman arches, above which are paired Corinthian columns supporting a pediment. A balustrade surrounds the roofline. The dome with a colonnaded drum is centered on the roof and topped with a finial consisting of a short column with an orb. Carved frogs can be found in the stone, for added decoration.

The recurring egg-and-dart trim (a decorative molding comprising alternating egg-shaped and dart or arrow-head motifs) is an example of the continuity and strict attention to detail evident throughout the building. It is carved into oak trim, furniture, and marble, and is even incorporated into adaptations of Corinthian and Ionic column capitals. The egg-and-dart detail was added while the plaster was still wet,

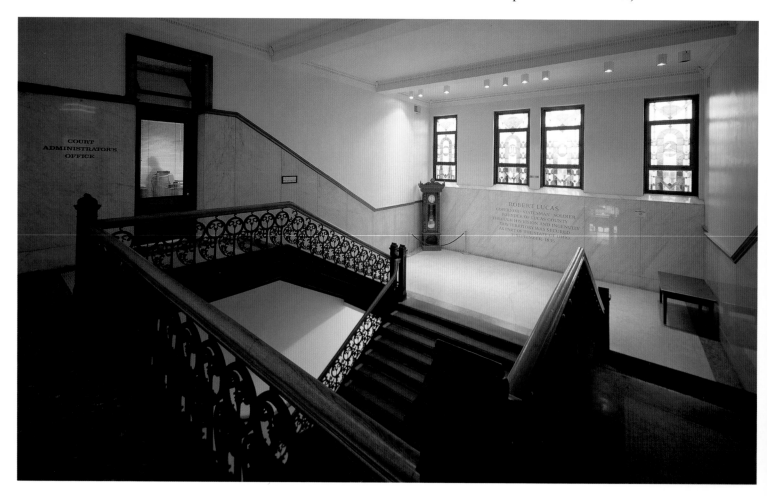

*Above: Staircase landing, commemorating Robert Lucas. The stained-glass windows were installed during the courthouse's centennial year.*

and it was also assimilated into the wrought-iron design of the staircases.

The frogs carved into the sandstone exterior and the frog-shaped tile mosaic located on the floor of the south entranceway serve as remainders that the courthouse was constructed on the marshy bed of the abandoned Miami-Erie Canal. Folklore maintains the area was so teeming with frogs that Toledo was sometimes referred to as "Frogtown."

During the courthouse centennial celebration, county officials again involved the community's elementary school children, this time in a contest to name the frog mosaic. The winner: Justice T. Frog.

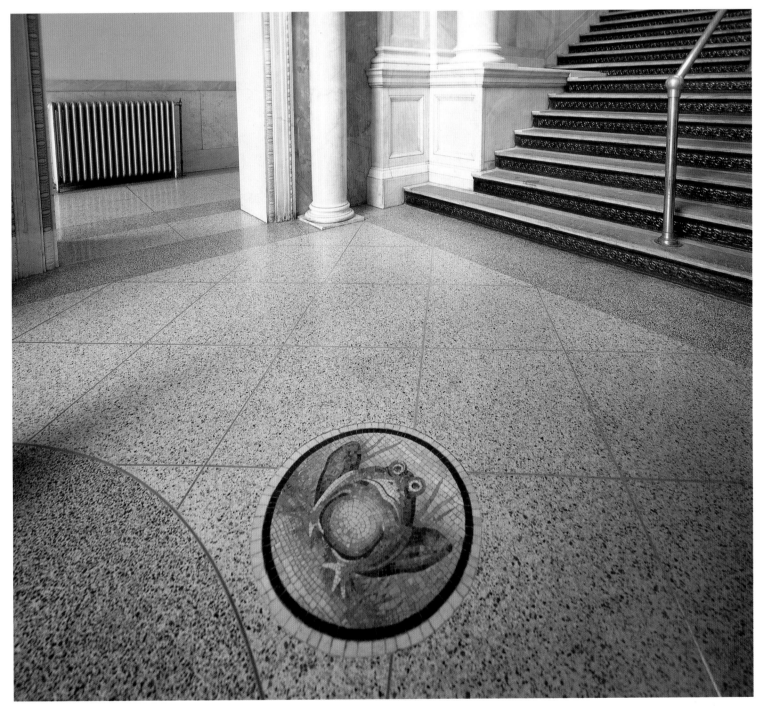

*Above: Frog mosaic on the floor of the south entrance: hand-fashioned marble chips in a cement mold.*

# Lucas County

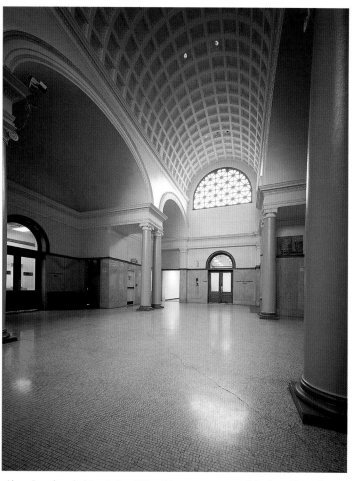

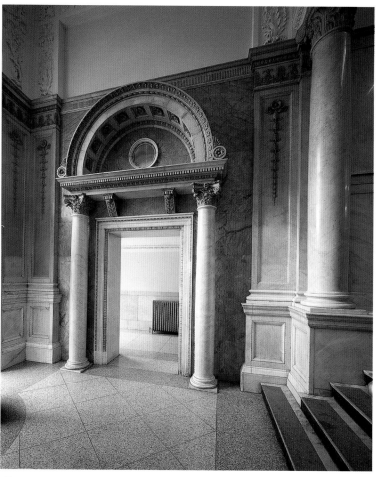

*Above: Barrel-vaulted fourth-floor lobby, with entrances to some of the eleven Court of Common Pleas courtrooms. The marble columns, with an adaptation of the Ionic capital incorporating the egg-and-dart trim, support the roof.*

*Above: In the marble doorway, the hand-carved composite Corinthian capital includes egg-and-dart pattern.*

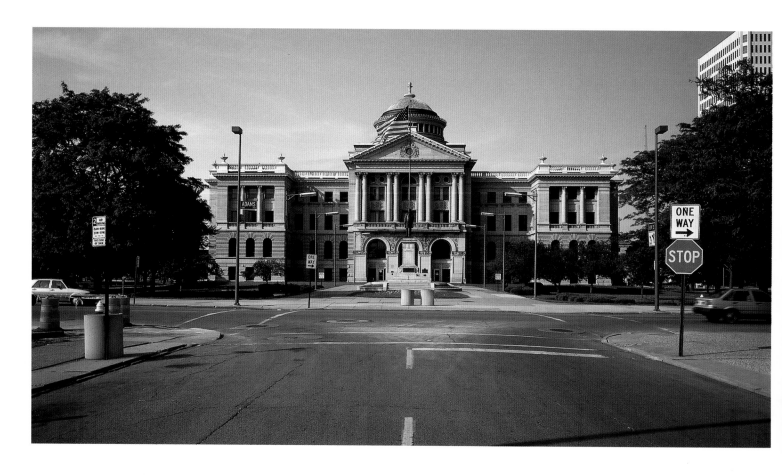

*Above: Courthouse, with statue of McKinley. It is Toledo's oldest public building still in use.*

# Trumbull County

*Origin of name: Jonathan Trumbull, Jr., Governor of Connecticut 1797-1809, who released*
*Connecticut's last jurisdictional claim to the Western Reserve by a Deed of Cession to the United States*
*County seat: Warren*
*Courthouse construction: 1895-97*
*Architects: LaBelle & French*

Nicknamed "The Stone Quarry" or "The Rock Palace," the Richardsonian Romanesque styled courthouse of Trumbull County offers visitors uniqueness inside and out. The third courthouse to occupy the site, it reflects the county's prosperity at the time of its construction.

The symmetrical south façade consists of a central bay with an arched, columned entrance flanked by circular turrets and pavilions. The windows are evenly placed, flat-arched on the first two floors, and round-arched (eyebrows) on the third. A round tower rises from the center, culminating in a columned cupola.

Upon the courthouse's completion, twelve foot tall, seven hundred pound copper statues of Justice were positioned on top of the four gables. To honor Trumbull native son William McKinley, the statue facing east (toward Washington D.C.) was put into place on March 4, 1897, the date of McKinley's presidential inauguration. As part of an eight million dollar construction, rehabilitation, and restoration project, fifty-one molds of the statues were made to recast broken sections, and steel support beams were replaced and hand polished with corrosion-retardant chemicals.

At the north entry a wide staircase immediately led to the second and third floors. In order to provide a vestibule area (where security could be installed) and a more graceful first-floor lobby, the staircase was moved back, and was divided into two stairs rising half way to the second floor and meeting at a landing before continuing as a single flight. The original stairway materials (white marble wainscoting, pink Tennessee marble treads, quarter-sawed oak banisters, and ornamental wrought iron railings with large wrought iron newel posts) were used in the rehabilitation.

Higher on the staircase, the décor becomes more ornate. Original color schemes were replicated by microscopic analysis of old paint chips found underneath more recent coats of paint, in an effort to return the rooms to their earlier brilliance. Much of the cast plasterwork was also restored.

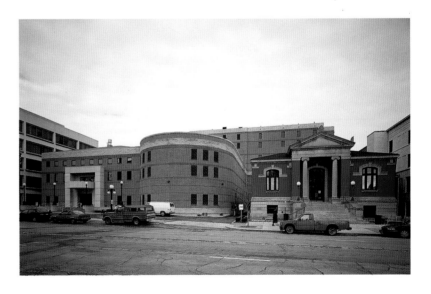

*Above: The new Trumbull County Jail echoes the rounded turrets of the Courthouse.*
*Next door is the county's law library.*

# Trumbull County

The third-floor courtroom, said to be the largest in the state, is forty by sixty feet with a twenty-five foot ceiling. The plaster walls and ceilings are polychrome, with frescoes and stenciling by Charles Hahne of Dayton. The gilded cherubs lining the ceiling are original to the room. Among others, the legendary courtroom firebrand Clarence Darrow (1857-1938) appeared in this courtroom.

*Following spread: Magistrate's hearing room located in a turret with oak chairs and tables original to the building and the bench from the Probate courtroom. A catwalk connects the hearing room with the magistrate's office which is located in the other turret (seen through window).*

*Clarence Darrow, born in Kinsman, Trumbull County, Ohio, achieved national fame as a partisan for union causes, as defense attorney in the 1924 case of Leopold and Loeb, as attorney in the Scopes evolution trial of 1925, and generally as defender of the indefensible. In 1928, around the time of Darrow's retirement from the practice of law, he was one of three attorneys hired by a local mobster, Jim Muncine, for his third trial on a charge of attempting to bribe the sheriff with $500 to allow him to operate an illegal gambling joint. The venue for the action was changed to the old Ashtabula County Courthouse in Jefferson, for the defendant to have a better opportunity for a fair trial by a jury less aware that the two prior Trumbull County convictions on the allegation were reversed on appeal. Darrow, a trial lawyer who was known for making the best he could of the facts, was unable to convince the jury of the defendant's innocence. The jury was divided, and Muncine had to be tried a fourth time on the charge.*

*Above: Common Pleas Courtroom. Ceilings of the halls and third-floor courtrooms are of stamped metal with patterns – highlighted in metallic paint.*

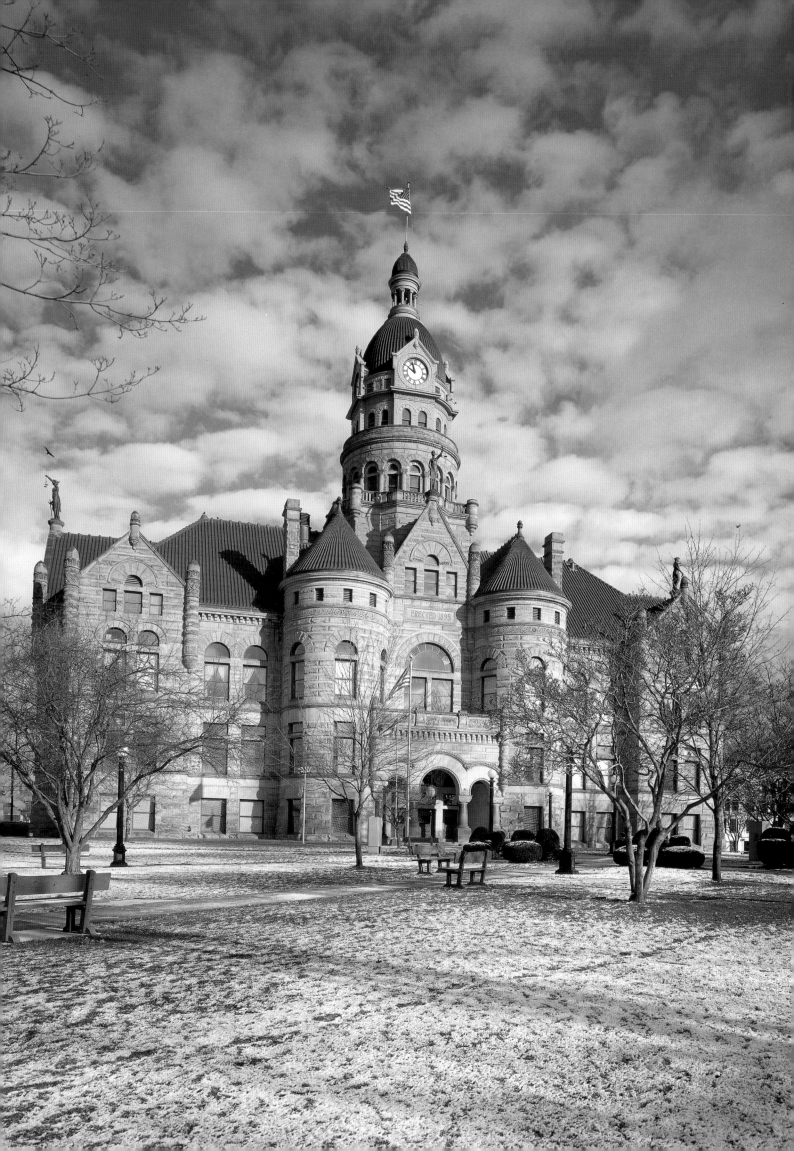

# Trumbull County

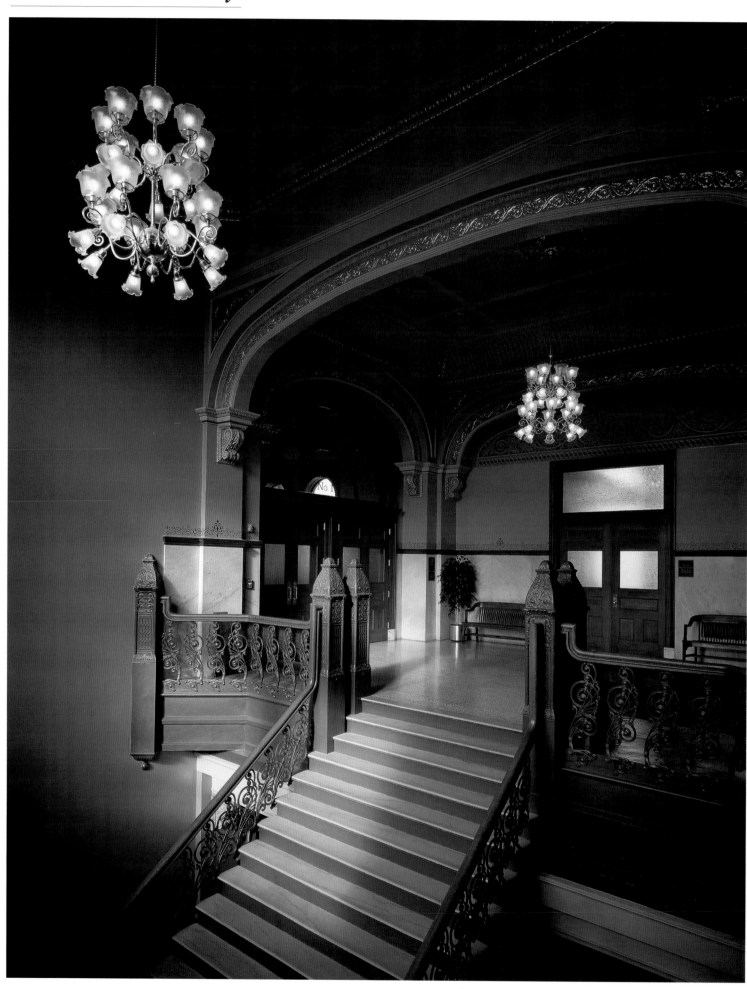

*Above: View of the reconfigured stairway and upper lobby: wide corridors with marble slab wainscoting enhanced by carved woodwork and mosaic floor.*

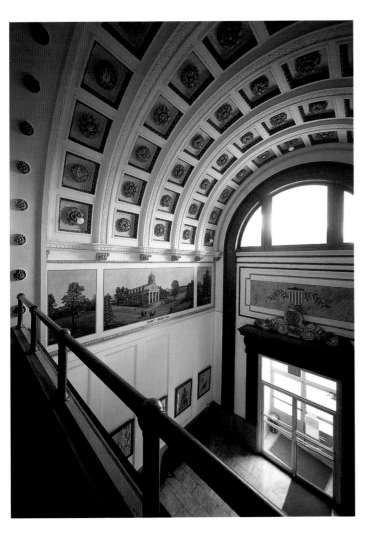

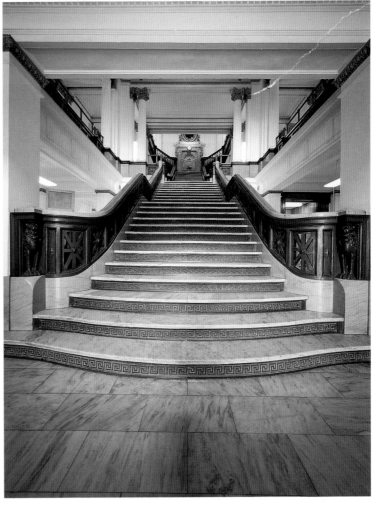

*Above: Entrance foyer, with coffered ceiling and mural of first courthouse.*

*Above: The main staircase.*

# Ottawa County

*Origin of name: Ottawa Indian tribe*
*County seat: Port Clinton*
*Courthouse constructed: 1898-1901*
*Architects: Wing & Mahurin*

The Richardsonian Romanesque styled Ottawa County Courthouse is characterized by arches and steeply pitched gables with finials. The square tower, located in the center of the roof rises to 132 feet above the ground. The top of the tower contains a belfry for the clock chimes, and the clock faces are located in gables similar to, but smaller than, those below.

The exterior of the building is constructed of North Amherst sandstone and the interior steps and wainscotting of pink Tennessee marble. The original intent of the building committee was to face the structure with native limestone from Marblehead quarries; however, agreeable arrangements could not be reached with the quarry.

The construction period of the courthouse lasted from 1898 through May 20, 1901. On that date, the county commissioners and building committee accepted the new courthouse, total cost of construction being $65,500.

The courthouse is constructed around the central stairwell that rises to the second floor and forms a vault. Four scenes, completed in 1908 and depicting Ottawa County, are painted on the walls outside the courtroom: "Quarrying", "Farming", "Fishing", and "Fruit Growing". These four original industries also define in large measure the significant immigrant groups that settled in the county. The French were the fishermen, the Danes were the farmers, the Germans were the fruitgrowers, and the Slavic peoples worked the quarries. The chandelier, hanging from the middle was taken from the courtroom when it was remodeled and the ceiling lowered.

Above the double stairway landing hangs a copy of William Powell's mural, "*Perry's Victory on Lake Erie.*" The original (installed March 30, 1865) hangs in the Ohio Statehouse and a significant replication appears in the Senate Wing of the Capitol Building In Washington, D. C. While the mural may not be of museum quality, the battle

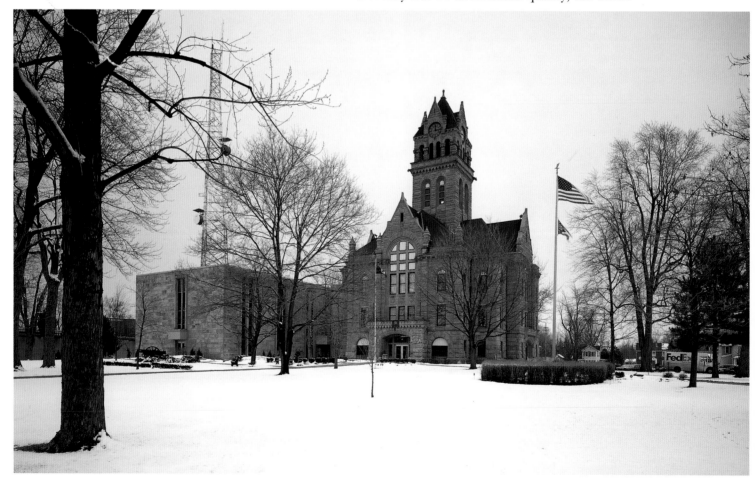

*Above: The Ottawa County Courthouse, with annex dating from 1974.*

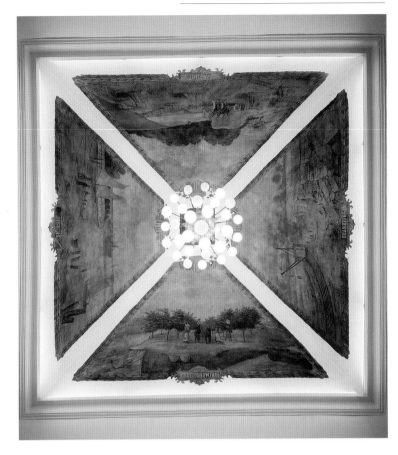

just off shore of Port Clinton during the War of 1812 had national ramifications, so the mural deserves its prominent position.

A young Oliver Hazard Perry (1785 - 1819) became commander of naval operations on the lake with the intimidating assignment to destroy the British naval power. Perry built and trained an armada at Presque Isle (near Erie, Pennsylvania) and on September 10, 1813, before noon, the British and American fleets joined battle a few miles away from Port Clinton. After the thorough defeat of a British fleet, Perry sent a victory dispatch to General William Henry Harrison: "We have met the enemy and they are ours – Two ships, two brigs, one schooner, and one sloop."

*Above: View of the decorated vault.*

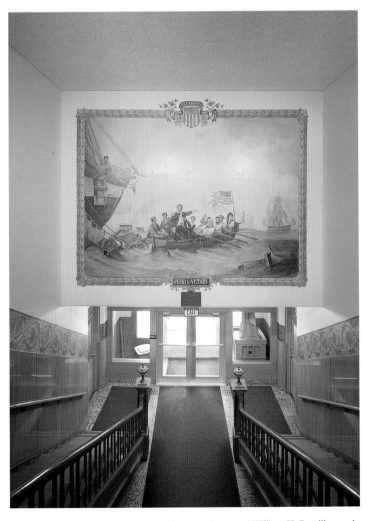

*Above: Double stairway from first to second floor, with a copy of William H. Powell's mural of "Perry's Victory on Lake Erie," depicting twenty-eight year old Perry transferring the colors from his battered flagship Lawrence to the Niagara.*

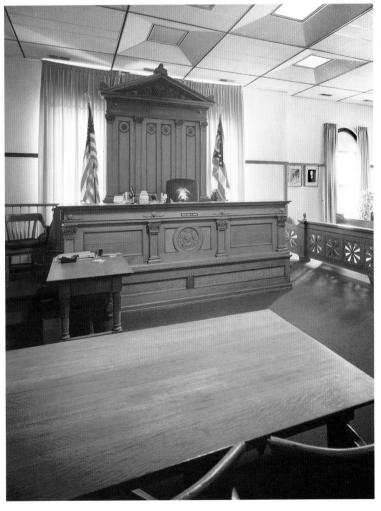

*Above: The White Oak bench is original to the building. Oral tradition holds that the intricate wood carvings on both the bench and the back bench were executed by inmates of the Ohio State Penitentiary.*

# Washington County

*Origin of name: George Washington, president of the Constitutional Convention when the county was formed in Ohio*
*County seat: Marietta*
*Courthouse constructed: 1900-1902*
*Architects: Samuel Hannaford & Sons*

A 1786 meeting at the Bunch of Grapes tavern in Boston lead to the formation of Ohio's first county, Washington. The Ohio Company formed at the meeting, comprised of former Revolutionary War officers and soldiers, acquired land in the Ohio territory for settlement. On October 27, 1787, it successfully completed the first large land sale in the United States with the Continental Congress, consisting of about one and a half million acres.

Surveyors, led by Rufus Putnam, set out from Massachusetts and reached Fort Harmar, at the confluence of the Ohio and Muskingum rivers on April 7, 1788. This is considered the date of Ohio's first permanent English-speaking settlement. Called Adelphi, its name was changed to Marietta (an abbreviation of the name of the French queen, Marie Antoinette) in honor of French assistance during the Revolutionary War. Marietta became the center of Washington County, the first county in the Northwest Territory. It comprised over half of what is now Ohio, from the Scioto River east to the Pennsylvania line and from the Ohio River north to the 41st parallel.

As Ohio's political system developed, town government played less of a role, in contrast with the government of many of the early settlers from New England. The first court, the Court of Common Pleas, was a county court assembled in a Marietta blockhouse (Campus Martius) on September 2, 1788. A larger one in 1823 replaced the initial courthouse, built around 1798, until the present building was constructed in 1902.

This building is characterized by a second story portico supported by Doric columns with a decorated pediment, triangular hood-moldings above the second-story windows, and a tall clock tower with dome. The lobby features a staircase with skylight, and a tile floor with a design similar to swastikas. Symbolizing "good luck and prosperity," this design has been incorporated into religious and decorative art for over three thousand years-appearing on Chinese, Arabic, Egyptian, Eastern, and Native American artifacts, on Greek coins, in the catacombs of the early Christians in Rome, and in Byzantine buildings. It was used by early Teutonic tribes before its adoption (in reverse form) by Nazi Germany as an "Aryan" symbol.

*Above: The Ohio Company land office, located at the Campus Martius or the Museum of the Northwest Territory, is reportedly the oldest existing building in the five original states of the Northwest Territory.*

*Above: 1804 map showing Ohio Company purchase (emphasis added).*

*Above: Staircase with tile floor.*

# Washington County

The courtroom, commemorating the county's early history, and restored to resemble its original condition, is painted in ivory, gold, bronze, and soft green colors with a frieze of cornucopias, tablets, and figures symbolic of justice. The names of the officials of the first Washington County Court, surrounded by laurel wreaths, are printed on the walls facing the judge's bench. Judicial Officers: General Rufus Putnam (1738-1824), General Benjamin Tupper (1738-1797), and Colonel Archibald Crary (1748-1812); Sheriff: Colonel Ebenezer Sproat (1752-1805); Clerk: Jonathan Meigs (1735-1823); and the Honorable Paul Fearing (1762-1822), the first attorney admitted to the Court.

*Above: Gold painted lions guarding lower level entrance.*

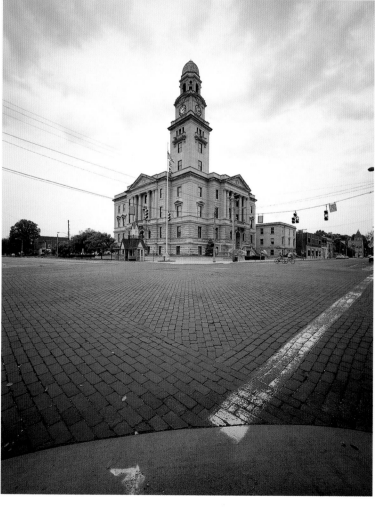

*Above: The Washington County Courthouse.*

# Greene County

*Origin of name: General Nathaniel Greene, Revolutionary War hero*
*County seat: Xenia*
*Courthouse construction: 1901-02*
*Architect: Samuel Hannaford & Sons*

Greene County's rock-faced courthouse, designed by Samuel Hannaford (1835-1910) in the Richardsonian Romanesque style, is characterized by stone construction, asymmetrical square clock tower, round-arched openings, and corbelled cornice. The solid Bedford stone building survived the 1974 tornado that severely damaged Xenia (killing thirty-four and causing $100 million in damages) although the tile roof, the four glass clock faces, and some of the gargoyles from the tower corners were damaged.

The stained-glass window, beside the judge's bench in the courtroom, also endured the tornado. While no pieces were broken, the window bowed from the changing air pressure as the funnel passed. A storm window that separates the art glass from the outside may have protected it. Later, the window was removed, in one piece, and refurbished.

The window dates from the courthouse's completion. During this period, stained-glass windows were popular decorative components. In addition to Justice, the following messages are incorporated into its design: "The Law Delights in Equity, It Covets Perfection, It is a Rule of Right, The Safety of the People is the Supreme Law."

One, rather cynical, Greene County historian, noting early lawyers' lack of education and legal training, wrote "the reason why Justice (as portrayed in the beautiful colored leaded window in the court room) is shown as a blind-folded woman was, because she feared to look upon the men who were to dispense the justice she was supposed to typify."

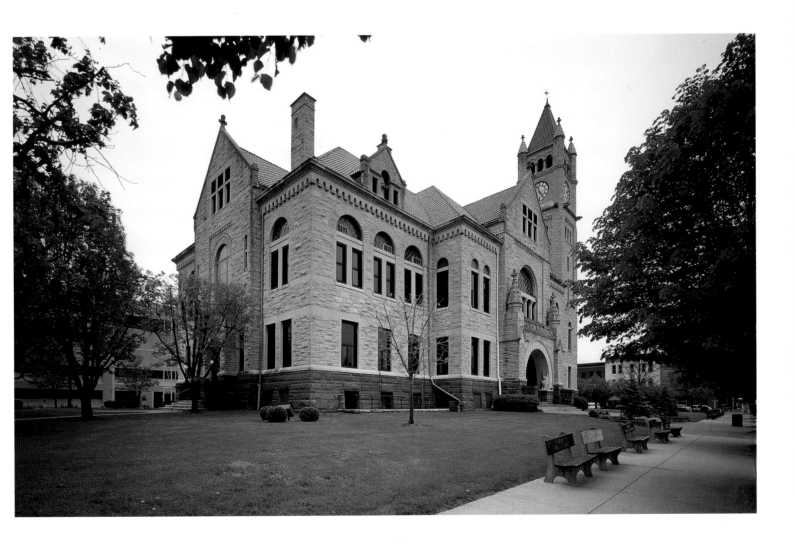

*Above: The Greene County Courthouse, with asymmetrical tower above the southwest corner.*

# Greene County

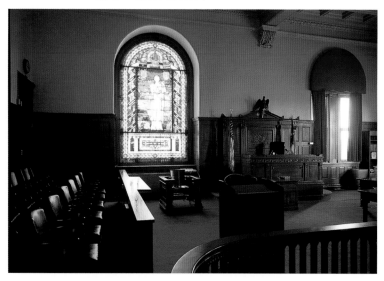

*Above: Courtroom 1, featuring the 18 foot by 10 foot stained glass window titled "Justice is Blind."*

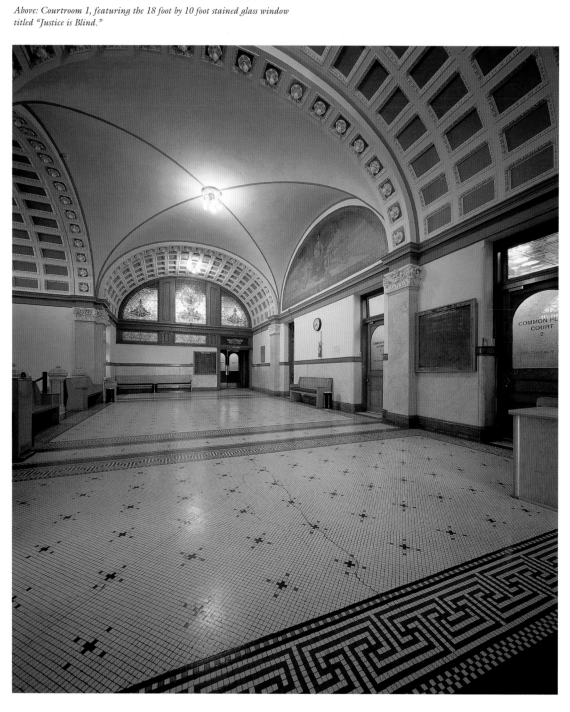

*Above: From the second-floor landing, a view of high arched ceilings, featuring inlaid panels, and a hand-painted mural.*

# Monroe County

*Origin of name: James Monroe, fifth President of United States, 1817-1825*
*County seat: Woodsfield*
*Courthouse construction: 1906-08*
*Architects: Samuel Hannaford & Sons*

In 1908 one of the ten largest clocks in the world was installed in the Monroe County Courthouse. The building's dome incorporates the large four-faced clock that was specially manufactured for it by the Howard Clock Company of New York City, at a cost of $2,775. Once a week, a janitor and his son climbed the ladder to the tower to wind the heavy crank, until in 1947 an electric motor was installed.

The courthouse is very different from the first log structure built for $137.00 in 1817. With the jail on the first floor and the courtroom on the second, the log building cost $100 for the woodwork and $37 for the stone and other work. The second and the third courthouses were destroyed by fire.

The Cincinnati architectural firm of Samuel Hannaford & Sons designed the fourth courthouse. Hannaford (1835-1910) started the firm when he was twenty-two years old. During his long career he designed residential homes, business and public buildings, including a number on the University of Cincinnati campus, and the Annex to the Ohio Statehouse.

Hannaford placed the main entrance of the Woodsfield structure between Ionic columns and an arched stone pediment. The exterior consists of cut stone and red and yellow brick which, according to local historians, were chosen to reflect the colors of autumn in the surrounding countryside. The yellow brick provides a contrasting effect in the quoins, within the pediments, and at other points.

*Above: The stained-glass window on the stairwell, with a large "M" in the center, reaches to the ceiling of the third-floor rotunda.*

# Monroe County

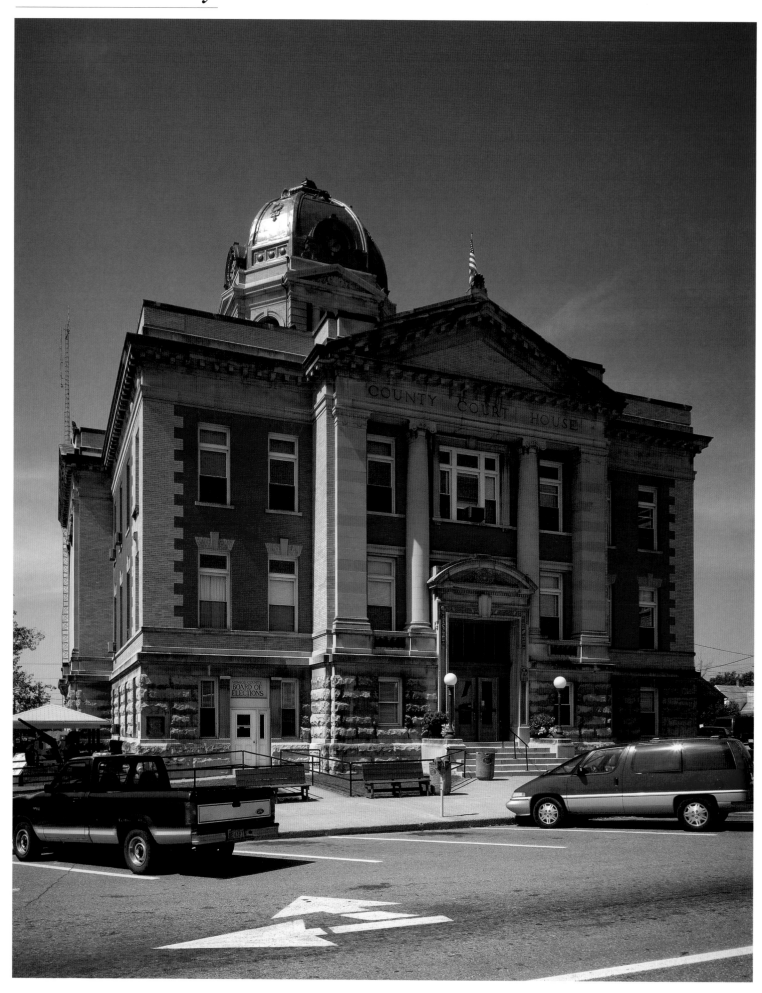

*Above: The Monroe County Courthouse.*

The interior resembles the outside, in both being restrained and intact. Hallways are finished with oak trim and tile floors. In addition to typical courthouse visitors conducting their county business, genealogists can be seen wandering the hallways and offices.

Courthouses are popular research laboratories for genealogists, who trace their family's descent through land records stored in the Recorder's Office, birth and marriage registries, wills and

trusts in the Probate Court, and military discharge documents, tax lists, and civil and criminal court records. Many of Ohio's early immigrants, traveling south on the Ohio River, stopped in Monroe County before migrating west. The Swiss were especially drawn to the hilly area because it reminded them of their homeland. Now many return for information regarding their past.

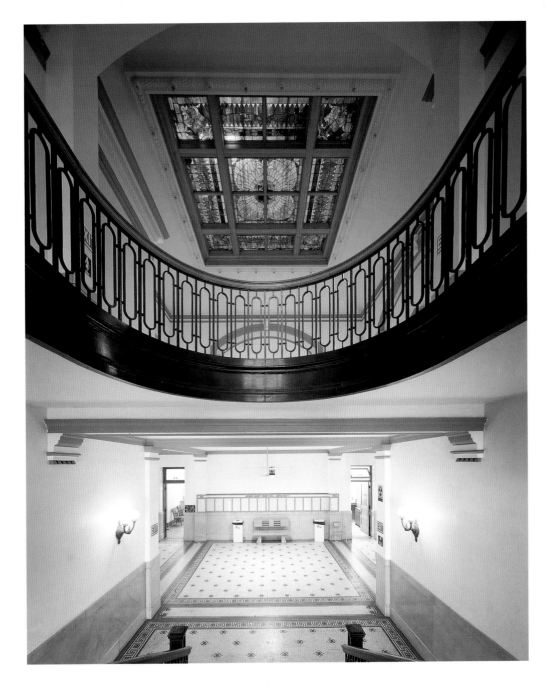

*Above: Below the dome is a stained glass skylight, measuring 20 feet by 20 feet , lighting the rotunda.*

# Summit County

*Origin of name: "Portage Summit," the highest land on the Ohio and Erie Canal*
*County seat: Akron*
*Courthouse constructed: 1905-08*
*Architect: J. Milton Dyer*

In 1825, the Ohio-Erie canal system was constructed along the Cuyahoga, Tuscarawas, Licking, and Scioto River valleys. By 1830, the canal connected Cleveland with Portsmouth. Although the railroads soon displaced them, the state-financed canal systems are credited with opening Ohio to settlement, and providing cheap transportation for goods and produce to distant markets.

Akron was one of many small towns that benefited from its location on the canal route. Its agricultural and industrial growth was such that in 1840 it became the county seat when Summit County was created from portions of Portage, Medina, and Stark counties.

A lobby display notes that before the first courthouse opened, President John Quincy Adams (1767-1848) unofficially dedicated it, on November 2, 1843.

*...As he was passing through Akron on the Ohio Canal, he had to disembark while his boat was passing through the locks. A delegation discovering his presence, persuaded him to*

*address the citizens of Akron. He was escorted to a packed courtroom of the New Court House, and delivered a snappy, twenty minute talk interrupted frequently by enthusiastic applause. At the close, as reported by the Beacon, "the distinguished man stepped forward and took each one by the hand, kissing each lady and all the babies in attendance."*

This structure, constructed on the site of the first, consists of two buildings–the courthouse, and the matching annex. The 1928 addition became necessary soon after the construction of the courthouse, because of a population surge in industrial Akron.

The Second Renaissance Revival building, designed by J. Milton Dyer, is typical of federal government buildings constructed during this period. It is a steel, concrete, and sandstone-faced structure with round-arched windows on the first floor. The windows of the upper two stories are framed in vertical order between flat piers. A plain entablature, cornice, and parapet surround the roofline.

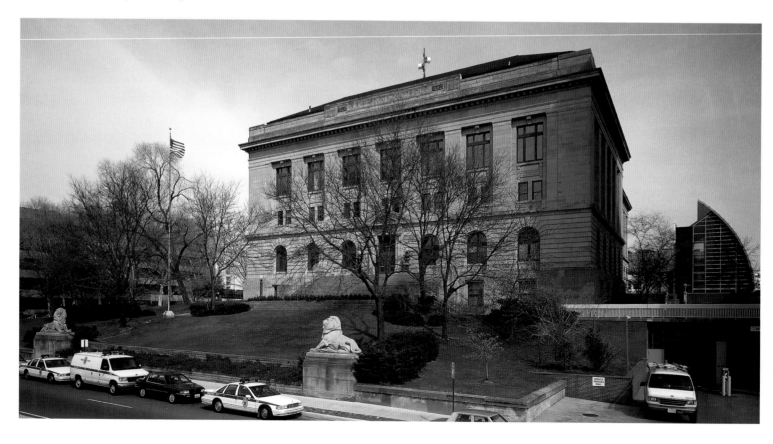

*Above: The Summit County Courthouse, a horizontal building without a tower.*

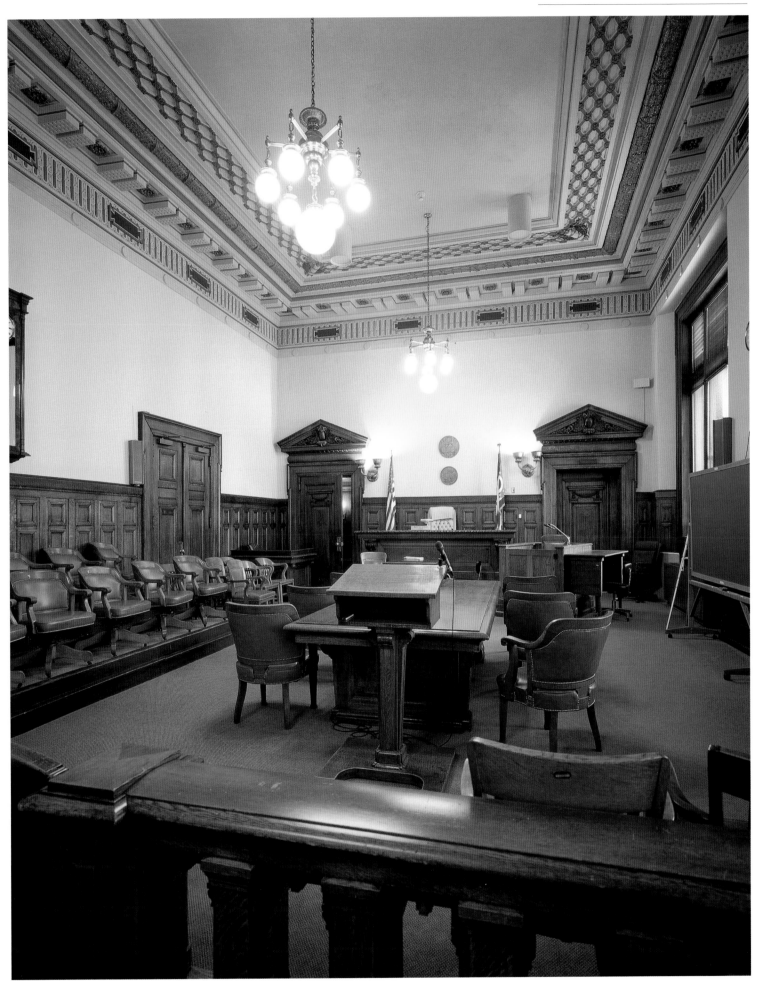

*Above: Restored Common Pleas courtroom.*

# Summit County

Cast-iron gates protect the Probate Court Clerk's Office. Documents and records on file include the 1886 marriage license application of Thomas Alva Edison (1847-1931), pioneer of the telegraph and the telephone, and considered inventor of the phonograph and motion pictures, and his second wife, Mina, who was the nineteen-year-old daughter of a wealthy Ohio manufacturer. Rubber industrialist Harvey Samuel Firestone's (1868-1938) one-page will hangs on the wall, overlooking records that include challenges to it.

One of the most noteworthy, heard by the Ohio Supreme Court in 1995, involved a great grandchild of Firestone who challenged the bank's administration of the trust that Firestone established for the benefit of his six children. The bank prevailed over the great grandson's assertion that it abused its discretion when it, among other things, withdrew approximately $1,000,000 from the corpus of the trust for legal fees it had incurred; paid legal fees incurred by the grandson in defending actions brought against him by other beneficiaries of the trust, and made distributions of the trust income totaling approximately $3,000,000.

The Court reasoned that as long as the trustee acts in good faith and does not abuse its discretion, a court would not substitute its judgment for that of the trustee. To be an abuse of discretion, a decision must be grossly violative of fact and logic, demonstrating perversity of will, defiance of judgment, undue passion, or extreme bias.

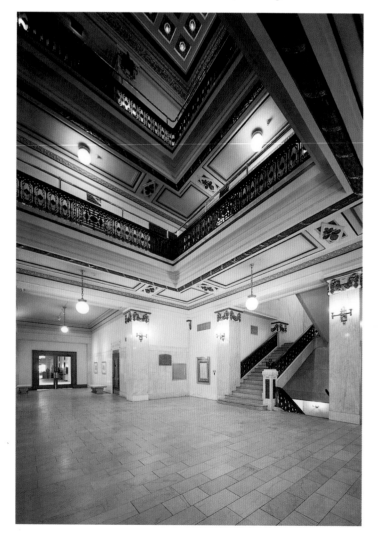

*Above: Balconies and leaded-glass coffered ceiling with a skylight enliven the brightly lit lobby.*

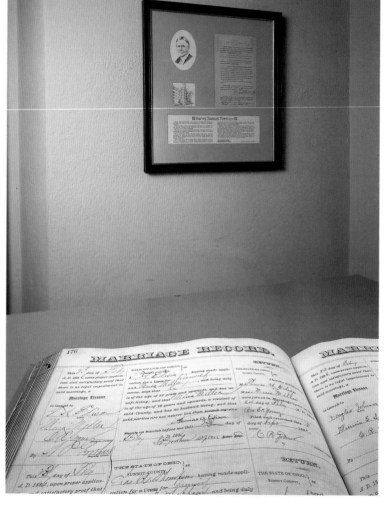

*Above: Firestone's will (on wall) and Edison's marriage license.*

# Lawrence County

*Origin of name: Captain James Lawrence, War of 1812 Naval Commander*
*County seat: Ironton*
*Courthouse construction: 1906-08*
*Architects: Richards, McCarty & Bulford*

A stone replica of an iron furnace decorates the grounds of the Lawrence County Courthouse, as a reminder that, in the nineteenth century, the county was the center of the Hanging Rock Iron Region–famous for producing some of the world's best iron. A bronze plaque lists the names of twenty-three blast furnaces built in the county between 1826 and 1909.

The Neoclassical stone courthouse sits on a hill near the downtown district of Ironton. It features Ionic pilasters on the façade, pedimented doors, and a dome protruding through the roof. A later annex was connected to the courthouse by a glass-enclosed ramp. The courtrooms and administrative offices were relocated to the extension, and the original courtroom partitioned into offices.

Within the vaults, file drawers, and storage bins of the hall of justice are many old secrets, belonging to people who died long ago. They are their last wishes, contained in unopened wills filed for safe keeping in the Probate Court. Although not required, state law provides that wills can be sealed and filed at the court until time to probate the estate. Most are executed, but sometimes a person forgets, moves, changes a name, or neglects to advise relatives of the will's whereabouts, and it is left forgotten and untouched. Some date back to 1897 when the law was instituted. Nobody can read them until the person dies and they take effect. So for those not opened, the secrets will remain forever.

The courthouse is one of many with restaurants or snack bars located in or near the main lobby. While most operate as a franchise of the Ohio

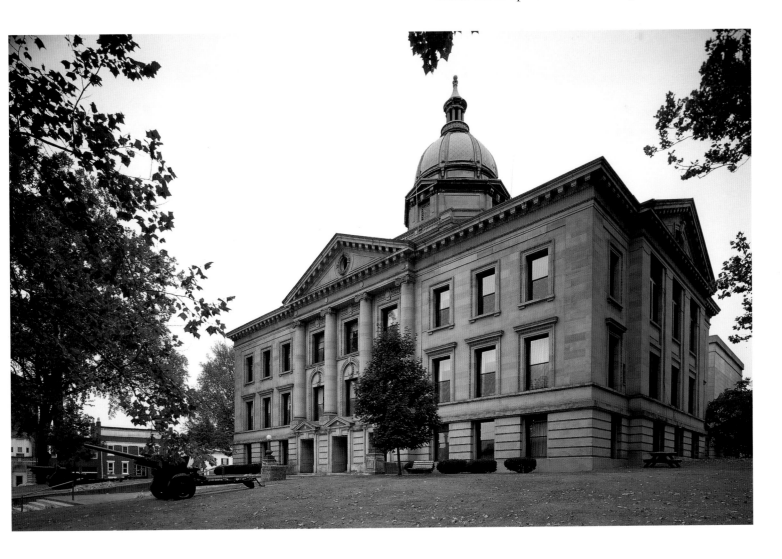

*Above: The Lawrence County Courthouse.*

# Lawrence County

Rehabilitation Services Commission (RSC) that rents space from the county and provides the equipment for the handicapped franchisee, this one is operated by the county commissioners' office, which took over when no replacement could be found after the last handicapped franchisee left.

*Above: Snack Bar. Banners from the historical open house, a week when each county office had a display.*

*Above: Stone replica of an iron furnace.*

# Crawford County

*Origin of Name: Colonel William Crawford, Revolutionary War Hero*
*County Seat: Bucyrus*
*Courthouse Constructed: 1906-08*
*Architect: Harlan F. Jones*

In its name, Crawford County honors the frontiersman William Crawford (1732-1782). A colonel in the Continental Army and a friend of George Washington, Crawford was occasionally ordered to lead parties against Native American tribes aggravated by the increasing number of settlers encroaching on their lands. In May 1782, he reluctantly accepted the command of an expedition to destroy the Sandusky towns of the Wyandot and Delaware tribes. After his troops were defeated by a combined British and native force, Crawford was captured, tortured, and burned to death. Today, a statue further commemorating him stands in a niche to the left of the courthouse entrance.

The small core of the building dates from 1856, when it was constructed of brick, with walls at least sixteen inches thick, and four wooden columns in front. During a 1908 renovation, the bricks were covered with stone, a front addition was added including the courtroom, and stone pillars replaced the wooden columns. A twenty-two by twenty-six foot stained-glass dome, consisting of sixty pie-shaped pieces (eighty inches wide at the rim), was installed above the courtroom to provide additional light for the gas fixtures.

In 1979, the dome was cleaned and restored, but was not artificially illuminated, as many others were. Since skylights often cause problems with condensation and leaking, many courthouse domes are encased in protective covering. Moreover, once electricity replaced gas lighting, the natural light from the domes became less significant.

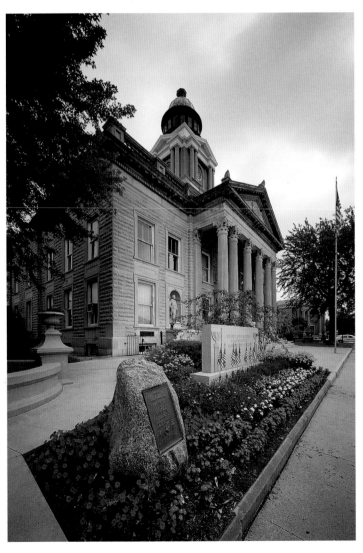

*Above: The Crawford County Courthouse, with low-pitched hip roof concealed by a stone balustrade.*

*Above: Hallway dating from 1908 construction.*

# Crawford County

*Above: A cast-iron fountain dating from 1908, which was stripped of at least thirty layers of white paint and repainted in more realistic colors. A pump was installed to recycle the water.*

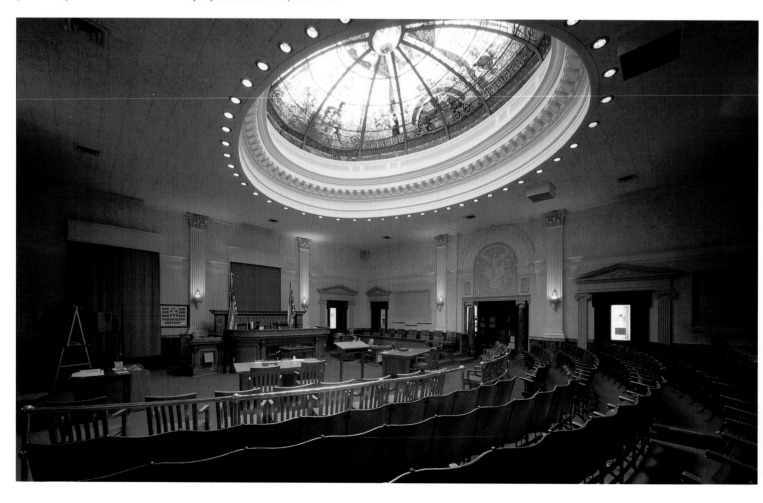

*Above: Courtroom. To the right of the bench are busts of circuit judges.*

# Lake County

*Origin of name: The county borders on Lake Erie*
*County seat: Painsville*
*Courthouse construction: 1907-09*
*Architect: J. Milton Dyer*

Allegorical figures representing Cain and Abel, biblical perpetrator and victim respectively of the first crime, flank the entrance to the Lake County Courthouse. Each was carved out of a single block of Bedford (Indiana) limestone, and installed on November 6, 1913. The Danish born sculptor Herman N. Matzen (1861-1938), hoped the figures would promote prison reform. He remarked:

> *Instead of taking figures, which are symbolic of what is produced in a court house, we have chosen to embody in two figures that which makes a court house necessary. The one (Cain), the absolute physical and impulsive creature, falsely termed criminal, and the other (Abel), gifted with mind and judgment, who should assume the responsibilities of turning super-physical forces into useful channels, instead of locking them up in cells for punishment.*

Behind the statues, engraved into the stone, are inscriptions reworked from quotations of Cicero and George Washington:

THAT REGARD BE HAD FOR THE PUBLIC WELFARE IS THE HIGHEST LAW

THE RIGHT TO A FREE GOVERNMENT PRESUPPOSES THE DUTY OF EVERY CITIZEN TO OBEY THAT GOVERNMENT

Cleveland architect J. Milton Dyer, who attended the École des Beaux Arts in Paris, designed the courthouse. Large Doric columns flank the entrance and an oversized entablature lies between the column capitals and the roof. The stone clock tower is topped with a copper-covered dome and a bronze eagle with wings spread. Inside, the first and second corridor floors are of Tennessee marble wainscoting almost ten feet high. The second floor is illuminated with a skylight. The rotunda is decorated with murals depicting Boyce Mill, Willoughby; ore docks at Fairport Harbor; Ashtabula, Lake County Line Road; and B & O Railroad, Painesville. Between the murals are portraits of such local luminaries as James A. Garfield, Samuel Huntington, General Edward Paine, and Thomas W. Harvey.

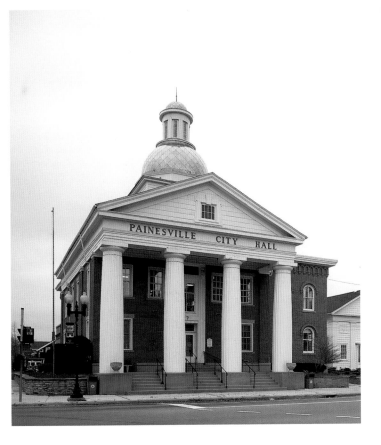

*Above: The first Lake County Courthouse, circa 1840, now the Painesville City Hall.*

*Above: Cain and Abel.*

175

# Lake County

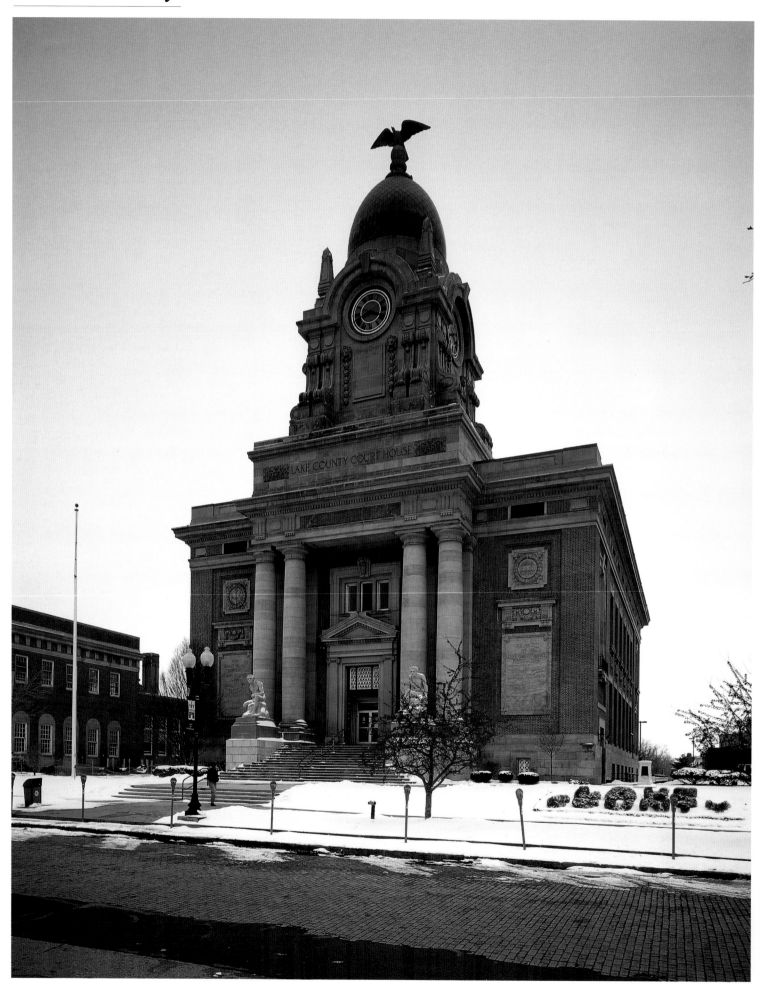

*Above: The Lake County Courthouse, built on a high base, with a grand staircase and façade contrasting with its modest rear.*

# Mahoning County

*Origin of name: Mahoning River. Mahoning is from an Indian word meaning a "lick" or salt licks*
*County seat: Youngstown*
*Courthouse constructed: 1908-11*
*Architect: G.W. Owsley*

The Mahoning County Courthouse, an example of Second Renaissance Revival style, was built during the county's golden industrial period, using the finest materials obtainable, such as terracotta, marble, and Honduran mahogany. The east façade features a central pavilion with six Ionic columns that rise through two stories and support a horizontal entablature. There is a balustrade above the cornice.

The lobby, considered the principal architectural element of the building, rises four floors and is capped by a forty-foot diameter dome of stained glass. Complementing the architecture are murals by Edwin H. Blashfield, who also created murals displayed in the Congressional Library rotunda in Washington D.C. The paintings on the outside curves of the supporting arches and the base of the dome (mural pendentives) depict women dressed in period clothing, each with a symbol of a particular legal period. These include a shepherdess expressing the ancient virtues

"Love & Tenderness," found in the child holding the lamb, the Law of Armed Force during the Roman domination, the Law of Faith in the medieval period when the Church was dominant, and Modern Law, created by the people, for the people, as seen in the Declaration of Independence, held up as a model for all nations. Under this figure's right arm is a ballot box.

Additional artworks in painting and stained glass fill the building. During the 1950s, piecemeal modernization destroyed some of its beauty and integrity: ceilings were lowered, covering carved decorative details; original railings, doors, and windows were replaced with stainless steel; added layers of paint concealed moldings; steel mill soot covered the granite exterior; artwork deteriorated; and fluorescent light fixtures replaced the originals. As the steel mills closed and the area encountered economic difficulties, the courthouse was further neglected. During the 1980s, in an effort to demonstrate the city's economic resiliency, the Mahoning County Commissioners, with the help

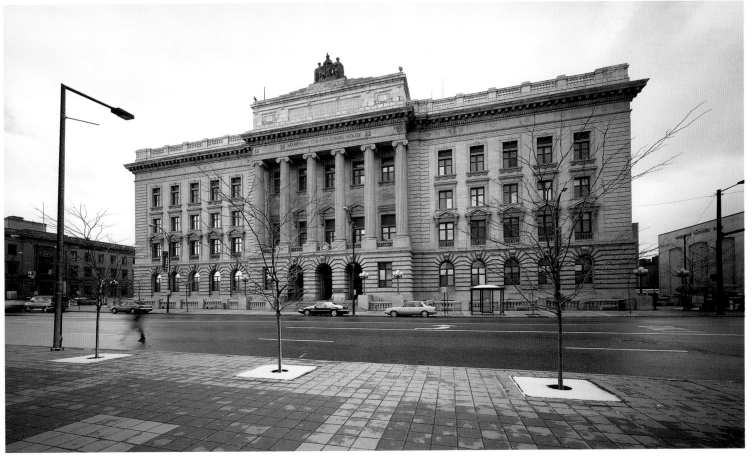

*Above: Exterior of the Mahoning County Courthouse. The following words are engraved below the three copper statues:*
A NATION CANNOT OUTLIVE JUSTICE—WHERE LAW ENDS TYRANNY BEGINS.

# Mahoning County

of the Courthouse Restoration Committee, set out to restore and modernize the building. The occasionally controversial renovation continued six years, and cost more than eight million dollars.

Today, radiating the spirit of the original while building on new technological reality, it serves as a model and inspiration for similar restoration projects. The exterior was chemically washed, windows replaced, and replicas of the original bronze doors were added. The interior was repainted in original 1910 hues, the artwork cleaned and retouched, and the six-foot high marble wainscoting was scoured. A new heating and air conditioning system was installed. Access for the elderly and disabled are available, and updated telephone and computer systems are now incorporated throughout the building and the county.

*Above: Stained glass arches illuminate the four hallways surrounding the rotunda.*

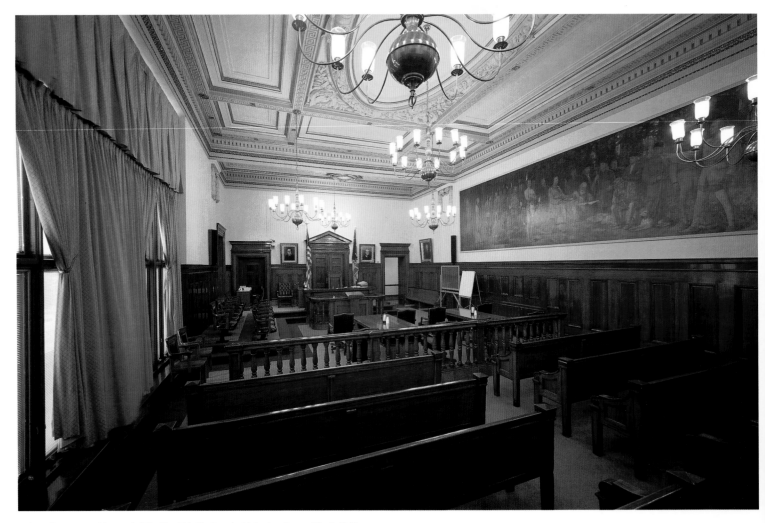

*Above: Courtroom with mural, "The First Trial by Law in Mahoning County," by C. Y. Turner, depicting the trial of an Indian for the murder of a man at the Salt Springs along the Mahoning River near Spring Common.*

*Above: Interior view of rotunda, with leaded glass dome divided into sixteen panels representing the townships of Mahoning County. The pendentives supporting the dome depict the development of Law.*

# Adams County

*Origin of name: John Adams, president during the time the county was organized*
*County seat: West Union*
*Courthouse constructed: 1910-11*
*Architect: T.S. Murray*

Before the Revolutionary War, portions of the region that became Ohio were not only claimed by Native Americans, French, and British, but by the colonies of Virginia, New York, Connecticut, and Massachusetts. The colonies based their claims on grants by English kings as far back as the seventeenth century. For example, the charter to the Virginia colony granted the land incorporating present sections of twenty-three counties from the Ohio River northward, between the Scioto and Little Miami rivers.

During the Revolutionary War, General George Rogers Clark (1752-1818) led expeditions against western British posts and various tribes. Under his command the Shawnees were defeated in the Battle of Piqua, near Springfield (August 8, 1780). Such efforts allowed the colonists to take control of land that became the Northwest Territory, and after the war American sovereignty in the territory was legitimized with the ratification of the 1783 Treaty of Paris.

Subsequently, the federal government set out to settle overlapping rights. A congressional committee proposed that states cede their western lands to the government for the national benefit. When Virginia reluctantly relinquished its claim in 1784, as part of a compromise it reserved nearly 4 ½ million acres, the Virginia Military District (VMD), where it granted land, including Adams County, to pre-Revolutionary soldiers from the state, in order to satisfy its military bounty warrants.

This county, the third oldest in Ohio was formed on July 10, 1797 by a proclamation signed by Winthrop Sergeant, Secretary of the Northwest Territory, acting on behalf of Arthur St. Clair, first governor of the Territory who was reportedly out of the Territory at that time. When Ohio became a state, Adams County was one of the original seventeen counties.

On April 13, 1803, the Ohio State Legislature created West Union as the county seat. The first courthouse was built in 1805, and the present (fourth) dates from 1911. In the 1970s, the front portico was added, along with the north addition that contains the courtroom, jail, until recently the county sheriff's living quarters, and office space.

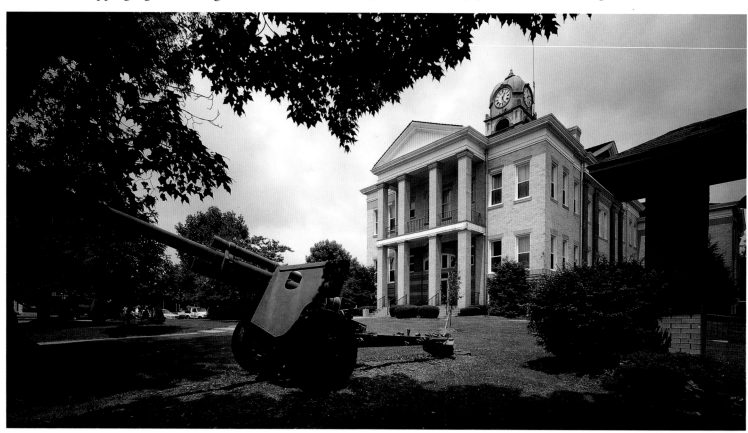

*Above: Courthouse. During the 1975 remodeling, the front portico was added with square brick columns. Pilasters adorn the east and west sides.*

*Above: Map of original seventeen counties.*

*Above: Prior to statehood, this map shows land from the Ohio River northward, between the Scioto and Little Miami Rivers, belonging to Virginia.*

# Adams County

*Above: This unusual courthouse ornamentation, above the front entrance, is a reminder in a rural county of Ohio's wildlife resources.*

# Cuyahoga County

*Origin of name: Cuyahoga River. Cuyahoga means "crooked"*
*County seat: Cleveland*
*Courthouse constructed: 1906-12*
*Architects: Lehman & Schmidt*

The Cuyahoga County Courthouse was the second building completed in Cleveland's downtown group plan. This early twentieth-century project, conceived by noted Chicago architect Daniel Burnham, sought to combine public buildings in a central mall, representing the ideals of good government with cultural, industrial, civic, and economic development. The integration was advanced by a common architectural style. Chronologically erected, the buildings included the Federal Building, County Courthouse, Cleveland Public Library, and the Board of Education building.

The Beaux-Arts style courthouse reflects Cleveland's turn-of-the-century prosperity. It took nearly six years to complete. Its exterior is faced with Milford pink granite from Massachusetts, while the interior marble floors and walls are from Georgia, Tennessee, and Colorado. The millwork in the courtrooms is finished in English oak.

Cleveland's cosmopolitan perspective is apparent in the building's decorative art. One series of exterior statues represents the rules of English law while another portrays the sources of natural law. Six interior murals, including the Constitutional Convention of 1787, relate to events from English and American judicial history. A large stained-glass window depicting Justice, without her blindfold, overlooks the lobby's Great Hall from the landing of a marble staircase, designed by Charles Schweinfurth, the architect for the interior decorations.

Solely a judicial building, it houses the Eighth District Court of Appeals, Probate Court, and a portion of the Common Pleas courts. The remainder of the courts are housed in the Justice Center, built in 1976 across Lakeside Avenue.

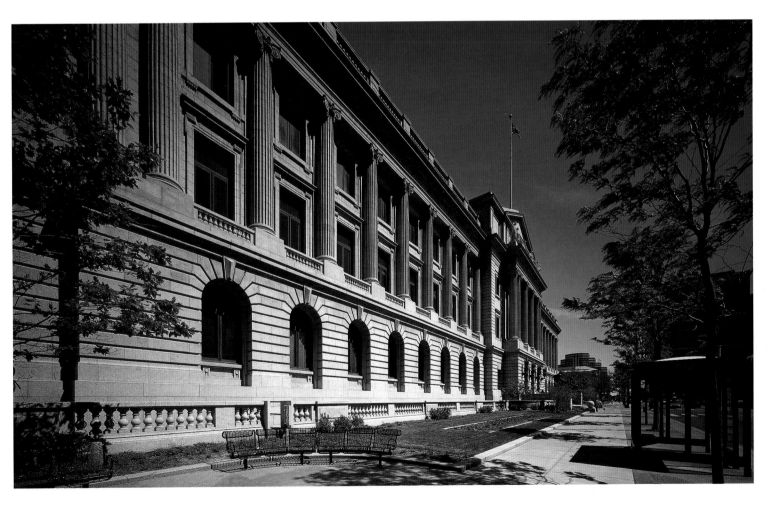

*Above: The Cuyahoga County Courthouse.*

# Cuyahoga County

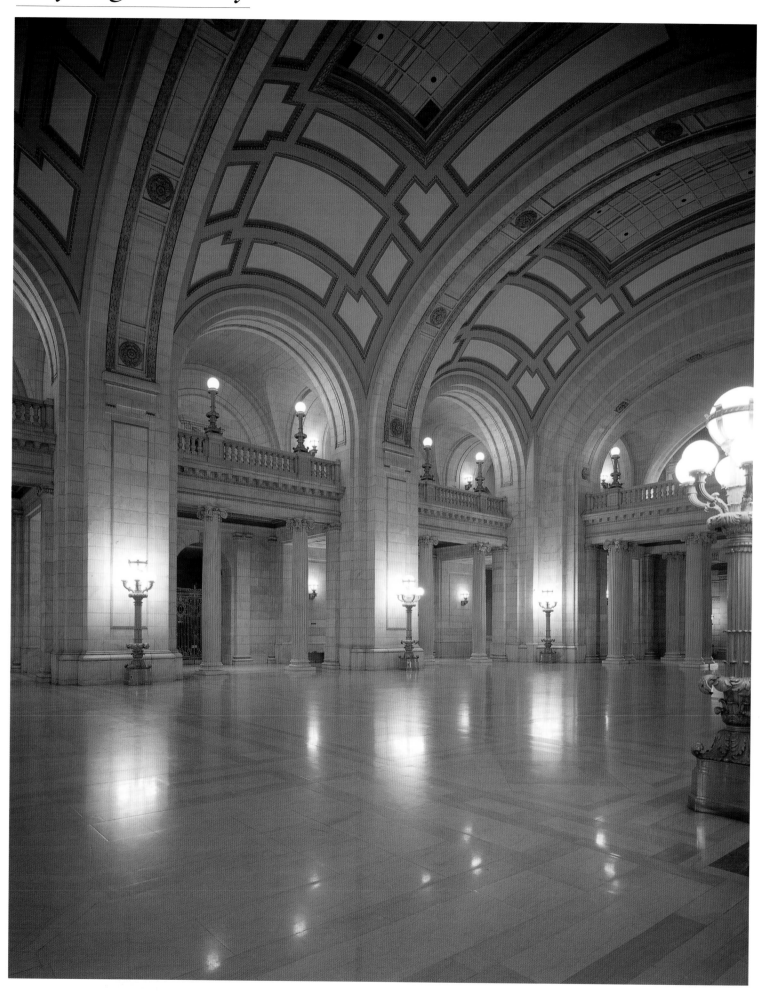

*Above: The main lobby.*

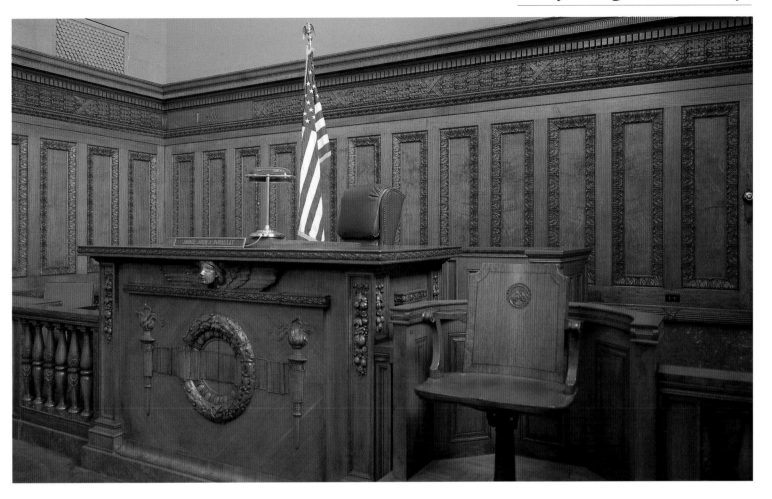

*Above: The Probate Court bench.*

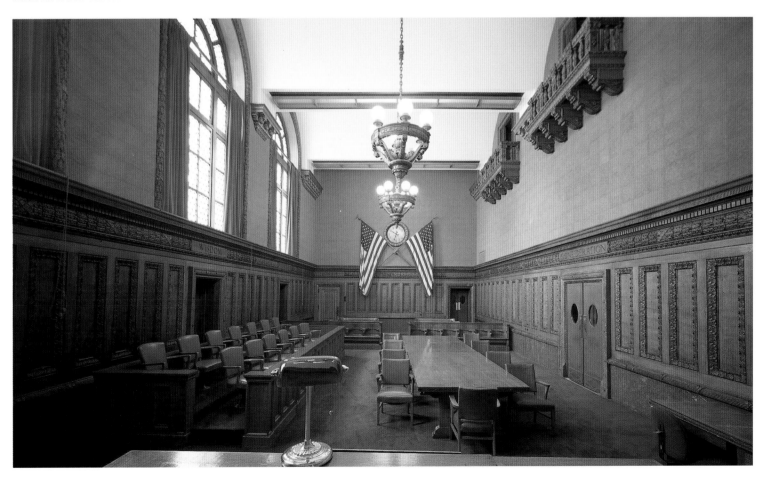

*Above: The Probate Courtroom viewed from the bench.*

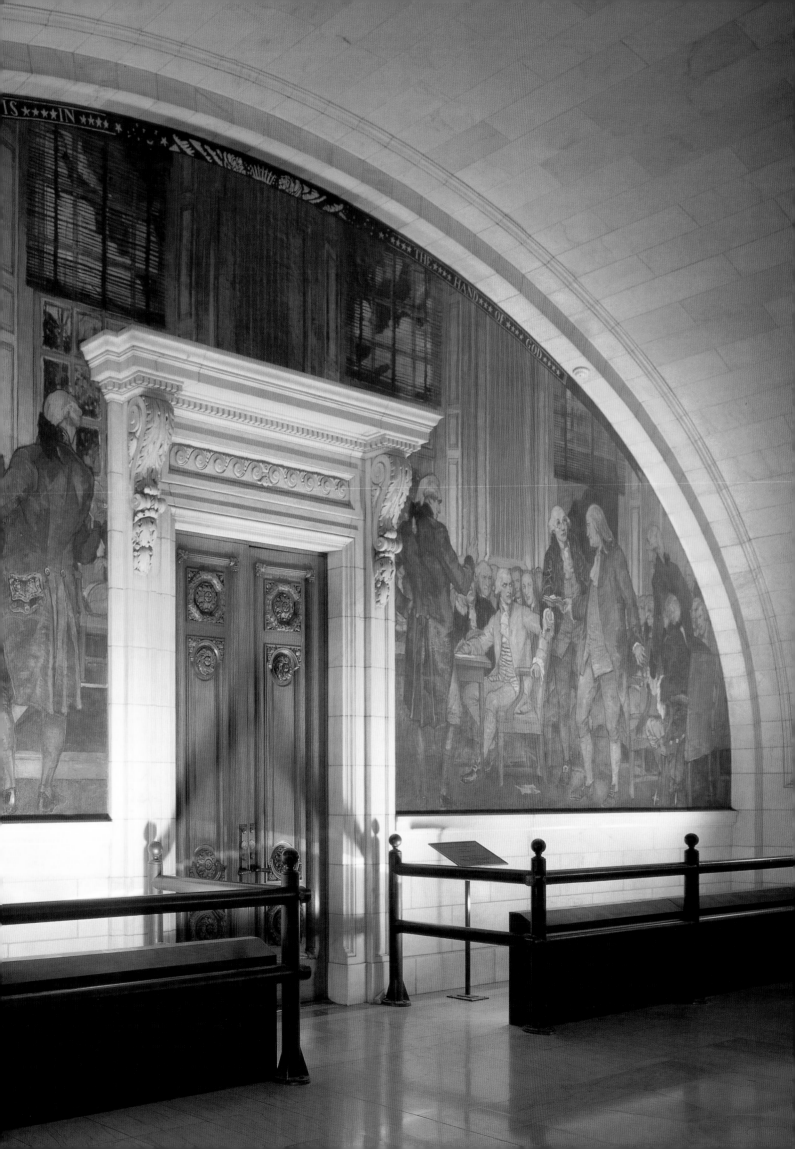

# Cuyahoga County

*Previous spread: The mural, "The Constitutional Convention of 1787," attributed to Violet Oakley of Philadelphia, surrounds the door leading into the Probate Courtroom, signifying the importance of the Probate Court. It portrays the moment on the last day of the Convention, with George Washington presiding, when Benjamin Franklin rose to urge adoption of the Constitution. His voice failed and he is shown handing his speech to James Wilson to read. The Constitution was adopted on that day.*

National attention focused on the Cuyahoga County Courthouse during the trial of Dr. Sam Sheppard, charged with bludgeoning his wife to death on July 4, 1954 in their suburban Cleveland home. Sheppard maintained that after he heard his wife cry out for him, an assailant knocked him out. The prosecutor contended it was Sheppard who killed her and left a trail of blood from the weapon. The defense argued that the blood came from a third person because the victim had bitten her killer, breaking two teeth, and Sheppard was not cut.

Public attention was insatiable, leading to the publication of unverified allegations. Sheppard was convicted and sentenced to the state penitentiary in Columbus. Ten years later, F. Lee Bailey successfully argued, on appeal, that Sheppard had been prejudiced by the excessive pre-trial publicity. The United States Supreme Court agreed, and ordered a new trial. On November 16, 1966, Sheppard was acquitted but he died a few years later. The case continued to fascinate the public through the movie and television series "The Fugitive." In February of 1997, it was announced that the DNA of two specks of the trail of blood was not that of Mrs. Sheppard.

*Left: A bronze statue of Chief Justice John Marshall, representing the judicial interpretation of the law at the federal level, stands before the east entrance, along with Ohio Chief Justice Rufus P. Ranney, symbolizing the judicial interpretation of Ohio law.*

# Huron County

*Origin of name: Huron Indian tribe*
*County Seat: Norwalk*
*Courthouse constructed: (1882) 1913*
*Architect: Vernon Redding*

In 1662, the area known as Huron County was part of a grant–a seventy-three mile strip of land "from sea to sea"–to colonial Connecticut by England's Charles II (1630-1685). The French disputed the claim until after the French and Indian Wars, when the Treaty of Paris (1763) granted England the Great Lakes region from Pennsylvania to the Mississippi River. After the Revolutionary War, state claims to the area were settled by the Northwest Ordinance of 1787 that created the Northwest Territory. Connecticut, however, retained a parcel, the Western Reserve, which began at the Pennsylvania-Ohio line and extended 120 miles westward to the Seneca and Sandusky county lines (see map under Muskingum County).

Within the western part of the Reserve, a half million acres called the Fire Lands have a distinctive history. In 1792, Connecticut granted these to sufferers whose property had been burned by the British during the Revolutionary War led in part by the traitor, Benedict Arnold (1741-1801). They were located in what are now Erie and Huron counties, Ruggles Township in Ashland County, and Danbury Township in Ottawa County. The Connecticut origin of the settlements is commemorated in the names of some of the county's townships: Lyme, Ridgefield, Norwich, Norwalk, Fairfield, New Haven, Greenwich, and New London. A map of the Fire Lands, with a brief historical description, hangs on the wall of the second floor of the courthouse.

The 1882 courthouse, the county's third, incorporated some of the walls and foundation from the county's second, built circa 1837. When the top floor of the 1882 building was destroyed by fire, it was remodeled in 1913 to its present form. Primarily of the Beaux Arts style,

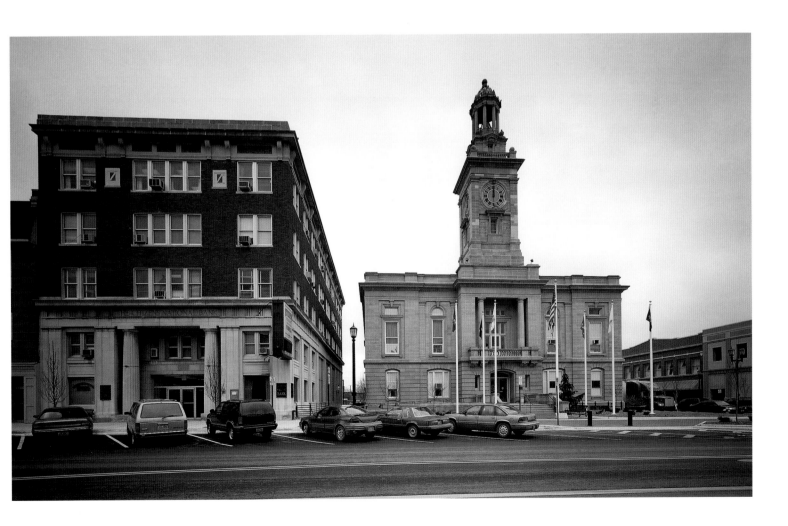

*Above: The Huron County Courthouse. Its site is a busy Norwalk intersection.*

# Huron County

*Above: Second floor, outside Court of Common Pleas office, with map and description of Fire Lands.*

it includes a rusticated ground floor, smooth masonry walls, a flat roof, and a projecting portico. A clock tower with a colonnaded belfry dominates the front façade.

Behind the judge's bench in the courtroom hangs a painting of Charles P. Wickham. Wickham, considered by many to be Huron County's foremost citizen, was born in Norwalk in 1836, his parents having migrated to Ohio from New York and New England. Wickham attended Cincinnati Law School, and practiced law in Norwalk before enlisting in the Fifty-fifth Regiment. He fought in a number of Civil War battles including Gettysburg, where he commanded the regiment. After the war he became a local prosecutor and judge, before being elected to Congress in 1886.

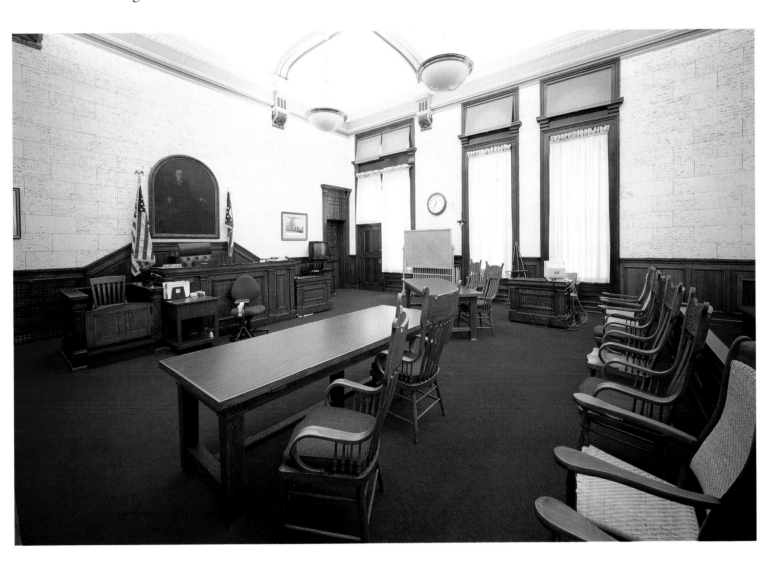

*Above: The painting of Charles P. Wickham, by Charles C. Curran, overlooks the courtroom.*

# Huron County

*Above: First-floor corridor.*

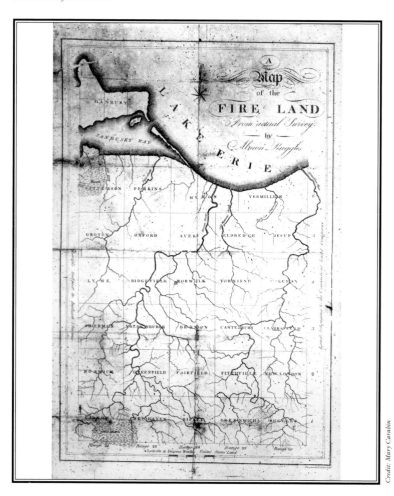

*Above: First printed map of Fire Lands, circa 1810.*

# Putnam County

*Origin of name: Israel Putnam, Revolutionary War General*
*County seat: Ottawa*
*Courthouse constructed: 1912-13*
*Architect: Frank L. Packard*

Few early Ohio county officials foresaw the burgeoning need for government services and revised criminal procedures a hundred, or even fifty, years ahead. Putnam County officers were an exception. In the Clerk's office is a framed quotation from The Courthouse Building Commission, as reproduced in the *Putnam County Sentinel* for February 1910:

> *This courthouse will be larger than necessary for present needs. We are not building for ourselves alone any more than the Revolutionary patriots fought for themselves 134 years ago. Their blood gave us liberty today. We want to give something to those who live after us. In the year A.D. 2000 may our posterity say that "they builded wiser than they knew."*

The Commission built wisely, as the courthouse remains unaltered, with no annex or additions.

Frank Packard's firm designed the building. Packard (1860-1923), educated at Ohio State University and Massachusetts Institute of Technology, operated his first office in Columbus from 1896-1898. After a two-year association with Joseph Yost (Yost & Packard), he established an independent office and designed many public and commercial buildings (by his own estimate 3,400) including the Old Armory at Ohio State University in 1897, later destroyed by fire.

The building, measuring forty by seventy-five feet, incorporates Beaux-Arts coupled columns and Second Renaissance Revival components. The first floor is constructed of rusticated stone with round-arched windows set in arcaded panels. A smooth stone belt course divides the first and second floors.

The second floor features rectangular windows, with alternating pediment and segmental arched architraves separated by paired columns. A decorated frieze and denticular cornice complete the four identical façades. The red tile roof is

*Above: Putnam County's veterans are listed in the halls of the courthouse.*

*Above: Stained-glass window.*

193

# Putnam County

hipped and gently pitched.

The interior of the courthouse is intact and in excellent condition. A central hallway on both floors runs north and south through the building with stairways located in the center of the west side. A large stained glass window lights the staircase landings, where profiles of Lincoln and Washington flank a large blindfolded Justice holding her scales. Offices and courtrooms are located on either side of the hallways.

*Above: Message above the courtroom main door: "Obedience to the law is liberty."*

*Above: Staircase with stained-glass window at the landing.*

194

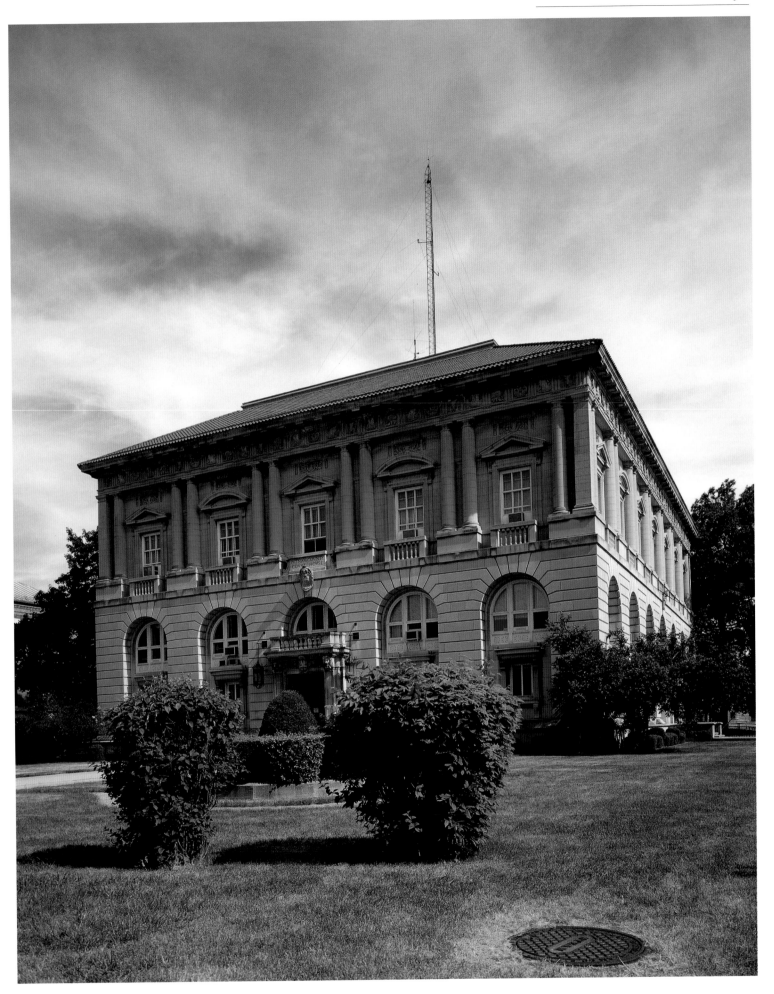

*Above: The Putnam County Courthouse. The centrally-positioned front and rear entrances are covered by small stone balconies with stone balustrades.*

# Putnam County

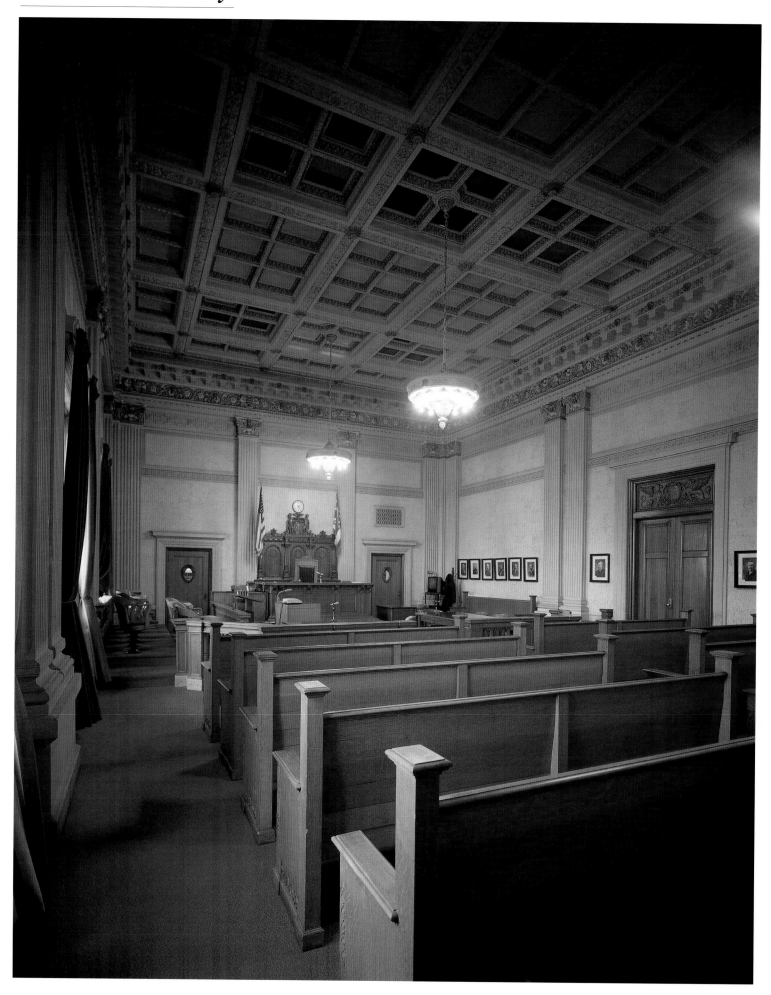

Above: The Common Pleas Courtroom, with ornamental details: wreaths, garlands of fruit
and flowers, sculptured cherubs, and lions' heads.

# Hardin County

Origin of name: *Colonel John Hardin, executed by Native Americans in 1792*
County seat: *Kenton*
Courthouse constructed: *1913-15*
Architects: *Richards, McCarty & Bulford*

A roadside sign notifies visitors driving through the agriculturally rich landscape into Hardin County that the county they are entering is home to the first recipient of the Medal of Honor, Jacob Parrott. He, along with other Hardin County patriots, is further commemorated in the Veterans Hall that, unusually, is located in the courthouse. The Hall, where local veterans socialize and participate in patriotic activities, was incorporated into the courthouse architectural plan when the building was constructed.

Hanging among artifacts from World War I, Spanish American War, and the Civil War is a portrait of Parrot with the following description:

*Born July 17, 1843 in Fairfield, Ohio.*

*During the American Civil War (1861-1865) he enlisted at the age of 18 in Company K, 33rd Ohio Volunteer Infantry Regiment and was the youngest member of the famous Andrews Raid.*

*The Raiders seized "The General" locomotive at Big Shanty, Georgia, April 12, 1862. Captured and later exchanged, Parrott was the first recipient of the Medal of Honor, March 25, 1863. He died December 22, 1908 and is buried in Grove Cemetery, Kenton, Ohio.*

The courthouse, where veterans continue to assemble in the Hall, is primarily in the neo-classical style. The building fills a city block in the middle of downtown Kenton. The exterior is symmetrical, with the east and west sides identical, and likewise the north and south. Constructed of Indiana gray limestone on a rusticated base, it features a pedimented central projection with Ionic colonnades. A stone balustrade accents the flat roof. Inside, a barrel-vaulted skylight brightens the three-story lobby. Containing over a thousand square feet of leaded stained glass, the skylight is approximately seven feet high, forty-nine feet long, and twenty feet wide. A smaller one, measuring thirty-three feet long and nineteen feet wide,

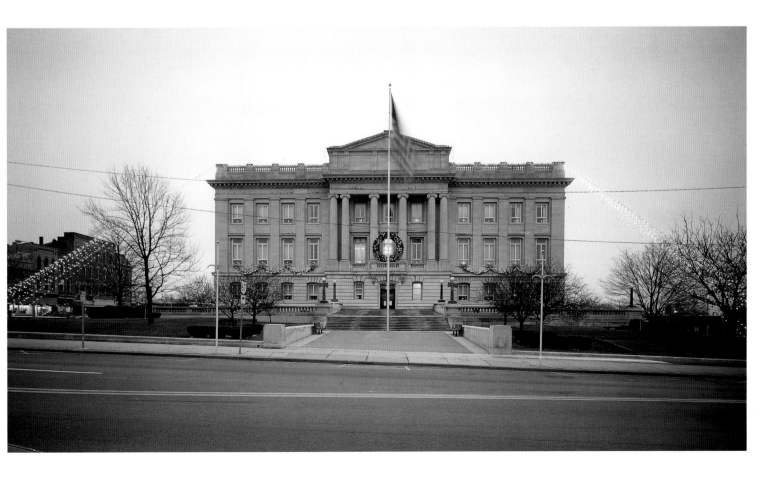

*Above: The Hardin County Courthouse, decorated for Christmas.*

# Hardin County

artificially lightens the courtroom. A steel and glass structure on the roof protects the skylights from the weather.

On either side of the lobby hang murals depicting scenes from the life of the frontiersman, Simon Kenton (1755-1836). Kenton, famous for his Native American expeditions, is honored as the county seat's namesake. The south mural shows Kenton battling the Shawnees and their British allies at Boonesboro, Kentucky, in 1777. During the confrontation Kenton is said to have saved the life of Daniel Boone (1734-1820).

The north painting depicts a British officer bartering with a Shawnee for the release of their prisoner, Kenton in 1778. During captivity, he was forced to run the gauntlet four times. In exchange for Kenton, the Shawnee reportedly received $100 worth of tobacco, salt and rum.

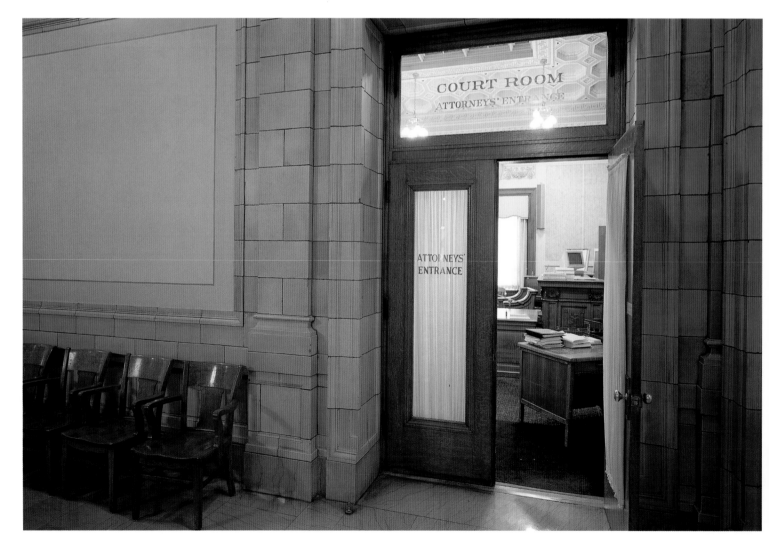

*Above: Office and courtroom doors are double oak with a single glass in each half, transom, and cut stone surrounds.*

*Right: The staircases are enclosed on the north and south ends by stone latticework of semi-circular arches. The thousand-pound bell hung, mounted on heavy timbers, in the 1854 courthouse.*

*Above: Veterans Hall, meeting place for G.A.R. and U.S.W.V.*

# Hamilton County

*Origin of name: Alexander Hamilton, the first Secretary*
*of the Treasury, 1789-1795*
*County seat: Cincinnati*
*Courthouse constructed: 1915-1918*
*Architect: C. Howard Crane*

A statue of a soldier stands in the lobby of the Hamilton County Courthouse, next to a marble plaque:

> *In Memory of*
> *John J. Desmond*
> *An attorney at law and*
> *Captain Co. B. 1st Regt. O.N.G.*
> *Who was killed near this spot*
> *March 29th 1884,*
> *While defending the Court House*
> *From lawless violence,*
> *This tablet is erected*
> *By Members of the Bar*

The lawless violence refers to the destruction of the previous courthouse in riots provoked by an unpopular manslaughter decision. The case involved the 1884 trial of William Berner for the murder of his employer. Berner and his accomplice Joseph Palmer were alleged to have stolen money from him before beating and strangling him. The public paid close attention to the matter because the alleged murder occurred when the county jail already held twenty-three persons accused of homicide, and public opinion was losing faith in the ability of the courts to protect citizens from criminals. Statistics showed most people favored convicting both men of murder and imposing the death sentence.

Berner's attorney believed his client, a white man, would receive a light sentence while Palmer, an African-American, would be hanged. He successfully argued for the separation of their trials. Even before the verdict was announced, people all over the county talked only of vengeance if the verdict was less than murder, and not whether the trial was being conducted in a lawful manner.

When Berner was convicted of manslaughter and the judge imposed only a twenty-year prison sentence, it was so unpopular that not only was the

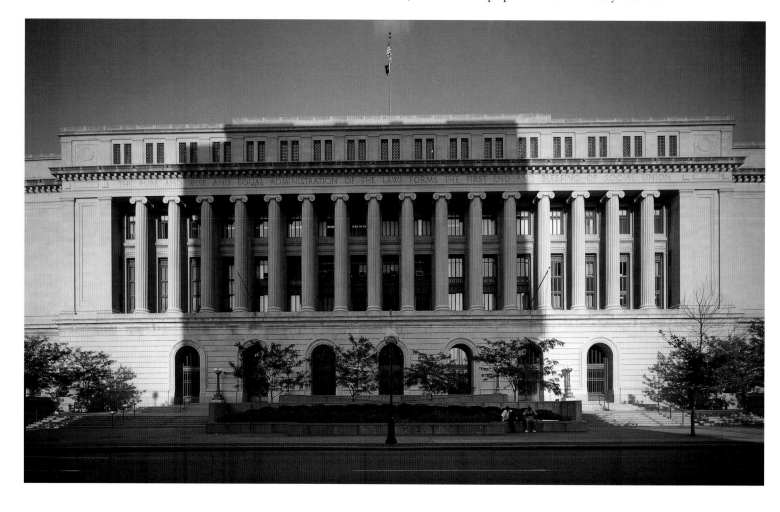

*Above: The Hamilton County Courthouse.*

jury threatened, but eight thousand angry citizens met to protest and march at the courthouse and jail. At first, the police and local militia were in control, but later, when the mob set buildings alight, the militia started firing shots at them. The next day, while the sheriff was defending the jail, rioters attacked and burned the courthouse, destroying irreplaceable records and one of Ohio's most historic facilities. When the state militia arrived during the second night, it cleared the streets around the courthouse, though it is estimated that as many as forty-five were killed and many more wounded.

After three days the melee was finally over, but the courthouse was destroyed. Moreover, even before it began, Berner was safely on his way to the Ohio Penitentiary in Columbus. Palmer was later

tried, convicted of murder, and promptly executed. It was reported that no jury would have dared to find any other verdict, after the experiences of the riots.

The succeeding courthouse, entirely fireproofed to withstand disturbances, occupies a city block. On October 7, 1915, William Howard Taft (1857-1930), graduate of Yale University and University of Cincinnati Law School, former president of the U.S., and Chief Justice of the U.S. Supreme Court, laid the cornerstone of a building constructed from New Hampshire granite, Bedford limestone, and a steel foundation. Its façade features a central projection with an Ionic colonnade in antis. Arched openings are present on the first floor; elsewhere the windows are rectangular. A projecting beltcourse, cornice, and flat roofline

*Above: Statue of John Desmond in the lobby.*

201

# Hamilton County

emphasize the horizontal lines of the Beaux Arts design. Flanking the doorways with brass doors are ornate light standards. The building is supplemented with the Justice Complex to the east and an Annex to the west.

The interior is intact. Wide-arched doorways featuring wrought bronzed screens lead into the main lobby, which is characterized by limestone vaulting, marble floors, granite columns, and various metal designs and plaques, including the following:

*Hamilton County was established in January 1790 by proclamation of General Arthur St. Clair, first governor of the Northwest Territory. This was the second county to be formed in the territory comprising the present states of Ohio, Indiana, Illinois, Michigan & Wisconsin. The first courts of the county were held in taverns near the bank of the Ohio River. The first court house built of logs in 1795 stood at the S.W. corner of 5th & Main streets. In 1802 it was torn down and replaced by a brick and stone structure. The jail with the whipping post and gallows stood for a time to the west near Walnut Street. The court house was occupied as a barracks during the War of 1812 at which time it was destroyed by fire. The third court house built on a portion of the present site in 1819 was destroyed by fire in 1849. The fourth court house built of stone in 1851 on the same site was partially destroyed by fire during the riots of 1884 and rebuilt in 1885. In 1915 the entire site was cleared and ground for the present building was broken March 14, 1915. The corner stone was laid October 7, 1915 by William Howard Taft former President of U.S. The building was completed and occupied in 1918.*

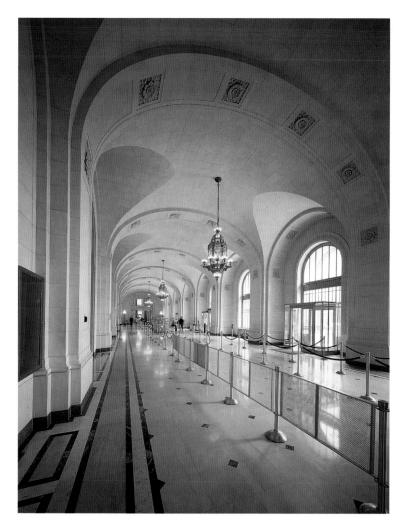

*Above: The main lobby.*

*Above: A conference room in the Law Library.*

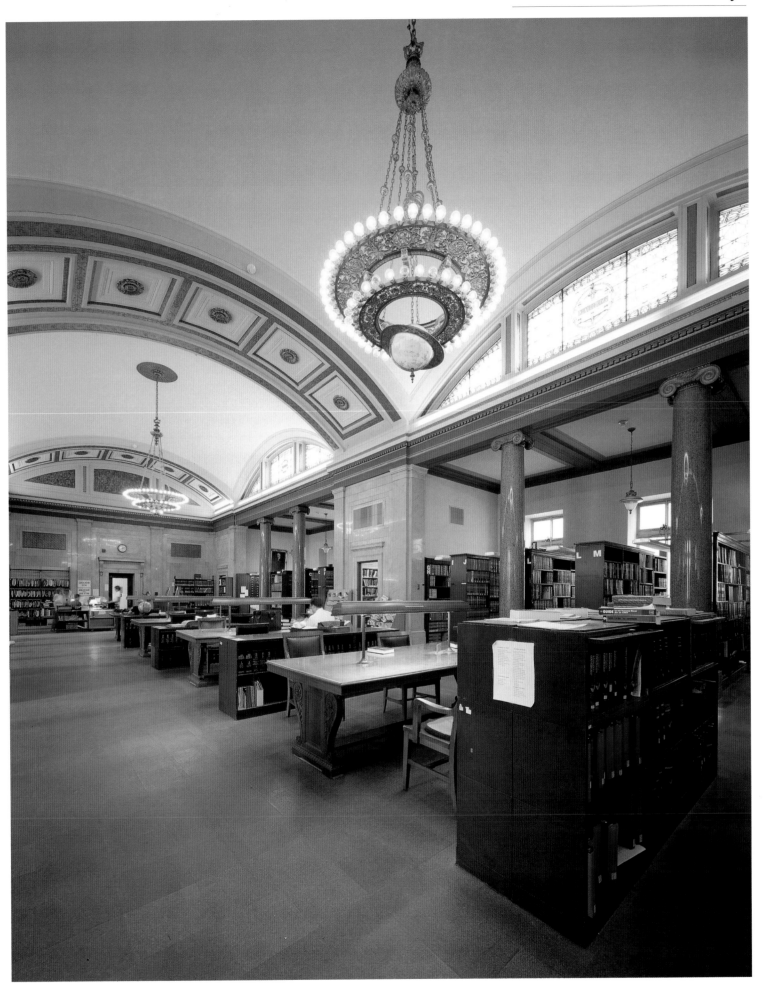

*Above: The Law Library.*

# Preble County

*Origin of name: Captain Edward Preble, Hero of the Revolutionary War*
*County Seat: Eaton*
*Courthouse constructed: 1917-18*
*Architect: Harvey H. Hiestand*

When Eaton native, Harvey H. Hiestand, designed the Preble County Courthouse in 1918, he incorporated a number of progressive ideas into the design. The building's exterior is Indiana Bedford limestone, and the interior Pennsylvania marble. The stone was mostly prefabricated at the quarries. Each piece was cut, shaped, and numbered according to its position in the building, before it was shipped, in sequence, to Eaton by railroad, and hauled by horse and wagon from the depot to the building site.

The pristine structure is equipped with a built-in early central vacuuming and air conditioning system, with outlets for hose attachments located throughout the building. Hiestand further designed an unusual storage room to store spare marble parts for future repair or use. The first-floor staircase is like a Chinese puzzle, the step slabs sliding back after removal of the brass railing, and the entire staircase coming apart to reveal a storage room beneath.

Below the parapet and above the first story on the pavilion of the exterior are evenly spaced Ionic columns at each end. Columns extend up above the third floor, where a denticulated entablature begins, extending to the outside bays.

Hiestand also added a fourth-floor jail, hidden from the outside behind a solid parapet. An elevator provided officials accompanying prisoners with easy access to courtroom hearings for over seventy-five years, until it became too small and outdated. On November 1994, a new $5.2 million facility was opened on the outskirts of town.

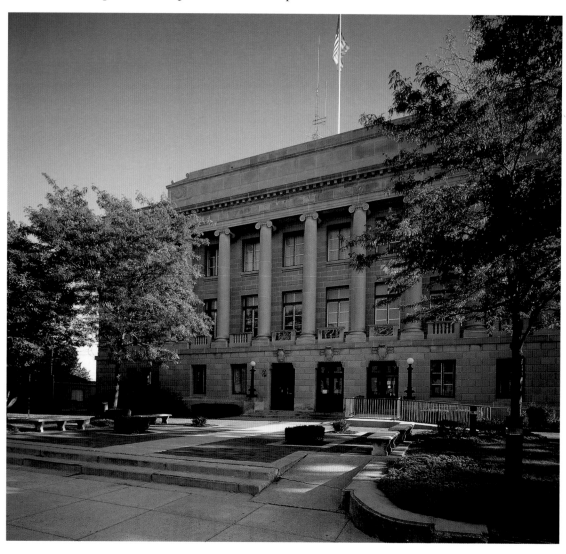

*Above: The Preble County Courthouse.*

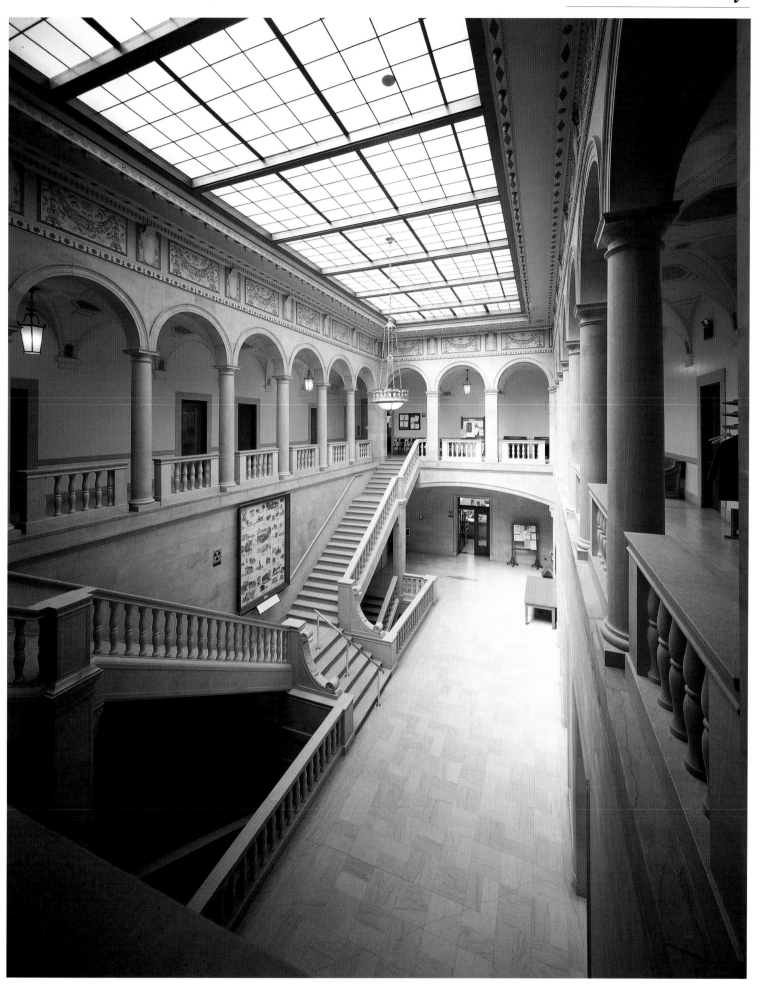

*Above: Central lobby.*

# Preble County

One of the problems with the old jail was the difficulty, in the small confined area, to separate violent criminals from short-term male inmates, women, and juvenile prisoners. So when Steven Barker was awaiting trial on a twenty-count indictment for rape, attempted rape, felonious sexual penetration, kidnapping, aggravated burglary, theft, and assault, he was considered too dangerous to mingle with other prisoners. Instead, officials put him into a steel and concrete cell with an adjoining bathroom, separate from the general prison population. Sometime during the night of August 31, 1993, just before the completion of the new jail equipped with cameras and other technology for monitoring inmates and visitors, Barker and his cellmate escaped. Using hacksaw blades, they sawed through steel bars covering a window in their cell. Because the passage allotted only eighteen inches diagonally, and their clothes were left in the cell, it is presumed they greased themselves with soap before squeezing through the tiny hole to freedom. Once free, they moved across the roof to the northeast corner and dropped enough rope, wrapped inside torn bed linen, to slide to the ground where, it is believed, an accomplice was waiting. After an intense manhunt by state, local, and federal law enforcement officials, the fugitive was captured nearly two months later in Texas. Since the new jail was still not open, Barker was returned to Indiana where he was also wanted for criminal actions. Today, the fourth floor is vacant.

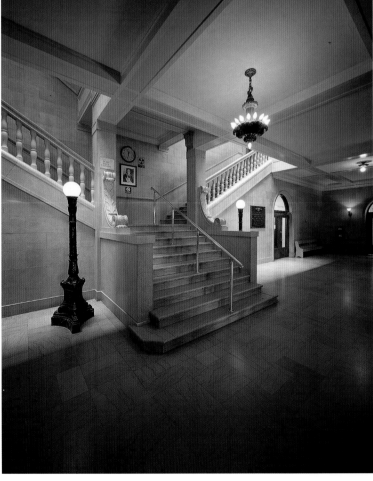

*Above: The location of the Barker escape.*

*Above: First-floor staircase hiding a storage room beneath the steps.*

# Clinton County

*Origin of name: George Clinton, vice-president of the United States in 1810, when the county was formed*
*County seat: Wilmington*
*Courthouse constructed: 1916-19*
*Architects: Weber, Werner & Adkins*

The Clinton County Courthouse, completed in 1919, is very similar in appearance to the U.S. Capitol as it looked prior to the Civil War and before the addition of the House and Senate wings. Just as the federal Capitol would be difficult to replicate today because of the prohibitive cost of materials and workmanship, this courthouse would also be difficult to reproduce. The original cost of constructing, furnishing and landscaping the courthouse and the jail was $367,756.95. It was probably not an extravagant sum for the time, but according to the 1921 Clinton County Building Commission's Record of Transactions, the expenditures listed below would surely be much higher today:

*Boyd & Cook, sewer through Court House site* ..........................$ 6,803.80
*Weber, Werner and Adkins, architects* ........................................12,594.52
*Avery Loeb Electrical Co., wiring Court House and Jail* .............3,173.43
*M.W. Townsend, mechanical equipment* ......................................23,893.87
*Hamilton Construction Co., constructing jail*............................21,403.77
*Western Building Co., constructing Court House* ....................171,839.22
*G.H. Benlehr, filling Court House and Jail site* ..............................144.50
*Dayton Power and Light Co., installing light and power*................950.00
*L.L. Compton, constructing sewerage service* ..................................656.53
*Yardley Screen and Weather Strip Co., Screens for jail*....................226.60
*Yardley Screen and Weather Strip Co., Screens for courthouse* ........750.00
*Louis Bloom Art Marble Co., extra marble work*..........................1,253.00
*Harry Walker, lettering doors* ..............................................................247.20
*The J.B. Schroder Co., finished hardware*......................................2,696.50
*William A. Renter, doors and jury box Common Pleas Ct.* .............330.77
*The Devere Electric Co., electric fixtures* .....................................7,696.00
*E.A. Thornhill & Son, shades and adjusters* ....................................720.42
*David E. Kennedy, cork floors* .........................................................1,456.39
*Grey Eagle Marble Co., marble for stairs* .........................................215.80
*Dayton Power and Light Co., Mazda lamps*......................................340.00
*The Gibson & Perrin Co., movable furniture* ...............................8,300.11
*G.M. Rice, benches and settees*............................................................831.40
*William A. Lay Co., tinting walls* ...................................................1,420.00
*William G. Andrews Co., decorating*............................................10,000.00
*G. Podesta, stucco fire walls*................................................................175.00
*Bangham & Gallimore, book cases* ....................................................500.00
*R.J. Patton Co., awnings for Court House* ........................................492.61
*Trebor Weltz, grading Court House grounds*................................4,997.42
*Fabric Fire Hose Co., fire hose*............................................................263.36
*Brewer & Brewer Sons, paving and curbing* ...............................12,636.65
*Leo Weltz Sons, landscape gardening* .............................................1,975.00
*Advertising* .........................................................................................768.52
*Expenses of Building Commission* .....................................................142.40
*Legal advice*.........................................................................................250.00
*Surveys*...................................................................................................43.00
*Frank Spurgeon, paving*...................................................................6,594.02
*Purchase of Court House site* ........................................................60,225.00
*Court cost in condemnation suit*.......................................................207.79
*Miscellaneous expense*.........................................................................532.35

More recently, a $650,000 restoration effort was initiated after falling plaster forced the closing of the rotunda stairway. Decorative plaster was cleaned and repainted, murals restored, and the leaded glass dome scoured and resealed by artisans working from scaffolding reaching eighty-five feet high. Restorers also removed shellac applied in an early preservation effort that had turned the building's walls and pillars yellow. Those pillars were finished in scagliola, a plaster composition made from powdered gypsum, lime, and horsehair incorporated into many grand buildings around the early twentieth century. Threads saturated with dye were imbedded in the mixture and when they were pulled out, they left colored streaks that looked like the lines through real marble.

*Above: Brass and copper light fixtures on top-floor railing.*

# Clinton County

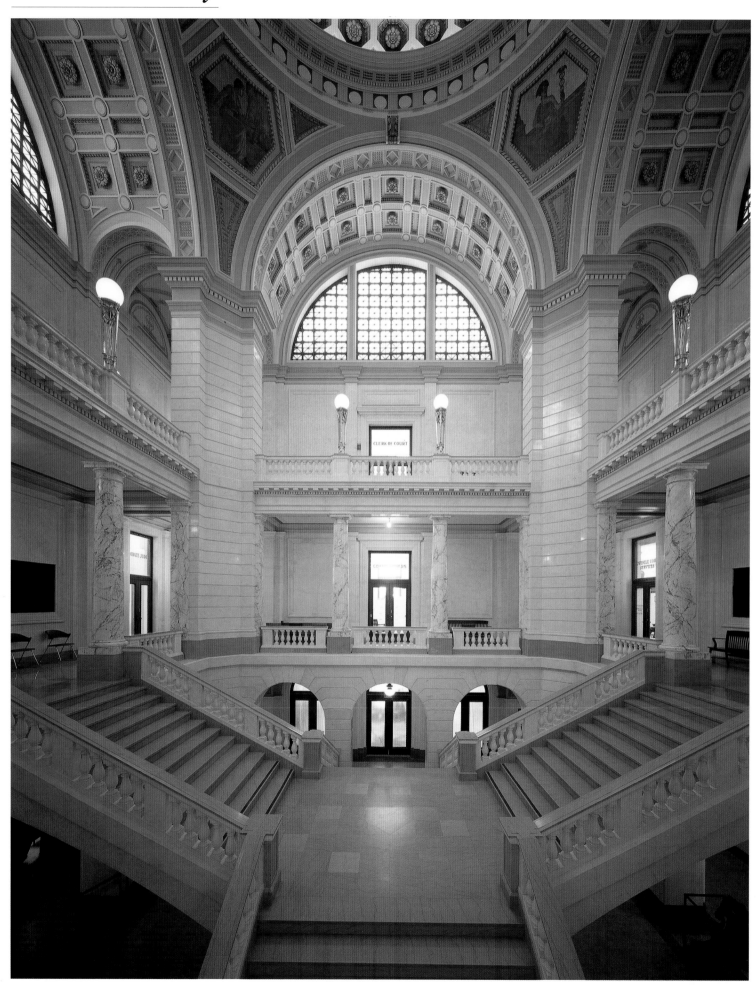

*Above: Marble stairs, flanked by faux marble columns.*

*Above: The Clinton County Courthouse, with dome.*

# Clinton County

Additional restoration included installing a new roof, updating the electrical and telephone systems, and replacing the front steps. As the work progressed, attention turned to the redecorated courtroom where a sensational murder-without-a-body trial unfolded.

The defendant was charged with aggravated murder and kidnapping in connection with the disappearance of his girlfriend. In yet another warning to domestic violence victims, their families, and law enforcement officials, testimony was given about the couple's well-known violent relationship from which she was apparently unable to extricate herself. The defendant's former step-sister-in-law, the only one to testify she saw him covered with blood shortly after the victim's disappearance, said that late that night the defendant appeared at her home, showered, and left with his gun-toting stepbrother carrying garbage bags allegedly to be used to dispose of the victim's dismembered body. Several hours later, the subdued brothers returned and the defendant took another shower using a scrub brush and bleach to remove more blood. Although defense attorneys vigorously questioned the witness's credibility and claimed the prosecution lacked physical evidence and proof of death, the defendant was convicted of the murder and kidnapping of his girlfriend. He was later sentenced to life without parole for the murder plus nine more years on kidnapping charges.

The Clinton County Prosecutor further indicted three others in connection with the crime. The father of the convicted murderer was charged with covering up or obstructing justice and tampering with evidence, but was acquitted. A police chief was accused of obstructing justice and dereliction of duty for mishandling the case when he called off a search, less than a week after the victim's disappearance, of the father's property where investigators wanted to drain a pond to search for the victim's body. He pleaded no contest to dereliction of duty and did not return to the police force. The defendant's half-brother and father's son was charged with obstruction of justice, tampering with evidence, and gross abuse of a corpse. He was convicted of obstructing justice and sentenced to eight years in prison. The brothers' cases were appealed.

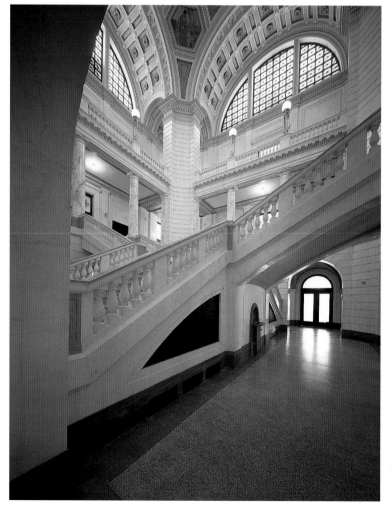

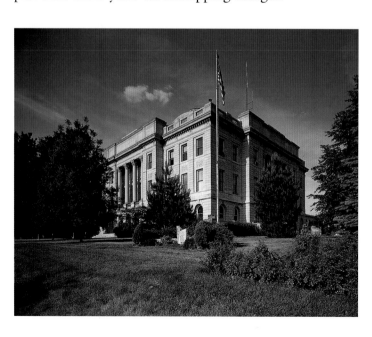

*Above: The Clinton County Courthouse.*

*Above: Stairway in the main lobby.*

# Mercer County

*Origin of name: General Hugh Mercer, Revolutionary War Hero*
*County seat: Celina*
*Courthouse construction: 1921-23*
*Architect: Peter M. Hulsken*

Mercer County, along with fifteen other Ohio counties, was established in 1820. When it was organized in 1824, the town of Saint Marys became the county seat where the county's first courthouse was constructed. Later, in1839, the county seat was removed to Celina and the second courthouse, located at the northeast corner of Main and Livingstone, was completed in 1841. After the eastern section of the county, including Saint Marys, was incorporated into the newly formed Auglaize County in 1848, Mercer County's third courthouse was constructed at the northwest corner of Main and Market Streets in 1868, shortly after the end of the Civil War.

Buildings, especially courthouses, say something about the beliefs and visions of those who build them. The present neoclassical styled courthouse, also located on Main Street, projects an air of dignity and respect for ancient Greek values of law and order. The finest materials available were employed in its construction. Mahogany wood is used throughout the interior and the Italian black marble in the staircase is considered unavailable today. Other decorative motifs include griffins, torches of Justice, scrolls, and egg-and-dart designs. The forty-foot high Ionic columns, bronze doors, leaded art-glass dome, and the marble entry halls extend an aura of permanence and stability.

The rotunda, illuminated by the natural light of the dome, contains frieze borders based on mythological figures from the Parthenon, built circa 432 B. C. Theseus is depicted killing a bull, as a symbol of the law in its struggle against evil.

In the courtroom, the red velvet curtain behind the judge's bench reflects an early English courtroom security measure. Long before bulletproof benches, duress alarms,

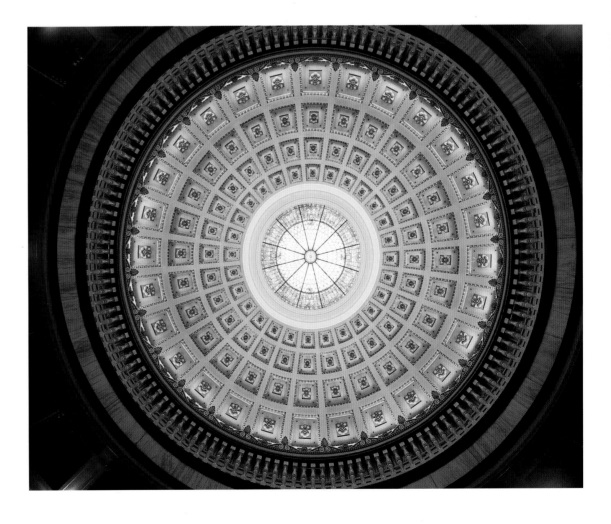

*Above: View up into the naturally-lit dome of the rotunda from the second floor.*

# Mercer County

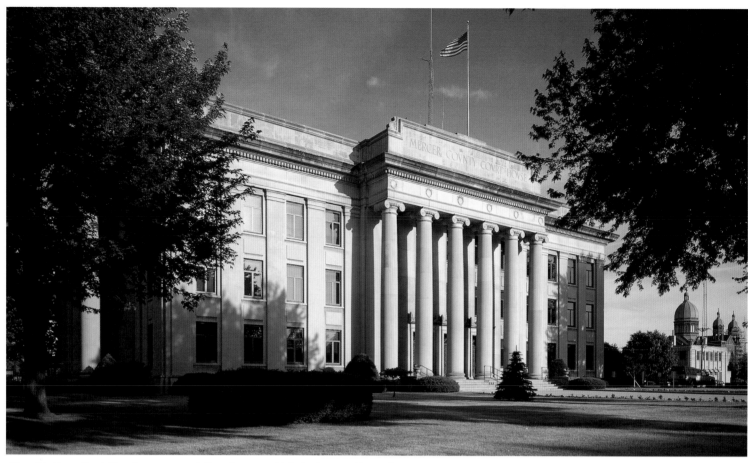

*Above: The Mercer County Courthouse, constructed of gray limestone, with Ionic columns, and bronze doors.*
*Above the columns are carved wreaths representing the victor's laurels.*

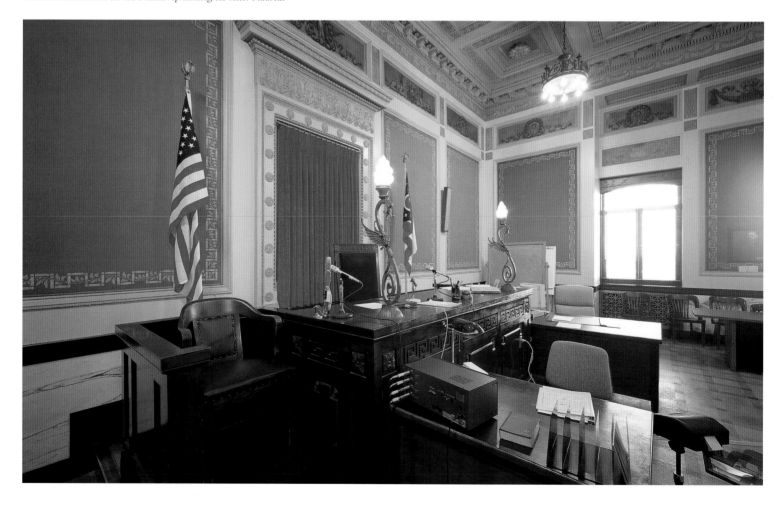

*Above: The courtroom features red velvet curtains behind the judge's bench, brass*
*light fixtures attached to the bench, and cork floors installed for absorbing sound.*

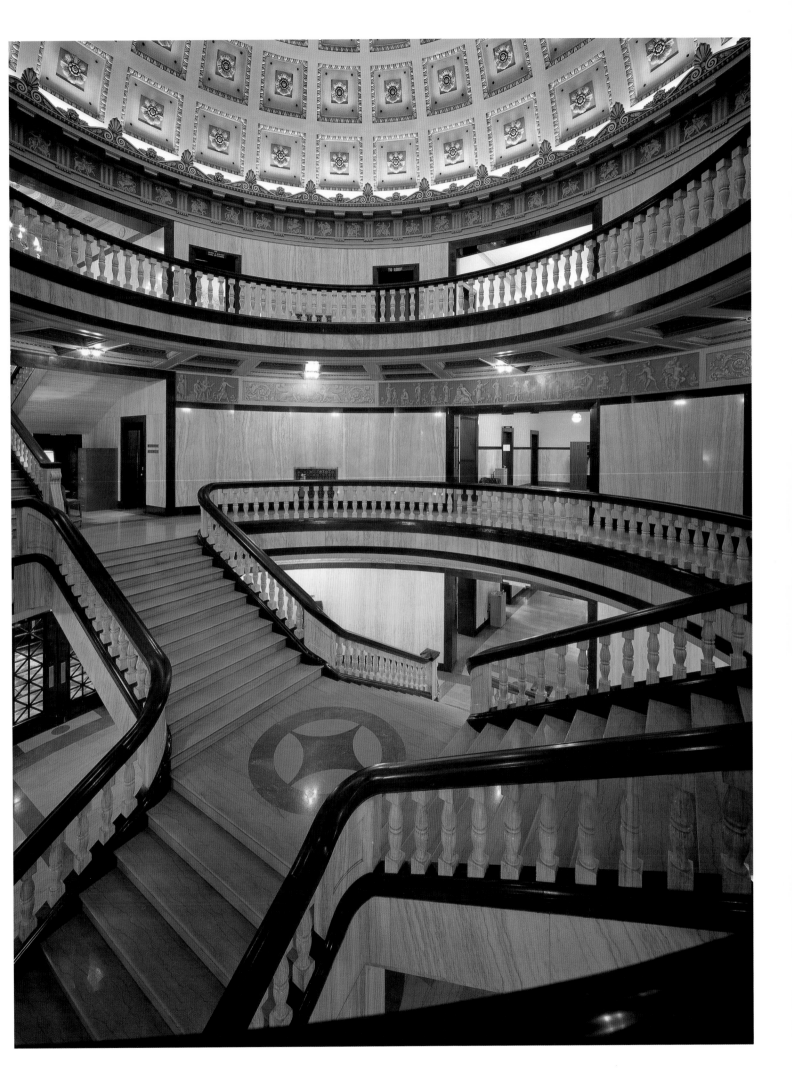

*Above: Stairwell, with stair railings cut concave to the radius, and sculpted frieze circling the rotunda.*

# Mercer County

and installation of other safety measures, judges disappeared through a door behind the curtain in the event of any threatening circumstances.

In 1992, the Probate courtroom, considered inadequate, was relocated to the Law Library, whose ceiling, floor, and bookcases were retained. Other offices have been relocated to the Central Services Building as the needs for space have demanded. Except for these changes, the original structure and floor plan remain as it was on its day of dedication, September 3, 1923.

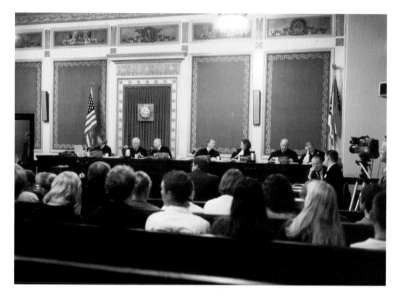

*Above: The Ohio Supreme Court in session in the Mercer County Courthouse.*

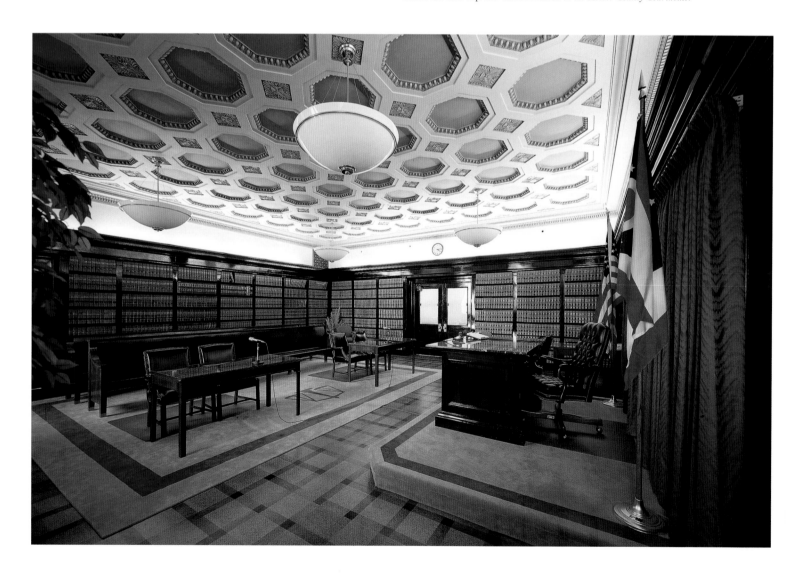

*Above: Probate Court.*

# Clark County

*Origin of name: General George Rogers Clark, who defeated the Shawnee Indians*
*in a battle near Springfield, on August 8, 1780*
*County seat: Springfield*
*Courthouse constructed: 1918 - 24*
*Architect: William K. Schilling*

Springfield became the county seat of Clark County, and when the National Road reached it, during 1838, its population substantially increased. Many weary travelers settled there rather than moving on, because at that time the road extended west only three more miles.

The first courthouse, constructed in 1828, soon became the most important place in town. In those days, men could become lawyers by reading the law. They quickly learned that attention to detail is an essential component to practicing law. An early Clark County murder case taught a lesson to the local prosecuting attorney. Two men robbed another of $15 or $20 after striking his head with a hammer and throwing him from a cliff into Buck Creek. It appeared obvious to everyone that the murderers would be hanged for such a crime. The prosecuting attorney's indictment was that the defendants had struck the victim with a hammer and thrown him over the cliffs into the water, but it omitted the conclusion that the blow and the drowning had together caused death. The defense attorneys, recognizing the error, required the prosecution to determine whether death resulted from the blow or from the drowning and the judge was compelled to sustain their position. With the prosecutor unable to say exactly when death occurred, the defendants were acquitted. The citizens were outraged and the prosecutor resigned.

The second courthouse, in the popular Second Empire Style, was constructed in 1881. In 1918, it was damaged by fire, and the present building, with a dome instead of a tower, rose from its foundations. Looking closely, indications of the earlier building, such as the first-floor windows, are evident. In addition, the entrance was moved from Columbia Street to Limestone, in response to changes in traffic flow between 1880 and 1924.

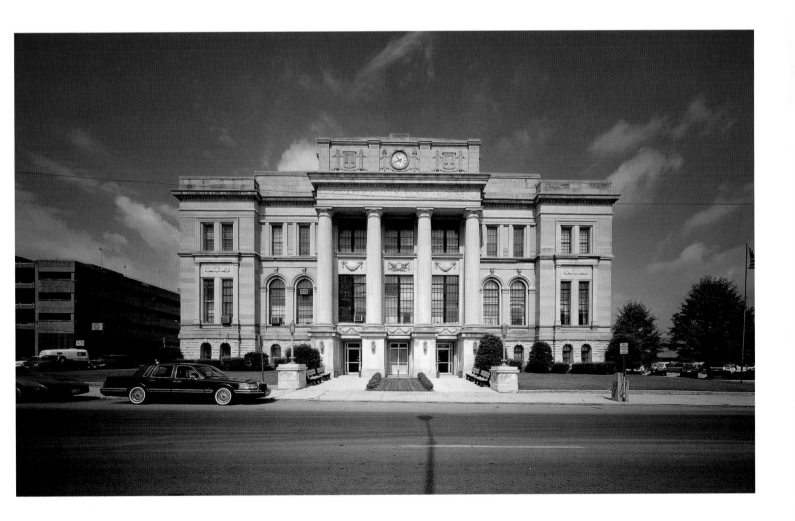

*Above: The Clark County Courthouse, with paired fluted columns.*

# Clark County

*Above: Open interior with staircase.*

*Left: The Lincoln letter on display in the Clark County Courthouse.*

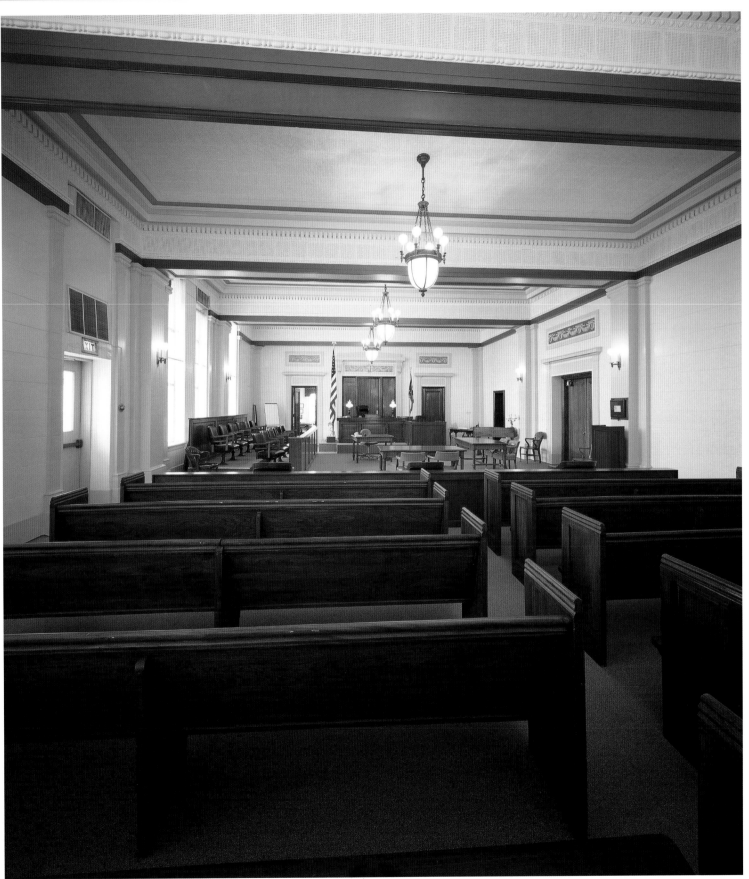

*Above: View of Court of Common Pleas courtroom.*

217

# Hocking County

*Origin of name: Hocking River*
*County seat: Logan*
*Courthouse constructed: 1923-25*
*Architect: Frank L. Packard*

On June 4, 1925, an estimated crowd of 20,000 to 25,000 people attended the Hocking County Courthouse dedication ceremonies, to celebrate the building's completion but also to pay tribute to the county's past. Although the temperature reportedly reached 98 degrees, the revelry continued through the daytime and into the evening. Activities included a Historical Pageant, depicting the county from its pioneer days to the present. One feature was the development of the automobile, with every model represented in the county displayed, from its oldest to the newest version: "anything that will run."

Main and Market streets were roped off, eliminating traffic noise, so that the spectators sitting in chairs and benches could hear the speeches of those accepting the building. Reception committees were on duty all day to give visitors tours, and band and orchestra music played continuously. In the evening, the Community Chorus performed, free of charge, at the Presbyterian Church.

The driving force behind the project was The Hocking County Building Commission, which chose Frank L. Packard of Columbus as the architect for the $250,000 courthouse. In drawing up the plan, he integrated (at the commission's suggestion) features of the courthouses in Preble, Putnam, and Mercer counties. Unfortunately, the architect and one member of the building commission failed to see the finished product, because both died about three months after construction began.

Located in the Logan business district, the three-story, rectangular, stone building is distinguished by its projecting central block whose four columns support an entablature with a frieze reading "Hocking County Courthouse."

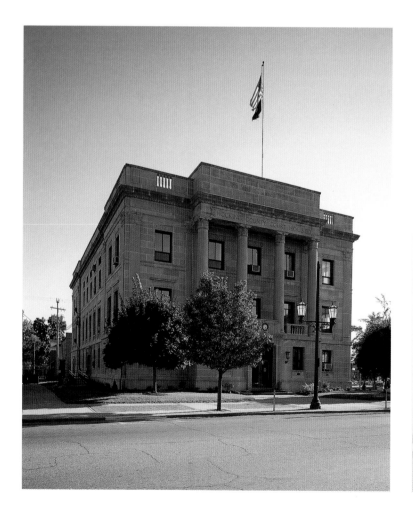

*Above: The Hocking County Courthouse.*

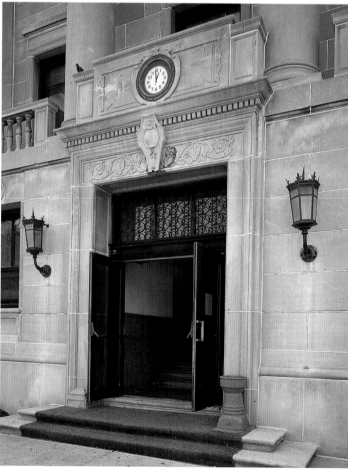

*Above: Close-up of entrance, with Art Deco renderings–grille-work and lamps.*

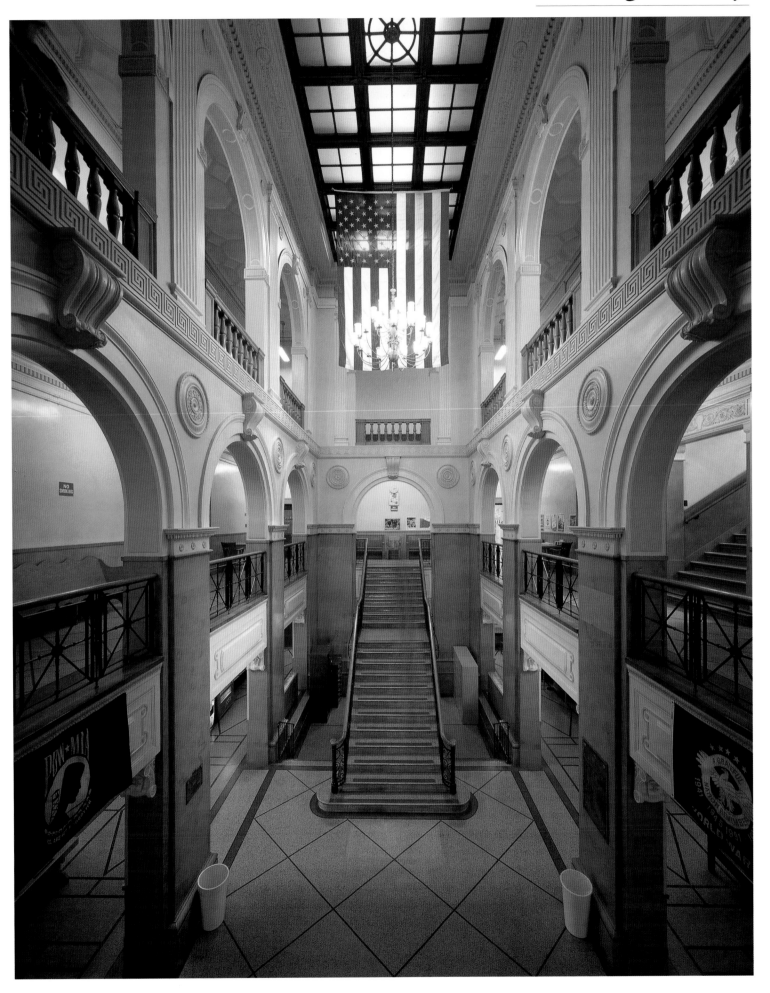

*Above: View of open court, from the main floor to the roof. This open well, surrounded by offices, provides both ventilation and light.*

# Scioto County

*Origin of name: Scioto River*
*County seat: Portsmouth*
*Courthouse constructed: 1924-27*
*Architect: John Scudder Adkins*

When the Scioto County Courthouse was constructed, a law library was added to the third floor. It is a large rectangular room with a barrel vault open to the sides, giving access to a balcony. Freestanding marble columns support an entablature at one end of the room, and pilasters at the other end give the impression of also supporting an entablature. Historical murals cover each end wall.

One of the large murals depicts a French delegation, led by Celeron de Bienville, landing on the banks of the Ohio River, at the confluence of the Scioto River, on August 22, 1749. These French fur traders discovered native people living on the land when they arrived earlier in the century. Although they were interested in keeping the Ohio territory under the dominion of France, the traders did not antagonize the tribes, because unlike later settlers, their interest was in doing business in furs, rather than occupying the area. The mural shows de Bienville being met by the English traders starting to infiltrate the region, and members of the Shawnee Nation, one of many tribes in the territory.

A second mural portrays the establishment of civil government with the inauguration of the first court in the Northwest Territory, on September 2, 1788 at Marietta. Both murals are attributed to H.H. Wessel.

On the wall, behind the librarian's desk, is a framed letter from William Howard Taft, President 1909-1913, Chief Justice of U.S. Supreme Court 1921-1930:

*Supreme Court of United States*
*Washington D.C.*

*December 5, 1924*

*My dear Mr. Bannon:*

*I have yours of December 3d. They asked me to recommend an inscription for the Hamilton County Court House, and I recommended something taken from the body of Liberties of Massachusetts. You can see the exact quotation, "to the end that this established / is a government of law and not of men".*

*Sincerely yours,*

*Wm. Taft*

(Handwritten by Mr. Bannon)

*From the conclusion of the Declaration of Rights–contained in the constitution of Mass of 1780, "to the end it may be a government of laws and not of men."*

*Mr. Henry Bannon*

*Portsmouth, Ohio*

*Above: Inscription on east face of the exterior.*

# Scioto County

*Above: Letter from William Howard Taft regarding a source of one of the courthouse's exterior frieze inscriptions.*

*Above: An old book in the Scioto County Law Library collection.*

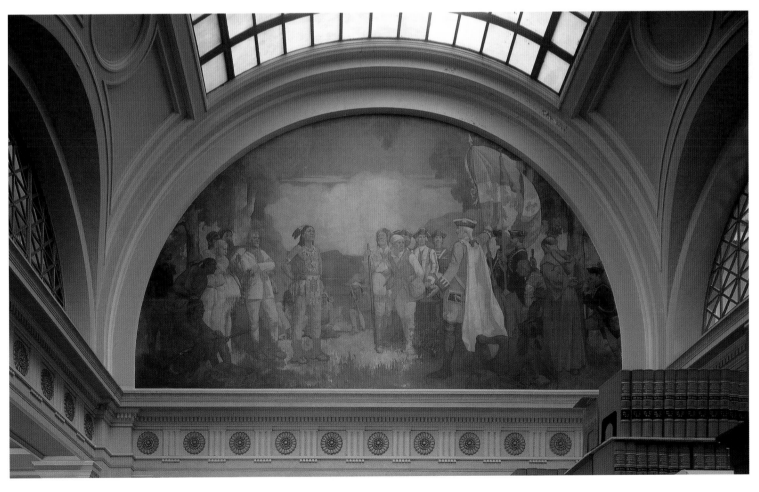

*Above: Mural in the Law Library.*

221

# Scioto County

The correspondence is the source for the inscription on the exterior east frieze. The engravings and sources on the other three friezes are as follows:

Main - "TELL ME YOUR CAUSE AND YE SHALL HAVE RIGHT"
*Thomas Mallory's Morte d'Arthur, Book 8, Chapter 29.*

North - "AND MY JUSTICE SHALL ANSWER FOR ME TOMORROW"
*Douay Version of the Bible, Genesis 30:33.*

West - "NO GOVERNMENT CAN STAND WHICH IS NOT FOUNDED UPON JUSTICE"
*Aristotle's Politics, Book VIII, 14-3.*

Another example of the law library as an historical repository is one of the books on the shelf, published in 1810, when nearby Chillicothe was the capitol of Ohio. It is titled *Acts passed at*

*The First Session of the Eighth General Assembly of the State of Ohio Begun and Held in the town of Chillicothe, December 4th, 1809 and in the eighth year of the said state also, the Reports of the Auditor and Treasurer.*

The austere classical courthouse, located in a predominantly residential area beyond the Portsmouth business district, is constructed of brick covered with a veneer of thin marble blocks. The second and third floors are tied together, on the main façade, by ten Ionic columns that support a projecting entablature. The cornice above runs the perimeter of the building and is supported by pilasters on the other sides. The fourth floor, above the cornice, has little ornamentation and still houses the county jail.

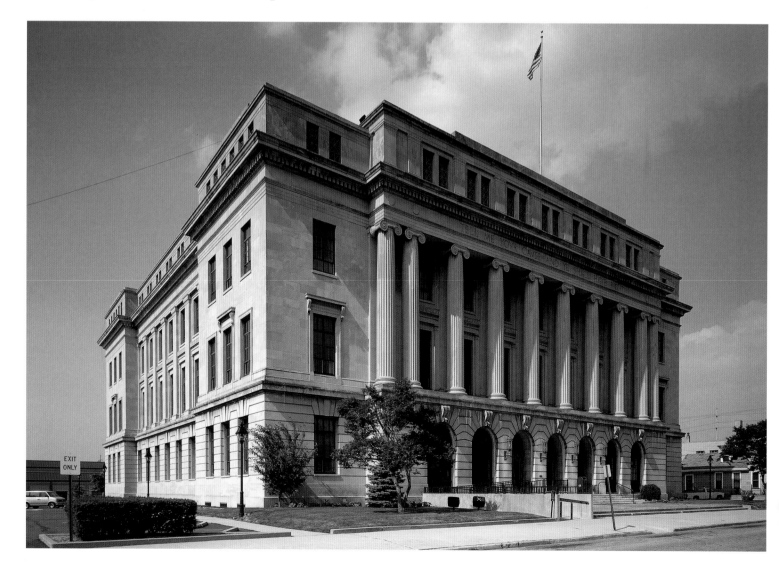

*Above: The Scioto County Courthouse.*

# Ashland County

*Origin of name: "Ashland," home of the Whig candidate for*
*president, Henry Clay, outside Lexington, Kentucky*
*County seat: Ashland*
*Courthouse constructed: 1928-29*
*Architect: Vernon Redding*

The Ashland County Courthouse sits on a rise in the center of a city block, just beyond the town center of Ashland. This less than central location is the consequence of the county being one of the last to be formed, in 1846, many years after Ashland was originally platted in 1815.

The plain and solid exterior of the stone courthouse, with its central projection, pilasters, and flat roofline, contrasts with the lobby, with its coffered ceiling, marble walls, and two open marble stairways. The second-floor hallway is lit with a large skylight.

Charles F. Kettering (1876-1958), inventor, scientist, and vice president of General Motors, who was born and reared on a farm near Loudonville in southern Ashland County, spoke at the dedication of the courthouse in 1929. On the main floor is a plaque commemorating Edmund G. Ross, Senator from Kansas. Ross was born in Ashland County and cast the deciding vote for acquittal in the impeachment trial of President Andrew Johnson in 1867. In voting "not guilty", Ross literally committed political suicide because he voted his conscience and not his party. Astronaut Colonel Robert C. Springer, mission specialist on the March 13, 1989, Space Shuttle *Discovery*, and graduate of Ashland High School class of 1960, is honored with a pictorial plaque depicting his activities in space.

The courthouse was built on the site of the first, dating from 1853. In the yard between the old courthouse and jail, gallows were constructed for Ohio's last public hanging, on May 16, 1884, the double hanging of William H. Gribben and George Horn, convicted of the murder of Harry Williams.

According to trial documents, the men were drinking and arguing in a saloon late one

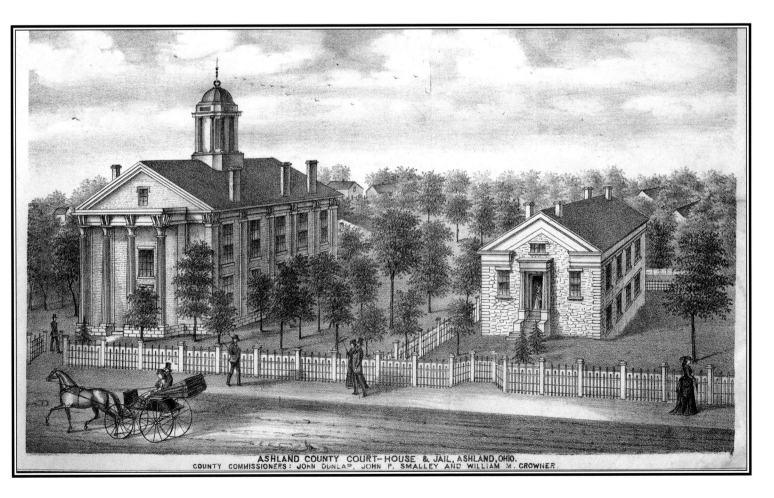

ASHLAND COUNTY COURT-HOUSE & JAIL, ASHLAND, OHIO.
COUNTY COMMISSIONERS: JOHN DUNLAP, JOHN P. SMALLEY AND WILLIAM M. CROWNER.

*Above: Illustration of old courthouse (1853) and jail (1848), where George Horn and William Gribben were*
*imprisoned and tried. The gallows were erected between these buildings. Picture source:* Caldwell's Atlas.

# Ashland County

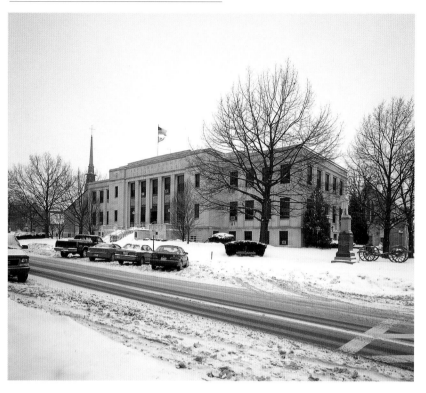

Saturday evening. On their way home, the fighting continued, and Horn allegedly hit Williams in the head first with a stone, knocking him down, and then split open his head with an ax, leaving blood, pieces of skull, and fragments of brain littering the roadway.

The defendants were tried separately. During Horn's trial, the judge ordered the victim's body exhumed. The head was severed from the body and, without objection, Williams' battered skull passed among the jurors for them to see the fracture which extended to the base of the skull, while a physician gave expert testimony that such an injury would cause immediate death. In less than three hours, Horn was found guilty of murder in the first degree.

Although Gribben insisted he had not touched or hurt Williams, the jury found him as culpable as Horn simply because he was at the murder scene and supposedly prevented the victim's escape. Both were sentenced to be hanged.

*Above: Ashland County Courthouse, built on the site of its predecessor.*

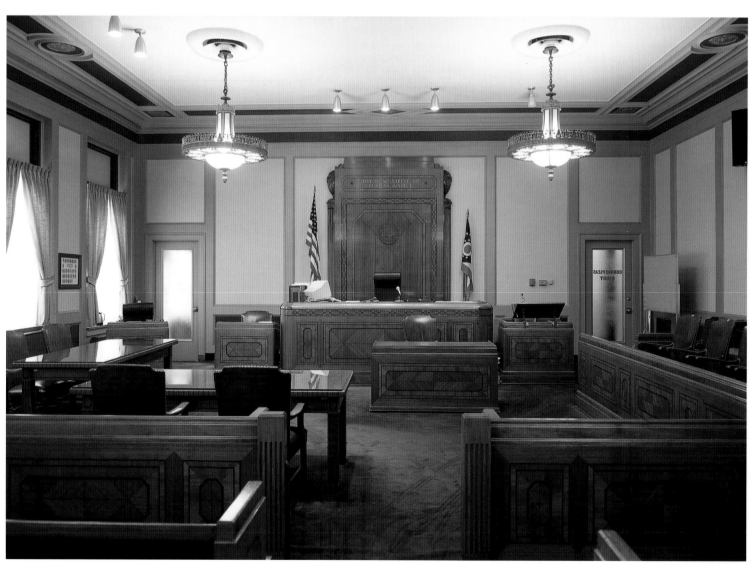

*Above: The courtroom, with mahogany paneling, and four large chandeliers.*
*Inscribed behind the bench: THERE IS NO VIRTUE SO GREAT AS JUSTICE.*

On the morning of the hanging, Ashland was in turmoil Reportedly, nearly 8,000 people (Ashland's population was about 3,000) were pushing at an eighteen-foot high fence surrounding the gallows specifically to keep them out, and were clinging to trees or rooftops in an attempt to see the execution.

Because of riots at hangings in other counties, over three hundred men of the Ohio Militia were brought to the courthouse, to control the mob. At the designated execution time, Horn and Gribben were taken to the platform, a lever was pulled simultaneously opening two trapdoors beneath, and they hanged until they were dead.

According to law, only the sheriff, his deputies, a clergyman, and not more than six persons delegated by the prisoner were allowed to view the hanging. Because the sheriff had so many requests, he "bent the law," and installed three rows of benches near the platform, reserved for citizens who were issued invitations as "assistants" to the execution. Nor was that the end of the matter. After the sheriff and his deputies cut loose the bodies, they were put on public exhibition inside the jail. Shortly thereafter, the Ohio Legislature banned public hangings.

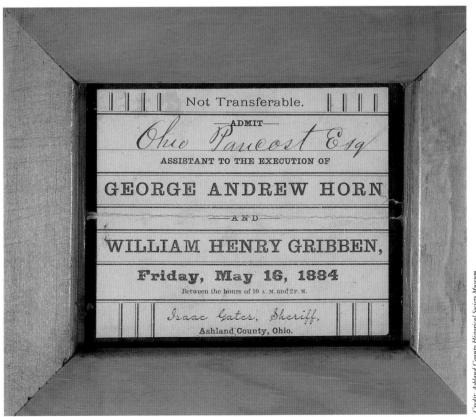

*Above: Official pass to the last public hanging in Ohio, issued to Ohio Pancoast, a local druggist.*

225

# Noble County

*Origin of name: James Noble, pioneer settler who first bought land in the county in 1814, or Warren P. Noble, chairman of the committee on new counties in 1851*
*County seat: Caldwell*
*Courthouse constructed: 1933-34*
*Architect: Charles J. Marr*

Noble County was the last Ohio county to be formed. Its courthouse, located in the center of a square, is the largest building in Caldwell. Substantially constructed with funds from the Works Project Administration (W.P.A.), this unadorned building continues to meet the requirements of a county with a population of less than twelve thousand. The county also saved money by using brick manufactured at nearby Ava. During the winter of 1933-34, thirty-four relief laborers reportedly laid forty-two thousand bricks in one six-hour shift.

The four interior decorative murals, outside the Court of Common Pleas, represent local history. A mural of the original courthouse is joined by a portrait of Noble Countian John Gray (1764-1868), believed to be the last surviving Revolutionary War veteran; James M. "Private" Dalzell, a Civil War veteran born in 1838; and, Lieutenant Commander Zachary Landsdowne (1888-1925), commander of the *Shenandoah*.

Landsdowne, an honor graduate from the naval academy at Annapolis, Maryland, was chosen as the American representative and observer to accompany the crew of the first British airship, the *R34*, to fly across the Atlantic Ocean. As one of the most promising officers in the naval air service, he was selected to command the U.S.S. *Shenandoah*.

Dedicated on October 10, 1923, it was the United States Navy's first large rigid airship. On September 3, 1925, while touring Ohio, an early morning storm broke the dirigible into two pieces over Noble County. This military and aviation tragedy, killing Landsdowne and twelve members of his crew, accidentally thrust Noble County into the national spotlight. The catastrophe continues to be memorialized in the Shenandoah high school appellation and with the students proudly calling themselves Zeps.

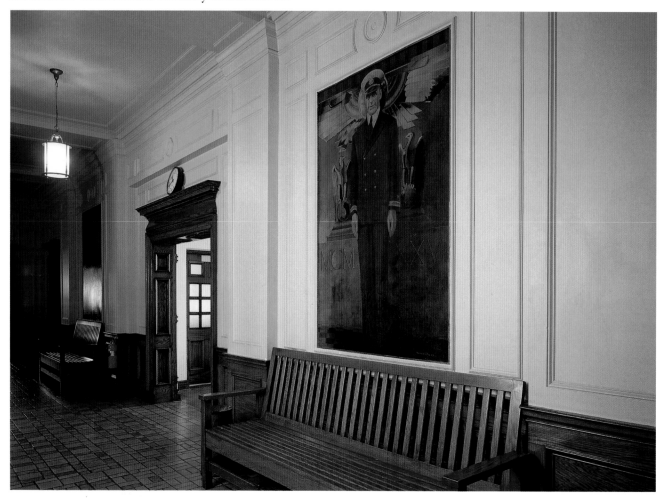

*Above: Mural depicting Commander Lansdowne of the* Shenandoah.

*Above: The atrium of the courthouse*

# Noble County

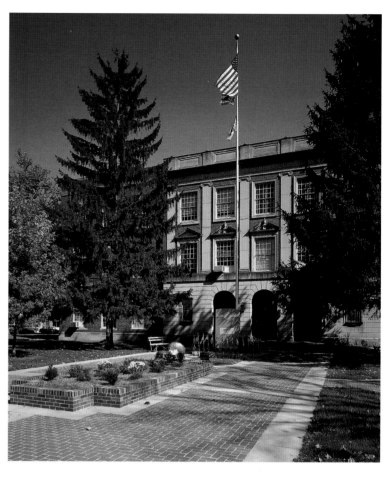

*Above: John Gray's grave in the family graveyard located about 250 yards north of his home.*

*Above: The Noble County Courthouse.*

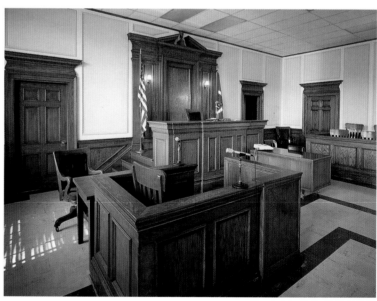

*Above: Courtroom.*

*Above: Monument erected on US Route 21, near Ava, in commemoration of the* Shenandoah *disaster.*

# Clermont County

*Origin of name: French for "clear mountain"*
*County seat: Batavia*
*Courthouse constructed: 1935-36*
*Architects: Old: Hunt and Allan; New addition: Steinkamp, Steinkamp & Hampton*

Above the entrance of the W.P.A.-built section of the courthouse is a carved likeness of President Ulysses S. Grant, the first Ohio-born President of the United States. Born April 27, 1822 at Point Pleasant, Clermont County, he is one of seven Ohio-born presidents. The other six are:

- *Rutherford Hayes, October 4, 1822, Delaware, Ohio (Delaware County)*
- *James Garfield, November 19, 1831, Orange Township now Moreland Hills, Ohio (Cuyahoga County)*
- *Benjamin Harrison, August 20, 1833, North Bend, Ohio (Hamilton County)*
- *William McKinley, January 29, 1843, Niles, Ohio (Trumbull County)*
- *William Howard Taft, September 15, 1857, Cincinnati, Ohio (Hamilton County)*
- *Warren Harding, November 2, 1865, Blooming Grove, Ohio (Morrow County)*

Clermont County's location, on the Ohio River, drew early settlers, like the Grants, from Maryland, Virginia, and Kentucky, many of whom opposed slavery. Before the Civil War, Clermont became a refuge for hundreds of fleeing slaves being led, by means of the "underground railroad," to the safety of Quaker settlements in Clinton County, or on into Canada.

A case following the Civil War, "The Kugler-Townsend Will Case," adds to the court's files and continues to interest local citizens, because of the money involved, the relations and associations of various litigants, and its peculiar circumstances. John Kugler, local businessman, married Rebecca West in 1842 and on January 4, 1868, died leaving his estate, estimated at half a million dollars, to his wife. On October 13, 1869, Mrs. Kugler married Edmund B. Townsend, and on June 26, 1871, Mrs. Townsend executed her will. She died two days later.

*Above: Old Courthouse wing. Constructed with the aid of the Works Progress Administration (W.P.A.), the red brick building has a wide limestone entablature supported by four square pilasters framing the main entrance, and three broad windows above, which light the courtroom.*

# Clermont County

*Left: Second-floor lobby, with slate floor outside three courtrooms.*

*Left: Attorneys' conference room, where they can make telephone calls and work in private. It contains framed silhouettes of Daniel Webster and Henry Clay, along with a print of the Capitol Steps, Washington, D.C.*

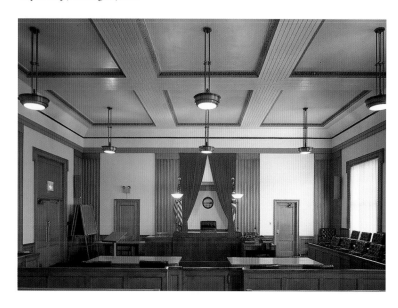

*Left: Courtroom in the WPA building. Now used for visiting judges.*

Her will read:

"I, Rebecca J.E. Townsend, of the town of Milford, Clermont Co., Ohio, do make and publish the following as my last Will and Testament. First, I give and bequeath to my beloved husband, E.B. Townsend, the sum of fifty thousand dollars ($50,000). Second, I give and bequeath to my good, kind, and attentive physician, Dr. P.B. Gatch, the sum of five thousand dollars ($5,000). Third, I give and bequeath to my brother, Samuel R.S. West, the notes and mortgages given by him to my late husband, John Kugler, deceased, and those given by him to me in my own right. Fourth, I give and bequeath to the children of my nephew, Samuel A. West, and to the children of my niece, Anna M. Lloyd, the sum of one thousand dollars ($1,000) to each child. Fifth, I give and bequeath to the children of my niece, Elizabeth D. Gatch, the sum of one thousand dollars ($1,000) each. Sixth, I give and bequeath to Josiah Drake the sum of five thousand ($5,000) dollars. Seventh, I give and bequeath to my nephews, Samuel A. West and John Kugler West, the sum of five thousand ($5,000) dollars each. Eighth, I give and bequeath to my nieces, Rebecca S. West, Anna M. Lloyd, and Harriet C. West, the sum of one thousand ($1,000) dollars each. Ninth, I give and bequeath to each one of the children of Sarah Ogg, of Catherine Drake, and Elizabeth Shultz, the sum of one thousand ($1,000) dollars to each child. Tenth, I give and bequeath to the children of David Kugler and Mathias Kugler the sum of one thousand ($1,000) dollars each, except Mathias Kugler, son of David Kugler, and John Kugler, son of Mathias Kugler: to these I give and bequeath the sum of two thousand five hundred ($2,500) dollars each. Eleventh, I give and bequeath to each child of my niece, Rebecca Julia Frazier, the sum of one thousand ($1,000) dollars. Twelfth, I give and bequeath to Joanah Collins the sum of five hundred ($500) dollars. Thirteenth, I give and bequeath to my little namesake, Rebecca Julia West, daughter of Samuel A. West, my piano and jewelry-box, with its contents. Fourteenth, I give and bequeath to Catharine Drake and her daughter, Ada P. Drake, my silver tea-set. Fifteenth, I give and bequeath to my nephew, Samuel A. West, my silver water-pitcher, two silver goblets and waiter, and my china tea-set; the balance of my silver, marked Kugler, I desire to be distributed among the remaining members of the family, as they may amicably devise. Sixteenth, I give and bequeath to my beloved husband, E.B. Townsend, my best bedroom set. Seventeenth, I give and bequeath to the Methodist Episcopal Church at Milford, Clermont Co., Ohio, the sum of six thousand ($6,000) dollars, which sum shall be placed at interest by them, and the interest shall be used by them perpetually in keeping in repair the church building and in paying the salary of the ministers of said church who may be appointed from time to time by the regular constituted authorities of the Methodist Episcopal Church to be the pastors of said charge in Milford, Ohio. Eighteenth, I give and bequeath to the Orphan Asylum at Cincinnati, Ohio, under the charge of the Protestant managers at Mount Auburn, the sum of two thousand ($2,000) dollars. Nineteenth, I give and bequeath to the Widows' Home, at Cincinnati, Ohio, under the charge of managers at Mount Auburn, the sum of two thousand ($2,000) dollars. Twentieth, I give and bequeath to the Missionary Society of the Methodist Episcopal Church the sum of six thousand ($6,000) dollars, to be placed at interest, and the interest to be used by them perpetually in the missionary work. Twenty-first, I give and bequeath to the Sabbath-school of the Methodist Episcopal Church located in Milford, Ohio, the sum of five hundred ($500) dollars; said sum to be controlled by the Quarterly Conference of said charge, and by it put at interest, and the interest to be by it perpetually used for the benefit of the Sabbath-school. Twenty-second, I give and bequeath to the Colored Orphan Asylum located in Cincinnati the sum of one thousand ($1,000) dollars. Twenty-third, I give and bequeath to Oakland Seminary, located in Hillsboro, Highland Co., Ohio, the sum of one thousand ($1,000) dollars. Twenty-fourth, I give and bequeath to the Cincinnati Annual Conference the sum of five thousand ($5,000) dollars, to be under the control of the trustees of said Conference, and by them put at interest, the interest to be perpetually used by them for the relief of superannuated and worn-out ministers and widows and orphans of deceased ministers of said Annual Conference; this to be known as the Kugler Bequest. The balance of my estate shall be equally divided among all the heirs herein named. Twenty-fifth, I hereby nominate and appoint P.B. Swing and Wm. C. Mellon as the executors of this my last Will and Testament, and do hereby revoke all former wills by me made. In testimony whereof, I have hereunto set my hand and seal this 26th day of June, A.D. 1871.

Rebecca J.E. Townsend.

Since the money legacies were more than the value of the decedent's personal estate and could not be paid without the sale of some or all of the real estate, and there was a dispute over who would inherit, after the payment of the legacies, the residue, a petition was filed for a construction of the will and an order to sell the real estate. Three groups claimed the residuum ("The balance of my estate shall be equally divided among all the heirs herein named"): her husband, Edmund B. Townsend; her blood-relatives, the Wests; and the blood-relations of her first husband, the Kuglers.

At the March term of 1872, the Clermont judge granted a decree for the sale of the realty, and decided substantially in favor of the West heirs. On appeal, the Ohio Supreme Court ordered the real estate to be sold to pay for the legacies, the Kuglers cut out, Townsend entitled to a small share, with the remainder to the West branch. But after paying the legacies, litigation fees and costs, the sale of the land, whose value had plummeted from depreciation and neglect, was not enough to cover the once grand estate.

Clermont County is growing rapidly in population, in the shadow of Cincinnati, and the dedication of new courtrooms alleviates growing pains in the county court system. The addition adjoins the old courthouse, built for a rural community of about thirty thousand residents, who required only one judge.

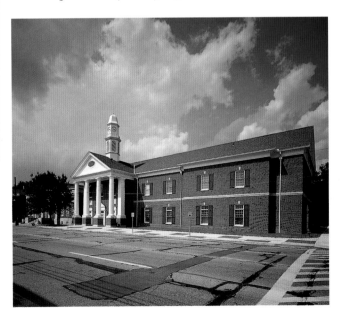

*Right: Courthouse addition, dedicated on May 14, 1998. Thomas Moyer, Chief Justice of the Ohio Supreme Court, was the featured speaker. There followed a reception and public tours of the building recognized for its state-of-the-art security, such ADA additions as signs in Braille, and the witness rooms.*

# Erie County

*Origin of name: Erie Indian tribe*
*County Seat: Sandusky*
*Courthouse construction: 1936-39*
*Architects: Myer & Holmes*

In 1874 when the Second Empire style Erie County Courthouse was completed, three figures of Justice stood above the entrance pediments, and a mansard roof and corner towers capped with iron cresting adorned it. The interior featured marble mantles and detailed plasterwork. Large bronze and gilt chandeliers hung in the hallways above black and white marble tiled floors.

On August 26, 1920, as the Common Pleas Judge Roy Williams was preparing to conduct a civil jury trial, he was having difficulty impaneling a jury–only one man was available. At the same moment, the nineteenth Amendment to the U.S. Constitution was ratified, providing equal suffrage for women, and Judge Williams was inspired to consider women jurors.

As the judge described the situation, "(w)hen I learned shortly after 10:30 this morning that suffrage had been proclaimed, I decided to impanel a woman jury. Twelve women were summoned. Twelve women served." The local newspaper further reported that the first women jurors, prominent in the civic affairs of Sandusky, listened as attentively and intently, and decided the case as efficiently as men: "Surely men jurors could not have been faster."

Ohio women had been waiting for such an opportunity since at least 1852, when The Ohio Women's Right Association was formed in an effort to secure their rights, and to influence the General Assembly to pass laws that would give them, among other things, control over their own property and the ability to sue and to be guardians, executors or administrators. While some states had already granted women the right to vote, Ohio voters rejected an earlier proposed constitutional amendment in 1912.

The courthouse no longer resembles the one where Judge Williams presided because it was remodeled during the 1930s, with funds from the Works Progress Administration (W.P.A.). While the original arched windows and exterior stone are visible on the lower floors, the mansard roof and ornamentation were replaced by a smooth limestone Art Deco exterior and clock tower. The Art Deco motif carries over into the interior.

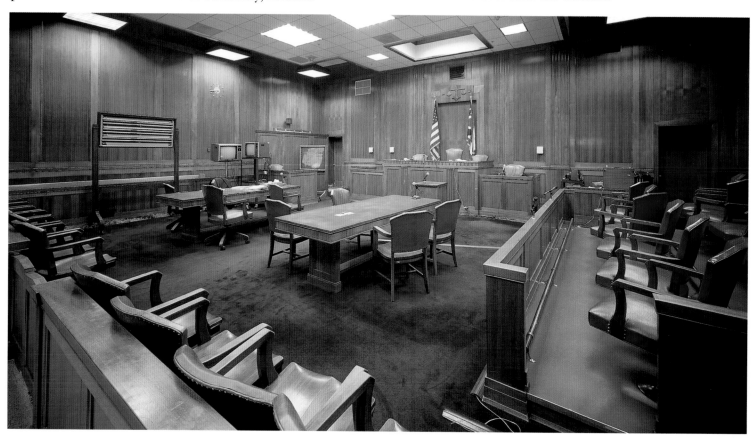

*Above: Courtroom.*

*Above: Erie County's first all-women jury.*

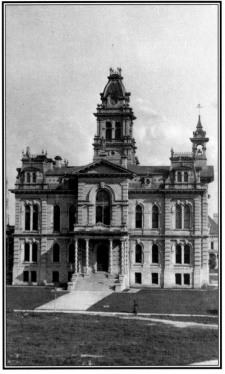

*Above: The Erie County Courthouse in 1878.*

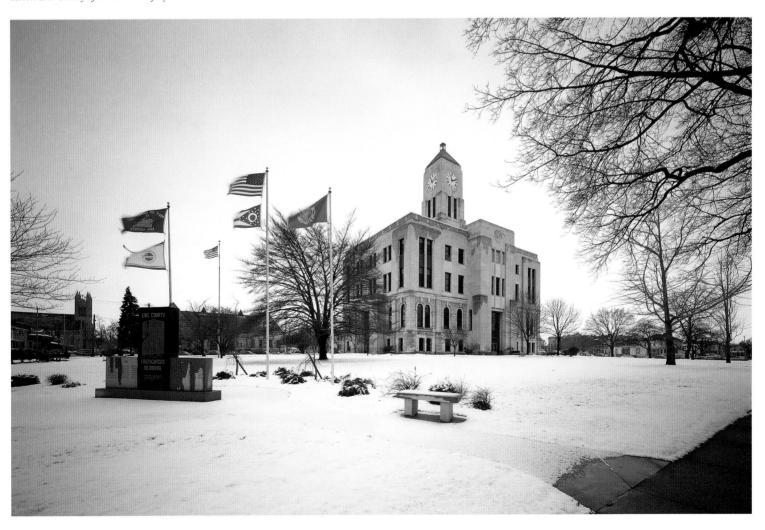

*Above: The Erie County Courthouse today.*

# Vinton County

*Origin of name: Samuel Finley Vinton, Ohio Statesman and U.S Congressman,
    known as the "Father of the Department of the Interior"*
*County seat: McArthur*
*Courthouse construction: 1938-39*
*Architect: unknown*

Vinton County is the smallest Ohio county in terms of population, at 11,098, according to the 1990 census, and was one of the last to be established. The Hocking and Scioto Rivers supplied access to neighboring areas, but it was more difficult to travel in the area that now comprises Vinton County because of the thick woods blocking the way. Today, much of the county land remains forested as part of Zaleski State Forest and Lake Hope State Park, both of which keep land out of the county list of taxable property.

From 1890 to 1900, fourteen lawyers practiced in the county, including H.C. Jones. At that time jurors were required by law to be property owners. During one of his cases, Jones objected that a juror did not own property. After an investigation revealed that the juror owned a cemetery lot, Jones responded to the court that Vinton County was getting pretty hard up when it had to go to the graveyard to obtain a juror.

Funds for the construction of the courthouse came largely from the Works Project Administration (W.P.A.). The first courthouse burned, and this replacement, built from bricks made in a local factory, occupies the same site. Originally, the county jail was located on the top floor, but it was closed during the 1980s when it failed to meet state requirements. Now prisoners are transported to other county facilities.

The entrance features three pairs of doors separated by piers, with a monument of a Union soldier standing outside. Its unveiling and dedication, to the memory of Vinton County soldiers, took place on June 8, 1914. The landmark, constructed of Vermont granite, is twelve feet high, with a seven by seven foot base supporting a bronze statue of a soldier. At one time, it was located in the main intersection of McArthur. When the community's one stoplight took its place, in about 1941, the monument was removed to its present location.

*Above: Courthouse and Civil War Monument. The iron railing is original to the first courthouse.*

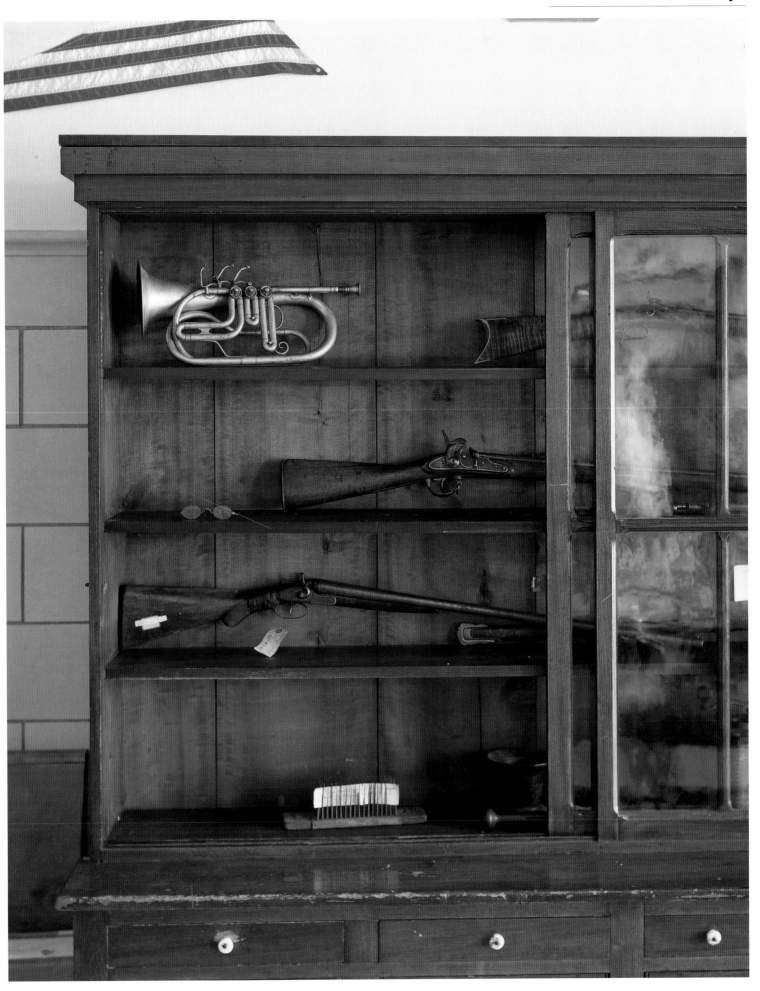

*Above: The lobby serves as a museum, with a cabinet displaying a shotgun used by an elderly man
to kill Sheriff Harold Steele when he was delivering a summons from the electric company.*

# Vinton County

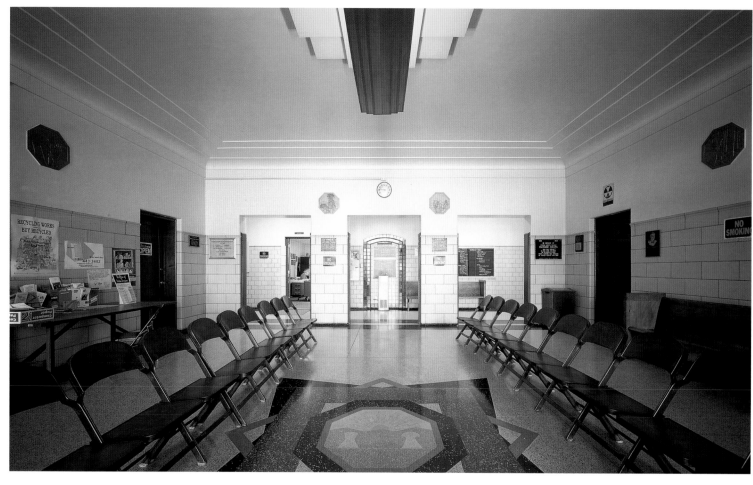

*Above: Medallions on the lobby walls celebrate activities indigenous to Vinton County, such as mining, forestry, and agriculture. A plaque referring to the Roosevelt administration and the W.P.A. can be seen through the center doorway. Art Deco floor tile surrounds the design of the state seal.*

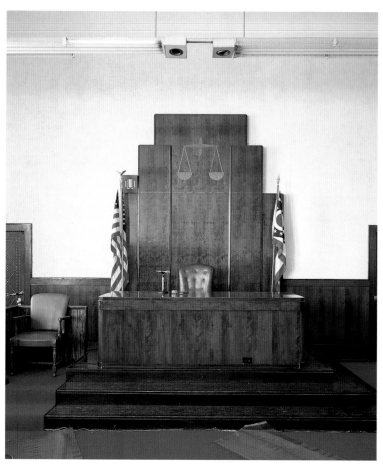

*Above: Courtroom, with handmade bench and furniture by Juvenile and Probate Judge Philip Rose, fashioned at home and assembled at the courthouse.*

*Above: Courtroom, with inlaid wood Scales of Justice behind the bench.*

236

# Jackson County

*Origin of name: Andrew Jackson, U.S. President*
*County Seat: Jackson*
*Courthouse construction: 1951-53*
*Architect: unknown*

The first term of the Jackson County Court of Common Pleas was held on August 12, 1816, under a large oak tree outside the house of William Given. Nearly every man of the county attended, including the salt boilers who drew water from the salt wells and boiled it to make salt, farmers, squatters and hunters, who reportedly came clothed in the skins of wild animals, businessmen, judges, and attorneys. John Thompson, presiding officer of the Second Judicial Circuit of Ohio, presided. Under first business, a petition for the establishment of a tavern was approved. The second was the impaneling of a grand jury, that held its session under another tree, surrounded by deputy sheriffs who kept the crowd at a proper distance. The first indictment was returned against two men involved in a fistfight that had started a riot. Both entered pleas of guilty, and were each fined $12 and costs.

The first courthouse, built of bricks in 1821, was ravaged by fire on September 21, 1860. The Civil War delayed construction of a replacement until 1868. This building also burned, in January 1951. Defective electrical wiring was determined to be the cause of this fire. Employees noticed electricity flickering until the circuit breakers languished and fire broke out on the rear stairway. Soon flames poured from the four-sided clock tower capping the building. Community volunteers carried out plat books, abstracts and other records from the County Recorder's office. Records stored on the second floor of the building were thrown out the windows, and moved out of the heavily watered area by volunteers, many of them elementary and high school students. Fires notwithstanding, Jackson County has records and case files dating from 1816, and Probate documents such as marriages and wills from 1835.

In 1953, reusing the outside walls of the charred 1868 building, a new three-story Eclectic styled courthouse was completed. Its obligatory small square tower marks its civic purpose.

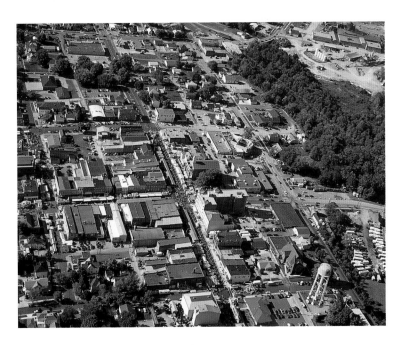

*Above: Aerial view of Jackson during a festival.*

# Jackson County

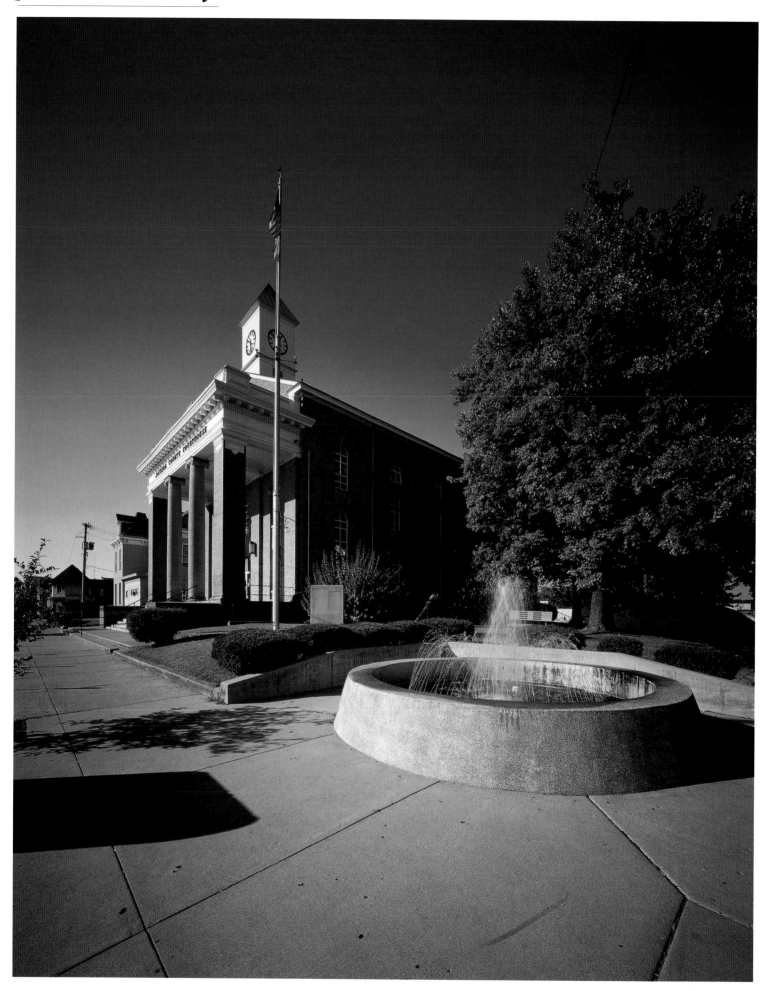

*Above: The Jackson County Courthouse.*

# Champaign County

*Origin of name: French for "plain," descriptive of the level land in the area*
*County seat: Urbana*
*Courthouse constructed: 1954-56*
*Architect: Philip T. Partridge*

The Champaign County's courthouse dedication occurred on June 8, 1957. An earlier one, built circa 1839, resembled the Hillsborough courthouse, with a tower and columns. In fact, an early indication of the county's frugality was evident when, instead of having their own blueprints drawn, a Champaign county commissioner received $8.00 for traveling from Urbana to Hillsboro to procure plans to replicate Highland County's.

By the 1940s, after fire had destroyed the fourth courthouse, Champaign Countians were still unwilling to "foot the bill" to compete with their neighboring counties for the most lavish civil temple. It was nearly ten years before the community approved funds to construct the courthouse. The first step toward a new courthouse was putting a bond issue up for vote in 1948, seeking to raise $1,120,000. It was defeated. A second bond issue was submitted to voters in 1949 in an effort to raise $875,000 for construction of a new building. This too failed.

Now a group of local citizens diligently campaigned for the passage of the bond issue. Pamphlets were distributed showing the poor storage conditions for records and official documents, along with photographs of the condemned jail conditions. Finally, the architectural plans decreased the building's proposed size, by deleting the fourth floor along with other reduced costs, and in 1952, county voters approved the third bond issue which realized a sum of $650,000 for the building of a courthouse.

Since the passage of the third bond issue only included building construction funds, county officials decided to pay for the cost of equipping the courthouse with money from the General Fund. This restricted resources for many years.

In spite of the acrimony, a ceremony accompanied the building's dedication. As part of the festivities, there was a parade from the municipal building to the courthouse parking lot led by the Urbana High School Band, an address by Governor C. William O'Neill, and an open house from 3:00 to 9:00 p.m.

*Above: A first-floor corridor, looking toward the lobby.*

# Champaign County

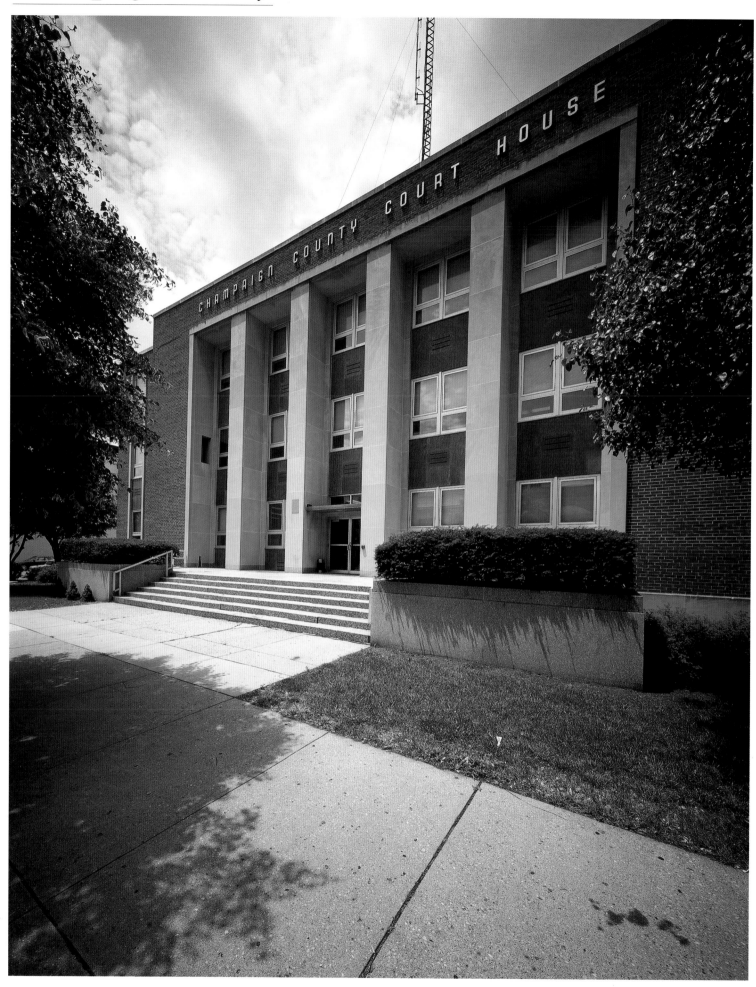

*Above: The Champaign County Courthouse.*

# Portage County

*Origin of name: The old Indian portage path between the Cuyahoga and Tuscarawas rivers*
*County seat: Ravenna*
*Courthouse constructed: 1959-60*
*Architect: C.G. Kistler*

Portage County, formed from Trumbull County, derived its name from the old Indian portage path of about seven miles in length between the Cuyahoga and Tuscarawas rivers, both of which flow within its boundaries.

Other than its engraved title and location on the public square, there is little to distinguish the courthouse from any other office building. It is an example of government buildings that look more like business buildings in today's consumer-and business-oriented society.

The only function remaining in the courthouse is court proceedings. In 1997, the sheriff's office and old jail were removed to a new facility, and a state-of-the-art courtroom, adjoining jury area and judge's quarters took their place. Microphones at the counsel tables, lawyer's lectern, witness box, and judge's bench enter arguments and information directly onto the Recorder's tape recorder. A holding cell, with its own elevator, is joined to the courtroom. Video surveillance camera and security measures are discreetly positioned, as is a television for playing video evidence.

In the comfortable jury room behind the courtroom, a newspaper column is prominently posted, with the following highlighted:

> *Speaking of trial dialogue, how about this exchange between the judge and a Portage County Man sentenced to 30 years to life in prison for murder who didn't quite understand the sentence.*
>
> *Would he get time off for good behavior and, if not, would he automatically be released at the end of 30 years, he asked.*
>
> *"Let me explain it to you this way," the Common Pleas Judge said. "Your parole officer hasn't been born yet."*

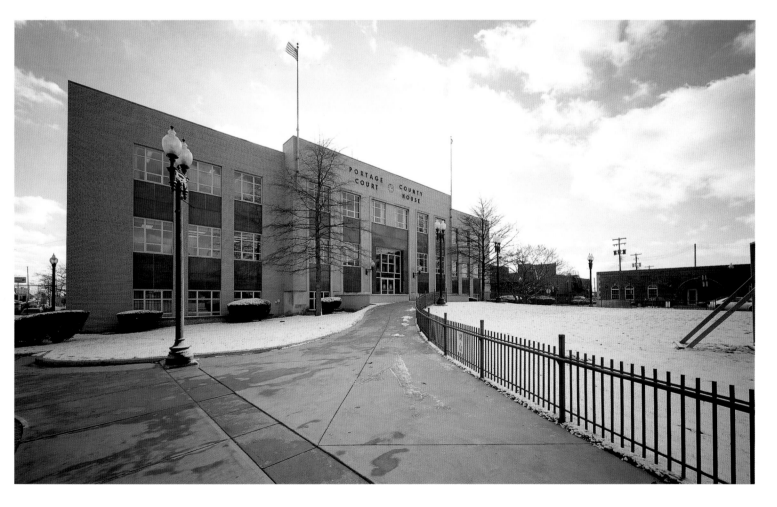

*Above: The Portage County Courthouse. For security reasons, access is limited to the basement side entrances.*

# Portage County

Outside the courtroom, the old wooden jury wheel is displayed, as a reminder of how jurors were once selected. Jury commissioners drew jurors by pulling ballot cards from the jury wheel. Today, technology facilitates the jury selection. The Jury Commission, under the supervision of the Court of Common Pleas, selects jurors by lot or chance using computers, according to statutory law.

*Above: Jury wheel, used to draw the names of all Portage County jurors between 1885 and 1985, sitting on a table in the 1997 courtroom.*

# Ashtabula County

*Origin of name: Ashtabula River, from the Indian name for "Fish River"*
*County seat: Jefferson*
*Courthouse constructed: 1960*
*Engineer and architect: Kujala and Koski*

Ashtabula is geographically Ohio's largest county, at 706 square miles. It offers an example of a local citizen playing a role in determining the site of the sought-after county seat. One of the Ashtabula county property owners was Gideon Granger, Postmaster General in President Thomas Jefferson's cabinet. He offered to build a courthouse, at his expense and on his land, if the village were named after the president and became the county seat. His offer was accepted, and the larger port of Ashtabula was shunned in favor of Jefferson.

Within Jefferson a number of buildings cluster together where judicial and administrative business is conducted. Until 1870, when a separate building was erected solely for the Probate Court, all county business was carried on in the old 1850 courthouse, which now accommodates county offices. The old Probate Court is now the commissioners' office and hearing room. A two-story glass and masonry building, labeled the Ashtabula County Courthouse, was constructed in 1960 with a Justice Center and court wing added later.

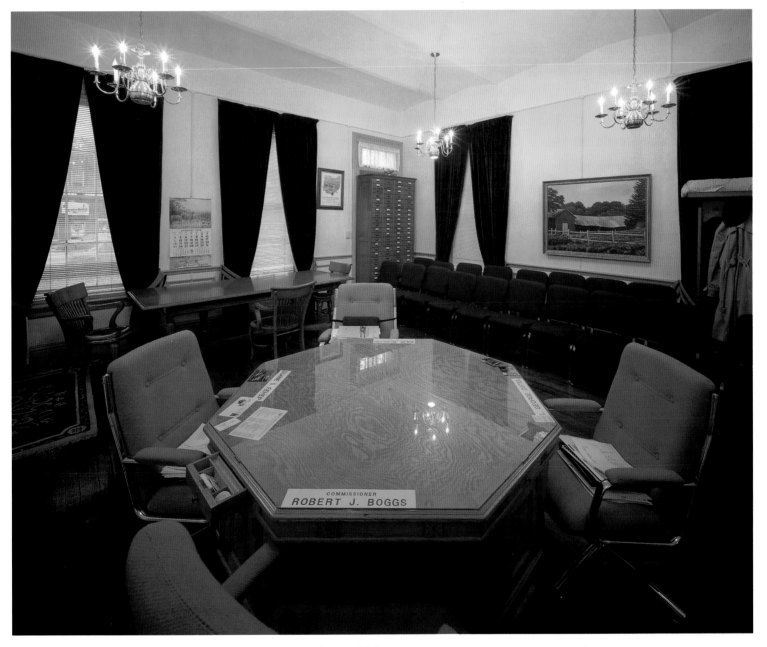

*Above: Old Probate courtroom, where the County Commissioners meet. The carved octagonal desk, built for the Commissioners circa 1860, is in three pieces so it can be taken through the door. Its top panel was cut from one tree.*

# Ashtabula County

The old courthouse and the old Probate Court are listed on the National Historical Registry along with a nearby building, designated Lawyers' Row. This unusual office resembles an early train station, constructed in wood with deep overhanging eaves and brackets, because when three lawyers hired an architect/builder to design their office, he apparently only knew how to design stations.

*Above: Lawyers' Row. To the rear stands the old courthouse, constructed in 1850 on the framework of walls left standing from an earlier 1836 building whose interior was destroyed by fire. The stone front porch is supported by double columns with exaggerated bulbous bases.*

*Above: An aerial view of the Ashtabula County Courts Complex.*

To all people to whom these presents shall come, Greeting.

Whereas the legislature of the State of Ohio did at their last session by their act set apart and erect the eastern part of the County of Geauga in said State into A New County called and to be known by the name of the County of Ashtabula and did further direct that Commissioners be appointed to establish the permanent seat of Justice for said County of Ashtabula according to the laws of said State. And Whereas Commissioners were duly appointed for the purpose aforesaid who accepted the trust and undertook to perform the duties aforesaid and in discharge of said duty in the Month of May last proceeded to said County of Ashtabula to establish said seat of Justice and while in said County examined for themselves such places as were offered to them for said permanent seat of Justice and such as they thought might be most useful for said purpose and attended to such facts and arguments as were offered by the different persons in interest. And whereas, during the aforesaid examination and hearing, the undersigned submitted to said Commissioners in writing under his hand and seal his proposal in the words and figures following, that is to say: To the Gentlemen Commissioners appointed to fix the seat of Justice for the County of Ashtabula—In case the permanent seat of Justice shall be fixed within the Town Plat of Jefferson, I bind myself to give for the use of the County of Ashtabula a lot of land of sufficient size and thereon to erect and compleat in a workmanlike and handsome manner a Brick Courthouse forty eight feet in length and thirty eight feet in width and not less than twenty five feet in height to be divided into suitable Offices and Jury rooms and a spacious and convenient Court room and also to erect and finish a good and substantial Gaol to be built of Timber Sixteen feet in width thirty feet in length and Seventeen feet in height and Calvin Pease of Warren who is Authorized to convey my lands in the State of Ohio is hereby authorized to pledge as security for the performance of the above propositions so much of my lands as the Commissioners shall think reasonable.

Witness my hand and seal at Jefferson the 5th day of May, 1808.

Gideon Granger (Seal)

# Richland County

*Origin of name: the richness of its soil*
*County seat: Mansfield*
*Courthouse constructed: 1967-68*
*Architects: Thomas G. Zaugg and Associates*

For its first fifty years, Richland was a rural county, with its income largely derived from grain and flour. When the railroads arrived, industry followed, and today both agriculture and manufacturing contribute to its economy.

On a wall in the courthouse lobby a glass chip mosaic depicts county scenes from 1814 to 1968, including the figure of John Chapman, also known as "Johnny Appleseed." As an itinerant nurseryman, he scattered apple seeds throughout the rich soil of central Ohio, in advance of the early pioneers. During 1818 and 1819 Johnny Appleseed purchased land in Richland County, as recorded in the first volume of the county's deeds.

Johnny Appleseed is also associated with the county's first courthouse, located in the upper room of a blockhouse that was built on the square during the War of 1812 to protect the early Mansfield settlers from Native Americans determined to hold onto the area. After the reported murder of a Mansfield merchant, settlers sought refuge in the unprotected block house, and it was Johnny Appleseed who volunteered to travel sixty miles to Mt. Vernon, and back, at night and through the rough wilderness, to bring troops to safeguard the settlers.

Including the blockhouse, there have been five Richland County courthouses. Controversy surrounded the demolition and replacement of the

---

John Chapman
To
Matthias Day
Recorded March 26th
1819

I John Chapman of the county of Richland and State of Ohio for and in consideration of a full value received by the hand of Matthias Day of the county and state aforesaid the receipt whereof I do hereby acknowledge fully satisfied with the said Matthias paying his proportion of the interest yearly, do transfer and set over all and singular my right, title interest, and advantages of a certain tract of land bounded as follows (to wit) in the South East quarter of Section Number fifteen, township twenty-one of Range eighteen beginning at the South East corner of said quarter section then turning North seventy six paces to an oak marked J.C. and N.R.W. thence east forty-two paces to a stake, thence South seventy six paces to the Section line, then West to the place of beginning containing twenty acres the same be it more or less, unto the said Matthias Day his heirs or assigns.

In testimony where of I have hereunto set my hand and seal this twentieth day of November eighteen hundred and eighteen.
Signed sealed and delivered
In presence of us

Isaac Osbun
 His
Nathaniel X Pluck          John Chapman seal
mark

State of Ohio, Richland County Before me the subscriber one of the acting Justices of the peace in and for the township of Madison county and state afore said, came John Chapman who acknowledged the signing and sealing of the within instrument of writing to be his act and deed for the purposes therein exercised.

Seal Given under my hand and seal this 20th day of November A.D.1818
                    Isaac Osbun
                    Justice of the Peace

*Above: The text of one of John Chapman's land deeds.*

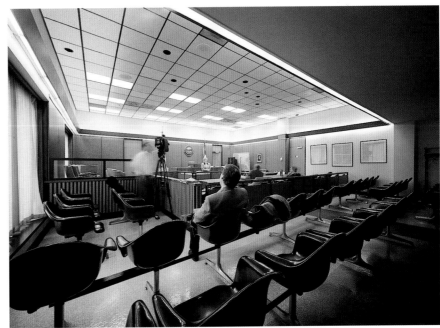

*Above: Waiting for a jury trial verdict.*

*Above: Civil War Monument depicting the 1812 Blockhouse.*

*Above: First-floor lobby.*

# Richland County

deteriorating fourth (1870) courthouse. Some in the county maintain that the old stone edifice was destroyed primarily because no one rallied public opinion to save it, and county officials reportedly wanted to reposition the courthouse at its present site. In the end, 1960s functionalism prevailed over a costly preservation effort.

Because it is built into the side of a hill, the fifth Richland County Courthouse takes on differing appearances depending on from which side it is viewed. From the front or north side it is a three story structure; from the sides it looks to have four stories, and from the south side, five floors. The building also features precast concrete arches forming a portico across the front façade.

The colonnade effect is continued around the building as a blind arcade. When the building was constructed, large round chandeliers hung from the portico, matching lights and chandeliers throughout the building. Deterioration as a result of weathering caused replacement of the outside chandeliers. Inside, elevators supplement plain functional staircases, located behind closed doors, providing a striking contrast with the ornately carved wooden banisters in earlier courthouses.

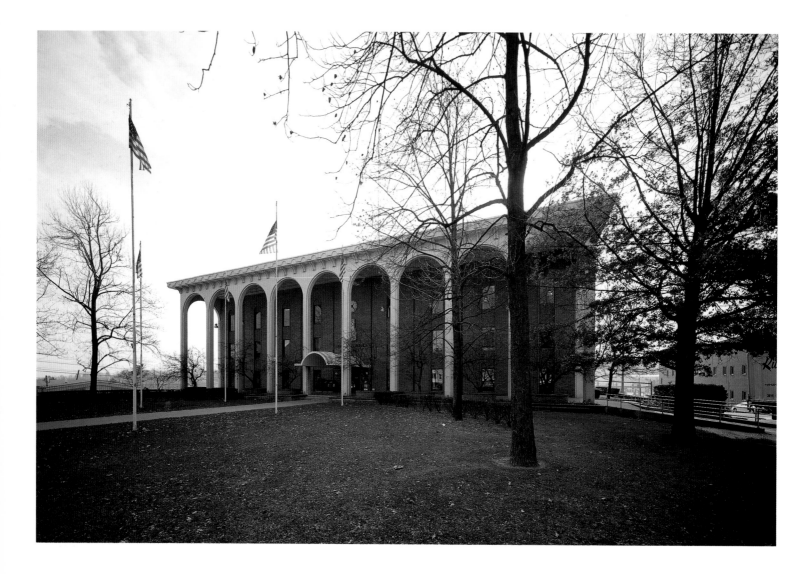

*Above: Richland County Courthouse.*

# Warren County

*Origin of name: Revolutionary War General Joseph Warren*
*County seat: Lebanon*
*Courthouse construction: 1979-80*
*Architects: A.C. Voorhis & Associates*

The Land Ordinance passed by the Continental Congress in 1785, directed that the land in the Northwest Territory be divided into civil townships, each one to be six miles square, to be further divided into thirty-six square sections, numbered after a regular pattern. Ohio was the first territory whose land was systematically divided in that fashion.

In the beginning Congress sought to sell large areas to land companies comprised of individuals, who in turn sold smaller portions to settlers. Under this plan, John Cleves Symmes, a prominent resident of New Jersey and a former member of the Continental Congress, petitioned Congress for a grant of about two million acres situated between the Miami Rivers in 1788. Due to financial difficulties he finally, on September 30, 1794, obtained a United States Patent Deed signed by President George Washington, conveying to him 311,682 acres between the Great Miami and Little Miami Rivers, bordering on the Ohio River and running north to about as far as Lebanon. Known as the Symmes or Miami Purchase, it is currently defined as Warren County, although it also includes portions of present day Butler and Hamilton Counties. The remainder of the Symmes Purchase reverted back to the government, and was sold to settlers under the designation of Congress Lands (see map under Muskingum County).

Subsequently, the population increased to the extent that the county was formed May 1, 1803, and the first courthouse constructed in 1805. The second followed in 1835. While buildings change over time, the latter was remodeled so often there is little visibly remaining of the original structure. The lines of the exterior are discernible only at the west and east façades, where arcading defines each bay. Upgraded, this structure is now used as a county administrative building.

This old brick courthouse is located near the Lebanon business district, but the newly constructed courthouse and jail are housed in a complex removed from the center of town. The campus-like grouping, built on farmland that at one time supported the Warren County Home, is now the location of various county agencies.

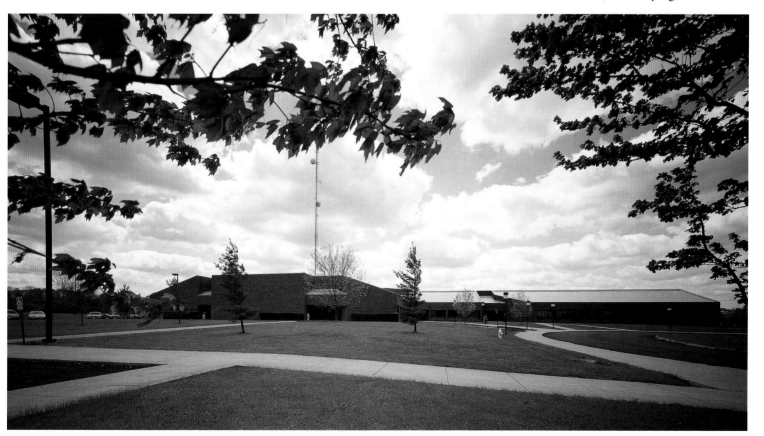

*Above: The Warren County Courthouse. This horizontal, one-story building, constructed with warm brown colored bricks and reduced ornamentation does not look like the courthouses of yesterday. Its functionalism, however, supersedes nostalgia.*

# Warren County

*Above: Courtroom. At the time of construction, television cameras were approved for courtrooms. At the judges' request, the courtrooms were altered and media rooms added, so cameras could remain behind glass (see window to the left of the entrance door) and be less disruptive to the participants.*

*Above: Lobby.*

*Above: An aerial view of the Warren County Courts Complex.*

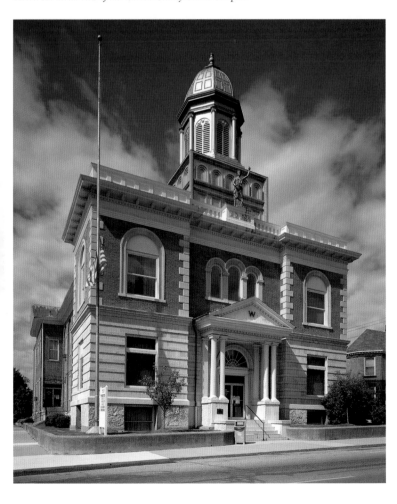

*Above: 1835 Courthouse, the county's second.*

# Gallia County

*Origin of name: Gaul, the ancient name of France*
*County seat: Gallipolis*
*Courthouse Constructed: 1983-85*
*Architects: Eesley, Lee, Vargo and Cassady*

The Ohio River contributes to the state's distinctive shape, and was a vital thoroughfare in populating the frontier. After the American Revolution, Congress sold land along the river to the Ohio Company and granted options to the Scioto Company (a subsidiary of the Ohio Company) for three-and-a-half million acres bordering on the Ohio Company's purchase. The terms of the agreement proposed that the Scioto Company sell the land first, and then settle with Congress. After selling some of the land to a group of French aristocrats fearing retribution during the French Revolution, it neglected to reimburse the Federal Treasury. After an arduous journey, the French arrived in Alexandria, Virginia, only to discover the deeds from the Scioto Company were worthless. Pandemonium ensued.

Through the intervention of Congress and President George Washington, the Scioto Company agreed to assist the French with their travel to the Ohio wilderness, and to help them build eighty log houses and four blockhouses facing the river. On October 17, 1790, the immigrants arrived at what is now the site of Gallipolis City Park. Their settlement was named Gallipolis: City of the Gauls. Five years later, Congress granted them free land (the French Grant) in what is now Scioto County (see map under Muskingum County). A few agreed to leave, although most refused, and in order to remain, bought their land again from The Ohio Company.

Soon after Ohio's admission to the Union, the legislature created eight new counties, including Gallia, and on May 2, 1808, the cornerstone was laid for the first courthouse to be constructed in the Gallipolis town square. It was replaced in 1848 by one at the present courthouse site. Both that second and the third

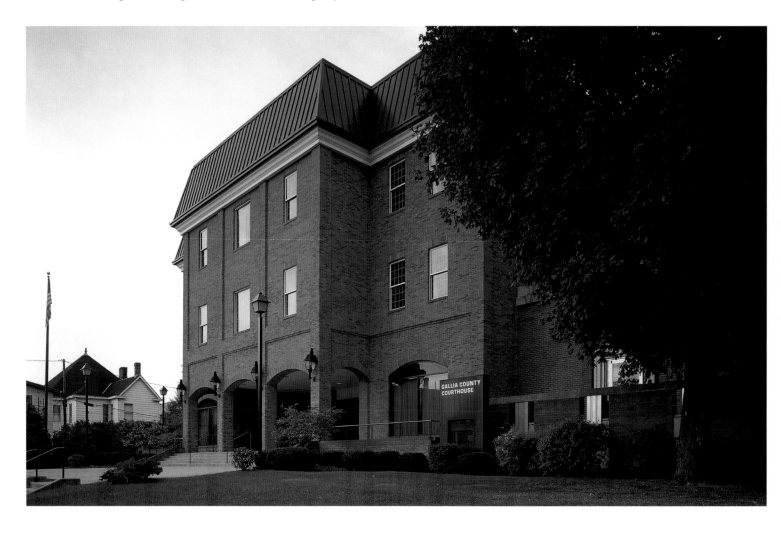

*Above: The Gallia County Courthouse.*

courthouses were razed by arsonists attempting to destroy indictment papers.

The fourth, an Italianate building completed in 1879, burned on January 8, 1981. The cause of this fire was believed to be a defective heater in use on the second floor. Seven persons were injured fighting the blaze, and the damage was estimated at over one million dollars. Its annex (completed in 1962) and most of the records were saved.

The fifth courthouse, dedicated on November 9, 1985, is built fireproof, with a steel frame, concrete floors, and a sprinkler system. It houses the county offices, has adequate storage space, and is accessible to the handicapped.

*Above: Gallipolis City Park and Town Square, with the Ohio River in background. This was the location of the first settlement and first courthouse.*

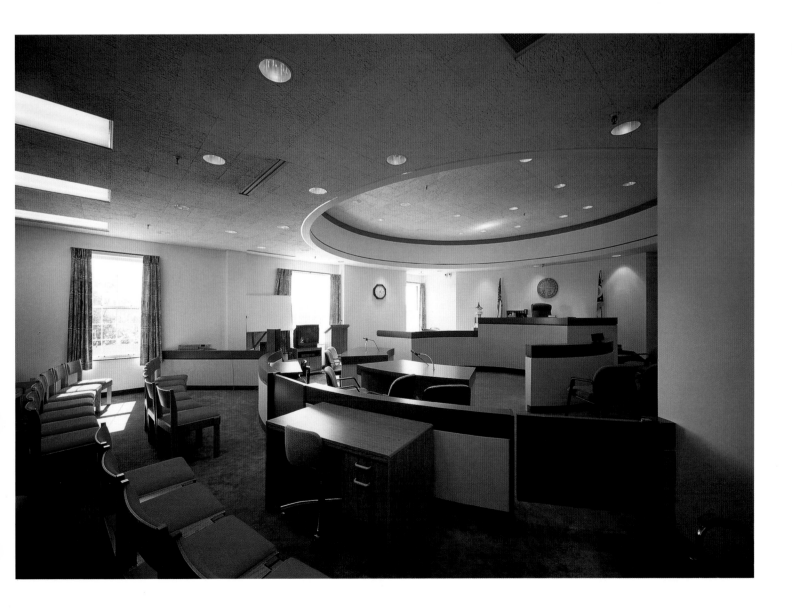

*Above: Round Common Pleas courtroom.*

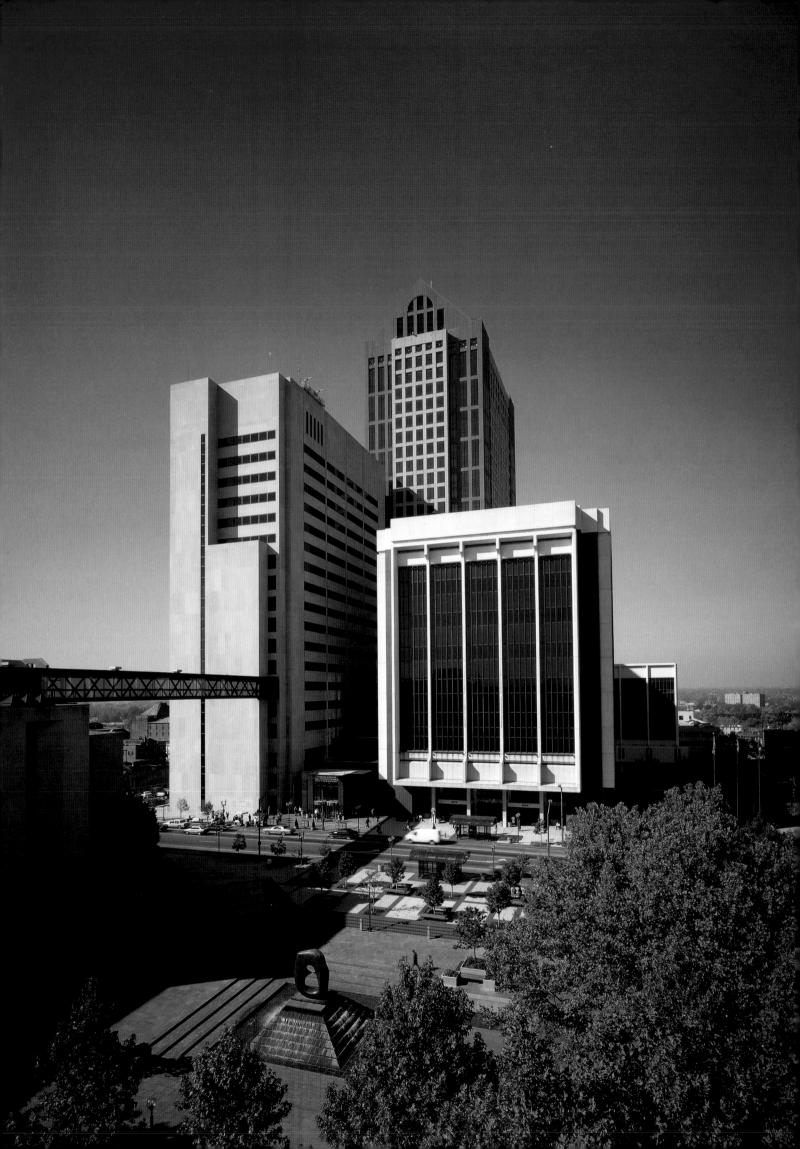

# Franklin County

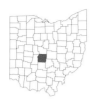

*Origin of name: Benjamin Franklin*
*County seat: Columbus*
*Courthouse constructed: 1989-91*
*Architects: URS Consultants, Inc.*

The Franklin County Courthouse is located within the County Government Center. The hi-tech county government complex of six buildings sits on the site of the demolished 1887 Courthouse structure. In fact, Franklin County's magnificent courthouse is the third building to serve such a purpose since Franklin County's founding in 1803. The original courthouse, built in 1840 was destroyed by a fire in 1879. Six years later, as a part of a July 4th celebration, the cornerstone for a new building was placed, and on July 13, 1887, the second Franklin County Courthouse was dedicated. This building, located on High Street between Mound and Fulton, served the county for almost 90 years before it was demolished in 1974. The newest courthouse was begun in February, 1989, and the first occupants moved in during October, 1990. The building, which cost $75 million, was completed on time in June, 1991.

The present Franklin County Courthouse is a 27-story tower complex rising 464 feet above Front Street. Providing 644,000 square feet of floor area, the new building incorporates approximately 25,000 cubic yards of concrete, 6,170 tons of structural steel, 540 tons of reinforcing steel, 194,000 square feet of granite chipped precast, and 47,350 square feet of conventional granite on walls, columns and floors. The extensive façade of the tower is granite chipped precast and standing seam metal.

The county's courthouse is the most recent addition to the Franklin County Government Center, which consists of a Juvenile Detention Center and parking structure, Hall of Justice, Municipal Court Building, and County Courthouse Annex and Parking Garage. An atrium opening onto High Street connects three of the buildings: the new courthouse, Hall of Justice and Municipal Court Building. The ground floor of the courthouse tower houses a two-story granite clad lobby and 250 seat auditorium. Floors three through six contain the Domestic Relations/Juvenile Court and hearing rooms. The upper 20 floors house the Court of Appeals, Probate Court, Judicial Administration, County Administration, Computer Center and Cafeteria. In all some 1800+ County employees call the tower their "working home."

Located at the southern edge of the Columbus downtown business district, this twenty-seven story high-rise is a part of the ever-growing Columbus skyline. The building is designed to serve and protect the county's judiciary and administrative functions. Surveillance cameras are incorporated

*Left: The Franklin County Government Center is a state of the art facility designed to efficiently and effectively serve the county's judicial, administrative government, and residents' needs.*

*Above: The lobby.*

# Franklin County

both in and out of the building while separate banks of elevators and corridors are provided for the convenience and safety of judges, jury, defendants, and the public. Some lobby areas contain walk-through magnetometers and x-ray machines.

Throughout the courthouse, art placed by the Columbus Museum of Art, is displayed as part of the Art in Public Spaces program through an agreement with the county commissioners.

Massive, finely engineered and fortified, but still striving to remain as accessible as those courthouses which sit on their grassy squares, Franklin County Government Center may be considered a statement of fine architecture coupled with wise planning. The building was designed with future needs, legislated program expansions, ease of maintenance, efficient service delivery, and overall service growth to the public in mind.

*Above: View of the computer, technical, and mechanical systems, painted in primary colors.*

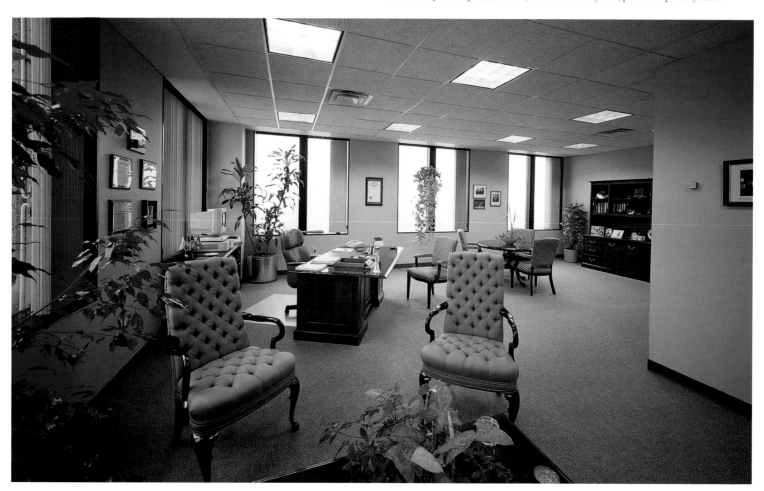

*Above: Because the role of county commissioners is so diverse, the daily work area designed for them permits the flexibility of office space, conference room, and visitor waiting area all rolled into one.*

256

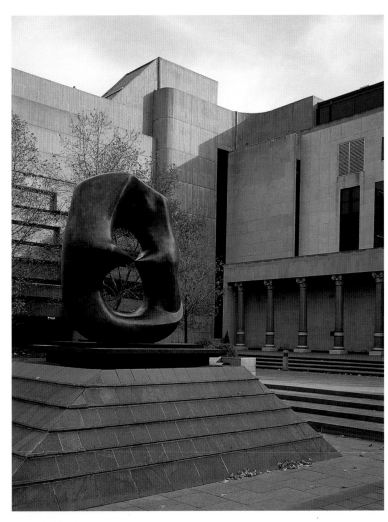

*Left: "Dorrian's Commons," is an open space memorial to former County Commissioner, Michael J. Dorrian. The commons area houses Henry Moore's giant bronze sculpture, "Large Oval with Points" which is on loan from the Columbus Museum of Art, to whom it was donated by the Lazarus Family. The pillars are remnants of the old Second Empire courthouse.*

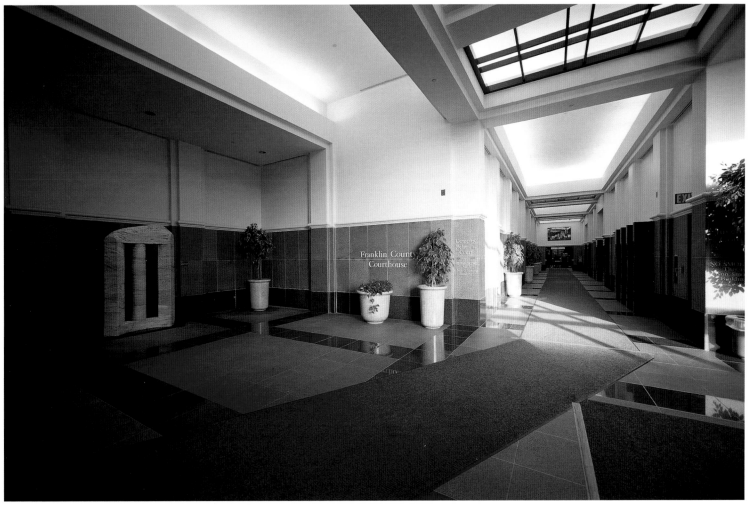

*Above: More of the artwork on display in the lobby, alongside a bank of elevators.*

# Glossary

**Americans with Disabilities Act (ADA)**
Public entities must provide equal access for people with disabilities, to the services, programs, or activities that they offer to the public.

**Arcade**
A row of arches with supporting columns or piers.

**Art Deco**
A decorative style of the 1920s and 1930s, characterized by bold outlines, streamlined and rectilinear forms, and the use of new materials like plastic.

**Ashlar**
Stonework in formed or cut rectangular pieces, laid either so as to form continuous courses the entire length of a wall (coursed ashlar) or combining stones of varied sizes (random ashlar), in either case without thick or irregular mortar joints.

**Baluster**
An upright, often vase-shaped, support for a railing.

**Balustrade**
A handrail supported by balusters. On many Renaissance buildings, balustrades appear above the main entablature.

**Bas-relief**
Sculptured relief, in which the projection from the surrounding surface is slight, and no part of the modeled form is undercut. See RELIEF SCULPTURE.

**Beaux Arts**
Les beaux-arts (the fine arts) refer to the aesthetic principles enunciated and perpetuated by the École des Beaux-arts in France. These emphasized the study of Greek and Roman architecture, and are characterized by symmetry, heavy ashlar stone bases, grand stairways, paired columns, monumental attics, grand arched openings, decorative swags, medallions and sculptural figures.

**Beltcourse**
A narrow horizontal band projecting from the exterior walls of a building, usually defining the interior floor levels.

**Bracket**
A support element under eaves or other overhang; often more decorative than functional.

**Cantilever**
A horizontal structural member, supported only at one end or along a single line by a wall or column, stabilized by a counterbalancing downward force around the point of the fulcrum.

**Capital**
The top decorated part of a column, pilaster or shaft supporting the entablature. Column capitals, while forming a satisfying visual transition from the vertical shaft of the column to the horizontal entablature, may also increase the structural efficiency of the column by providing broader support for the load. Corinthian order capitals are richly ornamented, Ionic less so, and Doric order capitals are simple.

**Classical**
Pertaining to the architecture of ancient Greece and Rome or to any architecture based upon them.

**Coffer**
A recessed, box-like panel in a ceiling.

**Column**
A vertical support, usually cylindrical in form, consisting of a base, shaft and capital (the Greek Doric column has no base). Columns are usually in a row (colonnade) with a space between each to carry an entablature, an arcade, or other load, but they are also sometimes used singly for decorative purposes.

**Corbelling**
Brick or masonry courses, each built out beyond the one below to support or form a rough arch, vault or dome.

**Cornice**
The top, projecting section of an entablature; also, any projecting ornamental molding along the top of a building, wall, arch, etc., finishing or crowning it.

**Corinthian Order**
See ORDERS

**Cresting**
An ornamental finish along the top of a wall or roof.

**Course**
A row of bricks or masonry blocks extending the length and thickness of a wall.

**Cupola**
A dome-shaped roof on a circular base crowning a roof or turret.

**Dentil**
A decorative molding made up of projecting blocks; so named because it resembles a set of teeth.

**Dome**
A vault of regular curvature raised on a circular base.

**Doric Order**
See ORDERS

**Dormer**
A vertically-set window on a sloping roof.

**Drum**
A cylindrical or other structure supporting a dome.

**Eclectic Design**
One that draws ideas and inspiration from many sources, rather than a single vision.

**Encaustic Tile**
Glazed and decorated earthenware tiles.

**Entablature**
The different classical orders are reflected not just in the forms of the column and the capital, but also in that part of the composition above the column, the upper part of the order that comprises the architrave (bottom), frieze (middle), and cornice (top).

**Façade**
The front or principal face of a building.

**Fanlight**
A semicircular or fan-shaped window with radiating members or tracery, set over a door or window.

## Federal Style

Popular in the early period of the United States (late 1700s through 1830s). Characterized by square or rectangular shapes, brick or frame, topped with low-hipped roofs. This style frequently incorporated fan and oval forms, narrow columns and moldings, exterior decoration limited to a porch or entrance, and delicate rosettes, urns, and swag-decorated cornices, doors, and window frames.

## Fluted

Having regularly-spaced, parallel vertical grooves or "flutes," as on the shaft of a column, pilaster or other surface.

## Fresco

A painting made on fresh, wet plaster; usually for decorating walls and ceilings. The plaster absorbs the colors and, when dry, preserves an image that is literally part of the wall.

## Frieze

The middle division of an entablature, between the architrave and cornice, usually decorated but sometimes plain. The decorated band along the upper part of an internal wall, immediately below the cornice.

## Functionalism

Modernism was based on a philosophy that saw a direct relationship between functional requirements and form, the former shaping the latter. It was a view that offered less place to emotional or symbolic elements in architecture.

## Gable

A triangular wall segment at the end of a double-pitched or gabled roof. It extends from the eaves or cornice to the ridge of the roof. In classical architecture, the gable is called a pediment.

## Greek Key Cornice

Also known as fret or fretwork. A geometrical ornament of horizontal and vertical straight lines repeated to form a band.

## Greek Revival Style

Based on the architecture of ancient Greek temples, it flourished in the United States during the 1830s and 1840s. It features columns, pilasters, bold simple moldings, pedimented gables, heavy cornices with unadorned friezes, and horizontal transoms above the entrances.

## Hood-molding

A large projecting molding over a window, originally designed to direct water away from the wall; also called a drip molding.

## Ionic Order

See ORDERS

## Italianate Style

Also known as Tuscan, this architecture of Renaissance Italy was popular in American architecture of the mid nineteenth century. Italianate features include shallow hip roofs, overhanging eaves with decorative brackets, an entrance tower, round-headed windows with hood-moldings, corner quoins, arcaded porches, and balustraded balconies.

## Lancet

A tall, narrow, pointed arch or window.

## Lantern

A turret crowning a dome, roof, or tower, usually pierced with windows for light or louvers for ventilation.

## Leaded Glass

Small panes of glass held in place with lead strips; the glass may be clear or stained.

## Lintel

A horizontal beam, of any material, spanning an opening, as over a window or doorway, or between two pillars.

## Mansard Roof

A roof having very steep sides on all four sides and a flat or nearly flat upper area.

## Masonry

Wall construction of materials such as stone, brick or concrete. Masonry is usually laid in mortar, a mixture of lime or cement with sand and water, which binds the whole. Stones and bricks are laid in "courses," or level rows.

## Moderne

Construction of glass and steel, combined with reinforced concrete and brick. Almost devoid of decorative detail, it is inspired by the new materials of modern technology.

## Mosaic

A method of decorating with patterns or pictures composed of small pieces of colored stone or glass set in wet cement that, when hardened, holds them in place.

## Mural

A large painting in any medium, made for a particular wall, either painted directly on its surface or onto a canvas or panel affixed to it.

## Neo-classicism

During the first decades of the twentieth century, the classical architecture of ancient Greece and Rome and the Italian Renaissance were the models for this style of public buildings. A number of influential American architects, trained classically at the École des Beaux-Arts in Paris, designed in this style. Characterized by largeness of scale, columns supporting porticos or full pediments, full eave-line entablatures, and stone balustrades or parapets rimming the edges of low roofs.

## Northwest Ordinance

Established the principle that the western territories would not be ruled as colonies. In 1783 the acquisition from Britain of the land from the Appalachians to the Mississippi doubled the size of the country, and laid claims to lands that had been inhabited by Native Americans. The Ordinance, adopted by the Confederation Congress in 1787 made three guarantees:

1. It provided that new states in the Northwest Territory would eventually enter the Union "on the equal footing with the original states."

2. It promised that "schools and the means of education shall forever be encouraged" because "religion morality and knowledge" were necessary for good government and the happiness of mankind.

3. And it permitted "neither slavery nor involuntary servitude," the first time the federal government banned slavery anywhere.

## Orders

An architectural "order" is one of the classical systems of carefully proportioned and interdependent parts that include a column and its entablature. Although the capital of each of the generally recognized orders is its most distinctive feature, each order also has its own characteristic system of proportion, so that any alteration in the size of one part necessitates a change in the size of all the other parts. The oldest, sturdiest and simplest of the orders is the Greek Doric (which is the only order without a base). The Ionic order is more slender, and has volutes of its capital and a three-part architrave. The Corinthian and composite orders are the most ornamented and the most slender; both have capitals decorated with acanthus leaves, but in the composite order capital the leaves are combined with the large volutes of the Ionic order.

## Palladian Window

A three-part window opening with a tall arched central window flanked by two shorter and narrower ones. Pilasters or columns usually frame each window.

## Parapet

A low, solid protective wall or railing along the edge of a roof or balcony.

**Pavilion**

A part of a building projecting from the main structure.

**Pediment**

A wide, low-pitched gable surmounting the façade of a building in a classical style; any similar triangular crowning element used over doors, windows and niches. The triangular area, often containing sculpture, between the entablature and the roof of a Greek or Roman temple.

**Pendentives**

A concave triangular space leading from the angle of two walls to the base of a circular dome. One of the curving triangular segments of vaulting which spring from the corners of a square plan to support a circular dome.

**Peristyle**

A range of columns surrounding a building or open court.

**Pilaster**

A flat representation of a column. A flat, vertical member projecting slightly from a wall surface and divided, like a column of one of the classical orders, into base, shaft, and capital. Although customarily supporting an entablature, it is most often used for decorative rather than structural purposes.

**Polychrome**

Multi-colored. Describes the use of many colors in decoration.

**Portico**

A major porch, usually with a pedimented roof supported by classical columns, and approached by a flight of steps.

**Quoin**

Units of stone or brick used to decorate, accentuate, or reinforce the corners of a masonry building.

**Reinforced Concrete**

The use of steel elements to overcome the weakness of concrete in tension. Combining massive concrete with steel reinforcing rods makes the most efficient use possible of both materials, thus reducing structures to the minimum possible thickness.

**Relief Sculpture**

Sculpture that is not freestanding, but is carved or cast to project from the surface of which it is part.

**Repoussé**

Shaped or ornamented with patterns in relief made by hammering or pressing on the reverse side–used especially of metal.

**Richardsonian Romanesque Style**

American Henry Hobson Richardson's interpretation of late nineteenth-century Romanesque Revival. Elements include round arches framing horizontal and rough-textured windows and door openings. Heaviness emphasized by stone/rock-faced masonry construction, deep windows, cavernous door openings and bands of openings. A single tower, massive and bold in outline, and often asymmetrical, crowns the structure.

**Rotunda**

A building or area of a building covered by a dome.

**Second Empire Style**

Flourished in the U.S. after the Civil War. Its inspiration was the monumental urban architecture of France during Napoleon III's Second Empire, and it characteristic feature is the mansard roof. Dormer windows provide light for the additional floor resulting from the mansard roof. Roofs are decorated with colored slates laid in geometric patterns.

**Second Renaissance Revival Style**

A reaction to the heavy eclectic ornamentation of Victorian design. Characteristics of the style are strongly differentiated stories, either by the use of stringcourses, contrasts in the degree of rustication, or arched openings on one floor and a columned balustrade above. Horizontality is usually emphasized. Fine decorative detail throughout. Doorways are usually centrally placed, and windows arranged in a highly ordered manner.

**Terracotta**

A fine-grained, brown-red, fired clay used for roof tiles and decoration; literally, cooked earth.

**Tracery**

Ornamental intersecting stonework in the upper part of a window.

**Transitional Style**

A term usually referring to a period of transition. Sometimes details of the later styles are used on the general forms of the earlier.

**Trefoil**

A design of three lobes, similar to a cloverleaf.

**Vault**

An arched ceiling of masonry.

**Volute**

A spiral, scroll-like ornament. An ornamental spiral, as on either side of an Ionic capital.

**Works Progress Administration (WPA)**

A work relief program, employing unemployed on projects of public benefit, first named the Temporary Civil Works Administration, then the Works Progress Administration (W.P.A.); later the Work Projects Administration; created by executive order in 1935. About 75% of W.P.A. projects were in construction, with the remainder in service projects. The majority of projects were planned, initiated, and sponsored by cities, counties and other public agencies; the proportion of sponsors' contributions ranged from 10% of the total cost of all W.P.A. projects in 1936 to about 30% in 1943. The results of the W.P.A. were varied-construction or repair of 650,000 miles of highways, roads and streets; construction of nearly 40,000 new public buildings, and the repair or improvement of more than 85,000 existing buildings; the construction or improvement of thousands of parks, playgrounds and other recreational facilities; the installation or improvement of public utilities' service and sanitation facilities; the extension of flood and erosion control, irrigation and conservation; the construction or improvement of thousands of airports and airways facilities; and the preservation of numerous historic buildings, including Independence Hall in Philadelphia and Boston's Faneuil Hall.

# Selected Bibliography

Allsbouse, Evelyn, *History of Paulding County*, Paulding, Ohio, 1964.

Architectural Foundation of Cincinnati, *Architecture and Construction in Cincinnati*, Vol. 1, 1987.

*Atlas of Morgan County, Ohio*, Paul R. Murray, New Philadelphia, Ohio, n.d.

Beatty, Elizabeth Gover, and Stone, Marjorie S., *Getting To Know Athens County*, The Stone House, Athens, Ohio, 1984.

Becker, Dan, *Their Buildings Now: Sidney Courthouse Square National Historic District*, Sidney/Shelby County Chamber of Commerce, Sidney, Ohio, 1981-1987.

Bentley, Elizabeth Petty, *County Courthouse Book*, Genealogical Publishing Co., Baltimore, Maryland, 1990.

Bentz, Carolyn, "Old Courthouses," from *In the Wonderful World of Ohio*, Ohio Department of Development; Columbus, Ohio, vol. 34, no. 10, October 1970, pp. 24-28.

Biggs, Louise Ogan, *A Brief History of Vinton County*, Heer Printing, Columbus, Ohio, 1950.

Burke, Thomas Aquinas, *Ohio Lands–A Short History*, Ohio Auditor of State, 1997.

Campen, Richard N., *Architecture of the Western Reserve 1800-1900*, The Press of Case Western Reserve University, Cleveland and London, 1971.

Campen, Richard N., *Ohio–An Architectural Portrait*, West Summit Press, Chagrin Falls, Ohio, 1973.

Carey, Carol Witherspoon, *Fayette County, Ohio–A Pictorial History*, The Donning Company Publishers, 1993.

*A Century of Progress*, Souvenir Edition, Antwerp, Ohio, 1941.

*The (Celina, Ohio) Daily Standard*, report from vol. XIX, no. 208, for September 3, 1923.

*Dictionary of American Military Biography*, Roger J. Spiller, ed., Greenwood Press, Westport, Conn., 1984.

Dirlan, Kenneth, *John Chapman, By Occupation a Gatherer and Planter of Appleseeds*, County Historical Society, Mansfield, Ohio, 1954.

Downes, Randolph C., *Evolution of Ohio County Boundaries*, The Ohio Historical Society, Columbus, Ohio, 1970. Originally published in Ohio Archaeological and Historical Journal, vol. XXXVI, Ohio State Archaeological and Historical Society, Columbus, Ohio, 1927.

Everts, Louis H., *History of Clermont County, Ohio with Illustrations and Biographical Sketches of its Prominent Men and Pioneers*, J.B. Lippincott & Co., Philadelphia, Pennsylvania, 1880.

Fleming, John, Honour, Hugh, and Pevsner, Nikolaus, *The Penguin Dictionary of Architecture*, 4th ed., Penguin Books, Harmondsworth, England, 1991.

Gibbs, David W., *Court-houses of Ohio, Specifications for the erection and completion of a court house in the town of Napoleon, for the county of Henry and State of Ohio as designed by David W. Gibbs, architect, Toledo Ohio*. Ohio Northwest Print, Napoleon, Ohio, 1880.

Goslin, Charles R., *The Fairfield County Courthouse Story*, published by Fairfield County Commissioners, Lancaster, Ohio, 1972 (revised 1975 and 1986).

Graham, A.A., *History of Fairfield and Perry Counties Ohio, Their Past and Present*, W.H. Beers & Co., Chicago, Illinois, 1883.

Graham, Bernice, *The Washington County, Ohio Common Pleas Court*, Marietta, Ohio, 1977.

Graham, Bernice, *The Washington County, Ohio Court House*, Marietta, Ohio, 1978.

Hamilton, R. Hayes, *Greene County and Its Court Houses, 1750-1950*, Buckeye Press, Xenia, Ohio, 1951.

Hill, Frank, *A History of Gallia County Courthouses 1806-1981*, Gallia County Historical Society, Gallipolis, Ohio, 1981.

*Harrison County Courthouse, Cadiz, Ohio 1895-1995*, Business Services Associates, Cadiz, Ohio, as commissioned by Harrison County Courthouse Centennial Committee in conjunction with the Centennial Celebration, August, 26 1995.

*Historic Counties and Court Houses of Ohio and the Prominent Men Associated with Them*, National Society of the Colonial Dames of America, 1966.

*Historic Lisbon, Ohio*, Lisbon Area Chamber of Commerce, Lisbon, Ohio, n.d.

*History of Defiance County, Ohio*, Warner, Beers & Co., Chicago, Illinois, 1883.

*History of Seneca County, Ohio*, Warner, Beers & Co., Chicago, Illinois, 1886.

Howe, Henry, *Historical Collections of Ohio*, 2 vols., C.J. Krehbiel & Co., Cincinnati, Ohio, 1888.

Huss, John E., *Temple of Justice, The Seneca County Court House*, 1983, unpublished.

Illman, Harry R., *Unholy Toledo*, Polemic Press, San Francisco, California, 1985.

*Inventory of Ohio County Archives #57*, Historical Survey, Works Project Administration in Ohio, Columbus, 1941, pp. 51-53, "Erection and Organization of Ohio Counties."

Jones, Paul Willis, *Wood County Courthouse, Historical Highlights 1894-1994*, Wood County Centennial Commission, Bowling Green, Ohio, 1994.

Knepper, George W., *Ohio and Its People*, The Kent State University Press, Kent, Ohio, 1989.

Krick, Melinda H., *A History of Paulding County's County Seats and Courthouses: A Centennial Anniversary Publication*, Paulding, Ohio, 1986.

*The Lake County Historical Society Quarterly,* vol. 21; no. 2, "President James A. Garfield Museum, Mentor, Ohio," June 1979.

*Lawyers in Southwestern Ohio,* editors Mary Lou Marks and Frank G. Davis, The Cincinnati Bar Association, Cincinnati, Ohio, 1972.

*The Lima (Ohio) News,* report from vol. 50, no. 45, for March 3, 1934.

Maienknecht, Theresa A. and Maienknecht, Stanley B., *Monroe County, Ohio–A History,* Windmill Publication, Inc., Mt. Vernon, Indiana, 1989.

Marshall, Carrington T., *A History of The Courts and Lawyers of Ohio,* The American Historical Society, vol. 1, New York, 1934.

Martzolff, Clement L., *History of Perry County, Ohio,* Ward & Weiland, New Lexington, Ohio, 1902.

Marzulli, Lawrence J., *The Development of Ohio's Counties and Their Historic Courthouses,* Gray Printing Co., for Columbus Ohio County Commissioners Association of Ohio, Fostoria, Ohio, 1982/3.

*Mercer County Ohio: History,* editor Joyce L. Alig, The Mercer County Historical Society, Celina, Ohio, 1978.

Montgomery County Historical Society, *The finest thing of its kind in America! The Story of The Old Court House, Dayton, Ohio,* Dayton, Ohio, n.d.

*Museum Echoes,* Ohio Historical Society, Columbus, Ohio, vol. 29, no. 11, for November 1956, pp. 83-86.

*News–Journal,* Wilmington, Ohio reports from issues for July 22, 1997, July 24, 1997, September 30, 1997, December 27, 1997. January 31, 1998, June 5, 1998, May 22, 1998, September 5, 1998.

*Northwest Ohio Quarterly,* Historical Society of Northwestern Ohio, Toledo, Ohio, vol. XXV, no. 1, Winter 1952-53, pp. 22-36.

O'Bryant, Michael, editor, *The Ohio Almanac,* Orange-Frazier Press, Wilmington, Ohio, 1997.

O'Daffer, Floyd, *History of Van Wert County,* Fairway Press, Lima, Ohio, 1990.

O'Kelley, Doramae, "Late 19th Century Courthouse Architecture in NW Ohio," *Ohio History,* v. 88, no. 3, Summer 1976, pp. 311-26.

Ohio Department of Development, *The Great 88,* Columbus, Ohio, 1993.

*Ohio Historic Inventory Manual,* Ohio Historic Preservation Office, Ohio Historical Society, Columbus, Ohio, 1992.

*Ohio and National Registries / Inventories,* Ohio Historic Preservation Office, Ohio Historical Society, Columbus, Ohio, 1992.

*Ohio Judicial System,* Supreme Court of Ohio, Columbus, Ohio, n.d.

Ohio Preservation Alliance, *The Courthouse Reconsidered (a statewide symposium),* Findlay, Ohio, 1994.

*Ohio Revised Code,* Columbus, Ohio, n.d.

*Ohio's 88 Counties,* Historical Sketches presented by the County Commissioners' Clerks and Engineer's Secretaries Association of the State of Ohio, The Rockford Press, Rockford, Ohio, n.d.

Pare, Richard (ed.), *Courthouse, A Photographic Document,* conceived and directed by Phyllis Lambert; writers Phyllis Lambert et al.; photographers Harold Allen et al., Horizon Press, New York, c. 1978.

Pickenpaugh, Roger, Editor, *Noble County Vistas,* Gateway Press, Baltimore, Maryland, 1991.

Pierce, James Smith, *From Abacus to Zeus, A Handbook of Art History,* 4th ed., Prentice Hall, Englewood Cliffs, New Jersey, 1991.

Poppeliers, John C., Chambers, S. Allen, Jr., and Schwartz, Nancy B., *What Style Is It? A Guide to American Architecture,* Historic American Buildings Survey, National Park Service, U.S. Department of the Interior, The Preservation Press, Washington D.C., 1983.

*Record of Transactions of Clinton County Building Commission, Showing Receipts & Expenditures in Connection with Erection of the New Court House and Jail,* Wilmington, Ohio, 1921.

Robertson, Charles, *History of Morgan County, Ohio, with Portraits and Biographical Sketches of Its Pioneers and Prominent Men,* L.H. Watkins and Co., 1886.

*The Sandusky (Ohio) Register,* report from August 27, 1989.

Schotterbeck, Seth S., *The Court House Square,* Preble County Historical Society, Eaton, Ohio, 1986.

*A Standard History of The Hanging Rock Iron Region of Ohio,* Willard, Eugene B. Editor, vol. 1, Lewis Publishing Company, Ohio, 1916.

Stebbins, Clair, *Ohio's Court Houses,* Ohio State Bar Association, Columbus, Ohio, 1980.

Tierney, Kevin, *Darrow, A Biography,* Thomas Y. Crowell, New York, 1979.

*Traveling The National Road,* editor, Merrit Ierley, Overlook Press, Woodstock, New York, 1990.

Tuscarawas County Genealogical Society, *History of Tuscarawas County, Ohio,* Taylor Publishing Co., Dallas, Texas, 1988.

Union County Commissioners, *Union County Re-Dedication Program,* Marysville, Ohio, April 23, 1994.

Union County Commissioners and Union County Historical Society, *A History of the Union County, Ohio Court House: 1883-1983,* Marysville, Ohio, 1983.

*Urbana (Ohio) Daily Citizen,* report for June 5, 1957.

Vastine, Roy E., *Scioto, A County History,* Knauff Graphics, Portsmouth, Ohio, 1986.

Virginia Historical Society, *The Virginia Magazine of History and Biography,* vol. 104, no. 49, Autumn 1996, Sandston, Virginia.

Wheeler, Thomas Bemis, *Troy in the Nineteenth Century,* Miller Printing Co., Springfield, Ohio, 1970.

Williams County Historical Society, *Williams County, Ohio: A Collection of Historic Sketches and Family Histories,* 1978.

Wolfe, William G., *Stories of Guernsey County, Ohio–History of an Average Ohio County,* Cambridge, Ohio, 1943.

*Wooster (Ohio) Daily Record,* report from July 27, 1993.